JÖRG BREU THE ELDER

Jörg Breu the Elder is published in the series
HISTORIES OF VISION
edited by Caroline van Eck, Vrije Universiteit, Amsterdam

Images are cultural constructions with their own poetics and histories, but so is vision itself. The aim of this series is to reconstruct these histories. It will be devoted to the study of works of art considered as ways of seeing, viewing practices, and the various codifications of visual perception connected with the arts and artistic theories through the ages.

FORTHCOMING, IN THE SAME SERIES

Defining Devotions
Nineteenth-Century Explorations of Later Buddhist Art in South Asia
Janice Leoshko

A Landscape of Grace and Terror: Modernism and the Maeght Foundation
Jan Birksted

Andrew Morrall

Jörg Breu the Elder

Art, culture and belief in Reformation Augsburg

ASHGATE

Published by
Ashgate Publishing Limited
Gower House
Croft Road
Aldershot
Hants GU11 3HR
England

Ashgate Publishing Company
131 Main Street
Burlington, VT 05401–5600 USA

Ashgate website: http://www.ashgate.com

British Library Cataloguing-in-Publication data

Morrall, Andrew
 Jörg Breu the Elder : art, culture and belief in
 Reformation Augsburg. – (Histories of vision)
 1. Breu, Jörg 2. Art – 16th century – Germany 3. Reformation
 and art – Germany
 I. Title
 709.2

Library of Congress Cataloging-in-Publication data

Morrall, Andrew
 Jörg Breu the Elder : art, culture, and belief in Reformation Augsburg / Andrew
 Morrall.
 p. cm. – (Histories of vision)
 Includes bibliographical references and index.
 ISBN 1-84014-608-7
 1. Art, German – Germany – Augsburg. 2. Art, Renaissance – Germany – Augsburg.
 3. Breu, Jörg, ca. 1480–1537 – Criticism and interpretation. 4. Reformation and
 art – Germany – Augsburg. I. Title. II. Series.

 N6886.A9 M67 2001
 759.3–dc21

 2001022061

ISBN 1 84014 608 7

Printed on acid-free paper

Typeset in Palatino by Manton Typesetters, Louth, Lincolnshire, UK and printed in Great Britain by Biddles Ltd, Guildford and King's Lynn.

Contents

List of Illustrations

2 The turn towards Italy

3 Breu and the Reformation

4 The '*deutsch*' and the '*welsch*': neoclassicism and its uses

5 Conclusion

Colour Plates at end of book

Acknowledgements

Many people have assisted in the course of writing this book. I would like to acknowledge my indebtedness to my supervisors of the thesis from which this study grew: to Professor Michael Kauffmann for his wise guidance and encouragement at every stage of preparation; and to Dr Jean Michel Massing, for his continuous interest and support. I have benefited greatly from their combined knowledge, expertise, and example. Dr Gode Krämer, of the Städtische Kunstsammlungen, Augsburg, read an early draft of my manuscript and has responded to my attempt to write on Breu with unfailing kindness, placing his own recent discoveries at my disposal, and generously providing photographs. I am greatly indebted to Dr Caroline van Eck, series editor of Histories of Vision, and to Pamela Edwardes and Ellen Keeling of Ashgate Publishing, for their editorial skill and patience in seeing this book through to completion.

Thanks are due to the staffs of the British Library, the Courtauld Institute Library and especially the Warburg Institute Library of London University, where much of the work was done, and which provided such a congenial and stimulating place of study. A London University travel grant enabled me to carry out research in Germany, which was made the more pleasurable by the friendly assistance of the staffs of the Augsburg Stadtarchiv and Staats- und Stadtbibliothek, of the Munich Staatsbibliothek, and of the Zentralinstitut für Kunstgeschichte over a number of summer campaigns. I am grateful also to the staff of the numerous museums who allowed me access to the works themselves and offered of their knowledge and expertise; in particular: Holm Bevers, Linda Cannon, Anneli Carrenbock, Renate Eikelmann, Thomas Hardy, Timothy Husband, Harald Marx and Jesse McNab. I wish to thank the museums and other owners, who have given permission for their works to be reproduced here, and those who have supplied photographs; in particular Pfarrer Josef Baier of the Katholisches Pfarramt, Aufhausen, Charlotte Ziegler of Stift Zwettl and Maria Prüller of Stift Melk, for the loan of colour transparencies. The sources of photographs are individually acknowledged in the List of Illustrations. I am most grateful to the Samuel H. Kress Foundation and to my own institution, the Bard Graduate Center, New York, for providing financial assistance towards the cost of reproductions and colour plates.

Among the many people who have supplied references, discussed ideas, and given practical assistance, are: Jane Bridgeman, Heinz Dormeier, Nicholas Eastaugh, David Ekserdjian, Tilman Falk, John Fludd, Anka Heimann, Daniel Hess, Jeremy Howard, Elizabeth McGrath, Michael Michael, Antje Schmitt,

Larry Silver, Alistair Smith, Patrick Sweeney, and Paul Taylor. My particular thanks are due to Herman and Nancy Kohlmeyer, for their support, practical and moral, and to Marianne Voss and Albert Bote for their unforgettable hospitality. My parents, Dr Eric John and Ursula Morrall, provided vital assistance with points of translation and transcription. To them I owe a debt of gratitude that runs deeper and extends over a far longer period than the writing of this study. Finally, I owe infinite thanks to my wife, Sassy, for her continuous love and support, and to my daughters, Rachel and Imogen, who have put up with me throughout with characteristic generosity and humour.

AM

For my Parents

Introduction: The artist's smile

Jörg Breu's life and career were co-extensive with the great era of German Renaissance painting. He belonged to the generation of artists, born in the 1470s, that included Dürer, Cranach, Grünewald, Altdorfer, and in his own city of Augsburg, Hans Burgkmair the Elder. Within the space of that single generation, the craft of painting was brought to new levels of accomplishment, its range of subject matter extended and its status among the sister arts significantly raised. The character of Breu's art and career was moulded by this context. His art may be counted as a defining part of the Augsburg school. His late style, in particular, is an important example of early German classicism and a conduit by which Italianate conventions entered into the German artistic tradition. Breu also possesses a position of singular historical interest. His career spans the dramatic years of the Reformation in Augsburg, when the city was riven with social and religious tensions, rioting and iconoclastic outbursts. Uniquely for a German artist, Breu left a record of his reactions to these events in a chronicle he wrote between 1512 and his death in 1537. In the course of this it is possible to trace the artist's conversion to the Protestant cause. The chronicle offers the opportunity, rare at this date, to penetrate the social and religious world of a German artist, and to a considerable extent, to set his work beside and within his life. It is the study of the artist within the context of two broad and related historical problems – the early reception of Italian art in Germany and the effects of the Reformation upon the nature and practice of art – that constitutes the subject of this book.

The broad outlines of Breu's artistic activity can be succinctly summarized. Born at some point in the later 1470s, he received his initial training in the workshop of the Augsburg artist Ulrich Apt the Elder, which he joined in 1493.[1] In the late 1490s he spent a number of years working as a journeyman and as an independent master in lower Austria. His monogram on an altarpiece painted for the monastery at Aggsbach, dated 1501, suggests his independent status by this date.[2] He was back in Augsburg in 1502, at which time he joined the painters' guild.[3] From this point onwards, Breu maintained a modestly sized workshop in the city and rose gradually to a position of considerable artistic eminence. From the second decade onwards, he won prestigious private, municipal and imperial commissions, notably the decoration of the Town Hall façade in 1516 and the wings of two sets of organ shutters in the funerary chapel of the Fugger family in the monastery church of St Anna. He designed glass-roundel series for both patrician and imperial residences and was one of several artists chosen to decorate the personal *Prayerbook* of Emperor Maximilian I. Throughout the Reformation

years of the 1520s and 1530s, he continued to work in a variety of media that included panel painting, fresco, woodcut and, increasingly, the decorated glass roundel, an area he came to dominate. In 1528–30 he contributed two paintings to historical and allegorical cycles made for Duke Wilhelm IV of Bavaria. In 1534, he handed over the running of the workshop to his son, Jörg Breu the Younger. He died three years later.[4]

The most striking characteristic of Breu's oeuvre as a whole is its wide stylistic diversity. His earliest attributable works, executed in Austria, show him to be an early and original exponent of the emergent Danube School idiom, a style quite foreign to the Augsburg tradition. Though the stylistic characteristics he developed there – in particular a powerfully expressive treatment of figure style and physiognomy – were never completely lost, on his return to Augsburg he drew closer to an established local manner shared by the elder Holbein, Hans Burgkmair and Ulrich Apt. This was based more on the fifteenth-century Flemish tradition, modified by the influence of Dürer and reflective of the tastes of a more metropolitan clientèle. In the second decade of the century his art began to register the influence of Italian art. This was limited to certain specific commissions and was self-conscious in its application. By this time also, he had developed a fluent and quite separate drawing style which he reserved for designs for painted glass-roundels and, to a certain extent, woodcuts. By the later 1520s, he had developed a strikingly idiosyncratic neoclassicism which increasingly dominated his output until his death.

No wholly convincing explanation of this curiously wayward and unstable sense of style has so far been offered in the considerable body of scholarly writing upon Breu. Indeed, a review of the historiography shows how the artist's broader position within the German Renaissance has followed equally shifting standpoints of art-historical writing since his rediscovery in the late nineteenth century. In the first part of the twentieth century, the time of greatest scholarly interest in Breu himself, historians of the German Renaissance focused their attention on the most forceful and innovatory artistic personalities. They created a hierarchy which, Vasari-like, concentrated upon the work of a number of outstanding personalities and left a shadowy majority of lesser craftsmen and *Kleinmeister* beneath. According to this premise, a flourishing era ended in the years around 1530, with the deaths of the great individuals such as Dürer and Altdorfer, while the Reformation finished off any lingering sign of artistic vitality. From the purely aesthetic viewpoint that engendered it, this picture worked well enough. It drew attention to the high artistic qualities and originality of these gifted individuals, while their collective achievement gave to the North something of the cultural prestige that Vasari's hero-artists had bestowed upon Italy.

Behind the writing of these early art historians lay a perspective governed by late-Romantic ideals, deeply coloured by the aesthetic of their own day. They celebrated genius, the display of individual temperament, the expression of emotion over reason. Their work also embodied a Hegelian notion of cultural history that fostered a strongly collectivist bias in their reading of

art, based around the idea of nation.[5] They sought (and found) in the work of artists they considered quintessentially German, like Cranach and Grünewald, the expression of a 'Germanic spirit'.[6] The very heterogeneous nature of German Renaissance art and the impulses towards individualism of the period neatly fitted the idea of the artist-creator, while its often emotive qualities suited early twentieth-century sensibilities and allowed them to see the Expressionist art of their own day as a continuation of abiding Germanic traditions.

A consequence of this cult of genius was to marginalize artists considered of the second rank. Breu's position was equivocal in that, while his early Danube School paintings – that is, his most obviously 'Germanic' works – were praised for their vigour, directness and spontaneity of expression, his later works were less well received. In general histories of the period his name appeared only briefly, eclipsed by the 'great' names. This tendency has continued: in recent studies, he has been used negatively, as a foil to artists of greater stature.[7]

The nationalism implicit in early interpretations of German Renaissance art laid stress upon the supposedly indigenous Germanic qualities of style and feeling and saw the intrusion of 'foreign', Italianate, characteristics as a dilution of a true national style.[8] This further marginalized artists like Breu, whose work exhibited a strong fascination with Italianate form. A further difficulty in appreciating Breu's later, 'mannerist' works lay in the tendency to view them against a Wölfflinian conception of Italian classicism as a monolithic tradition of ideal form. German classicism was deemed aesthetically inferior (and therefore, by the logic of the aesthetic approach, less worthy of serious consideration) because of its apparent inability to grasp the rules of Italian art theory. Artists who fell under the spell of Italy were thus doubly misguided in their abandonment of a 'true' indigenous tradition and in developing an inferior and unsatisfactory hybrid style.

These biases are exemplified in the first critical survey of Breu's paintings, written by Ernst Buchner in 1928,[9] which remains the main account of Breu's career to date. Buchner gave most space to the early Austrian altarpieces, seeing in them Breu's strongest works, where the untramelled Germanic spirit was most fully revealed. He characterized Breu's subsequent career in Augsburg, from 1502 until his death in 1537 – that is to say, his full professional career – as a long decline in his artistic powers, fatally weakened from the second decade onwards by his contact with Italian art. Breu's 'mannerism' was seen as a regression from the artist's early participation in the great flourishing of an indigenous style. Buchner explained this 'decline' in personal, psychological terms, as a loss of spirit in later life, already present in the second decade, but exacerbated by the onset of the Reformation.[10] He viewed Breu's various changes of style as manifestations of an individual temperament and did not consider the larger artistic context or cultural milieu in which he was operating. For Buchner, Breu's 'mannerist' period became 'dry' and 'bloodless' because the style no longer sprang from within, as it had notionally done in his early 'expressive' phase. Despite a descriptive

aptness in Buchner's account, such a personal and ahistorical frame of reference did not allow him adequately to address or even to recognize the importance of what is one of the most historically significant aspects of Breu's career: his response to Italian art. It also ignored the fact that Breu was at the height of his maturity, at the head of a thriving workshop and held in high regard by his contemporaries.

The distortions to the historical personality that such adherence to a priori principles of aesthetic value engendered, can be summarized in the qualities of a self-portrait drawing, dated 1517, which may serve also to introduce the artist (Fig. 0.1).[11] In its format, it may be compared with a similar and exactly contemporary self-portrait by Hans Burgkmair, made in connection with a portrait medal (Fig. 0.2).[12] In terms of draughtsmanship, of variety and suggestiveness of touch, the comparison favours the latter. Breu's outline is thin, hard and unmodulated. There is a tendency towards an almost overemphatic statement of fact in the desire to define the fleshy planes of the cheek and a certain clumsiness in their differentiation, as compared with Burgkmair's economy and delicacy of mark and stroke. The nose is given an undue prominence by a hard and continuous outline, the eye-sockets are formulaically rendered. The three-quarters rendering of the volumes of the head in space, though accurate and formally successful in balancing the composition, narrows the side-ways glance into a look of sly cunning. Yet despite these weaknesses, there can be no doubting the pride and self-assertion in the image's conception, expressed in the bold set of the chin, the direct, scrutinizing glance and, uniquely in self-portraiture at this date, the mouth curled at the corners into a half-smile. This is quite at odds with the solemnity of expression, habitual in self-portraiture of the period, registered in the Burgkmair. These qualities express an individuality and originality, which, in turn, bespeak an artistic and commercial confidence. In the artist's smile the historical personality asserts itself and disengages from the issues of aesthetic judgement. In 1517, the artist was at the height of his career, one year after completing several prestigious imperial and civic commissions and probably at the time engaged in the decoration of the Fugger Chapel in St Anna, Augsburg.[13] To speak of an artist losing interest or direction is clearly anachronistic.

The nationalism implicit in Buchner's writing is evident in the writings of other scholars in the 1930s.[14] Indeed, scholarly interest in Breu reached a peak in the late 1920s and 1930s and the number of articles produced is testimony to the momentum given to study of the German School by the enduring influence of *Geistesgeschichte*.[15]

In the aftermath of the Second World War, studies on Breu underwent a fallow period. In the face of the recent extremes of nationalism, Hegelian collectivism as a model of historical explanation was now wholly discredited. The general cultural assumptions, which for the preceding 40 years had given German Renaissance art a particular interest, even popular relevance, were no longer tenable, and with them collapsed the theoretical basis that had sustained study of German art as a whole, and which had

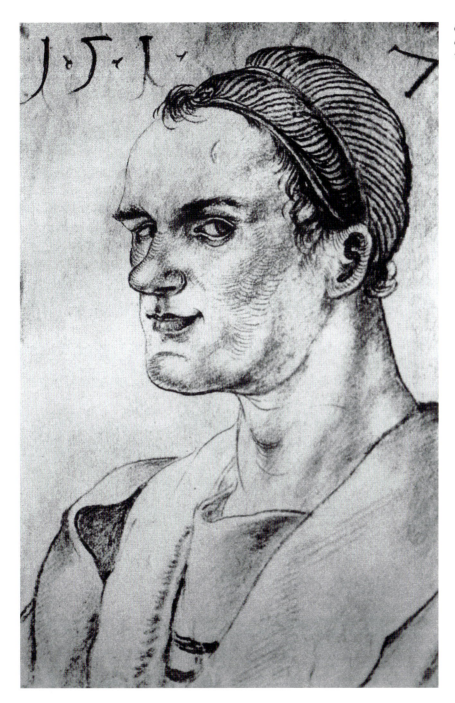

0.1 *Self-portrait*, chalk, heightened with red on paper

0.2 Hans Burkmair, *Self-portrait*, 1517, black chalk

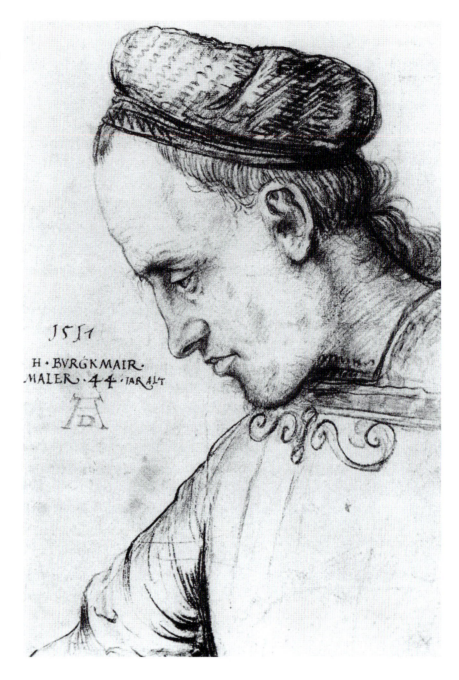

given Breu a position of modest historical significance. It was not to be replaced. An overall theoretical framework for the study of German Renaissance art was not to reappear until Marxist and social historians in the 1970s revitalized study of the Reformation. In the interim, Breu was marginalized to the position of a minor artist of a minor school of painting. Scholarly interest in him was expressed in isolated articles that addressed

problems specific to individual works, without regard to the artist's broader historical position.[16]

Since the late 1970s Breu has received more attention. César Menz's study of the three early Austrian altarpieces was the first to concern itself with factors other than the purely formal. His attempt to find a theological and cultural context for the violent Passion imagery of the early works significantly extended understanding of the works concerned.[17] The Italian sources and influences behind Breu's work were rigorously sifted in a thesis by Henriette Blankenhorn;[18] and the Organ Shutters in the Fugger Chapel in St Anna, Augsburg, have come under particular scrutiny.[19]

A second strand of Breu scholarship has involved not his art but the chronicle the artist wrote between 1512 and his death.[20] Friedrich Roth's erudite introduction to his printed edition remains the essential starting point for the subject.[21] He was interested in the chronicle mainly for the light it could throw upon the larger political events of the city, rather than what it revealed about Breu and his work. As such, he regarded it as of limited historical value. Carla Kramer-Schlette's subsequent comparative study of the chronicle with three other contemporary chronicles also found it disappointing as a source for the political history of the city.[22]

The first scholar to use the evidence of the chronicle to interpret Breu's paintings was Gode Krämer.[23] Drawing on the knowledge that Breu was an early and passionate supporter of the Evangelical cause, he interpreted the iconography of a number of religious works of the early 1520s as specifically Lutheran in their emphasis.

Most recently, Pia F. Cuneo's book, which grew out of her doctoral thesis, concentrated upon the political context of four of Breu's works, carried out for civic, imperial and aristocratic patrons. She addressed the ways in which such art might have functioned as an extension of the patron's political identity and ambitions. She further discussed the manner in which audiences of varied political and ideological interest might have received them.[24]

The present study seeks to build upon these previous researches by widening the historical framework in which Breu's art may be understood. In the first place it tries to redress the view of earlier, formalist historians, of Breu's development as a decline into a dry mannerism. It is concerned with a historical explanation of style, its contexts, semantic meanings and reception, rather than stylistic development per se. As such, the study avoids two assumptions underlying the earlier interest in stylistic development. One was the idea, central to the cult of genius, of an artist's career as somehow a journey towards an ultimate form of creative and spiritual self-expression. This process conventionally involved an (often teleologically determined) path of development, from an early, derivative phase, to a form of mature, personal expression. (Buchner's study of Breu gained interest precisely because he inverted this traditional scheme.) The second assumption was that this process gave the artist a place within a broader, underlying framework: his work became a tributary within a greater stream of national or period style. This grew out of a belief in Historical Progress.[25]

In the following, where style is at issue, the focus is upon the relationship between style and meaning; how, in the broadest of senses, the manner of visualization fitted the nature of the work, be it one of private religious devotion, or of public monumental art. Of the meanings conveyed through style, one might define as 'primary' those which have to do with the central, most literal function of the work at hand (in an altarpiece, for example, the communication of theological significance through the treatment of theme). 'Secondary' meanings one may term those which speak to broader areas of social or cultural experience, usually incidental to the 'primary' function. These may be communicated through a variety of means – the choice of subject matter perhaps, or a particular ornamental language or other set of stylistic characteristics. In the period covered by this book, for example, understanding of local (gothic) and *welsch* ('foreign'/'Italianate') styles came to be coloured by their association with distinct social groups, cultural circles or confessional attitudes, and to carry quite specific tonal and emotional registers.

Recovering such meanings necessarily entails setting a work of art within the broader culture of the time, recognizing that the work's individual expression and reception are conditioned by common attitudes, by patterns of thought and feeling, rooted in that culture. In the following chapters, connections with Breu's imagery are sought in a variety of areas from within the surrounding world of significance, which include lay drama, meditational handbooks, conventions of typography and musical notation, religious polemical writings, and literary and scientific texts. The attitudes they reflect, the assumptions they embody and the structures they adopt are employed to wrest parallel meanings from Breu's surfaces, to recapture something of the quality of feeling that a particular set of forms or ornamental language could connote. By paying attention to the semantics of Breu's artistic vocabulary, by scrutinizing the different modes he adopted for distinct commissions, one can come to understand how his 'style' – to twentieth-century spectators rather bizarre and opaque – was a language filled with implicit meanings.

The second broad intention of this study is to restore to the artist a measure of historical significance. Breu was no theoretician or thinker like Dürer; neither was he a particularly brilliant manipulator of paint like Grünewald or Altdorfer. His artistic oeuvre is lively, individual and creatively responsive to manifold influences, in particular to the burgeoning, international culture of print, which came into its own during his lifetime. Breu's historical importance lies in the fact of his situation as a craftsman-artist at a particular – and critical – historical moment. Taken together, his work and written testimony allow a rare insight into the tone and texture of a conservative craft world, inured to workshop and guild practices at a time when the aesthetic, cultural, social and economic bases of art were undergoing rapid change. Breu's reactions to the massive social and cultural forces that engulfed him are not only uniquely interesting in themselves, but are in many ways representative of the condition of many artists during the Reformation years.

His career bestrides a watershed between two cultural eras and his work registers the transfer of creative energies from religious painting to secular and applied forms of art. His case, it is hoped, will complement those of the better known, more 'canonical' figures, and contribute to a more complete view of the historical situation of the artist on the cusp of the early modern period.

The book is organized in a broadly chronological manner but is divided into themes. Chapter 1 introduces the artist's work up to about 1517 and examines his development within the context of workshop practice. It establishes Breu's place within the professional groupings of his peers, and presents an integrated study of his various activities across several media: fresco, panel painting, prints, glass roundels and designs for other practitioners. Chapter 2 charts Breu's early responses to Italian art, setting his borrowings from Italy against the cultural and intellectual background of patrician and humanist taste and interest in Augsburg. The third and longest chapter deals with Breu's production during the Reformation years. The artist's religious and social views are adduced from the entries of his chronicle and then set within the context of emergent popular Protestant beliefs in Augsburg. The complex effects of the doctrinal and social strife are traced in the content and handling of a number of Breu's works of the 1520s, as well as in the changing nature of his output. Chapter 4 traces the evolution of Breu's late style, and attempts to explain its overt neoclassicism as one consequence of a new conception of the function of the arts, born in the wake of the Reformation.

Notes

1. No record of his date of birth survives. For his entry into the Apt workshop see Stadtarchiv, Augsburg (henceforth 'StAA'), *Malerbuch* 73c, fol. 34v; and Vischer (1886), 536.

2. Given the normal minimum training period of three years, Breu could have been working as a journeyman as early as 1496.

3. StAA, Reichstadt Schätze, *Zunftbuch der Maler, Glaser, Bildschnitzer und Goldschlager*, 1502, no. 72c, fol. 38v; see Vischer (1886), 542.

4. StAA, Reichstadt Schätze, *Malerbuch*, 72, fol. 65; see Vischer (1886), 542. The date of his death is problematic. It is recorded in the *Malerbuch* in the year 1536 (ibid., 537). This is contradicted by Breu's *Chronicle*, the entries of which are carried on without apparent breach of continuity or literary style from 28 December 1536 to 8 January 1537, and with later entries up to 12 May 1537. (There are two subsequent additions, one, the literal transcription of a satirical poem, the other a brief entry for the year 1542. This last can clearly not be by him.) In the tax records, made up annually in October, his name appears in 1536, but not in 1537. On the evidence of the *Chronicle*, most commentators, including the present writer, have followed the opinion of Friedrich Roth, who in the introduction of his edition of Breu's *Chronicle*, assumes a date of death between May 1537 and October of the same year, when the new tax assessments were made. See Breu (1906), introduction, 15–16. For an argument that the *Chronicle* entries after 28 December 1536 are by a subsequent hand, see Cuneo (1991).

5. For a summary and critique of Hegel's influence, see Gombrich (1969); and *idem* (1984), 51–69, '"The Father of Art History". A Reading of the Lectures on Aesthetics of G. W. F. Hegel (1770–1831)'.

6. For examples of acute analyses of style, explained in terms of a manifestation of a collective national spirit, see Hetzer (1929) and Wölfflin (1931), where the Germanic is compared to the Italian.

7. See F. Anzelewsky (1984), 276; and Koerner (1993), 235–6.

8. See for instance Wescher-Kauert (1924), 996–9, in which the move towards a decadent mannerism in German art is seen as a consequence of a dependence upon Italian models.

9. Buchner (1928a), 273–383.

10. Ibid., 336, 380 and esp. 383.

11. Formerly Stettin, Pommersches Landesmuseum. See Holze (1937/8), 38–9.

12. Chalk drawing, Hamburg Kunsthalle; the medal by Hans Schwarz, dated 1518, is in Berlin, Staatliche Museen Preußischer Kulturbesitz, Skulpturengalerie, inv. no. 5363; See Berlin (1977), 111–13, no. 19.

13. Holze (1937/8, 38–9) makes the convincing suggestion that the drawing is related to a 'self-portrait' within the Fugger Chapel organ shutters.

14. See for instance Beenken (1935), 59–73. Buchner was to be caught up in the extreme nationalism of the time. As a leading scholar of German art and Director of the Bavarian State Museums throughout the period of the war, he was a frequent adviser to Hitler in his acquisitions of paintings, and implicated in the Nazi art thefts. He was entrusted by Hitler with the removal of the entire Ghent altarpiece and Dirk Bout's *Last Supper* altarpiece from Louvain, parts of both of which had been claimed from Germany by Belgium in 1918 under the Treaty of Versailles. See Nicholas (1994), 32, 34, 80, and esp. 142–4.

15. Antal (1928), 29–37; Steif (1930–31), 221–5; *idem* (1931), 62–9; Tietze and Tietze-Konrat (1932), 135–8; von Schmelzing (1936), 10–14; Göhler (1936), 14–17; Holze (1940), 5–12.

16. See Wegner (1959), 17–36; and Baumeister (1957), 45–54.

17. Menz (1982).

18. Blankenhorn (1973), supplemented recently by Baer (1993).

19. See Biedermann (1982), 28–34; and Bushart (1994).

20. The manuscript, not in Breu's, but in a later sixteenth-century hand, is in Munich Staatsbibliothek (Cod. Oef. 214). It consists of 21 bifolios of paper and is unbound.

21. Roth (1906).

22. Kramer-Schlette (1970).

23. Krämer (1980a), vol. 3, 115–33.

24. Cuneo (1991) and (1998). The works she discusses in her book are *The Battle of Pavia* (woodcut, c.1525), *The Triumphal Entry of Emperor Charles V into Augsburg* (woodcut series, c.1530), *The Story of Lucretia* and *The Battle of Zama* (oil on panel, 1528 and c.1530).

25. The first assumption grew out of the nineteenth-century Romantic conception of the artist's career as a struggle towards the highest expression of Self, and out of the Hegelian notion of an ineluctable progress of Art towards ultimate spiritual realization; the second grew from Whig (and later Marxist) concepts of historical perfectibility, formulated in terms of national histories (in Renaissance art, the move from 'unrealistic' to 'realistic' art was regarded as a part of this process, hence the traditional assumption of Italian superiority).

The artist and his workshop, c.1498–c.1517

Beginnings: the Austrian altarpieces

Breu's earliest attributable works are three winged altarpieces, all painted for monasteries in lower Austria, executed during the artist's *Wanderjahre*, sometime between the last years of the fifteenth century and Breu's return to Augsburg in 1502 (see Figs. 1.1, 1.2 and 1.5 and Plates 1 and 2).[1] An altarpiece painted for the monastery at Aggsbach (now housed at the Augustiner-Chorherrenstift Herzogenburg) is signed with his monogram and dated 1501. It formed the nucleus around which the other two, at the monasteries of Zwettl and at Melk, were grouped. These were attributed to Breu by Otto Benesch and Ernst Buchner respectively. Their exhaustive search for the roots of Breu's style was extended in 1981 by César Menz.[2]

These three works form a self-contained group within Breu's oeuvre. They are painted in an innovatory style and emerge fully-formed: nothing earlier in date has survived that might shed light on the route that brought him to this point. What is particularly surprising is their lack of reference to the art of late fifteenth-century Augsburg, to the painterly tradition of Breu's initial training in the studio of Ulrich Apt the Elder. Furthermore, the early expressive vehemence displayed here is not repeated in Breu's later surviving Augsburg works. An eight-year gap in his known production has only reinforced the isolation of these works. His next securely dated works were painted in a quite different, politer idiom, more characteristic of Augsburg.[3]

The Austrian works are remarkable in two major respects. First, in the *Zwettl Altarpiece*, they seemingly invented an idiom in which landscape plays a dominant, expressive role and ties figures and their settings into a single unified whole. The panel of *St Bernard in the Fields* (Plate 1) is strikingly original both as a landscape composition – in its successful integration of different scales of near and far – and for its observations of mundane genre detail, of monks at work in the fields, or the wayside shrine on the brow of the hill. Second, in the Passion scenes of the Aggsbach and Melk altarpieces, there is a concern with a powerfully expressive figure style and physiognomy. In the Aggsbach *Flagellation* panel (Fig. 1.1), a terrible violence is expressed through a jagged articulation of flailing limbs around the hunched and abject figure of Christ, by the bestial expressions of Christ's tormentors and by the hard, wiry line that articulates their sinewy exertions. In both these aspects of his work have been seen the beginnings of the so-called Danube

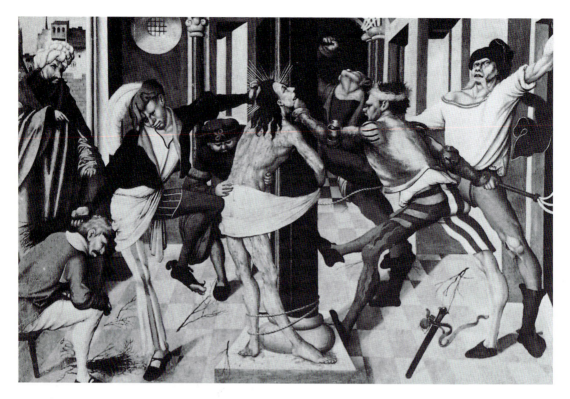

1.1 *The Flagellation of Christ*, oil on panel, outer wing, Aggsbach Altarpiece

School.[4] Their characteristics were shared by a number of artists working in the vicinity, notably Rueland Frueauf the Younger and Lucas Cranach, who, like Breu, came from elsewhere. Their sudden, parallel development of what was in essence a new, highly original style is one of the strangest phenomena in the history of German art.

The previous researches into Breu's early style sought similarities with a variety of painters in attempts to throw light upon the obscurity of his earliest *Wanderjahre*.[5] In particular, César Menz demonstrated the importance to Breu's development of the Munich painter Jan Polak. Breu's Zwettl and Aggsbach altarpieces share fundamental conceptions of design and approach with Polak's works that suggest direct contact between the two artists.[6] The wild, caricatural violence of Breu's *Flagellation* or *Crowning of Thorns* scenes in the panels for the Aggsbach altarpiece of 1501 (Figs 1.1 and 1.2) finds a direct precedent in Polak's Passion frescoes in the *Pfarrkirche* at Pipping, dated 1475 (Fig. 1.3).[7] The affinities of composition and parity of treatment are so close that one may endorse Menz's theory that Breu spent some part of his *Wanderjahre* as an assistant in the Polak workshop.[8]

Menz sought to explain the extreme nature of Breu's Passion imagery in the Aggsbach altarpiece by setting it into the context of the late-medieval Carthusian tradition of affective meditation upon the sufferings of Christ. The monastery of Aggsbach on the Danube was a Carthusian foundation. The setting for the altarpiece was almost certainly the high altar of the monastery church, dedicated to the Virgin. It was appropriate therefore that

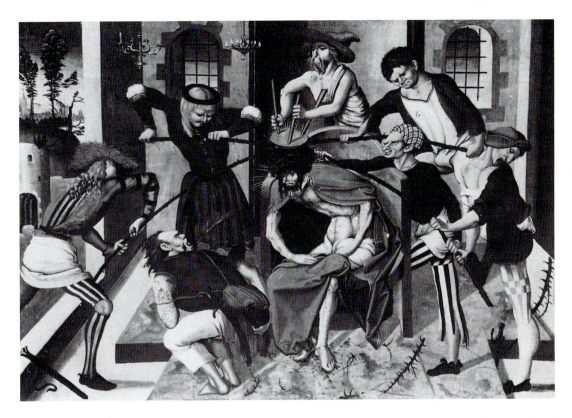

the enclosed panels should portray scenes from the life of the Virgin, set around a (lost and probably carved) central shrine.[9] The six outer panels of the closed altarpiece are devoted to the Passion. Menz explained the powerful treatment of this theme on the closed wings in relation to Carthusian habits of prayer and devotion. Central to these was a version of the widely-practised tradition of affective meditation upon the Passion, which by the late Middle Ages had become, in the words of Eamon Duffy, 'the central devotional activity of all seriously minded Christians'.[10] This process was one by which the individual identified and empathized with the sufferings of Christ, a phenomenon that led to a morbid preoccupation with his wounds, blood and specific instruments of torture. As laid down in such influential Latin treatises as the *Meditationes Vitae Christi*, of the mid- to late-thirteenth century, by the Pseudo-Bonaventure, or the fourteenth-century *Vita Christi* of the Carthusian, Ludolph of Saxony, this method involved the participant in an imaginative effort to summon up a vivid step-by-step mental re-enactment of the events of the Passion. The point of these written descriptions was to evoke in the reader a vivid sense of the real presence of the suffering Christ and to provoke feelings of love and compassion. The extraordinary violence and malevolence of Christ's tormentors and the graphic literalness of Christ's sufferings in the panels of the Aggsbach altarpiece (Figs 1.1 and 1.2) find close parallels in the many vernacular handbooks on meditation that followed their Latin models in the succeeding centuries.[11] The violence accorded Christ

1.2 *The Crowning of Thorns*, oil on panel, outer wing, Aggsbach Altarpiece

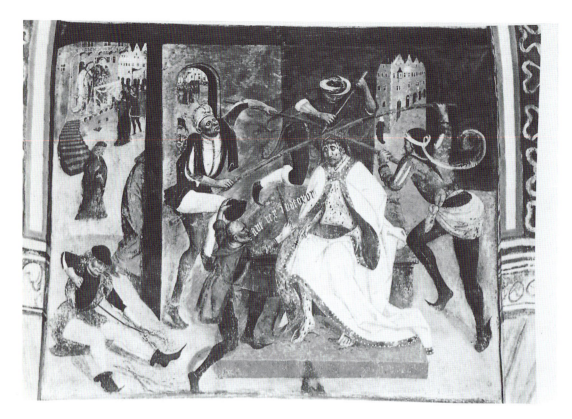

1.3 Jan Polak, *The Crowning of Thorns*, fresco, 1475

is described in the meditational tracts with an inventiveness and in an obsessive detail that went far beyond the biblical descriptions. As James Marrow has demonstrated, such torments and tortures were drawn from the language of the Psalms, the Prophets and the Book of Job, in which violent visitation and affliction are described in richly metaphorical and graphically detailed terms. These passages were regarded as antitypes of the sufferings of Christ and thus a legitimate means by which to comprehend Christ's own torments, which themselves receive only summary treatment in the New Testament accounts. This imagery in turn, was adopted by painters and sculptors.[12] In Breu's Aggsbach *Flagellation* (Fig. 1.1), one of the tormentors appears to be engaged in turning the body of Christ. This narrative detail can be traced back to a tradition within the meditational handbooks by which the torturers ensured that no part of Christ's body escaped their blows. This convention was itself a rhetorical elaboration upon the prophecy of Isaiah 1. v.6: 'A planta pedis … ' ('From the sole of the foot unto the top of the head, there is no soundness therein; [only] wounds and bruises and swelling sores'). In a similar manner, the grotesquely snarling faces and the wild abandon of Christ's attackers summon up the commonly-used metaphor of wild dogs of (Vulgate) Psalm 21, v.16: 'Circumdederunt me canes multi' ('Yea, dogs are round about me').[13]

Menz was surely correct in drawing parallels between Breu's imagery and the literary tradition of Carthusian mystic piety. Breu's painting must have

closely matched the religious imagination of the monks. Yet the precise nature of the relationship is unclear. Though it is possible, as he suggested, that the altarpiece's character was determined by the demands of the patron, it is more likely that his designs were chosen for their conformity with the monks' tastes.[14] Though a Carthusian patron might have suggested the inclusion of certain symbolic elements as part of an overall theological programme,[15] the tenor of the imagery, responding to the aesthetic impetus of Polak's example, is the artist's own; the conception and imaginative empathy with the theme existed prior to the commission.

Furthermore, the function of the panels as narrative images on the exterior of a high altarpiece was quite traditional and was not obviously structured around the meditational programme as found in the handbooks. More directly related to this process are printed meditational aids of the later fifteenth century, of which, *The Way to Contemplation and Meditation upon the Passion of Jesus Christ* (Fig. 1.4), printed in Augsburg in *c.*1477 may serve as an example. The Latin text of this broadsheet consists of short, abbreviated phrases, which summarize the themes to be covered.[16] It surrounds a Crucifixion scene, which, in strongest contrast to Breu's panels, is ideogrammatic in its simplicity. Both text and image act purely as triggers to response. Graphically-rendered altarpiece imagery was apparently supererogatory to the meditational process implied here. That this was so not only for practised, literate mystics like the preacher, Geiler von Kaisersberg, but even for his unlettered congregation, is evident in his advice to buy cheap prints and use thus:

If you cannot read, then take a picture of paper where Mary and Elizabeth are depicted as they meet each other; you buy it for a penny. Look at it and think how happy they had been, and of good things ... Thereafter show yourself to them in an outer veneration, kiss the image on the paper, bow in front of it, kneel before it.[17]

An account by Luther, reported in his *Tischreden*, of a vision he experienced while engaged in a conventional form of mystical exercises, also indicates the self-sufficiency of 'inner sight' without recourse to external, naturalistic imagery.[18]

Meditation therefore was not necessarily central to the altarpiece's purpose. David Freedberg has made the point that the experience of such images may have been enhanced for those already immersed in the literary meditative tradition;[19] and, certainly, for the less ascetic majority, for illiterate monks or lay brethren, the realism of the paintings would have directed the visual imagination in the steps of the same process.

Nonetheless, there is no reason to suppose that the purpose of Breu's imagery differed in any way from the Passion scenes that decorated innumerable late-medieval altarpieces: it was primarily and conventionally didactic. As such, it is difficult to avoid the conclusion that the affective naturalism of these panels emerged from the artist's own artistic concerns. The power of the work, as Benesch and the early commentators recognized, derived from the artist's own engagement in the theme and it is to him and not the injunctions of his patrons that one must look for an explanation of

1.4 Anonymous broadsheet: *Passionis Jesu Christi via contemplationis et meditationis quadruplex*, (Augsburg, Ludgwig Hohenwang, *c.* 1477), woodcut

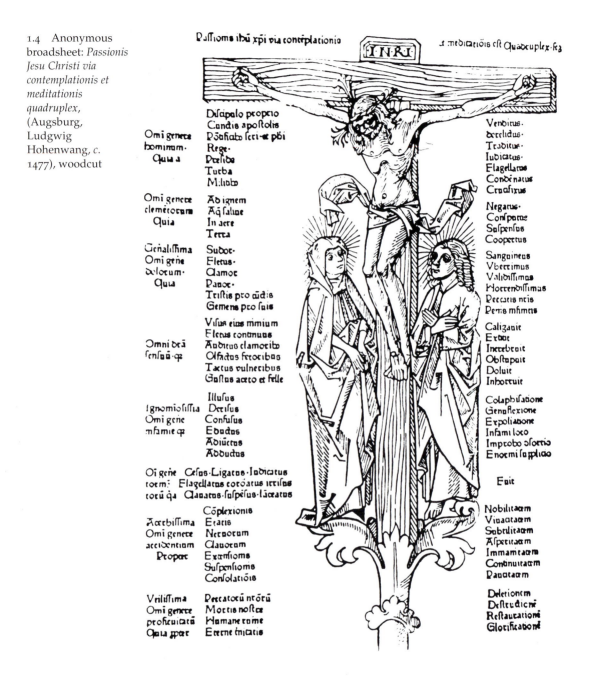

the style. He was able to extend, powerfully and brilliantly, the shrill vocabulary of violence established by Polak's studio. In doing so, it is clear that Breu was responding to the events of the Passion in a manner that conformed closely to widespread habits of popular lay devotion.

Menz, drawing upon a long historiography on the connections between medieval drama and painted Passion imagery, clearly showed the propinquity of spirit that connected Breu's Aggsbach Passion paintings with contemporary

Passion plays. He demonstrated general similarities in the bizarre costumes worn by Christ's tormentors in the Aggsbach panels and those from surviving costume directions of contemporary plays; in the individual characterization of the 'enemies' of Christ; and in the use of stylized gestures, particularly the ritual dance-step, associated with Christ's enemies.[20] As Menz acknowledged, the relationship of painting with theatre was elliptical and it is difficult to gauge with any exactitude the influences of one medium upon the other. They were reciprocal, their shared features the product of a common culture.[21]

Even so, the analogy stands. The didactic and imaginative power of religious drama of the day is well attested.[22] Its success was clear to the laity who were for the most part responsible for funding and staging them, the guildsmen and learned citizens who took seriously the religious well-being of their city.[23] Surviving stage directions of contemporary Passion plays indicate that fullest dramatic emphasis was placed upon the graphic implementation of violence in the Passion scenes. The central religious significance of the pathos of Christ's suffering seems increasingly to have been expressed through melodramatic special effects and technical trickery. Menz cited a surviving Frankfurt play, in which the torturers placed the crown of thorns on Christ's head with the help of two staffs, just as in Breu's Aggsbach composition (Fig. 1.2), while a bag of blood, placed under the crown was made to burst over the actor as it was pressed down.[24] Numerous similar effects reveal an interest in conveying the dramatic immediacy of Christ's suffering through extremes of simulated violence.

Breu's panels constitute the mystery play's analogue in painting. Like the plays, their intention was to further religious instruction and to inspire devotion. Breu's paintings show how the entirely popular piety of the Passion play had invaded the high altars of the Church. The ascetic imagination of the cloister had met the meaty surges of spirit of the cobblers' or butchers' guild. In an altarpiece for a monastic church there are the same gut passions, the same brutal emphases as in the mystery play. The spiritual content is reduced to an empathic reaction, provoked by a simple opposition of good subjugated brutally by evil, of Christian versus non-Christian-as-enemy, expressed in terms of crude, peasant anti-Semitism.

Though the Church entirely sanctioned such painted imagery, just as it embraced lay drama into its liturgical practice, it is important to recognize both as the expressions of a peculiarly secular piety. They were the inventions of laymen and laywomen who sought imagery that fitted their own relationship with God, their own craving for consolation and their need for a doctrine of salvation that found in the mundane physicality of Christ's suffering an act of divine identification with the limitations of the pulse and sweat of their own human existence.

What was Breu's position with regard to this lay tradition? In a sense the artist inevitably adopted the role of theologian. As Max Friedländer once commented, the practice of art in the Middle Ages 'raised itself above other manual occupations in so far as it served spiritual instead of earthly needs. The artist had something in common with the priest'.[25] The artist's

interpretative faculty had the power to mould and direct the piety of worshippers as much as the language of sermon. This was particularly so in the context of devotional habits that addressed the senses so directly. Painting could express, more immediately than words, the grossly corporeal. That the issue of the 'theological' role of painters was a real one at this time may be seen in the objections of the radical reformer Andreas von Karlstadt, who, in his denunciation of images, sneered at the pretensions of artists for assuming the priest's sacred interpretative role.[26] Luther also implicitly registered this aspect of the painter's art when he recognized a distortion in precisely this kind of Passion imagery, which he considered aroused hatred of the Jews more than compassion for Christ.[27] In Breu's fierce emphases and glosses is revealed the artist's creative absorption in, his close personal identification with, the lay affective tradition. While one must hestitate in inferring the artist's own religious convictions from his imagery, his early Passion paintings express a Christocentric piety – a desire to apprehend directly and unmediated the sufferings of Christ – that is entirely compatible with the Reformed beliefs that he was to express with an analogous verbal force later on in his *Chronicle*.

The Aggsbach altarpiece constituted something of a climax in this kind of fervid expressionism. Already in the altarpiece at Melk, painted within the following year, substantial changes in style are evident. These may be summarized as a tendency towards a more monumental style, in which figures are given greater physical substance, are more plastically modelled, painted in more detail and take up a greater amount of space within the picture; in general, there is a tendency towards compositional simplification and clarity (Fig 1.5 and Plate 2).[28]

The chief impulses behind this stylistic development were on the one hand, a degree of influence from contemporary Augsburg art, in particular, Holbein's and Burgkmair's *Basilica* series for the Convent of St Katherine;[29] and on the other – and most importantly – the influence of prints, of Schongauer and especially of Dürer. Already apparent behind the imagery of the Aggsbach altarpiece, prints were of primary importance both as models for individual figures and for overall conception.[30] The figures in the panel of the *Agony in the Garden* (Fig. 1.5), are taken wholesale from the same scene in Dürer's *Great Passion* series (B.6). Without slavishly copying his model, Breu has reformulated the composition by simplifying the forms, eliminating detail and giving the figures greater formal prominence in the composition.[31] One may see in this example the early influence of a print culture which in the future was to lie at the heart of Breu's creative method. From this point onwards, Breu increasingly employed prints as the starting point for his own formal inventions, creatively adapting to his own purposes poses and figure-types taken from a wide range of sources.

When Breu returned to Augsburg, by October 1502, he appears to have left the completion of the altarpiece at Melk to either assistants or other artists.[32] For the next seven years there is a blank in Breu's datable oeuvre, punctuated by two problematical panels and some scant documentary evidence of his activities. Despite this lacuna, there is enough material to

1.5 *The Agony in the Garden*, oil on panel, outer wing, Melk Altarpiece

recreate an idea of the nature of his workshop and of his relative standing among his peers.

Economic background

In October 1502, Breu joined the Augsburg painters' guild, established his own workshop and immediately engaged two apprentices. The years of

Breu's professional life, from this time on until the late 1530s, witnessed profound changes in the nature of artistic production in the city. Augsburg was one of the fastest growing cities of the Empire. The third largest city, after Cologne and Nuremberg, its population grew from 20 000 in the late fifteenth century to nearly 40 000 by the time of Breu's death in 1537.[33] The city's economy was dominated by small, family-run workshops in the numerous traditional crafts, represented through a guild system. The chief industry, textile production, drew large numbers of immigrants from other parts of Germany and Europe. At the same time, the spectacular rise of the great banking houses like the Fugger and the Welser encouraged the city's position as a centre of north–south trade. Their extreme wealth, the international scope of their business concerns and their sophistication in matters of fashion and taste brought to the city great commercial and cultural prestige. Together these circumstances combined to foster the rise of specialist industries, such as silver- and metalworking, cabinetmaking, clock- and instrument-making. By the end of the century, Augsburg was the most important manufacturing centre of luxury goods in Germany.

With the expansion of the general population came an increase in the number of craftsmen, stretching the membership of the guilds to insupportable proportions. As Sebastian Brant expressed it, already in the late fifteenth century:

> No trade is honored o'er the land
> They're overcrowded, overmanned
> Every apprentice would be master
> For all the trades a great disaster ... [34]

The reactions of the Craftsmen's Guild to this situation can be seen in ordinances, like those promulgated by the sculptors' and glaziers' sections in 1517, which imposed strict limits on the number of apprentices a master could employ.[35] Greater numbers brought greater competition. As with most craftsmen, the majority of painters remained in the category of what the tax records termed *Habnit* (literally 'have-nothing'), those whose tax threshhold never rose above the mandatory payment for all – even property-less – citizens. The city records are littered with the evidence of the hardship and insecurity of these artists' lives.[36] Given the intense competitiveness of Augsburg artistic life, it is of relevance to ask to what extent factors of training, peer-grouping or expertise may have helped Breu's career.

Compared to most contemporary artists, Breu was relatively well-off. Though his tax payments during the first decade of the century barely rose above the *Habnit* level, a significant leap occurred in 1510, from which time until his death, he paid the relatively high sum of between four and five florins per annum.[37] Yet, because the tax lists did not distinguish between wealth derived from earnings and income from property, they provide no indication of the size or productivity of his workshop. Given the small amounts of tax in the returns of the more successful contemporary artists,

moreover, it is probable that Breu's income was based more upon the latter, perhaps due to an inheritance.[38]

Johannes Wilhelm's compilation of the tax payments of the Augsburg painters has established that Breu stood within the top 7 per cent in 1518–19 and the top 11 per cent in 1529–30. Wilhelm suggested that this indicated that Breu belonged to a small group of artists, distinguished from the 'executive' majority by creative talent.[39] What is certain is that, together with Hans Burgkmair, Breu built up one of the two largest workshops in the city during the first two decades of the century, comparable to, and even exceeding in size, the workshops of the preceding generation of masters.[40] Burgkmair took on a total of 11 apprentices before 1520, to Breu's nine.[41]

Quite how Breu was able to do this is not clear from the surviving archival sources. The number of his apprentices suggests considerable activity during the first decade of the century, but no securely datable works of this period have survived. One possible factor which helped Breu establish himself was the patronage of his master Ulrich Apt. Apt was an influential and powerful figure within the Craftsmen's Guild. As treasurer as early as 1493 and as a *Zwölfer* (a guild representative on the Large City Council) from 1517 at the very latest, Apt wielded considerable influence and was able to obtain work for his circle, particularly in the form of civic commissions.[42] Moreover, alone of all the artists of his generation, Apt can be shown to have continued a professional association with his former pupils. In a chronicle entry of 1516, Breu records his part in the fresco decoration of the Town Hall, and explicitly states that he worked beside Ulrich Apt and another ex-pupil, Ulrich Maurmüller.[43] There is evidence to suggest that Apt and his circle established something of a monopoly in fresco painting within the city. No firm documentary material survives to show that the other workshops practised this art, with the exception of Leonard Beck, whose training as a miniaturist perhaps made it difficult for him to break into the field.[44]

One can cautiously point to groupings amongst the major workshops around specific branches of artistic expertise. All competed for the large church commissions and routinely painted smaller religious works. Burgkmair, through the patronage of Conrad Peutinger, the learned Secretary of the City Council, dominated the area of woodcuts, particularly the prestigious commissions of the Emperor Maximilian I, from which the Apt circle was for the most part excluded. Breu was to develop a speciality in the field of glass-roundel design and make it his own. The Holbein studio concentrated on panel painting. Apt and Breu appear to have dominated fresco work and public civic commissions.

Works in fresco

Breu's position as Apt's pupil and associate, as much as his manifest abilities, probably allowed him to pursue a career which in many ways replicated that of his master. He too maintained a position of authority (*machthaber*)

within the guild, serving as treasurer.[45] His competence in fresco-painting, like his master's, enabled him to command important commissions in this field. Though nothing remains, a summary of what is known about his activity in this area shows how central it was in the fortunes of his workshop.

In 1506, a few years after his return from his journeyman's travels in Austria, Breu is recorded at work in the church of St Moritz on a piece of decorative painting (probably fresco) behind the altar.[46] In 1509 he painted a huge effigy of St Christopher on the north façade of his own parish Church of the Holy Cross, in return for a burial plot in the church cemetery.[47] This was an important commission, intended to be a prominent local feature, which drew upon the widely held belief that a daily glimpse of an image of St Christopher protected the viewer from sudden death. Though no longer extant (it survived until 1926), it can be glimpsed in a seventeenth-century engraving of the church by Johann Ulrich Kraus.[48] This work echoed a similarly 'giant' St Christopher attributed to Ulrich Apt and dated 1491, on the south wall of the Cathedral, which iconoclasts of the 1530s failed to deface.[49]

By 1516, when Breu came to paint the Town Hall frescos together with Apt and Maurmüller, he was no amateur in this branch of his trade. As the oldest and most senior of the artists, Apt is named as the representative (*Vertreter*) of the other artists.[50] He would certainly have provided the principal liaison with the patrons and it is to him that payments were made. Yet Breu in his *Chronicle* makes clear that he was the artistic and executive head of the project when he boasts that: '... I, Jörg Breu, was the master in charge, responsible for everything, from the largest to the smallest detail and provided all materials and costings.' ('... ich, Jorg Prew, was maister darüber und muest allen sachen vorstan vnd der erst und letzt sein davon. und gab allen zeug darzu und costung.')[51] Breu moreover contributed the largest number of assistants to the project: two apprentices and four journeymen, as compared with Apt's contribution of his son Michael, and Maurmüller's single apprentice.[52]

Knowledge of the content and appearance of the frescoes comes today only from a letter written to the Emperor by Conrad Peutinger, who drew up the programme, in which he asked for approval of the scheme.[53] His suggestion of a series of ancient Roman Emperors and Kings of Spain and Sicily, making up a genealogy of illustrious Habsburg forebears, may be glimpsed in an etching by Wilhelm Peter Zimmermann of 1618 which shows a partial view of the Town Hall façade.[54]

The enormous prestige attached to the decoration of the Town Hall, the centre of public civic life, its programme drawn up by the city's leading humanist, ratified by the City Council and requiring the Emperor's approval, reflects Breu's position amongst artists in the town. His competence in fresco did not spring from a vacuum. It is possible that a certain amount of Breu's work of the first decade entailed secular fresco decoration of private houses, though none has survived. The evidence of small fragments in domestic settings attests to the fact that the patrician classes increasingly decorated

their houses not only with glass and panel paintings of profane subjects but also with similar wall paintings.[55] A chimney decoration by Jörg Breu the Younger, depicting a scene from the life of Marcus Curtius and dated 1544, was extant in Annastraße 2 until its destruction in 1944. It indicates that the workshop probably continued to produce this kind of work and developed it into a particular didactic humanist type.[56]

Surviving records show that Breu was engaged in two substantial fresco schemes in the 1530s. One was for the Fugger town house, which he left uncompleted.[57] The other records the Breu workshop, since 1534 under the leadership of the younger Breu, engaged from 1535 to 1536 in the fresco decorations of the chapel and castle of Pfalzgraf Ottheinrich at Grünau.[58] Though these no longer survive, fragments of other, secular fresco schemes by the younger Breu also indicate the continued centrality of the medium in the workshop.[59] In the later 1530s and early 1540s in particular, when the Reformation climate in Augsburg made the position of painters extremely difficult, the younger Breu was evidently able to survive through this specialization.

The lucrative and prominent nature of working in fresco was clearly of central importance for the prestige and economic well-being of the workshop. The other main staple of the business was panel painting, at least until the later 1520s, when Protestant antipathy to religious images assumed importance in the town. It is chiefly from the surviving panel paintings, their painterly character, stylistic variety and iconographic interest, that one gains an understanding of Breu's artistic personality and the practical operations of his workshop.

Panel painting: style and patronage

Recognition of Breu's stylistic diversity is nothing new. The versatility he exhibits between the expressive realism of the Austrian works and the neoclassicism of his latest style is undoubtedly due in part to the personal outlook and experimental predilections of the artist, as well as to the particular contingencies of training and geography. No other Augsburg artist had so complex and fluctuating a development. It is possible that Breu's origins as a weaver's son set him apart from such contemporaries as Hans Burgkmair or Leonard Beck or the younger Ulrich Apt, who, as the sons of artists, grew up with strong inherited traditions of artistic precept. Yet, if the circumstances of his upbringing might have encouraged in him a certain detachment and freedom in relation to inherited traditions, the very possibility of his stylistic flexibility was necessarily also the product of external conditions under which he worked. Breu came to early maturity as an artist at a time of great stylistic innovation. The powerful influence of Dürer and an increasing knowledge of Italian art, primarily through prints, provided enormous stimulus for change, fostered as much by shifts in the tastes and expectations of patrons as by the artists' own interests. Increasing artistic self-consciousness

stimulated a desire for originality of handling. New secular subject matter –
for Augsburg artists, particularly the commissions of the Emperor Maximilian
I – necessitated new formal inventions which governed not only the portrayal
of subject but also notions of an 'imperial' style. Another kind of secular
patron, best exemplified by the Fugger family, whose interest in Italian art
and culture set them self-consciously apart from the more conservative clerical
and noble patrons, helped to break the authority of the Gothic and stimulated
the emergence of a 'modern' italianate style. Art in Augsburg in the first two
decades of the century loosened its links with the relatively stable and
homogeneous qualities of fifteenth-century gothic art. These changes were
signalled not merely in the types of art produced, but extended even to
artistic practice and changes in workshop organization.[60] In this sense, Breu's
striking stylistic range may be seen as a kind of weather vane of his own
cultural climate, signalling in its experimental freedom, in its lack of fixed
points with regard to tradition, the profound changes that were occurring in
both practice and patronage.

The dearth of surviving work from between 1501 and 1512 makes it
impossible to form any coherent view of Breu's development until the second
decade.[61] From 1512 onwards one may isolate two overlapping strands of
development. The first is the clear desire of the artist to align himself with
the reigning style of high religious art in Augsburg. The second is a
commitment to a modern style, a creative response, principally, to the example
of Dürer and to the new figurative, compositional and ornamental language
spreading northwards from Italy. This section is concerned with tracing
Breu's stylistic evolution during this period in Augsburg.

The prevailing style of Augsburg religious art was developed by the
generation preceding Breu, including his teacher Ulrich Apt, Thoman
Burgkmair, Hans Holbein the Elder, and extended by contemporaries such
as Hans Burgkmair and Leonard Beck. It reached its fullest development in a
series of altarpiece commissions of the 1490s and early 1500s, for the
Cathedral, the Church of the Holy Cross and the Dominican Monastery of St
Catherine.[62] Collectively, these works affirmed a conservative, essentially
Flemish idiom, distinguished by material richness, preciousness of detail,
monumental forms, dignified gestures, gravity and restraint of emotion: the
antithesis, in other words, of Breu's early Austrian works. There can be little
doubt that in developing such characteristics of style, Breu was adapting to
an established taste, preferred by the patrician elite, who saw in its dignity
and gravitas a fitting medium through which to express their piety and
social position.

Breu's most complete surviving statement of these ideals is the large
altarpiece panel, today in Koblenz, of the *Adoration of the Magi*, signed in
monogram and dated 1518 (Fig. 1.6).[63] Its format derives generally from
Ulrich Apt's panel of the same subject, painted in 1510 for the Church of the
Holy Cross in Augsburg and now in the Louvre.[64] The stress upon richly
embroidered garments and finely wrought metalwork, the abundant use of
gold paint and the careful rendering of portrait heads in the physiognomies

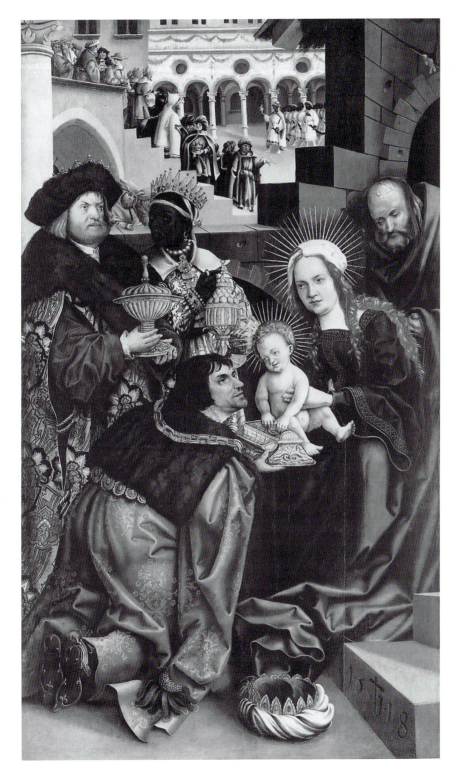

1.6 *The Adoration of the Magi*, signed and dated 1518, oil on panel

1.7 Hans Holbein
the Elder, *Portrait of
a Man in a Fur Hat*,
varnished tempera
on panel

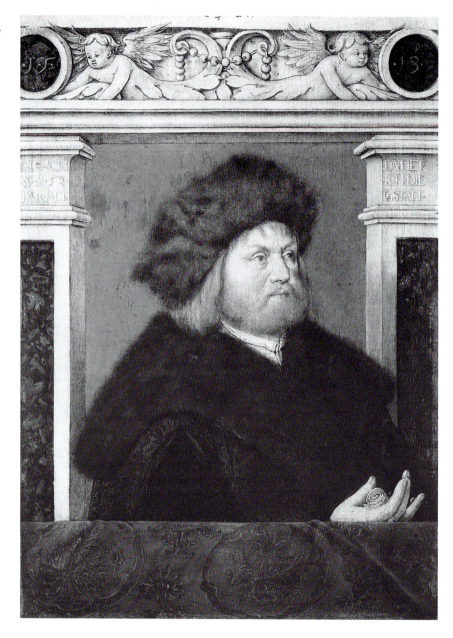

of the two foreground magi, embody the material values of the fifteenth
century and in all probability reflect the demands of the patron(s), whose
identity is unknown. The Christ Child's gesture of taking gold coins from
the proffered casket held by the foreground magus-patron might be seen
as a strikingly direct allusion to the financial benevolence of a wealthy
patrician patron to the Church. Indeed, there is evidence that points to the
patron's involvement. The face of the magus standing on the left is based
very precisely on a portrait by Holbein the Elder, dated 1513 and now in

Basel (Fig. 1.7).[65] Though the sitter remains unidentified, it is clear that the commission belonged to an important, probably local, patrician family.[66] While the use by Breu of a portrait drawing by another artist might suggest the intriguing possibility of collaboration between workshops, it is more probable that the patron himself owned and provided the model. Certainly it has been very faithfully transcribed, even to the extent of retaining the voluminous fur hat and painting the crown somewhat incongruously on top.

In its similarity with other Augsburg altarpiece fragments from the second decade, for instance Leonard Beck's *Adoration of the Magi* (Fig. 1.8)[67] or the anonymous panels of the *Life of the Virgin*,[68] Breu's painting shows its conformity with the prevailing style. The comparison with the Beck shows up an inherently wooden quality in Breu's work, that stems from his difficulties in rendering a convincing foreground space, the awkwardly angular arrangement of architectural motifs, and his inability to unify the discrete elements, as Beck has learnt to do, by the application of directional lighting, that divided the space into broad areas of light and shade. On the other hand, what most distinguishes Breu's work from the prevailing convention and makes his work startlingly fresh, is his inclusion of italianate elements, particularly the background view of a Venetian 'piazza', with the Carpaccio-like processions of the magi's entourages clad in exotically 'eastern' costumes. Such elements reveal quite plainly the artist's familiarity with contemporary Venetian painting, and may be regarded as an attempt to introduce a modern cosmopolitan flavour into the Augsburg tradition. The meticulousness of technique, the precise and careful attention to detail, on the other hand, is entirely northern. The evident concern with a high degree of finish marks the work out as an expensive commission made for a wealthy patrician family.[69]

By contrast, a panel of the *Deposition* of roughly similar date represents a more humdrum, and entirely typical, product of the Breu workshop (Fig. 1.9).[70] It shares with the Koblenz *Adoration* the same tone of emotional restraint inherited from Netherlandish painting, conveyed in the balanced composition, the muted brown-green palette and the conventional figure types. Qualitatively, however, it is not in the same class. Indeed, setting the *Adoration* beside the *Deposition* shows up the latter's overall technical mediocrity. The treatment of the faces in the *Adoration*, for instance, is executed with a much greater subtlety. The shadowing of the face of St Joseph deepens the illusion of realism and charges it with emotional content (see Fig. 1.6). Even the neutral realism of the patron-magi's portrait-likenesses has a meticulousness absent in the other work. There, by contrast, the faces lack any real psychological depth. Indeed St John's expression of grief is more evocative of squinting disapproval. This is all the more surprising when one compares it to the underdrawing as uncovered by infra-red reflectographic photography (Fig. 1.10).[71] This reveals a sensitively-drawn head, set amid curling locks, the eyes hooded-over and pouched in sorrow, the mouth pursed. The pathos of expression in the drawing has been preserved, despite alterations to the angle of the head, that has left it somewhat

1.8 Leonard Beck,
*Adoration of the
Magi,* oil on panel

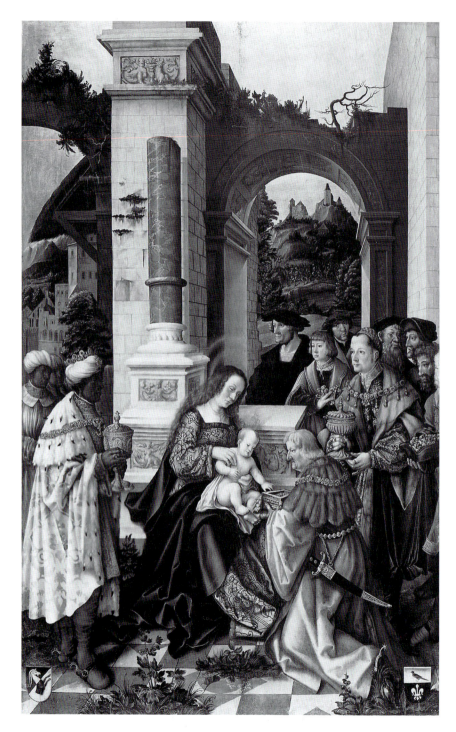

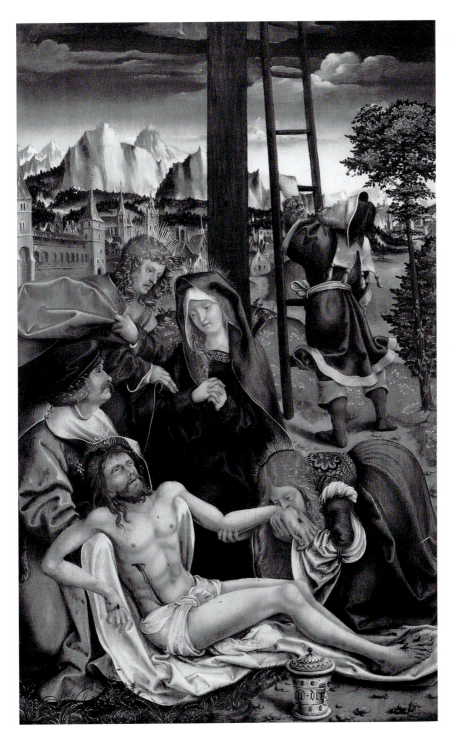

1.9 *The Deposition,*
oil on panel

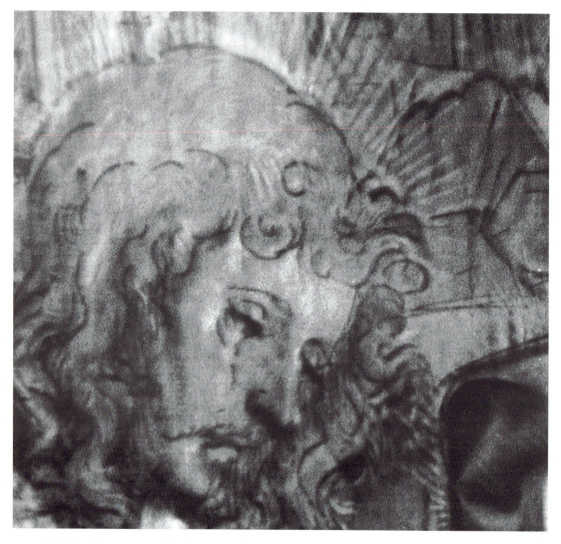

1.10 The Deposition,
underdrawing,
detail of the head of
St John

unresolved. The mouth is seen in profile, but the nose has been pushed into three-quarter view, bringing the upper-left cheek unnaturally into view. In the *painted* head, the nose has returned to profile, become sharper, the right nostril more pinched; the left eye has been lowered out of alignment with the right; and the mouth, strangely angled downwards, sits uncomfortably amongst the conflicting viewpoints, misaligned with the other features. All sense of the restrained grief of the under-drawing has vanished. Not only have the lines of the original drawing been misinterpreted, especially around the mouth area, their expressive intention has been misconstrued. The crudity of the painted head might point to the work of an assistant. The presence of colour notations scribbled onto the under-drawing, also made visible by infra-red reflectographic photography – a *'rot'* (red) on the cloak of St John (Fig. 1.11), a 'b' (*blau* = blue) beneath the hat of the figure holding a ladder on the upper right – tends to support this possibility. At the very least, the qualitative differences between

1.11 *The Deposition,* underdrawing, colour notation

these two works point to differences in their status: a prestigious commission from an important patrician family on the one hand, and a more routine production on the other. Though the issue of authorship cannot be conclusively resolved in the latter case, the variability in quality between the two works is part of a broader pattern within Breu's surviving oeuvre, explanation for which may lie in part in the use of apprentices or assistants.

Comparable in quality to the *Deposition* are a number of more or less routine Madonna panels, which, conventionally enough, formed a staple of the workshop. A *Madonna and Child* (private collection) shows a similar ability to evoke a tender mood through the muted tones of the landscape, together with an equal blandness of facial expression. The pose is dependent upon the *Adoration of the Magi* woodcut from Dürer's *Life of the Virgin* series (B.87) (Figs 1.12 and 1.13). It demonstrates the usefulness of such prints as models in the routine composition of small devotional paintings.[72]

It was in fact the continuing suggestiveness of Dürer's designs that pulled the direction of Breu's work away from his earlier expressive tendencies and opened him up to impulses from Italy. This is clear as early as 1512, the date of Breu's lost panel of the *Madonna and Child with Sts Catherine and Barbara*, which has little in common with his earlier Austrian work (Fig. 1.14).[73]

1.12 *Madonna and Child*, oil on panel

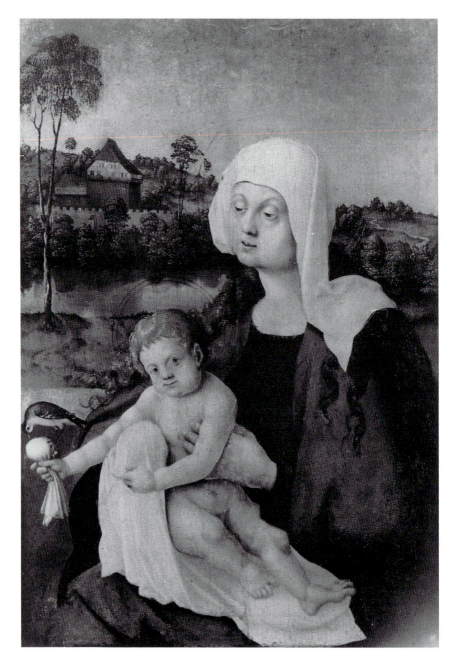

Dürer's example is powerfully evident in the Madonna type: the Virgin and saints seated on a grassy bank before an expansive landscape. Such idyllic imagery, marked by the intimacy of the saintly group and the beauty of the natural setting may be compared with Dürer's *Mary with Many Animals* of 1503.[74] There are also elements derived from Venetian landscape painting, such as the fortified wall ascending the distant hillside, crowned by the castle.[75] St Catherine's dress, with its opulent sleeves, fashionably slit, and

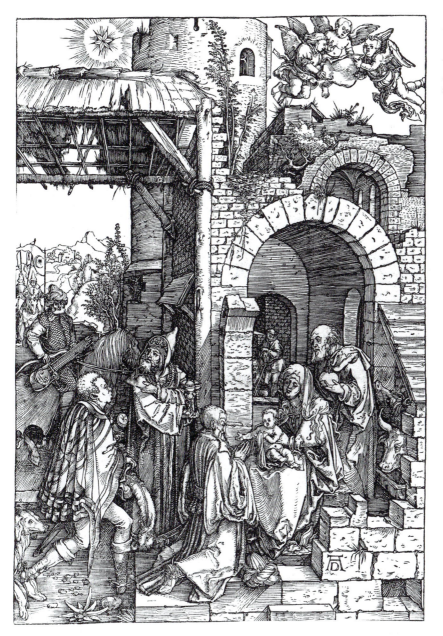

1.13 Albrecht Dürer, *Adoration of the Magi* (B. 87), woodcut, from the *Life of the Virgin* series

cut extravagantly off-the-shoulder, also reveals a knowledge of Venetian fashions and is comparable to Dürer's costume studies of Venetian women.[76] The foreground angels, excitedly disbursing *cartellini* inscribed with the Christian virtues from a casket, are a charmingly blue-stocking product of Augsburg humanism.

A more direct link between Breu and Dürer is to be found in Breu's *Madonna and Child* panel at Aufhausen, of *c.*1512–15. It is based upon a drawing bearing Dürer's monogram and dated 1509 (Plate 3 and Fig. 1.15).[77]

1.14 *The Madonna and Child with Sts Barbara and Catherine*, signed and dated 1512, oil on panel

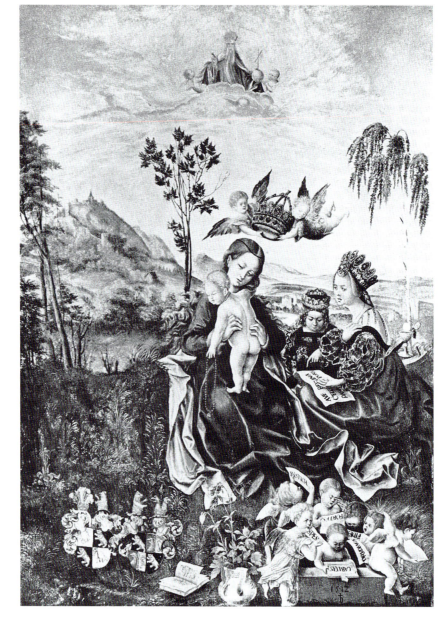

Though Dürer's authorship of this drawing has not been universally accepted, most commentators have recognized at the very least a close dependence upon a Dürer original.[78] Dürer was in Augsburg twice – on his way to and return from Venice in September 1505 and the spring of 1507. During his initial stay he seems to have established firm relations with the Fugger family and obtained from them a number of commissions.[79] It is possible that the Basel drawing was made within the context of designs for the Fugger Chapel. Dürer's first rough plans for the tomb epitaphs were begun

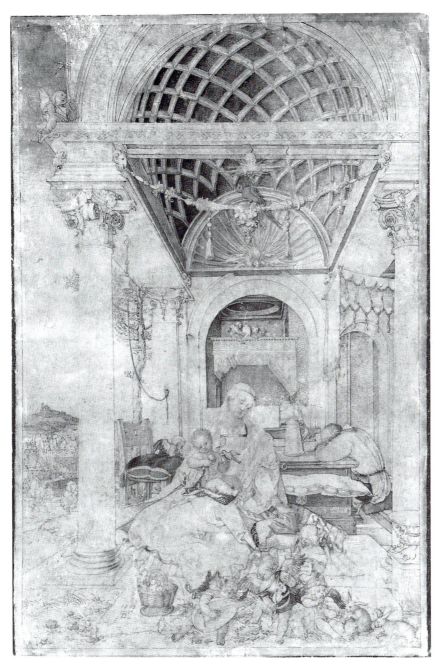

1.15 Albrecht Dürer, *Madonna and Child in a Hall*, pen, ink and watercolour on paper

as early as 1506 and it is possible he was closely involved in designing both the iconographic programme and the architecture.[80] Certainly, the architecture within the drawing is close in conception to that of the Chapel itself (Fig. 1.16).[81] That of Breu's painting, which has been transformed into an open-sided Renaissance pavilion, is even closer, for it replaces the coffered ceiling of the drawing with a Gothic ribbed vault.

1.16 *The Fugger Chapel*, St Anna, Augsburg

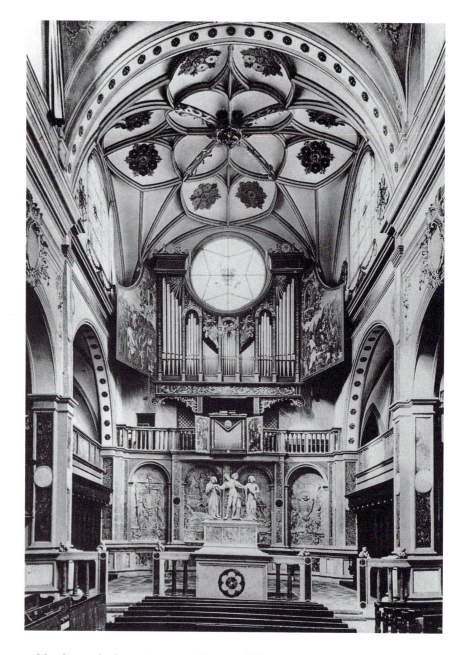

No direct dealings between Breu and Dürer can be inferred from these correspondences. The character of Dürer's drawing is that of a cartoon or finished pattern which could be shown to the patron. It is meticulously finished in its details and partly touched in in watercolour to give indications of colour. The suggestion has been made that it was a model for a painting to be set into the brass altar screen of the Fugger Chapel, ordered from the Vischer workshop but never realized; and further, that the execution of the painting passed to Breu because of Dürer's lack of time or unwillingness to

carry it out.[82] On the other hand, the Breu panel is so fundamentally different in many respects from the Basel drawing that, either he was working from a later, modified design, or he created an entirely new conception himself. That the classicism of Breu's painting owes more to Augsburg than to the Nuremberg master makes the latter suggestion more likely. These changes are discussed below in the context of Breu's developing classicism.

Breu's most personal and original attempt to adapt italianate ideas during the second decade is to be seen in his commission for the Organ Shutters of the Fugger Chapel in St Anna (see Figs 2.26 and 2.27 and Plates 5–8). This can only be inexactly dated to c.1517. While a full discussion of the iconography and style of the Organ Shutters is given in Chapter 2 in the context of Breu's response to Italian art, the salient stylistic innovations must be mentioned here. A steep but logical perspectival space is articulated through the architecture. The most significant development is a concern with light: for the first time his work displays an interest in the logic of the fall of directed light, expressed in terms of strong, simple contrasts of tone, and a fascination with cast shadows (see Plates 7 and 8). He also uses light and shade in a constructional sense as a means to define volumes. The figures are modelled with a kind of exaggerated emphasis, so that the planes of drapery folds, for example, are divided into simplified areas of over-emphatic tone. The highlights have an unnatural intensity, the transitions to deep shadow are very abrupt. The result is an unnatural clarity of plastic statement, softened only by a diffused intensity of the highlights. The oddity in the expressions of certain of the faces (for example in the *Choir* scene, Plate 8) is also created in part by the undue strength of the modelling. Similar characteristics are found in the panel of the *Holy Kinship* (Fig. 1.17),[83] where facial expressions probably intended to convey a due solemnity, are rendered through this emphatic modelling as ill-tempered scowls. The fall of light in both works is haphazard and irrational, apparently highlighting and shadowing the figures for pictorial effect rather than to serve narrative or thematic clarity. This striking effect finds its closest contemporary parallel, perplexingly, in Florentine painting, for instance in the early works of Jacopo Pontormo.[84] The adoption of such Italianate techniques is accompanied by 'Renaissance' architecture and ornament.

Undoubtedly, it was both the subject-matter and the position of the Organ Shutters in the self-consciously 'Renaissance' setting of the Fuggers' funerary chapel, which demanded from the artist something wholly unprecedented in his experience. Breu rose to the challenge with a technical boldness and with a degree of wilful pictorial experimentation that is startling and utterly unique in Augsburg painting of this period. Set beside his early Austrian altarpieces and the contemporary, or only slightly later, Koblenz *Adoration* and *Deposition* panels, the variety of styles and effects they collectively display reveals an artist of extraordinary range and fertility, who could vary his style between the modern and experimental and the more conventionally local. The example of the Fugger panels, moreover, reveals how the particular pressures of patronage could produce entirely new forms of art. The strange,

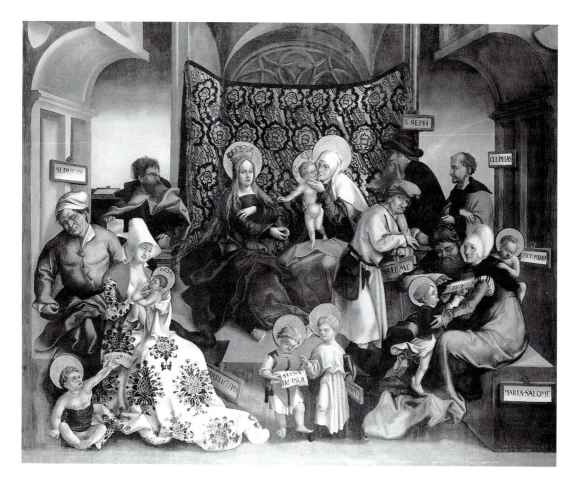

1.17 *The Holy Kinship*, oil on panel

isolated uniqueness of the work that resulted, made outside the indigenous artistic tradition, yet with only a partial, occluded, knowledge of the Ultramontane, enshrines a precise and critical moment in the history of style in Germany, revealed as a moment of flux, experiment and uncertainty. Style, in this case, was as much the product of the times as of the man.

The artist as designer

Besides working in fresco and panel painting, another significant part of Breu's activity was as a designer for works in media in which his own workshop had no immediate expertise. This was a conventional and time-honoured part of the painter's position within the Craftsmen's Guild, by which his skills in draughtsmanship were hired out to traditionally more mechanical crafts such as stained glass and metalworking. Breu made designs for at least three media: woodcut, sculpture and especially the decorative glass roundel, which last area he came to dominate. In the case of woodcuts, the printing houses of Augsburg were dependent upon the painters to supply

them with illustrative and decorative designs for the wide range of literature they produced. What surprises in Breu's case is the relative paucity of woodcut designs that survive, as compared with contemporaries such as Burgkmair, Beck or Schäufelein. Only in the later 1520s can one trace a discernible increase in output from the Breu studio, a likely consequence of diminished commissions in other media in the wake of the Reformation. His activity in the second category, sculpture, can be surmised from a small number of drawings which relate directly to existing sculpted reliefs. Though the evidence is scanty, it is sufficient to raise the quesion of the degree to which Breu and his fellow painters contributed to the development in this period of distinctive types of sculpture, particularly relief sculpture. Lastly, while Breu's leading and innovatory role in the field of glass-roundel design has long been recognized, the precise nature of his involvement with glass decoration and its processes remains obscure. So far no attempt has been made to unravel the bewildering number and types of drawing connected with glass roundels. In attempting to do so, it is possible to shed further light upon the working relations between the different sections of the Guild.

WOODCUTS

A woodcut image of the *Virgin and Child, with Sts Pelagius and Conrad*, signed in monogram and dated 1504, constitutes Breu's earliest datable work in woodcut, as well as the first dated example of a work executed in Augsburg on his return from Austria (Fig. 1.18). It formed the first inner page of the *Missale Constantiense* of Hugo von Landenberg, Bishop of Constance between 1496 and 1523, whose coat of arms is prominently displayed on the Virgin's socle. The same missal contains a further, full-page image of the Crucifixion, similarly monogrammed. This devotional book was published by the Augsburg publisher Erhard Ratdolt and marks the beginning of Breu's relationship with this prominent printing house.[85] In the second decade, Breu executed further designs for liturgical books for Ratdolt. In 1515, he made the images for a second *Constance Breviary*, comprising a similar woodcut frontispiece of a Madonna flanked by the patron saints of Constance, followed by a series of five full-page illustrations and elaborate borders and initials.[86] He also provided woodcuts for a *Regensburg Breviary*.[87] These were evidently prestigious commissions, made to order for important clergymen, who wished, by their dissemination, to enhance their spiritual authority. Hugo von Landenberg who commissioned the *Constance Breviary*, stated specifically in the preface, that he placed his coat of arms on the title-page, so that he would be considered the spiritual originator of this new edition.[88] That these are with one exception the only works in the medium that Breu signed indicates their prestige.

That exception was Breu's contribution to another prayer book, a *Passional*, commissioned by the Emperor's personal chaplain, Wolfgang von Maen, and published in 1515 by the Augsburg publisher, Hans Schönsperger.[89] Breu provided three woodcuts out of a total of 28, the others being by Hans

1.18 *Virgin and Child, with Sts Pelagius and Conrad,* woodcut *Missale Constantiense* (Augsburg, E. Ratdolt, 1504)

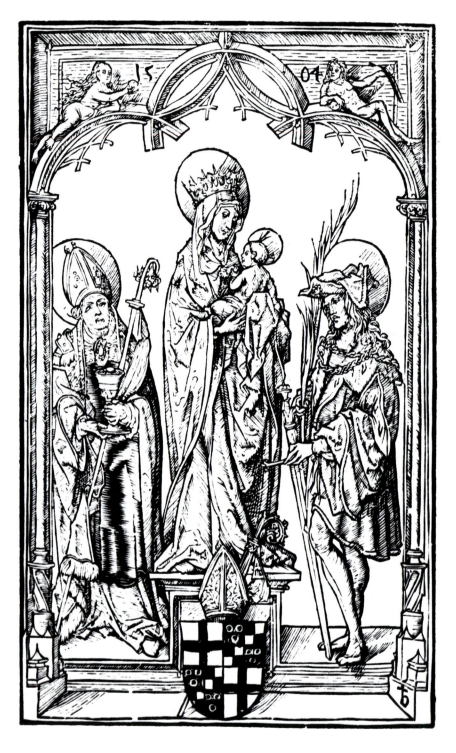

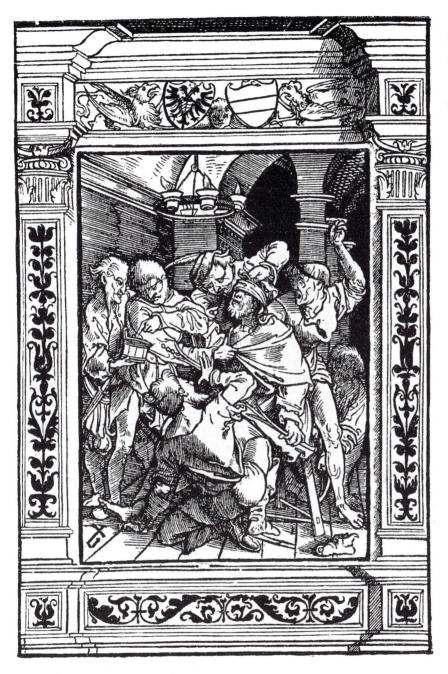

1.19 *The Mocking of Christ*, from Wolfgang von Maen, *Das leiden Jesu Christi …* (Augsburg, Hans Schönsperger, 1515), woodcut

Burgkmair (9) and Hans Schäufelein (16). All are contained within classicizing, niello-like borders by Burgkmair. The three woodcuts, a *Mocking of Christ*, *Christ before Pilate* and a *Man of Sorrows* before whom the author prays, are among Breu's most accomplished works in woodcut. They have been executed with obvious care. The *Mocking of Christ*, in particular, is a complex and expressive variation of a theme he knew well (Fig. 1.19). The varied poses of

the figures are knit together into a tangled yet legible grouping of flailing limbs, lent substance by a tonal range and variety that is rare in his woodcuts. For, with a few exceptions, there is an expressive poverty in his use of this medium, which is all the more surprising, given his natural talent as a draughtsman. His powers of harmonious design and pictorial balance, seen repeatedly in his drawings for glass roundels (see Figs 1.35, 1.36 and 1.38) rarely surface in his woodcuts. This difference can be explained only partially by the limited competence of intermediary wood-cutters, which he appears always to have used. Breu seems to have lacked much feeling for the medium; the emphasis of his workshop lay in other fields. Certainly, he played little part in the great imperial woodcut programmes won by the Augsburg printing houses and which occupied the labours of Burgkmair, Beck and Schäufelein. Breu's only contribution was a single woodcut to Maximilian's fictional autobiography, the *Theuerdank* (*Theuerdank in danger on a Chamois Hunt*, an image later corrected by Beck).[90] It is probable that this field of expertise was cornered by these other artists and that Breu's services were only called upon in those cases when the other artists were unavailable.

Besides liturgical works, Breu's other main woodcut commissions of the first and second decades involved illustrating popular vernacular stories: the well-known *Fortunatus*, and the travel stories of a supposed Italian merchant, *Vartoman von Bologna*.[91] Both were fanciful tales about the travels and adventures of merchants and explorers, of clear appeal to the merchant community of Augsburg. The illustrations in each were conceived largely in simple outlines, one for each chapter, succinctly referring to the content of each. While the large number of illustrations shows an ambition to produce a book that was lavish by the standards of the day, their simplicity reveals the limitations of cost (Fig. 1.20). The artistic quality is low and little imaginative effort has gone into their conception. Only in the higher artistic quality of the title-page of the *Vartoman* (Fig. 1.21), which shows the author presenting his book to its dedicatee, the Duchess of Urbino, is style used to do honour to both author and patroness.

When Emperor Maximilian I died in 1519, much of the impetus behind publishing in Augsburg came to an end. His large-scale literary projects were abandoned and only the *Theuerdank* reached completion. The heads of the two foremost publishing houses, Erhard Ratdolt and Johannes Schönsperger, were also at the end of their lives. It was the onset of the Reformation, however, that affected the character of publishing most significantly. The humanist taste for editions and translations of classical and Italian texts gave way to the demand for religious polemic in the form of small, cheaply produced pamphlets. These rarely required good quality woodcuts or title-pages, they were often produced anonymously and were, by their very nature, ephemeral.[92] Breu's woodcut commissions throughout this period reflect the changing nature of the publishing business. They will be considered in Chapter 3 in the context of Breu's reactions to the Reformation.

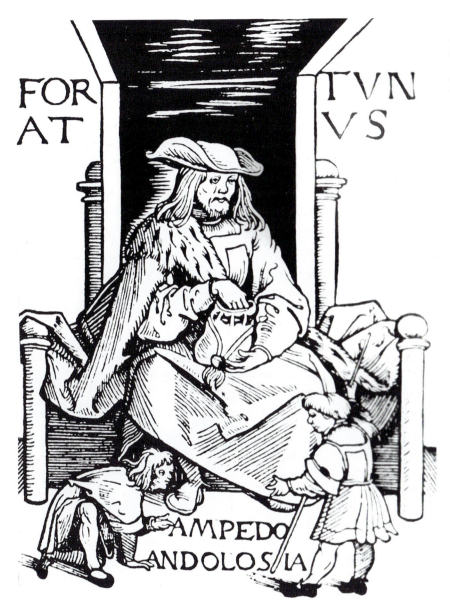

1.20 Title-page to *Fortunatus und seinen Seckel* (Augsburg, Hans Otmar, 1509), woodcut

DESIGNS FOR SCULPTURE

A part of Breu's activity lay in making designs for sculpture. The extent of his involvement is difficult to gauge. Wolfgang Pfeiffer has already shown the relationship between a drawing of the *Flagellation* in the Nationalmuseum in Warsaw, convincingly attributed to Breu, and a relief in Solnhofen limestone of the same subject in the Germanisches Nationalmuseum in Nuremberg (Figs 1.22 and 1.23).[93] Though the original context of the relief is unknown, it was almost certainly part of a carved Passion series that perhaps formed the

1.21 Title-page to *Die Ritterliche und lobwirdig Raysz … Ludowico Vartomans von Bologna …* (Augsburg, Hans Miller, 1515), woodcut

predella of an altarpiece.[94] Pfeiffer established the relief's dependence upon the drawing, noting in the grasp of details, the fluency of the poses and correctness of proportions the superior quality of the latter.[95] To this may be added the observation that the figure of Christ and his left-hand tormentor of the drawing are dependent upon an Italian source: the engraving of the *Flagellation of Christ with the Pavement* by a follower of Mantegna (Fig. 1.24).[96] Though Breu has altered the character and angle of the heads and softened the incline of Christ's body, the similarities of the scourger's tunic, with the same fluttering 'ribbon' at the waist and torn hose at the knee, make clear his dependence upon the Italian source. Pfeiffer dated the drawing late in Breu's

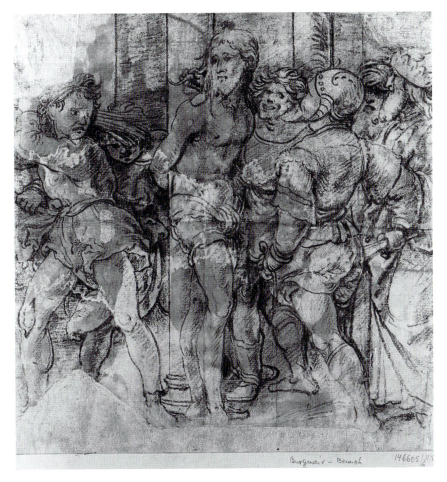

1.22 *The Flagellation*, black chalk on paper

career, finding correspondences with the Basel *Samson and the Philistines* and the 1534 *Meitinger Epitaph* (see Figs 4.4 and 4.15).[97] This dating is given circumstantial force by the fact that Breu made use of the same Mantegnesque print in 1528, adapting the armoured figure on the foreground right for a figure in his *Story of Lucretia*, painted for the Duke of Bavaria (Plate 10). The younger Breu was to re-employ the same figure for an image of a Habsburg prince in the later 1530s (Fig. 1.25).[98]

The drawing has been cut down on all sides. It measures 272 × 267 mm. The relief measures 287 × 270 mm and it is fair to assume that the two were once of equal size. This might suggest that the drawing was therefore made not as a general design, but rather as a scaled cartoon from which the sculptor worked directly. As Pfeiffer suggested, the many surface blemishes are possibly a result of this workshop usage.[99] The sculptor of this particular piece has not been identified. Qualitatively, it does not compare with works by the best proponents of low-relief sculpture such as Hans Daucher or Viktor Kayser. Nor can the piece be linked satisfactorily by style with any surviving panel of related size or subject matter.[100] If carved by a workshop

1.23 Anon., *Flagellation,* carved relief in Solnhofen limestone

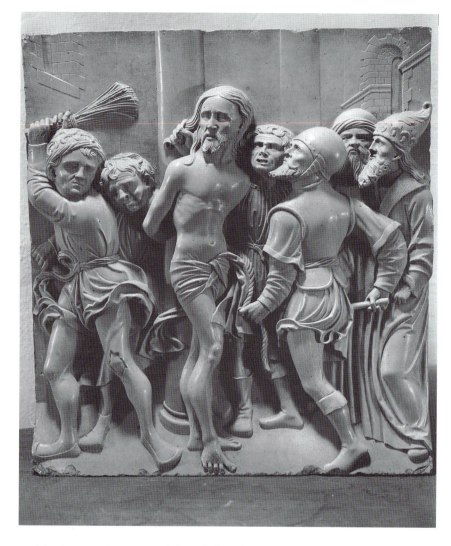

assistant, as a minor part of the whole scheme, it would show that Breu was extremely closely involved in the production of the carved altar, providing not merely an overall design, but making scaled, working drawings even for the minor parts of the work. Such working drawings are by their nature extremely rare, particularly for sculpture. Their existence is known principally through archival records, as for instance those mentioned in connection with the bronze statues of the tomb of Maximilian I in the Hofkirche in Innsbruck.[101]

Somewhat more numerous are those drawings produced by painters for stone-carvers that provided an overall design.[102] It is in this light that one may look at a drawing of unusual oblong format in the collection of the Public Library and Art Gallery in Folkestone that is unmistakably by Breu's hand (Fig. 1.26). It was catalogued there as *The Blind Invited to the Feast,* though beyond the carrying of staffs there is little to suggest that the figures are thus afflicted. It is executed in brown ink and grey wash on paper and is inscribed

1.24 Andrea Mantegna (attrib.), *The Flagellation with the Pavement*, engraving

by a later hand: 'di Luca di olanda', indicating a provenance from an Italian collection. The style and figure types are entirely characteristic of Breu's graphic manner in the 1520s. In the predilection for profiles turned obliquely into the picture space, as well as details of costume such as the cross-banded leggings, one finds correspondences with both the Warsaw drawing and the Munich *Lucretia*. The format is suggestive of a predella relief and one might look for a connection with relief carving. In fact, it finds an exact correspondence with a relief panel in Solnhofen limestone in the Szépüvészeti Múseum in Budapest (Fig. 1.27). Simon Meller argued convincingly for an attribution of this relief to Viktor Kayser.[103] He also correctly identified the subject matter as the *Feast of the Passover*, taken from Exodus 12. It represents a literal depiction of verse 3:

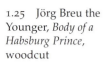

1.25 Jörg Breu the Younger, *Body of a Habsburg Prince*, woodcut

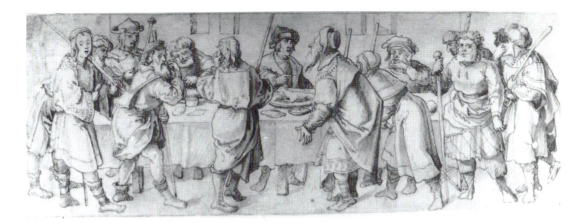

'... they shall take to them every man a lamb ... ', and verse 11: '... And thus shall ye eat it; with your loins girded, your shoes on your feet, and your staff in your hand; and ye shall eat it in haste.' The participants are shown standing round a table on which lies the lamb, in a state of readiness for their journey. The scene is relatively rare and in Christian art was usually used as a prefiguration of the Last Supper. Breu's design has been determined by this association, for it takes over formal characteristics of a conventional Last Supper scene. The lamb is placed in the centre, in front of the head of the household whose hand is raised, if not in benediction, then at least in a dispensing role. He acts as the focal point, balancing the two groups of attendant figures on either side. This is true of the relief even more than the drawing; in the former, the central figure seems dressed in contemporary apparel and actually clasps the lamb with one hand, and gestures with the other.

Despite the similarity of general design, the differences of detail are considerable. The sculptor has not succeeded in capturing either the same breadth of figure-type, the confident twists of the bodies or the sense of flow between figures. His figures are held in stiffer, more staccato rhythms; the sculptor has been unable to follow the draughtsman's oblique poses in space and has flattened his figures, stressing either frontal or profile views. The costume of the figure on the extreme left has been changed in the relief, to one that makes its gender unequivocally female; and more women have been made out of the background figures on the right. The relative measurements – the relief 28 × 79 cm, the drawing 9.8 × 27.1 cm – establish that, in this case, the drawing acted as a preliminary guide to the composition and the details of the relief were worked out later.

Unfortunately no other related works can be found that would suggest a context for it. Yet at the very least this discovery establishes an interesting link between Breu and the sculptor Viktor Kayser. Karl Feuchtmayr characterized Kayser as one of the most extreme exponents of the style that developed in the 1520s which mixed the Gothic with Italianate elements and which, as he perceptively noted, was particularly associated in painting with Jörg Breu.[104]

1.26 *The Passover Feast,* pen and brown ink and grey wash on paper

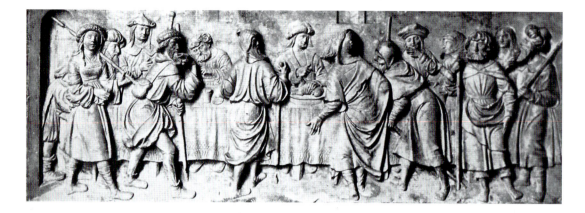

1.27 Victor Kayser, *The Passover Feast*, carved relief in Solnhofen limestone

One further drawing by Breu suggests itself as having a connection with sculpture. This is the strikingly beautiful drawing in the Nationalmuseum, Stockholm, of a design for a family epitaph, depicting the *Fourteen Auxillary Saints* (Fig. 1.28). It is one of the most carefully executed drawings within Breu's oeuvre and conforms in type to the kind of presentation model that would be shown to the patron. The 'Renaissance' arches and coffered ceiling, together with the wealth of ancillary sculptural ornament, strongly suggest some kind of carved monument. The closest parallels to the drawing's architectural and sculptural character are goldsmiths' designs for reliquaries in the form of small altarpieces, such as those recorded in the *Halle'scher Heiltumscodex* in Aschaffenburg (Fig. 1.29). These structures were wrought in silver and gold, the central scenes executed in enamel.[105] These miniature shrines of the *Halle'sches Heiltum* can be dated between 1520 and 1526/7,[106] which accords well with the dating of Breu's drawing.[107] Though Breu's design was clearly for a large votive altarpiece, these examples provide an insight into the broader context of south-German classicism in which Breu's own style was developing.

In this regard, Breu's architecture shares certain affinities with that contained in a number of small, ornamental relief panels produced by Hans Daucher in the 1520s. There is the same kind of coffered arch, capitals, sharply-lipped cornicing and putto-type in Daucher's *Madonna* relief of 1520 in the Maximilianmuseum, Augsburg (Fig. 1.30). Though Daucher's architectural surround is very close to the architecture in Holbein the Elder's *Well of Life* in Lisbon, of 1519, it is interesting to note Daucher's dependence for his narrative scenes in the coffered vault upon designs also employed by Breu. Two left-hand scenes, one of a man (Joseph) being pushed down a well, the other of a camel train, are taken from woodcuts that Breu provided for an edition of the popular tale *Fortunatus*, printed in 1509 by Hans Otmar. This dependence cannot, of course, establish Breu's direct involvement with the relief, for the prints were public property by 1518. Nonetheless, another scene, of *David and Goliath*, on the right-hand side is either based upon Breu's pen-and-ink version of the subject that he did as decoration for Maximilian's *Prayerbook* in 1516 (see Fig. 2.15), or upon a common prototype.

1.28 Design for an epitaph with the *Fourteen Auxillary Saints*, pen and black ink on paper

Daucher used the same scene, with slight modifications, in an earlier version dated 1518;[108] in each, the relative sizes, the poses, Goliath's snail-shell helmet, the oddly crowned David figure, parallel the Breu drawing. Given the eclecticism of Daucher's sources in the Augsburg relief, this connection may be explained as much by a common source, possibly an Italian niello, as by Breu's direct involvement in the carved design.

Nonetheless, this series of connections and interconnections, both general and particular, constitutes sufficient evidence of Breu's substantial involvement in the design of relief sculpture. Nor was he an isolated case. Other prominent painters of Augsburg are known to have carried out similar projects. Hans Burgkmair produced a detailed modello for Gregor Erhart's

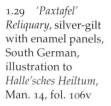

1.29 *'Paxtafel'*
Reliquary, silver-gilt
with enamel panels,
South German,
illustration to
Halle'sches Heiltum,
Man. 14, fol. 106v

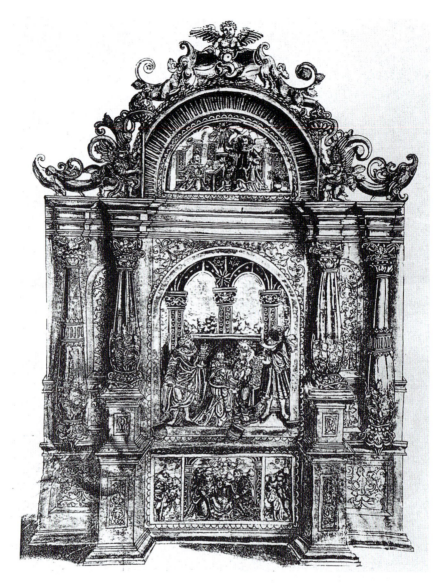

Equestrian Portrait of Maximilian I for the choir of St Ulrich's in 1500.[109] Hans
Holbein the Elder, too, created designs for a carved epitaph ordered in 1497
by Konrad Mörlin, abbot of Sts Ulrich and Afra. Drawings by him also
survive that were the basis of two small silver statuettes.[110] Perhaps the most
famous of all, in the context of Augsburg at this period, are Dürer's designs
for the two epitaph reliefs of Ulrich and Georg Fugger in the Fugger Chapel
in St Anna.[111] What these examples clearly reveal is the prestige and status of
the painters as the most creatively fertile group within the Craftsmen's Guild,
who would be called upon to design important commissions, irrespective of
medium. They also demonstrate the close interconnectedness of the various
sections of the Guild and a degree of interdependence rarely alluded to in

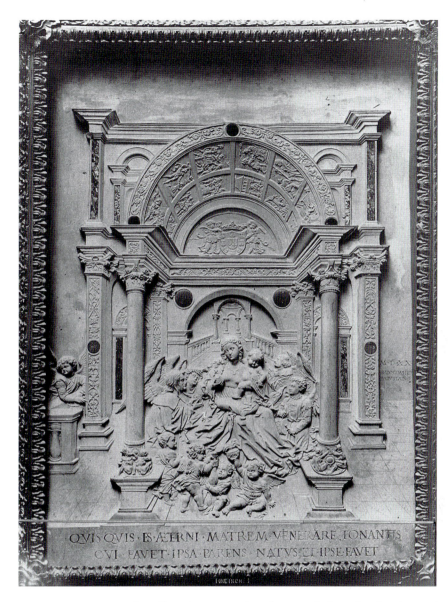

1.30 Hans Daucher, *Virgin and Child in an architectural setting*, 1520, carved relief in Solnhofen limestone

surviving contracts. Finally, what is strikingly revealed is the freedom of borrowing and the cross-fertilization of artistic ideas between the various media that shaped a whole regional style and allowed a relatively small number of designers, Breu central among them, to determine a collective response to Italian 'Renaissance' forms.

DESIGNS FOR GLASS

Of all Breu's output as a designer, that for glass-paintings is the most important. A substantial part of his surviving oeuvre is made up of circular drawings in ink and wash, made as preparatory designs for painted glass

1.31 *Sol*, pen and
black ink on paper

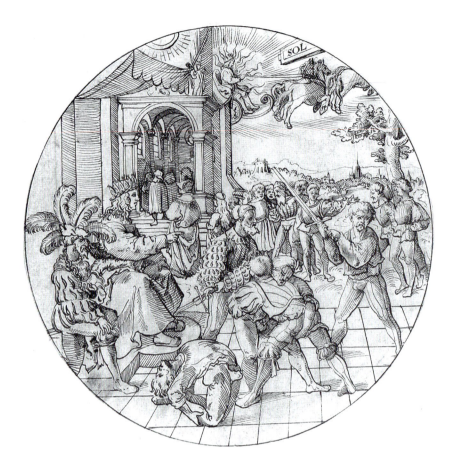

roundels, although of the latter only a small number have survived. It is
nonetheless difficult to say with any accuracy precisely how important a
branch of his workshop activity it formed. Was it, as has been supposed, a
relatively minor byline in what was primarily a painting workshop? Did
Breu paint on glass himself, or did he merely execute the designs for the use
of independent glass-decorators?

Though the majority of the surviving designs date from the 1520s, a
substantial number date from the first half of this period, testifying to Breu's
early involvement in the glass-roundel form. The subjects are drawn from
biblical, allegorical, genre and, from the 1520s onwards, classical sources.[112]
These last in particular, indicate a taste for this expensive and luxurious
medium amongst an educated circle of humanist patrons. Of the designs
from the second decade, it is possible to reconstruct, at least partially, a
number of glass-roundel series from individual drawings scattered through-
out European museums. The astrological theme of the *Planets and their Children*
seems to have met with a certain success, for at least two series of designs,
each with an allegorical representation of a planet and its attendant 'children'
can be pieced together from surviving drawings, glass roundels and later
painted variants (Fig. 1.31).[113] Other, apparently single, designs on related

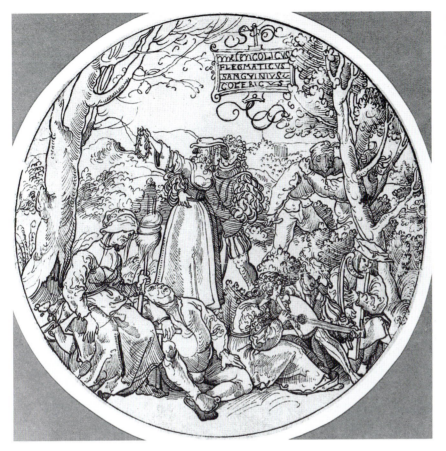

1.32 *The Four Temperaments*, pen and black ink

themes survive from these years, including a particularly beautiful allegorical scene representing the *Four Temperaments* (Fig. 1.32).[114] A tournament scene, highly Dürereque in style, now in the J. Paul Getty Museum (Fig. 1.33) can be compared to a surviving glass panel that closely follows it.[115] Though evidently a finished drawing, the penmanship of the Getty sketch is very free. In later examples, continuous outlines and a regularity of pen stroke assume greater precedence.

These later qualities of style are to be seen in designs for Breu's most prestigious known glass commission: a series of 18 circular drawings, made for the Emperor Maximilian I, 14 of which depict his military campaigns, the remainder, scenes of his hunting expeditions (Fig. 1.34).[116] Dörnhöffer connected these designs with a series of 'copies' (*ain abschrift etlich gemeltes*) mentioned in a letter of 14 June 1516 from the Emperor to his treasurer, Jacob Villinger. Villinger was charged to instruct Hans Knoder, the court artist, to paint and fire these designs onto glass, intended for 20 windows in the new tower of the Emperor's hunting lodge at Lermoos.[117] Dörnhöffer explained the discrepancy in number between the 18 surviving drawings and the 20 mentioned in the letter by suggesting that the two missing drawings had possibly portrayed the *War against the Gelders* and the *Siege of Liège*.[118] This

1.33 *Tournament
Scene*, pen and black
ink over black chalk

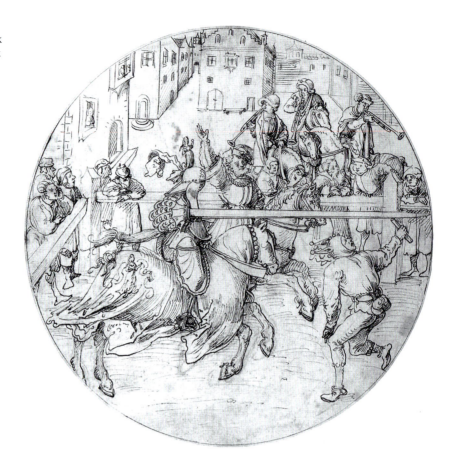

assumption has been universally accepted. On the other hand, the implications
of Breu's involvement in the commission – solely as designer, not the executant
– have not been followed up.

The nature of Breu's activity in the production of glass can best be studied
through a series he created a few years later for the wealthy merchant
Höchstetter family in Augsburg. The subject matter was the *Months of the
Year*, a theme traditionally aristocratic and rural in its imagery. Breu
transformed this with great originality to reflect the life-style of the merchant
patron in both his urban context and that of his country estates. The
iconography, patronage, dating and surprisingly influential artistic legacy of
these designs have been thoroughly examined by a number of scholars.[119] A
close examination of the physical nature of the surviving drawings can
further understanding of the processes of glass-roundel production.

THE DRAWINGS FOR THE *MONTHS OF THE YEAR*

As early as 1938, Jakob Rosenberg summed up the general view of Breu's
designs for glass roundels that has not been substantially altered since:

1.34 *The Hungarian War*, pen and black ink on paper

As everyone conversant with the study of early German drawings knows, a large proportion of so-called Breu designs for stained glass are in reality only copies carried out in his workshop. The group comprised of drawings in this class is at once vast and puzzling, and it must be admitted that the line of demarcation between autograph productions and contemporary copies is not altogether clearly defined.[120]

This judgement applies particularly to the many studies for the *Months of the Year*. Some 60 versions of various of the 12 designs that make up the series exist in museums throughout Europe and America. The main criterion behind the study of these drawings to date has been the issue of authenticity: is this or is this not by Breu's hand? The same (largely unresolved) question has been applied to the surviving glass panels after his designs. As a result of this method, those drawings designated 'copies' have been regarded as being of only marginal interest and their peculiar characteristics as well as the problem of why they should exist in such numbers have not been addressed. A more fruitful approach, perhaps, is to consider the drawings from the point of view of their possible functions within the workshop. For the large numbers of surviving drawings from the sixteenth and seventeenth centuries

that make up the genre of glass designs, attaching a precise function to a single surviving design is often an impossible task. Yet this body of work – of numerous variants of a single design – is unique and offers an opportunity to study the operations of a workshop more closely.

Viewed in this light, Breu's designs for glass fall into three broad categories. First, autograph drawings – there exist both initial sketches of the idea and highly finished, carefully executed examples; second, a more complicated category of high quality versions made up of ink and areas of wash; and third, simple outline copies. A striking example of the first category of highly finished, autograph work is the series of drawings for the *Wars of Maximilian*, in the Kupferstichkabinett in Munich (Fig. 1.34). These drawings are conceived entirely in terms of line, used with great assurance as both contour and shading. Different degrees of emphasis with which the ink has been applied help establish distance, and on a purely ornamental level, distinguish between various figure and landscape groupings. Areas of parallel shading establish a controlled system of tonal distribution across the design and create a lively chiaroscuro pattern. The finish is crisp and exact.

The completely *linear* conception makes these drawings inappropriate as models for the glass-painter, who would have had to translate the complex effects of line into simpler fields of coloured stain. Such drawings, in all likelihood, represent the master design, the finished conception that would be shown to the prospective patron and, if accepted, might have become the patron's possession. Alternatively, they would have remained in the workshop as the prototype from which further copies could be made. One may be sure that such is the status of the *Wars* series. As discussed above, they were supplied by Breu as models for Maximilian's court artist, Hans Knoder, to carry out. In this case Breu acted purely as the designer.

Amongst the many surviving versions of the *Months of the Year*, there is no exact equivalent of this type. The drawings that seem in the assurance of their execution to be most nearly of autograph status are the drawing of *January* in the Albertina, Vienna and six drawings from the Kupferstichkabinett of the Staatliches Museum in Berlin (Fig. 1.35).[121] They constitute the second category. Wegner was convinced that they were autograph, though Baum before him had considered them to be superior workshop drawings.[122] The quality of drawing is indeed extremely high yet they differ from the *Wars* series in that the parallel strokes denoting shaded areas have been lightly covered by a layer of wash, and certain outlines have been redrawn in thicker ink. They lack the tight discipline and precision of line, the self-conscious finish of the showpiece, that characterizes the *Wars* series. One senses a somewhat freer, more improvised quality in the handling of outline that suggests a workshop rather than a public usage. Regarded in this light, there is no reason to doubt their autograph status as possible second versions of a putative original, intended to be used as working models that would keep the prototypes intact as reusable assets of the studio. The areas of wash would have been put in as guidelines for the glass-painter. A second possibility is that they belong to that category of drawing, common in stained-glass

1.35 *The Month of January*, pen and black ink and wash

workshops, known as a *vidimus* (literally 'we have seen').[123] If, in the case of a private commission, the original design became the property of the patron, a version of that original – the *vidimus* – was made for the glass-painter. This second version possessed the status of a legal document: it established what the patron had seen and what the glass-painter would produce. The quality of this second version was also therefore necessarily very high, in close proximity to the original. Secondary, working copies could then be made from this version.

These, the simple outline copies, make up the third category of drawing. The set of *Months* today in the Kunstmuseum in Basel is a good example. An examination of the design for *June* reveals a copy of the most rudimentary and mechanical kind (Plate 4). The lines employed are uniformly thin, empty of expressive content and suggest the inexperienced or indifferent hand of a workshop apprentice, merely inking in lines that have been transferred from an original drawing. The most dramatic indication of this mechanical process is the use of two kinds of ink which meet abruptly in the figure of the fork-holding peasant woman on the left-hand side; the greater part of the design was executed in a dark brown ink which ceases abruptly in the five right-hand drapery folds of her dress and in the tresses of hair by her left cheek. Black ink is taken up to complete her and her companion on the extreme left.

1.36 *The Month of June*, pen and black ink on paper

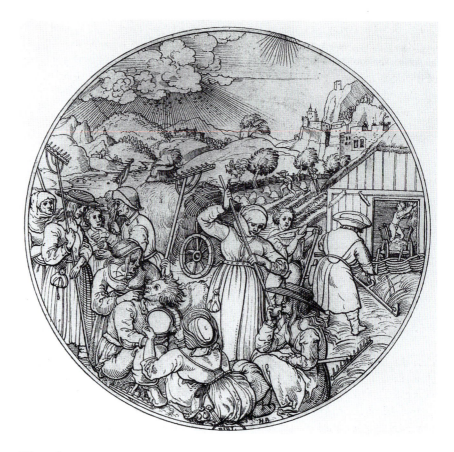

What this point of juncture reveals is that the draughtsman was moving progressively from one side to the other until he ran out of ink. That he began the peasant woman at the outlines of her right-hand side – the folds of her skirt and her hair – shows that he possessed no graphic conception of the overall figure he was drawing, no sense of how the lines should articulate the planes of the body. The artist was quite literally filling in lines! The feebleness of this method becomes apparent in the weakness of her right hand and in the blank expressions.

Another indication of tracing lies in the blank passage of the central woman's left arm that merges with that of the scythe sharpener behind: the copyist has missed certain lines that would have made clear the distinctions between the forms, as seen in the Göttingen or Dresden versions of the same design (Fig. 1.36). Finally, the faces of two of the seated foreground figures have been gone over later with a thicker-nibbed pen in freehand in an attempt (not wholly successful) to give better definition to their expressions.

By and large the other 10 designs of this series (*December* is lacking) are similar in kind. The *April* differs from the rest by including parallel shading which helps to create interval, suggest volume and differentiate planes. The *September* version stands alone in that it is drawn more freely, in thicker lines, executed with a broader nib and contains much more italic expression.

The Basel drawings are therefore simple copies pared down from a complex original to the barest outlines. They were manifestly employed as working cartoons for the glass-painter, made specifically for the transfer of the outlines of the design onto the upper surface of the glass. This is the method invariably employed on the surviving glass roundels. The washes of coloured stain are applied to the underside. The drawing would have been placed beneath the clear glass panel and the lines simply painted on the surface of the glass.

Close examination therefore reveals considerable distance from Breu's own hand in certain of the copies. Both the series in Bern and in Göttingen (Fig. 1.36), fall into this category. Indeed the monogram H.B. found on the Göttingen drawings is evidence, if further proof were needed, of another hand. Not only do the various versions discussed above manifestly come from (at least two) different workshops, they seem to represent different stages in the process of production, between Breu's original design and the finished glass, the simplest made by craftsmen outside his immediate circle. This strongly suggests that Breu acted solely as supplier of designs to glass-painting workshops.

Painters, glaziers and glass-painters

Can the implications thrown up by the physical nature of the drawings be substantiated by documentary evidence about glass-painting in Augsburg? Was glass-painting considered the prerogative of the glaziers or of the painters, or indeed of an independent category of glass-painters? The records of the Craftsmen's Guild for the period of Breu's lifetime are exiguous and detailed records of the Glaziers' section of the Guild only begin in the late 1540s. Nonetheless there is sufficient material about the nature of guild regulations to enable a partial reconstruction of the way in which labour was organized.

The Guild of Craftsmen was divided into four parts: painters, goldsmiths, sculptors and glaziers. The guiding principle underlying this division of labour was that each master should work solely in the area of his training. This was asserted as early as 1460 in a decree issued by the Guild, that stipulated that if a master were to work in a field other than that of his training, it should be duly reported to the Guild. Yet as Hans Huth pointed out, the mild tone of the promulgation suggests that overlapping did occur.[124] Indeed the workshop of Gumpolt Giltlinger may be cited as one which, in the later fifteenth century, carried out tasks in various media, including painting, sculpture and glass-painting under the aegis of a single enterprise. Giltlinger himself, though a painter, is referred to as *Glasser* in surviving contracts that involve the furnishing of glass decorations.[125] Under increasing economic pressure during the early sixteenth century, however, such monopolist practice was increasingly met with opposition from the individual sections of the Guild. An ordinance of 1522, initiated by the painters, expressly forbade activity by younger craftsmen in any area other than their own, though it permitted established masters to continue as they had before.[126] This might suggest that the painters hoped to safeguard their prerogative to

paint on glass. A much later document of 1560, which records a dispute over the dividing lines of competence precisely between the craftsmen at issue here – the glaziers and the painters – at one point refers back to this original 1522 ordinance and tells us something of its consequences.[127] The document consists of the deputations of various masters from each section of the Guild, called in to settle a matter which had recently arisen. Glaziers were apparently refusing to make glass that they were forbidden to decorate themselves. The various masters summoned to testify affirmed that Guild members had always each kept to his own area of training. When the expertise of another craft was necessary, it was traditional to either make use of another workshop, linked by ties of family or kin, or to use an apprentice from the requisite craft. Thus a painter's and goldsmith's apprentice might be loaned to a sculptor's shop for the polychroming and gilding of a statue.[128] As regards painters and glass-workers, the document provides two interesting if oblique statements. First, that painters had the right to sell and display glass in their own premises, but were not permitted to have glazier apprentices attached to their studios;[129] and second, that in the case of church commissions which involved both glass-work and painting together, it had been the custom for years that both glaziers and ordinary painters (*die flachmaler*) would employ an apprentice glass-painter.[130]

The inferences to be drawn are fourfold. First, that painters traditionally might paint on glass for glass-workers tied to them by family or kin; second, that painters' apprentices might be hired out for this purpose; third, that cooperation in the production of painted glass items between the glaziers and the painters was such that a painter could regard and sell them as his products as much as could the glazier; and fourth, that the painting was also done by a separate class of specialist glass-painter and that painters were not permitted to attach such craftsmen or apprentices to their workshops.

Such evidence brings one closer to answering the question of Breu's relationship with workers in glass. The existence of a separate category of glass-painter explains the status of the Basel copies, for instance, and helps confirm the strong impression that they were not made in Breu's immediate circle but are adapted copies by a glass-painter for transferring the outlines of the design onto glass. Breu, as the designer of the series, was probably the initiator of the project and the one the patron in all likelihood approached. As such he had the right to sell them through his own studio.

What of the separate category of glass-painters? A study of the lists of Guild registrations and deaths of Guild members, where the profession of the individual is normally specified, allows one to build up a picture of the numbers of workers in glass and their organization. As one might expect, a few families dominated the trade in glass-working throughout the sixteenth century, the sons normally following the trade of their fathers. In all but two cases in the whole of the sixteenth century, the Guild lists refer to these individuals' trade simply as *glaser*. One exception is Florian Giltlinger, who was explicitly referred to as *Glassmaler* ('glass painter') when he qualified as a master in 1510.[131] The other was Hans Braun, who, as the large number of

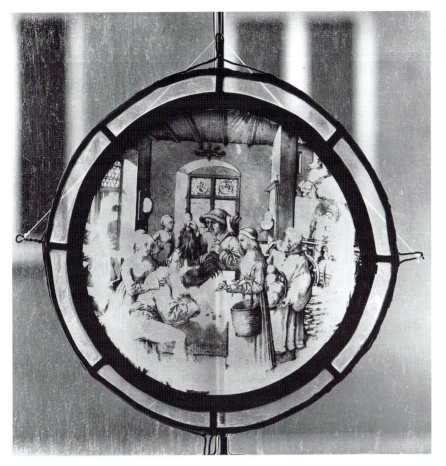

1.37 *The Month of October*, silver-stained glass roundel

references to him in the documents indicates, was a leading figure in the glass trade in Augsburg. He is referred to at times simply as *glaser*, but more often as *glasschmeltzer*; and this is how he himself signed his name in official correspondence. It indicates one engaged in the firing of glass, a presumably unusual form of specialization in the trade.

Florian Giltlinger was the second son of the painter Gumpolt Giltlinger whose large workshop, as noted above, carried out commissions in many different media. It is interesting in this respect that Gumpolt trained his younger son, Florian, as a master glass-painter. Florian died in 1547 and *his* son, Endris Giltlinger took over his father's rights to Guild membership in 1563, also as a glass-painter.[132] He was to present *his* son Christoph as an apprentice in 1580, to learn *das Glas und Glasmalern* ('the practice of glass and glass-painting').[133] One can therefore plot a continuous tradition of specialist glass-painters in one family at least, throughout the century.

The other single mention of a specialist glass-worker appearing in the Guild lists – Hans Braun – may also be connected with Breu's glass designs. He is first heard of in connection with painted glass roundels in 1515, when he was paid 14 florins to install eight roundels of painted glass in the new

1.38 *Joseph and Potiphar's Wife*, yellow-stained glass roundel

council chambers of the Town Hall. Hans Burgkmair had received payment for glass designs (*visier zu glesern*) shortly before.[134]

Much later, in 1531, Braun is mentioned, preparing seven glass roundels 'after given designs' for the chapel of Jagdschloss Grünau near Neuburg (*ain glaswerck von geschmeltzter arbait sienbenerlay veldungen in die capellen zur Grienau inhalt gegebner visierungen*). In 1535 and 1536 further payments were made to him for additional glass-work.[135] Breu's workshop was commissioned to execute the painted decorations for the Jagdschloss between 1536 and 1538, that is to say, at the same time that Braun was active there. A contract of 1537 exists, granting the not inconsiderable sum of 200 gulden to decorate the Grünau chapel, amongst other works.[136] The *Jorgen Prew maler ... zu Augspurg* must of course have been Breu the Younger for he had taken over control of the workshop by this time and his father had died probably in the first part of 1537. What the documents establish is that even if the Breu workshop provided the designs for the glass decorations (the 'given designs' of Braun's earlier contract), it was Braun – working independently – who executed them. Unlike the earlier Giltlinger enterprise, the Breus did not, on their own, carry out the glass-painting and smelting.

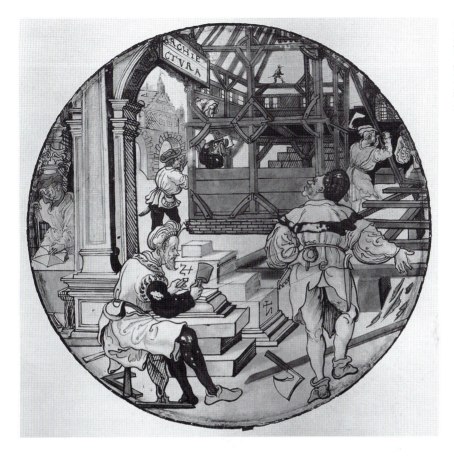

1.39 After Monogrammist SZ, based on a composition by Jörg Breu, *Architectura*, silver-stained glass roundel

Breu and Braun had probably collaborated already in the 1520s on other glass projects. This might be inferred from the initials H.B. that are found on the Göttingen *Months* series. If one accepts that this is Braun's monogram, then these drawings (one dated 1526) would be Braun's working cartoons after the Breu studio prototypes. It would indicate a working relationship between the two of considerable long-standing.

When one turns to the surviving glass roundels themselves, it is immediately clear that they were painted by different hands. The large stylistic distance between say, the *October* in the Augsburg Maximilianmuseum and the *Story of Joseph* series in the Bayerisches Nationalmuseum in Munich (Figs 1.37 and 1.38) – both very skilfully painted – is explainable only in terms of two different glass-painters of quite distinct artistic personality.

These roundels are contemporary pieces, but other glass panels exist, made after Breu's designs, which can be shown to be of a much later date. A roundel in the Cloisters in New York, illustrating *Architectura*, from a series of the *Septem Artes Mechanicae*, is closely related in style to Breu's preparatory designs for such a series now in Vienna (Fig. 1.39).[137] This panel is itself based upon a drawing, also in Vienna, after a Breu original but signed by the Monogrammist SZ. Other variants of the series exist: Tobias Stimmer also

1.40 After Jörg Breu, *Mercatura*, silver-stained glass roundel, signed with monogram and dated 1562

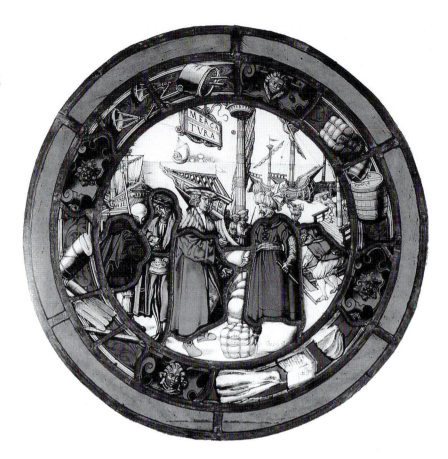

made a modified version of the same design, now in the British Museum, London, as well as another, *Vestiaria*, dated 1558.[138] These examples perfectly illustrate how Breu's designs were disseminated throughout glass workshops and continued to be of value long after his death.

The same point may be made by four further roundels, much restored, in the Museum für Kunstgewerbe in Dresden, from the same series: *Milicia*, *Vesticia*, *Mercatura* and *Venacio* (Fig. 1.40).[139] The *Mercatura* is signed with the monogramm (JM ?) and is dated 1562. This might be tentatively associated with Hans Miller, documented *Glaser* of Augsburg. Certainly the evidence, archival and stylistic, demonstrates that one should look for the identities behind such initials in the lists of glass-workers rather than painters.

One can conclude that though, technically, Breu was allowed by the Guild to practise glass-painting, even after 1522, it is unlikely that he ever did so. His status was that of the designer, the initiator of the series, who would have negotiated with patrons and, while subcontracting out to glaziers, established his authorship in his most prestigious commissions with his monogram. The art of glass-painting, from at least 1510 onwards, was becoming the province of a new class of specialized practitioners, who by the 1560s were a discrete group of craftsmen. Through them, an artist like

Breu could spread his influence over a large area and well beyond his own lifetime.

Notes

1. For his possible itinerary within Bavaria and Austria, see Benesch (1928), 9–20; for an identification of Breu with the 'pictor ex Khrems' see Göhler (1936), 14–17.

2. Benesch (1928), 229–71; Buchner (1928a), 273–383; Menz (1982).

3. For instance, *The Virgin and Child with Sts Barbara and Catherine*, signed and dated 1512, formerly Berlin, Kaiser Friedrich Museum, inv. no. 597A. See von Schmelzing (1936): 10–14.

4. Benesch (1928, 270) saw him as one of the early pioneers of the style. A. Stange (1964, 55f.), related the Zwettl altarpiece to Altdorfer and Huber's works, though concrete connections cannot be shown. F. Dworschak (Stift Florian-Linz, 1965, 23) maintained that all the qualities of the subsequent Danube School painters were already present in Breu's work. F. Winzinger (1965, 18f.), hesitated in calling Breu one of the 'father's of the Danube School', seeing his work as too old-fashioned in its concentration upon form, and lacking Cranach's and Altdorfer's sense of atmosphere.

5. Buchner (1928a), 272–5; and Benesch (1928), 263–5; posited Breu's probable itinerary from Munich down the Isar as far as Passau, where he would have been familiar with the Frueauf workshop; Anselewsky (1968, 185–200), suggested Breu met the lower-Rhenish engraver, the Master PW, while both were in the Frueauf workshop. See also von Baldass (1938) for connections with the Master of the Life of St Benedict; Mair von Landshut and Hans Wertinger have also been invoked as important influences upon Breu. See Menz (1982, 34–5) for a summary of the opinions around the issue.

6. Menz (1982, 33), following Benesch (1928, 254), convincingly suggests the diagonal arrangement of the deathbed scene of St Bernard derives from the requiem scene of St Arcasius in the church of that name at Ilmmünster.

7. Ibid., 62.

8. Ibid., 34.

9. Ibid., 50.

10. Duffy (1992), 235.

11. Marrow (1979), 33–170. He traces the literary tradition of these handbooks from the Latin treatises into the flood of vernacular handbooks of the fourteenth, fifteenth and sixteenth centuries.

12. Ibid.: 47–50.

13. Ibid.: 36–9.

14. Menz (1982), 51.

15. The prominence of the pillar in the Nativity scene for example, a reference to the future scourging of Christ, might have been part of a desired programme, as Menz suggests (ibid., 52).

16. Freedberg (1989), 177–8.

17. Clemen (1937), 14, translated by Ringbom (1965, 29, note 40); cited in Freedberg (1989), 177; see also Burke (1974), 142.

18. 'On Good Friday last, I being in my chamber in fervent prayer, contemplating with myself, how Christ my Saviour on the cross suffered and died for our sins, there suddenly appeared on the wall a bright vision of our Saviour Christ, with five wounds, steadfastly looking at me, as if it had been Christ corporeally.' In Kerr (1943), 57; cited in Forde (1984), 15.

19. Freedberg (1989), 174.

20. Menz (1982), 74–6. On the costume directions, see Evans (1943).

21. Often, the producer of plays and the artist were one. The sculptor, Wilhelm Rollinger, whose carvings of the choir stalls of Vienna Cathedral show the stylizations of gesture common to Passion Plays, was director of the Corpus Christi play between 1486 and 1519 (see Rupprich 1954); the painter and illuminator Hubert Caillaux illuminated the text of a mystery play, preserved in the Bibliothèque Nationale and also painted the scenery and oversaw the staging of the drama (see Mâle 1982, 182).

22. The effectiveness of drama is graphically illustrated in the instance of the Cumbrian man in the reign of James I, who, when questioned about his knowledge of Jesus Christ, replied that he

had heard of him, for when young, he had seen a Corpus Christi play at Kendal, where 'there was a man on a tree and the blood ran down'. See Duffy (1992), 68.

23. Ibid., 70–71; also Beadle and King (1984), xii.

24. Fröning (n.d.), 276; cited by Menz (1982), 76.

25. Friedländer (1969), 97.

26. Andreas von Karlstadt, *Von Abtuhung der Bylder* (Wittenberg, 1522), B iib, D iia, B iva; reprinted in Hoffmann (1983), no. 9.

27. 'Sermon von der Betrachtung des heiligen leydens Christi', in *Martin Luthers Werke. Kritische Gesamtausgabe* (1883–), vol. 2, 136. '… Zum ersten bedenken ettlich das leyden Christi alßo, das sie über die Juden tzornig werden … Das mag wol nit Christus leyden, sondernn Judas und der Juden bosheyt bedacht werden.'

28. Menz (1982), 81–5.

29. Benesch (1928, 259), maintained that Breu received important impulses from Holbein's and Burgkmair's *Peter* and *Lateran Basilika* paintings; the points of resemblance between the latter and the Melk *Agony in the Garden* are very obvious.

30. See Buchner (1928a), 293–300, and Menz (1982), 82–5, for the print sources of Breu's compositions.

31. Menz (1982), 85.

32. Buchner (1928a, 303), maintained that the outer panels were by other hands. See also Menz, 97.

33. John (1984), 188.

34. 'Keyn handwerck stat me jnn syn waerdt/Es ist als überleydt, beschwaerdt/Jeder knecht, meyster werden will/Des sint yetz aller handwerck vil/ … ' (*Narrenschiff*, Brant Sebastian (1854 edn), 49–50; English translation, Brant Sebastian (1944 edn), 173).

35. Huth (1967), 78–9. For the glaziers see StAA, *Handwerkgesetze*, 72a Bl. 18a, 1517; and Vischer (1886), 497.

36. For instance, the painter Jörg I. Lutz, took on three apprentices shortly after qualifying as a master of the Guild in 1513, but, unable to make a living, dissolved his workshop shortly afterwards, as the record of his continued bankruptcy dealings show. The cycle of poverty and uncertainty is vividly illustrated by one of these apprentices, Sigmundt Gutterman, who is recorded in 1534 running a brothel (patronized by a number of artists, including the Breus, father and son). As he explained in the court proceedings against him, he was forced into this form of employment by financial need. See Wilhelm (1983), 70 and 483–4.

37. In 1503 he paid the so-called *Habnit Steuer*, the smallest amount of tax levied; in 1504 he rose to 60 dn. 33kr. 2dn. and between 1505 and 1508, 45dn. 25 kr. 1 dn.; in 1509 his payments dropped slightly to 30dn., 16kr., 3dn.; between 1510–15 he paid 30dn. 4fl.; 1516–27, 30dn., 5fl., 1528, 30dn., 5fl., 30kr., 1529–33, 30dn. 5 fl., 30 kr., 6 dn.; 1535–36, 30dn., 4fl., 6dn. (StAA, *Reichstadt Steuerbücher* 1498–1528).

38. An entry in the records of the city court of 1510 cites a dispute over financial matters between Breu and his brother-in-law, one Rößlin, although details are not given (StAA, *Reichstadt Gerichtsbücher* 1510, fols 496, 189a, 199a). In the same year he moved into the tax district 'In der Krottenaw', perhaps taking over the house of his widowed mother (she is recorded as living with him from that year on). For Holbein's tax payments (his highest, 1 Florin 12 Krone, was in 1504), see Wilhelm (1983), 501–2.

39. Wilhelm (1983), 68 and 75–6.

40. For the numbers of apprentices hired by Gumpolt Giltlinger, Thoman Burgkmair, Hans Holbein the Elder and Ulrich Apt the Elder, see Wilhelm (1983), 479, 432, 504 and 312–13 respectively.

41. Ibid., 412 and 420.

42. Ibid., 393–4. Apt's own first civic commission was in 1485, to paint the pointers of the clock on the *Frauentor*; his highpoint came in 1516 when he won the commission to paint the exterior of the Town Hall, as well as four panels for the new rooms of the interior. His pupil Ulrich Maurmüller possibly owed his livelihood to Apt's good offices, for, of limited ability, he succeeded in getting continuous employment from the city Master of Works (*Baumeister*), in such minor tasks as painting the town coat of arms where and when necessary, or the repainting of public works of art.

43. 'Anno domini 1516 jar fieng ich, Georg Prew, an zu malen mit sampt Ulrich Appt und Ulrich Maurmüller das rathaus..' (*Chronik*, 22).

44. Wilhelm (1983), 75 and 411. Beck's first major fresco was outside the city, in Würzburg, where he decorated the choir of the Cathedral. This was, moreover, in 1511, eight years after he had matriculated to the Guild.

45. Cuneo (1991), 80. Breu is mentioned as such in a *Kopialbuch* (FA 6.1.3. fol. 350r) in the *Fürstlich und Gräflich Fuggersches Familien- und Stiftungsarchiv*, Dillingen an der Donau. The *Rentenkauf* of 15 May 1540, copied from an original document, no longer extant, reads: 'Hans Lutzen den Rat, Hansen Braun, Glaser, beide Zwölffer, Jörgen Prewen dem Eltern, maler und Hansen Sibenaich glaser, baid puchsenmaister, all vier burger und gwalthaber der maler und glaser in Augspurg.'

46. StAA, *Reichstadt Schätze*, Zechpflege von S. Moritz, Sign. 11a: '1505, 24 november aufgeben dem maler, vom gemell bey dem sacrament Hauß plaw ann zu streichen auf guett Rechn. 6 fl. … 1506: 2 märz dem prevn, maler, hinder dem sacrament hauss zu mallen, auff die 6fl., so er for Empfangen hatt, 3fl.. 14 october hab ich dem prewe maler zalt – auf arbaitt, das er hinder dem sacrament geheuß hat gemacht, 3 fl., als sein Knab die getter roth angestrichen, 8 fl., endlich demselben 20 fl.' Reproduced in Vischer (1886), 578–9.

47. Recorded in Augsburg, *Staats- und Stadtbibliotek*, Codex Aug., 330, 127: *Liber rerum Monasterii Crucis, 1618*. Cited in Riedmüller (1916–19), 629–31.

48. Illustrated in Augsburg (1980), vol. 1, 396, cat. no. 406.

49. The bottom portions alone have been effaced. On this, see Rasmussen (1980).

50. StAA, *Baumeisterrechnungsbücher*, 1516, fol. 69r (1 August) and fol. 60r (4 October). The surviving documentation concerning the Town Hall decorations is assembled in Wilhelm (1983), 677–8.

51. *Chronik*, 22.

52. Ibid., 22: '… darob hett ich vier gesellen und zwen Knaben, und Ulrich Apt ain sun Michl, und Ulrich Maurmüller ein Knaben.' This point was also made by Cuneo (1998), 58.

53. StAA, *Reichstadt, Peutinger Konzept H*, fol. 292r, 9. VI. 1516: 'Ferrer, allergnadigister herre, mir ist von dem rat zu Augspurg das rathaus daselbs das angeben des gemeels daselbs bevohlen worden. Nun wird ich under anderem E.[ueres] kais.[erlichen] Mt.[Majestäts] geschlecht von Romischen kaiseren und kunigen, auch kunigen von Hispanien und Sicilien, daran malen lassen und des furnems, wie ich die an dem zedel, hiebei mit dem C bezaichnet, aufgeschriben hab, dorauf E. kais. Mt. in aller undertanigkait bit, mir hierauf gnadigen bescheid zu geben und solchs auf das furderlichest zu tun; dan ich bin in derselben arbeit auch, ob E. Mt. solchs also gefällig seie oder ain anderem monung haben wollen, mich in demselben nach E. Mt. beschaid und wollgefallen auch wissen zu halten.' Reproduced by Wilhelm (1983), 677.

54. Illustrated in Augsburg (1980), vol. 1, 366.

55. A bathing scene, *in situ* at Ludwigsstraße 1 until 1953, and known today only from photographs, is an example of this; see Wilhelm (1983), 78.

56. Illustrated in Augsburg (1980), vol. 2, 24.

57. In the *Chronicle*, Breu complains bitterly about this commission, alluding to the length of time expended (four summers and half a winter), unnecessary rebuilding and loss of his own time and earnings (*Chronik*, 71, 23 June 1536): 'Item adj. 23. brachmonat hab ich herrn Anthoni Fuggers hinderhaus ausgemalt und hab daran 4 summer und ein halben winter gemalt. solche grosse, unnutze bauung und abprechen ist da geschehen. ist mir die costung mit saumnus, verdorben zeug, aufhörung und anfang der zeit auf ain neues nit bezalt worden, hab alle ding sten miessen lassen.'

58. See Rott (1905), 17–18.

59. Augsburg (1980), vol. 1, 269–71, cat. nos 221–7.

60. Tilman Falk (1976, 3–20, esp. 17–19) has argued that the reduced size of Holbein the Elder's workshop and the abrupt change in Holbein's style and working methods from 1510 onwards were the result of a deliberate break with the givens of late gothic altarpiece painting; that from this point on, he abandoned pattern-book models and drew from life. In other words, Holbein gradually reduced his workshop practice from 1510 onwards in order that he might more easily pursue his own creative work and not be tied down by the constraints of leading a large entreprise.

61. Only four paintings survive from the years 1501–12: 1) a double portrait of, apparently, Agnes Breu, the artist's sister and her husband, the armourer, Coloman Helmschmied (Thyssen-Bornemisza Collection, Madrid, inv. no. 1930.63). See Lübbeke (1991), 1556–61; 2) a *Coronation of the Virgin*, so far unpublished, and known to this author only from a monochrome photograph. It exhibits characteristics found in the Melk altarpiece together with traits found in Breu's works from the second decade (see Morrall 1996, 51–2). 3, 4) As this manuscript was going to press, Dr Gode Krämer of the Städtische Sammulungen, Augsburg, very kindly brought to my attention two small panels he discovered in a private collection, an *Annunciation*, dated 1509, and an *Adoration of the Magi*, signed in monogram (see Kramer 2000). This discovery sheds important light on this first decade in Breu's career.

62. See for instance, Holbein's Weingartner altarpiece, 1490, Augsburg Cathedral; the Holbein and Burgkmair *Basilika* Series for the Convent of St Catherine, between 1499 and 1504 (today in

Augsburg, Städtische Sammlungen); and the altarpiece by Apt for the Church of Holy Cross, 1510 (two panels remain, now in Karlsruhe and the Louvre, Paris).

63. Koblenz, Mittelrheinisches Landesmuseum, inv. no. 328.

64. Buchner (1928a), 334.

65. Basel, Öffentliche Kunstsammlung, Kunstmuseum, inv. no. G.1981.1. The connection was first noticed by Stiassny (1893, 297); see also Schmid (1894), 22.

66. The same figure occurs in the execution scene of Holbein's *St Catherine* altarpiece. Berlin (1982, 32–9), suggests Jakob Höchstetter, Marx Pfister or Leonard Weis as possibilities. Gode Krämer (2000, 209–10) has recently suggested that the same figure occurs in the head of a Magus in the *Adoration of the Magi* panel of 1509.

67. Augsburg, Städtische Kunstsammlungen, inv. no. 5345; see Goldberg (1978), 47–9.

68. Augsburg, Städtische Kunstsammlungen, inv. nos L.920 and L.921; see Goldberg (1978), 19–20.

69. The recent cleaning and restoration have revealed a good state of preservation. I should like to thank Dr Weschenfelder, Director of the Mittelrheinisches Landesmuseum, Koblenz, and his curator, Dr Anneli Karrenbock, for allowing me access to study the painting; thanks are especially due to Thomas Hardy, the restorer, for discussing the painting with me and for providing photographs of the panel during restoration.

70. Buchner (1928a), 334.

71. My thanks to Dr Nicholas Eastaugh for carrying out the examination and for preparing a composite mosaic of the underdrawing. For a full discussion of the role of preparatory drawings, underdrawings and painting practice, see Morrall (1996), 85–111.

72. For another instance of borrowing see the *Madonna* in Agram, Landesgalerie (Buchner 1928a, 353–4, pl. 255); a *Resurrection of Christ* (St Anna, Augsburg), is dependent upon Dürer's version from the *Large Passion* woodcut series (B.15).

73. Formerly in Berlin, destroyed in 1945 and known only from black-and-white photographs. The painting had been substantially altered; the coat of arms was probably added in the late sixteenth century, painted over a kneeling donor and possibly additional saints. This makes the attitude of the Christ Child understandable. See von Schmelzing (1936), 10–14.

74. Vienna, Albertina (Winkler 296); an observation made by Blankenhorn (1973, 16).

75. See, for example, the background of Giovanni Bellini's *Coronation of the Virgin* of 1474, Pesaro, Museo Civico.

76. Vienna, Albertina (Winkler 69), or the drawings of St Catherine in Berlin and New York (Winkler 74 and 90).

77. The painting is today in the Lady Chapel of the Oratorianer-Wallfahrtskirche Maria Schnee in Aufhausen (Kr. Staubing). It was given to that church in 1665 by the Augsburg citizen Bernhard von Pichlmayr. See Feuchtmayr (1921, 793), who first attributed the work to Breu. His attribution has been generally followed since, though the names of Burgkmair (Riehl 1912, 324; Rauch 1973, 112), the Petrarch Master (Schindler 1985, 47), Altdorfer or Wolf Traut (Friedländer 1891, 131) have also been unconvincingly evoked. I would agree with Feuchtmayr's attribution and dating of c.1512–15.

78. Basel, Kunstmuseum, Kupferstichkabinett. Winkler (1936–39, vol. 3; no. 466), Buchner (1928a, 328), Stange (1967, 20), and Bushart (1994, 102) all accept Dürer's authorship. Tietze and Tietze-Konrat (1932, 135) considered it to be by Breu himself; Blankenhorn (1973, 23) suggested it might be a copy of a lost Dürer painting.

79. Rupprich (1956–69), vol. 1, 253. In a letter to Pirckheimer of 12 or 16 February 1507, Konrad Fuchs says he will not hold on to Dürer for as long on his return journey. The commissions Dürer received probably included the three life-size chalk drawings of the three Fugger brothers, subsequently owned and recorded by Sandrart in 1679; also the *Madonna of the Rose Garlands* altarpiece for the German merchant community church in Venice, San Bartolomeo al Rialto. See Bushart (1994), 102, n.257.

80. See the arguments of Bushart (1994), 99–111.

81. The inspiration for the architecture is the tomb of Doge Andrea Vendramin in SS Giovanni e Paolo, then still in Sta Maria dei Servi, and which had struck Dürer even on his first visit to Venice. This also inspired one of the first rough plans for the epitaphs. See Bushart (1994), 102, n.257.

82. Schindler (1985), 48–49; Stange (1967), 20.

83. Present whereabouts unknown; formerly (1988) Robert Holden Gallery, London.

84. See, for instance, the *Story of Joseph*, National Gallery, London.

85. Documented by Dodgson (1903), 335–50.

86. *Breviarium iuxta ritum et ordinem alme ecclesiae Constantiense.* See Hagelstange (1905), 3–17.

87. *Breviarum Ratisponense* (E. Ratdolt, Augsburg, 20 November 1515). See Dodgson (1900), 199–201.

88. Hagelstange (1905), 3–4.

89. Wolfgang von Maen, *Das Leiden Jesu Christi unseres erlösers …* (Johannes Schönsperger the Younger, Augsburg, 1515); illustrated in Geisberg (1924–30), vol. 8, plates 377, 378, nos. 850–52; see also Dodgson (1911), vol. 2, 109, no. 1.

90. Dodgson (1911), vol. 2, 6, no. 3, and 58, no. 510.

91. *Fortunatus* (Hans Otmar, Augsburg, 1509) and Barthema, *Die Ritterliche und lobwirdig Raysz … Ludowico Vartomans von Bologna, von den Landen Egypto, Syria, Arabia, Persia, India.* (Hans Miller, Augsburg, 1515). See Geisberg (1924–30), vol. 6, plates 261–8, nos. 606–50 and vol. 5, plates 211–18, nos. 431–74.

92. Bellot (1980), vol. 1, 89–94.

93. Pfeiffer (1965), 120–26.

94. Ibid., 122. He cites the predella of the altar of the Fugger Chapel and the sides of the stone retable of the Eggenberger altarpiece, formerly in the Deutsches Museum, Berlin, as examples of this type.

95. Ibid., 123.

96. For the print see Levenson et al. (1973), 200–5.

97. Pfeiffer (1965), 122–3.

98. Illustrated in Röttinger (1909), 72.

99. Pfeiffer (1965), 125.

100. For other works, see Pfeiffer (1965), 126, n. 16.

101. As discussed in Oberhammer (1935), 136f.; cited by Pfeiffer (1965), 125, n. 20.

102. See, for instance, designs by Burgkmair for altarpiece reliefs in Falk (1973), 22–6. Also Huth (1967 edn), 37–45.

103. Meller (1928), 440.

104. Feuchtmayr (1927), 20: 46–7.

105. *Halle'scher Heiltumscodex*, fol. 106v, Aschaffenburger Schloßbibliothek: 'Eyn silberne verguldte taffel mitt den heyligen dreyen Konigen unnd andern bildern In eyttel golt geschmelcztt. Inhalt 36 Partikel'; cited in Steingräber (1928), vol. 1, 223–33.

106. Ibid., 231. They are recorded in the painted inventory of 1526/7 but not in the printed inventory of 1520, suggesting they were made in the intervening period.

107. Buchner (1928a, 364) dated it *c*.1522–25, a date which has been generally accepted.

108. *The Virgin crowned by two Angels*, Vienna, Kunsthistorischesmuseum.

109. Von Baldass (1913), 359–62.

110. Lieb, Stange, (1960), cat. no. 84, also nos 54, 62, 87, 60, 61.

111. Winkler (1936–39), nos 483–488; Strauss (1974b), vol. 3, nos 1506/40, 1506/41, 1510/20, 1510/21.

112. See Appendix.

113. For the reconstruction of one of these series and an attribution to Breu of a glass roundel in the Burrell Collection, Glasgow, see Morrall (1993), 212–14. For the other series, see Appendix, below.

114. Unpublished and last recorded at sale: Boerner, Leipzig, 28 November 1912.

115. The drawing is in the J. Paul Getty Museum, Los Angeles (inv. no. 89.GA.16), the glass roundel in the Germanisches Nationalmuseum, Nuremberg. See Schmitz (1913), vol. 1, 156, fig. 256.

116. For an exhaustive examination of the patronage, subject matter and style, see Dörnhöffer (1897), 1–55; also Stiassny (1897–98), 296–98. He mentions a glass roundel of the *Swiss War*, dependent on the series, then in the Museo Carolino Augusteum in Salzburg, but no longer extant. For other related surviving glass roundels, see Appendix.

117. 'Wir schicken dir hiemit ain abschrift etlich gemeltes so wir in zwainzig scheiben malen und schmelzen und in unsern neuen thuren zue Lermus in etlich fenster einsetzen lassen woellen, wie du sehen wirdest, und empfelen dir darauf mit ernst, das du solch arbait unserm hofmaler zue Augspurg, maister Hansen Knoder, vonstunden zue machen andingest' (Letter, Maximilian to Jacob Villinger, 14 June 1516); published in Zimmermann (1863), part 2, LXVI:

72 JÖRG BREU THE ELDER 

no. 400. For information about the hunting lodge at Lermoos and Maximilian's stays there, see Cuneo (1991), 323 and 332–3, for a useful summary.

118. Dörnhöffer (1897), 10.

119. Baum (1923), 110–20; Wegner (1959), 17–36. Cuneo (1991, 190–276), erected a hypothetical argument for the identity of the Höchstetter patron, sought to identify portrait representations within the designs and attempted to find implicit social criticism of the merchant patron in the treatment of subject matter. Her arguments, such as the suggestion (p.246) that the tree felled by a peasant in the *March* scene is placed so as to appear about to fall upon the merchant, are unconvincing. See also Dormeier, in Boockmann (1994), 148–221.

120. Rosenberg (1938), 46.

121. Of the eight designs in Berlin, Wegner rightly discounts the February and March scenes as copies, and regards the rest as autograph; see Wegner (1959), 17–36.

122. Ibid., 17; Baum (1923), 113.

123. For a discussion of the *vidimus*, see Wayment (1979), 365–76.

124. Huth (1967), 78–9.

125. See Beutler and Thiem (1960), 163–4.

126. StAA, 72a, *Handwerkgesetze*, Bl.11,a. 1522: 'Item es ist zu wissen das ein erber Handwerck der maler mit den meren erkannt hat. Wenn sich begabe das hinfur einer das Handwerck kauffen oder annemen wurde oder wollte, derselbig soll sich ains Handwercks allein, welches er under den vieren gelernet hast, underziehen und gebrauchen und sich der anderen aller muessigen und entschlahen. Doch sollend die maister die jetzt vorhanden sein nit begryffen sonder ausgeschlossen sein. Anno 1522 am Sontag nach Esaltacionis crucis.'

127. StAA, *Glaserakten*, 31 August 1560. Published and discussed in Morrall (1994), 137, and nn. 15, 16, 17, 18.

128. StAA, *Glaserakten*, 31 August 1560. Testimony of Hans Burgkmair the Younger: '... ain Jeder der das so er gelernet/ allain getriben hab/ und die andern handwerck Jme vnnd seinen Kindern/ Soenen oder toechtern durch heirat nutz machen mogen.' Testimony of Hans Braun, *Glasschmeltzer*: 'Sey 50. Jar Maister/ aber nie gesehen/ das ainer mer dann ain handwerck getriben oder treiben hab durffen/ oder gesellen darauf halten/ vnd welcher ander[s?] red/ der spar die warhait/ Sagt auch Maister Gregori hab allwegen wann er ain Creutz herrgot gemacht/ ain Malergsellen die farblen anzustreichen/ vnd die schoss zuuergulden ain Goldschlagergsellen darzu gebraucht/ ... '

129. Ibid.: '... So hab ain Jeder Maler fuog vnd macht wann er wil glaeser zu kauffen/ vnd dieselben jn offnen Laden failzuhaben/ aber doch kainem glaser gsellen Darauf zuhalten.'

130. Ibid.: Testimony of Sigmund Ost, Glazier: '... so sey vor Jarhen weil man in den kirchteil zuglasen vnd zumalen gehabt/ gebreuchig gewesen das etwo ain glaser ain Glasmalergesellen zuhilff genomen/ Gleichergestalt haben die flachmaler auch gethon.'

131. StAA., *Zunftbuch der Maler, Glaser, Bildschnitzer und Goldschlager*, 1495–1548, 720, 1510.

132. StAA., *Malerbuch*, 82.

133. Ibid., 233.

134. See Wilhelm (1983), 237.

135. Munich, Reichsarchiv, Neuburg, Kopial b. 111 fol. 183, quoted in Rott (1905), 188.

136. Ibid.: 184: 'Ist ein bedingszettel wie durch hertzog Ottheinrichs baumeister Jeremeien Wagner mit Jorgen Brew malern zu Augspurg gedingt worden etlicher gemecher und die capell in der Grienaw zu malen, welche all und wie sie gemalt sollen werden, specifiert werden. Wird im gemacht 200 gl. inmuntz und ein somerklaid, die Farben soll er selb geben, aber holtz und bettgewant weil er arbeit, soll im Jr. f. gn. geben. Sonntag nach Martini 1537.' Munich, Hausarchiv, Pfalz-Neuburg, *Schlosser und Schatzkasten*.

137. See Husband (1991), 171. The three drawings in the Albertina, Vienna are of *Vestiaria*, *Metalaria* and *Mercatura* (nos 13.255, 13.256, 13.258).

138. British Museum, nos 1899-1-20-56, and 1899-1-20-57; see Thöne (1936), 95, and figs 23 and 24, plates 3 and 4.

139. Dresden, Staatliche Kunstsammlungen, Historisches Museum, inv. nos A 156 (MfDG: Mk60–246), A153 (MfDG: Mk60–241), A168 (MfDG: Mk 60–236), A165 (MfDG: Mk 60–239). They were returned in the late 1980s from Russia to the Deutsches Historisches Museum, Berlin, where they were seen by the present writer. See Morrall (1994), 143–4.

The turn towards Italy

Augsburg and the South

More than any city in Germany, Augsburg forged strong cultural and economic ties with Italy. Its particular susceptibility to influence from the South lay in its relative proximity and in its position on the main trading routes. The great merchant families of Augsburg, like the Fugger and the Welser, maintained strong commercial links with the Italians, keeping offices in the major cities of Venice, Rome and Genoa. They adopted Italian business methods, routinely educated their children in Roman Law at the universities of Bologna, Pavia and Padua, and took a lively interest in Italian fashions in art and architecture.[1] The worldly tastes of these families and their patronage of art and architecture, stimulated an interest in Italianate forms. The example of Jacob Fugger ('the Rich'), patriarch of Germany's most extensive international banking and trading empire, was central to this process of acculturation. He had long experience of Venice, having spent several formative years there, based at the *Fondaco dei Tedeschi*, the German merchant headquarters. It was to the modern architecture and art of that city that he looked when planning his own building and decorative projects. He remodelled his own palace in 1515, basing his design on Venetian prototypes.[2] The most complete surviving testimony to his preoccupation with Venetian art, however, is the funerary chapel in the Carmelite monastery of St Anna, which he built for himself and his brothers Ulrich and Georg. As Bruno Bushart has demonstrated, the chapel's plan, the types and disposition of piers and windows, the ornamental details, and materials all recall the repertoire of Mauro Codussi and Pietro Lombardo. The forms of the altar statuary are so strongly Venetian in character that scholars are still divided over whether to attribute them to a northern or Italian hand.[3] It is not surprising that when Breu came to design the painted shutters for the great organ that dominates the main wall of the chapel, he also looked to modern Venetian art in order to conform to this ambient style. The motif, within the small organ shutters, of over-lapping planes of a marble arcade, receding in strong foreshortening, is derived from Tullio Lombardo's *Anianus* reliefs on the façade of the Scuola Grande di San Marco (see Plates 7 and 8).[4]

In this case, Breu can be seen to be responding creatively to the stylistic preferences of his patron. Certainly the modern style came to be associated specifically with the Fugger and other wealthy banking families. As Bernd

Roeck has argued, they used a taste for things Italian – and Italianate – as an outward demonstration of a particular mentality, symbolic of the values of their class – the new urban merchant elite – by which to differentiate themselves from other social groups.[5] The resentment of members of the older feudal class towards these '*nobiles mercatores*', these 'ennobled shop-keepers', their trappings and their art, is well expressed in Ulrich von Hutten's dialogue *Praedones*, or *The Thieves*. He sarcastically compares the Fugger Chapel with an edifice fit for royalty ('Regium in morem'), and has his friend, the knight Franz von Sickingen, categorically exclaim: 'I say it is unnatural to bring to Germany things which do not have their origin in Germany' ('Imo contra naturam dico adportari quae hic non nascuntur').[6] For many contemporaries, artistic style was understood in social terms, coloured by political and ideological associations.

An important consequence of Fugger patronage, therefore, was to associate the 'Italianate' with high finance, power and international prestige. At the same time, such patronage gave impetus to a growing humanist culture, characterized already in the later fifteenth century by such figures as Sigmund Gossenbrot or Adolf Occo, who even then collected Italian art.[7] They were followed by a generation of humanists, chief among whom was the civil lawyer Conrad Peutinger, also educated in Italy, and Secretary to the Augsburg City Council. From 1499 he built up a collection of antique marbles, Italian weapons, prints, medallions, plaques, books and manuscripts.[8] He maintained a wide correspondence with humanists in Italy and the rest of Europe, and was a keen patron of literary humanist enterprises.[9] His role as adviser in the literary and artistic projects of the Emperor Maximilian I gave him a pivotal position of influence in the encouragement of humanist taste.

Indeed, the Emperor's attachment to the city of Augsburg, his frequent and prolonged visits there, and his employment (via Peutinger's agency) of local artists and craftsmen on his multifarious commissions, gave enormous impetus to the revival of the sense of the city's imperial, Roman past (retained in its Latin name 'Augusta'), and to the formation of an 'imperial' style appropriate to the Emperor's propagandist ambitions. Peutinger and Maximilian's joint involvement in establishing the theme of Habsburg genealogy for the façade of the Town Hall (discussed above) vividly illustrates the convergence of humanist learning and imperial *Representatio* upon an important city landmark.

These contexts for the Latinate style – of wealth, of learning and of power – gave powerful encouragement to a general process of stylistic infiltration that was already underway and would, by gradual degrees, transform the aesthetic of northern Europe. One chief route by which Italian styles entered the city was through its printers. In the course of the later fifteenth century, they had made Augsburg an important centre of book publishing. Their affinity – and rivalry – with Venetian printers can be registered as early as 1472 in such figures as Günther Zainer, who used the *antiqua* script in a calendar in that year.[10] The prominent printer Erhart Ratdolt maintained a workshop in Venice from 1486 onwards. When he eventually returned to

Augsburg to continue his business there, he brought with him not merely sets of Italian and antique characters but an expertise and authority that was emulated by other publishers.[11] By the second decade of the sixteenth century, humanist printing houses, such as those of Grimm and Wirsung, or Johannes Schönsperger, were producing fine Latin and vernacular printed editions of the classics and Italian literature. These, together with the more conventional religious material, were routinely decorated with borders and frontispieces of a hybrid classicism that drew upon north Italian – particularly Lombard – decorative prints and local Gothic forms. This particular brand of decorative classicism found its way from there into all the other media and forms of art.

Such, briefly sketched, were the circumstances and conditions which determined the notion of the *welsch* style for the generation of artists who grew to maturity in the first two decades of the sixteenth century. Their gradual, piecemeal sense of the Italian, both ancient and modern, came from the coins and medals and print collections of the merchants and humanists,[12] in addition to the few quattrocento panel paintings and artefacts that had been brought back by individual collectors.[13] The native classicism forged by the Augsburgers was dependent more on the figurative style of the north Italian printmakers and niellists than the works of central Italian artists. Overridingly it was the art and architecture of Venice which most influenced Augsburg painters in the formation of a Renaissance style: a striking example of the influence of commerce upon taste.

Perhaps because subject matter in the field of painting was tied to set habits and conventions appropriate to religious devotions, the new style took longer to take root in this medium. The artist who was the first to work consistently in a 'Renaissance' manner was Hans Burgkmair.[14] Already in 1501, his contributions to the *Basilica Series* of lunettes painted for the Convent of St Katherine show knowledge of Italian architectural forms and monumental panel paintings, reflecting an early journey across the Alps.[15] According to Baer, the year 1507 was a turning point: thereafter, Burgkmair increasingly employed classical and Venetian Renaissance architectural structures and decorative elements in paintings and woodcuts, in subjects religious and profane.[16] The patronage of Peutinger and, through him, the Emperor, was important in this respect. The humanist ambience and the nature of the commissions encouraged him in this direction.

As we have seen, Breu's adoption of Italianate elements can be traced only from the second decade and then only in certain commissions, alongside a body of work that continued to contain no classical reference. Indeed, Breu's classicism seems to have developed precisely in the context of commissions from the Emperor Maximilian and, later, the Fugger family, both of whom possessed, in their separate ways, an interest in – one might almost say, an ideological commitment to – a Latinate style. While the taste of patrons provides a general context for Breu's own interest in Italian art, close examination of the artist's early exercises in classicism, executed within the period *c*.1512 to *c*.1517, will show more precisely to what ends he employed

the style, in what contexts he considered its use appropriate, upon what types of subject matter he could impose it and what meanings he was able to express through it.

The Aufhausen Madonna

The dependence of this work upon a preparatory watercolour drawing dated 1509 by Dürer and its possible connection with the Fugger Chapel in St Anna has already been discussed in Chapter 1 (Plate 3 and Fig. 1.15). While a concrete connection cannot be proven, this dependence suggests the painting was executed soon after the drawing, thus at some point around 1512. The painting holds an important position in the development of classicism within Augsburg art, for it is the first surviving painted example to place the Madonna and Child beneath an elaborate classical portico. Though the design was clearly Dürer's, the conception had already been introduced earlier in a woodcut by Burgkmair of 1507 (Fig. 2.1), where a similar classical portico, supported by columns, is placed obliquely into the picture space and set before an extensive hilly landscape. Similar symbolic plants, fruit and birds reinforce the Marian themes of purity (lily of the valley), wisdom (parrot) and knowledge (fig leaves).[17]

The changes Breu wrought upon Dürer's original design build upon Burgkmair's invention. They are interesting for the light they throw upon his own notions of the classical and of his knowledge of Italian art. Breu transformed Dürer's original hall and adjoining annexe into an open-sided, centrally-placed pavilion, which assumes the character of a Baldacchino for the Virgin. By this means, he approached the format of the Venetian *Sacra Conversazione*, established by Antonello da Messina and Giovanni Bellini, where similar architectural edifices provide a frame for the saintly personages beneath.[18] The flat pilasters with grotesque relief carving and the carving on the socles of the foreground pillars also differ from the original drawing. The prints of Zoan Andrea and Nicoletto da Modena have been rightly invoked as probable sources,[19] yet their usage strongly recalls the architectural detailing of the Lombardo workshop, or the frames of such Venetian altarpieces as Giovanni Bellini's *Madonna and Saints* in the Sacristy of the Frari.[20] Furthermore, the relief of the *Judgement of Solomon*, with which Breu replaced Dürer's scalloped lunette, suggests direct cognizance of Mantegna's *trompe l'oeil* grisaille paintings of biblical and classical scenes, although no exact prototype survives. The angels sitting on the edge of the balustrade of the circular opening at the rear of Breu's edifice also recall the putti in the illusionistic ceiling of the *Camera Picta* in the Palazzo Ducale in Mantua. These references, some no more than echoes, are a measure of Breu's involvement both in the art of Italy and in the artistic ideas surrounding the Fugger Chapel, where carved putti, in attitudes of grieving reflection, decorate the altar wall.

Breu's painting therefore transforms Dürer's original conception into something more distinctly Northern Italian in character. The artist could

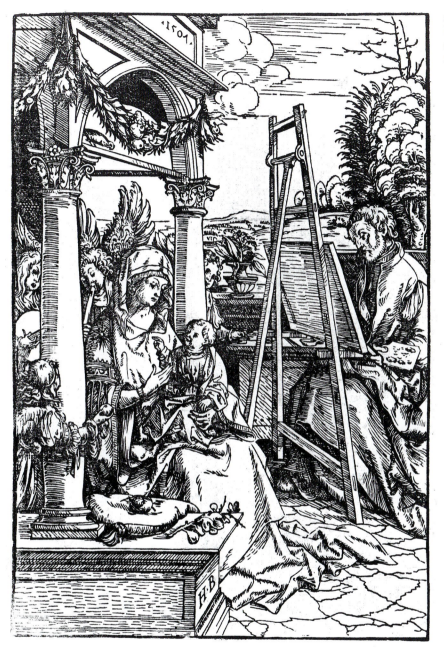

2.1 Hans
Burgkmair, *Madonna
and Child with St
Luke*, woodcut, 1507

probably have drawn his inspiration from print sources and ideas in Augsburg
without direct acquaintance of Venetian altarpiece design. At this date, prints
remained his most important means of access to the new style. It was to
these that Breu turned a few years afterwards, in 1515, when he was drawn
into the orbit of the Emperor Maximilian's literary projects and commissioned
to contribute designs for his *Prayerbook*.

The *Prayerbook* of Maximilian I

Breu's participation in the prestigious artistic projects of Maximilian had begun in 1514 with his designs in glass for the Lermoos series of imperial campaigns and hunting scenes (see Fig. 1.34). It was perhaps due to their success that he gained in the following year the commission to decorate the margins of a portion of the Emperor's personal prayerbook. The text of this work was a compendium, chosen by the Emperor himself, of favourite prayers, psalms and passages from Scripture, appended to a Book of Hours. The nature of the project was unusual in that the text was printed rather than handwritten, with a specially designed fracture, on expensive vellum, apparently in an edition of 10 copies.[21] Though possibly begun as early as 1508, the printer's colophon states that the printed text was completed only on 3 January, 1514.[22] Under the supervision of Conrad Peutinger in Augsburg, parts of one of these 10 copies, apportioned by signatures, were then sent out to various German artists for decoration in pen and ink. Dürer received the first nine signatures, the largest number apportioned (the very first, containing the liturgical calendar was held back). Breu, along with Burgkmair, Cranach, Baldung Grien and Altdorfer and a member of his workshop were subsequently allotted the remainder. Breu decorated two signatures (XV and XVI). Of decorated signatures XVII and XXI–XXIV, no trace remains.[23] The project that thus encompassed the collective energies of these considerable artists remained unfinished at the Emperor's death in 1519.

Giehlow was the first to attribute a portion of the drawings to Breu. Executed in either a red or a green ink, they illustrate the parts of the *Prayerbook* devoted to the offices of *Terce*, *Sext*, *None* and *Vespers*. For the first two, Maximilian had chosen Psalms 120–22, with two concluding prayers for *Terce*; Psalms 126–8 make up *None*; and Psalms 110, 113, 122, 127 and 147 were chosen for *Vespers*. This quotient is now in the Bibliothèque Municipale in Besançon. Nineteen of the 25 illustrations are marked in a sticky black ink with the initials MA, in a later sixteenth-century hand. Other artists' monograms were added in the same ink on the other illustrated pages, though the writer was mistaken in a number of his attributions. Giehlow suggested that MA stood for Mathis Aschaffenburg, the name by which Matthias Grünewald was known in the latter part of the sixteenth century.[24] Though the work of establishing authorship has been resolved, little attention has been focused on the precise character of these drawings, their meaning and function and their relationship with the productions of the other illustrators.

The purpose of the *Prayerbook* has been much disputed. Some commentators have concluded that the 10 copies on vellum mentioned in the surviving correspondence constituted the complete edition of printed books and that the illustrated copy was intended for the Empror's sole use.[25] Others have seen the *Prayerbook* in the light of the overtly public and propagandist function of Maximilian's other literary endeavours. According to this view, the illustrations were intended to be turned into woodcuts and thus more widely propagated.[26] It has been strongly argued that the *Prayerbook* was intended

for members of the Order of St George, founded by Frederick III and extended by Maximilian, dedicated to the propagation of a crusade against the Turks. Frequent mentions of St George in the text and two illustrations of him in the margins as well as the inclusion in the text of Offices which would have matched specific devotions performed by members of the Order of St George, strengthen this view.[27]

Certainly, the lack of unity in the different artists' treatment of their material and the unfinished quality suggests that the *Prayerbook* drawings were first drafts rather than the final version. Dürer did not complete his section.[28] Baldung, in all likelihood receiving his portion after Dürer and Cranach, fared worse and apparently returned them to Peutinger unfinished.[29] Pages on which he had worked were finished off by the Altdorfer workshop, and in Augsburg, by Burgkmair and Breu. That Altdorfer, despite the great care and inventiveness of his designs, meted out certain pages to an assistant of lesser ability, strongly suggests that the commission was not inspired by the desire to possess original drawings by first-rate artists.

The portions decorated by the Augsburg artists by contrast are scantier in character and show little concern for the decorative nature of margin illustration. The assumption by scholars has been that they were rushed, left incomplete and ill-considered. Yet Breu's designs – 23 pages in all – differ markedly in conception from those of the other contributors. They consist for the most part of self-contained units, sometimes at the base of the text, sometimes floated up one margin. His drawing on fol. 79v, of a classical candelabrum, contains the date 1515, the only firm date for any of the illustrations. As the Emperor came to Augsburg on 2 January 1516, it is possible that he desired the completion of the illustrations by his arrival.[30]

Breu's drawings are of two kinds: those that are freely drawn and those (almost half) that are quite closely copied from Italian nielli.[31] These latter tend to be more tightly drawn, with a firmer sense of form, within a closed outline; the former are, with a number of exceptions, more loosely constructed and freer in their relationship with the page. The division into these two groupings extends also to subject matter: the 'free-hand' illustrations draw for the most part from traditional religious devotional imagery, whilst the copies draw on imagery that is classical and allegorical. It is in fact with these adaptations, that classical themes make a sudden and dramatic entrance into the artist's oeuvre. Why should Breu have chosen such imagery for this particular project? Was it for general effects of fantasy and formal invention or did they contain meanings related to the text they decorated? Was the impulse to use them the artist's or was he advised by Peutinger, the official coordinator of the programme?

IMAGE AND VERSE

Connections may be found between many of Breu's drawings and the text, though the relationship is neither straightforward nor consistent. In some

instances, Breu appears to have taken his cue from a single word. The St Peter on fol. 82v refers to the prayer in the text: 'Hear us O God of our salvation and guard us in the protection of the Apostles Peter and Paul …' (Fig. 2.2); but there is no sign of a St Paul, or indeed the other apostles mentioned in the same prayer. Likewise the meditating angel at the base of fol. 76r (Fig. 2.3), with lute laid to one side and book closed, offers no direct connection with the imagery of the text. Only the single word *requievi* ('I was

2.3 *Prayerbook of Maximilian*, fol. 76r: *Angel*, pen and red ink on vellum

given to rest') directly above, might have prompted the melancholic and reflective pose.[32] In a similar way, the words, *Ave maris stella* ('Hail, Star of the Sea …') on fol. 92v obviously suggested the *Woman of the Apocalypse* of Revelation 12, v. 1, whom Breu faithfully reproduced in the left-hand margin, 'clothed with the sun, and the moon under her feet, and upon her head a crown of twelve stars' (Fig. 2.4). This allowed him to extend the decoration to include St John on Patmos below. This process of responding in a freely

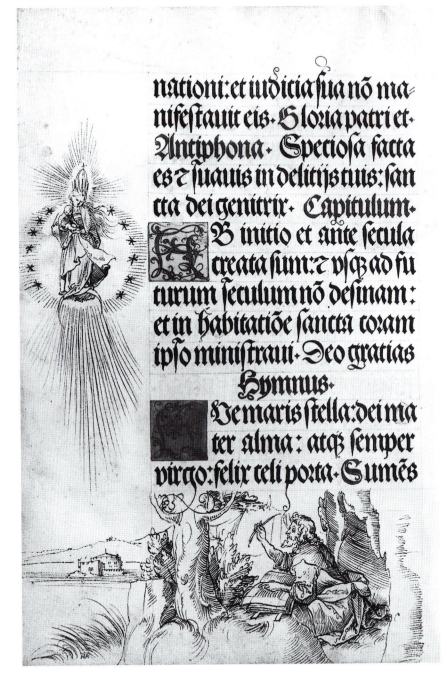

liberati fumus· Adiutorium
noftrum innomine domini:
qui fecit celum et terram·Glo
riapatri. Pfalmus·
Qi confidunt in domi
no ficut mons fpon nõ
comouebitur in eternum:qui
habitat in bierufalem·Mon
tes in circuitu eius:et domin⁹
in circuitu populi fui: er hoc
nunc τ vfcþ in feculum:Quia
non derelinquet dominus vir
gam peccatorum fuþ fortem
iuftorum: vt non extendant

2.5 *Prayerbook of Maximilian*, fol. 81r: *Christ on a Mountain*, pen and green ink on vellum

associative manner to single verbal cues was conventional practice among late medieval illuminators.[33]

In other instances the artist responded imaginatively to the central themes of a particular text. Fol. 81r contains the figure of Christ standing on top of a mountain, with arms out-stretched, his head in a blaze of light, high above two prostrate bearded figures on the lower left (Fig. 2.5). To Giehlow, this was a scene of the *Transfiguration*, to Strauss, *The Sermon on the Mount*.[34] The

image has points in common with both biblical scenes, yet does not accurately portray either. Nor does the adjacent text refer to either event. It is Psalm 125, vv. 1–3: 'They that trust in the Lord shall be as Mount Zion, which cannot be moved, but abideth for ever.' The image conjoins two elements of the text, the notion of a resplendent Lord, in whom trust is placed; and the immovable mountain of Faith. The artist is responding inventively to the central meaning of the Psalm, creating an image that sums up its essence. In finding a means to do so, the model of the *Transfiguration* came to his mind. Despite a certain expressive poverty, this kind of free play with religious themes is striking in its creation of an imagery that mirrors but is quite distinct from the metaphorical language of the psalm.

In other examples one sees a looser relation to the text. The St Christopher, on fol. 87r (Fig. 2.6), is not specifically named in the text, yet as a saint frequently invoked against the perils of travel and as protection against sudden death, he aptly decorates the prayer that begins: 'O all ye saints of God, Be pleased to pray for our salvation and the salvation of all …', and continues on the unillustrated verso: 'order also the footsteps, the deeds, and the wills of all thy servants, in the path leading to salvation in thee.'[35] The image of the hard path of virtue on the road to salvation matches that of the traveller St Christopher, struggling against the current.

Several illustrations simply convey the theme of music appropriate to the decoration of the psalms. These include the three singing cherubs on a garland on fol. 75r; David playing his harp on the margin of fol. 89r, accompanying Psalm 112, vv. 1–4 (Fig. 2.7); and the image of Orpheus playing to the animals on fol. 75v (Fig. 2.8). Adapted from a niello by Peregino da Cesena,[36] it too evokes the sense of musical accompaniment around the text of the psalms, charging the words with a specific context of nature, both ancient and wild, possibly prompted by the antiquity of the psalms themselves and by the 'mountains' in the adjacent phrase from Psalm 120, v. 1: 'Levavi oculos meos in montes, unde veniet auxilium mihi' ('I will lift up mine eyes to the hills, whence cometh my help').

By contrast, in the figure of Arion riding the back of a dolphin (fol. 80r; Fig. 2.9), one finds a derivation from a niello source used with understanding of the figure's identity and with some sophistication in regard to the text. Adapted from a print by Peregrino da Cesena (Fig. 2.10), the only substantial alteration was to the angle of the head. Breu's Arion is made to look up, a change that aptly echoes the words of Psalm 122, vv. 1–2, in the text: 'Unto thee lift I up mine eyes, O thou that dwellest in the heavens … So our eyes wait upon the Lord our God until that he has mercy upon us.' The theme of Arion, saved from drowning by a dolphin, is also symbolically appropriate for the immediately following passage, taken from Psalm 123, which employs the metaphor of water and God's saving powers:

If it had not been the Lord who was on our side when men rose up against us … then the water had overwhelmed us and the stream gone over our souls; then the proud waters had gone over our souls.

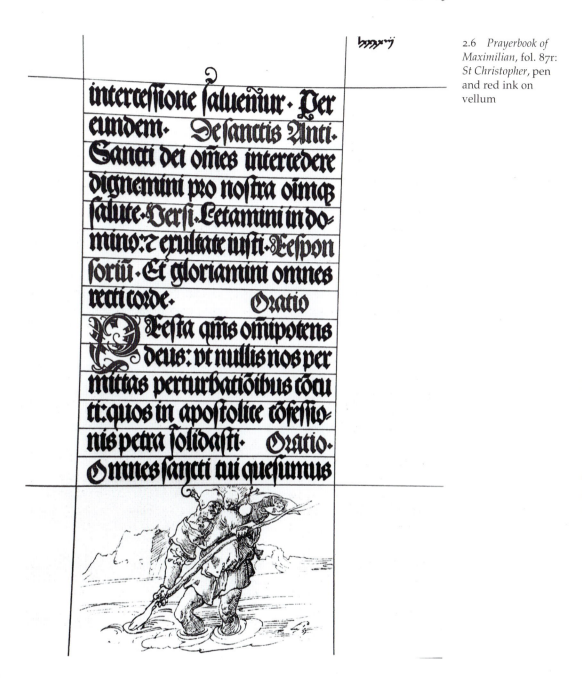

2.6 *Prayerbook of Maximilian*, fol. 87r: *St Christopher*, pen and red ink on vellum

Though this part of the text is on the undecorated verso, the similarity of theme between the image and text is not accidental. The emblem-like use of Arion here, of a classical figure used as an allegory of the human soul, might prompt one to suppose Peutinger's involvement, with his interest in epigrams and emblems.

This manner of matching existing prints allegorically with a particular passage of text is a striking feature of Breu's approach to the decoration

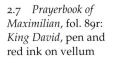

2.7 *Prayerbook of Maximilian*, fol. 89r: *King David*, pen and red ink on vellum

and markedly different from that of the other illustrators of the *Prayerbook*. It may be seen in his other borrowings. In his use of Peregrino's niello, identifiable as *Mercury Conferring the Son of Semele to Ino* (Fig. 2.11), Breu has carefully extracted the figure of Ino, suckling her children, with Jupiter as an eagle behind (fol. 86v; Fig. 2.12), thus transforming the image into a kind of *Caritas* figure. It is adjacent to a prayer that invokes the intercessionary powers of the Virgin for man's salvation ('... forgive the

2.8 *Prayerbook of Maximilian*, fol. 75v: *Orpheus*, pen and green ink on vellum

transgressions of your servants, and, as by our own deeds, we cannot please thee, may we find salvation through the prayers of the mother of thy son …'). The image of a *Caritas*, suckling children, (powers of succour and support) below an eagle (Jupiter/Deity) may be seen as an apt analogy of the general meaning of the text, rendered in classical and allegorical terms.

ſtra: opprobrium abundanti-
bus: et ðſpectio ſuperbis. Glo
ria patri et filio. Sicut erat.
Pſalmus.
Iſi quia domin⁹ erat
iŋnobis dicat nũc iſrael

2.9 *Prayerbook of Maximilian*, fol. 80r: *Arion*, pen and green ink on vellum

The use of a *Prudentia*, carefully transcribed from a Peregrino niello, to accompany another prayer celebrating the intercession of the Virgin, fulfils a similar metaphorical purpose (Fig. 2.13). The fruitfulness and virginity of the opening lines ('Oh God, who have vouchsafed the salvation of humankind by the fruitful virginity of the blessed Virgin Mary') are evoked by the figure's cornucopia and mirror. Her triumph over the Devil is symbolized by the dragon beneath her. Breu has ignored the original meaning of the figure in this context, using the image in an elliptical relationship with the text that extracts the Virgin's qualities and offers them up in abstracted form.

In the remaining decorations, the relationship with the text is general and one can sense a certain strain in matching the images at his disposal with the particular texts. The figure of *Fortuna/Venus Marina* (Fig. 2.14), with billowing sail and agitated wind god above, copied from Peregrino, conjures up an image of 'haste' at the beginning of the adjacent prayer: 'Domine ad adiuuandum me festina', ('Make haste, O God, to deliver me …'); a St Jerome, contemplating his crucifix in the desert at the bottom of fol. 85v, stands as a general image of piety to match the words of Psalm 126, vv. 1–3, 'Blessed are those who fear the Lord'.

No obvious link exists between the David and Goliath on fol. 91r and its attendant text, Psalm 126, vv. 1–4 (Fig. 2.15):

2.10 Peregrino da Cesena, *Arion*, niello

Except the Lord build the House, they labour in vain that build it. Except the Lord guard the city, the watchman waketh but in vain … Lo, children are an heritage of the Lord and the fruit of the womb is his reward. As arrows are in the hands of a mighty man, so are children of the youth [in the Vulgate 'Ita Filii excussorum'].

It is possible that the David was chosen to match the notion of children as 'arrows'; the Goliath figure, the watchman who waketh but in vain.

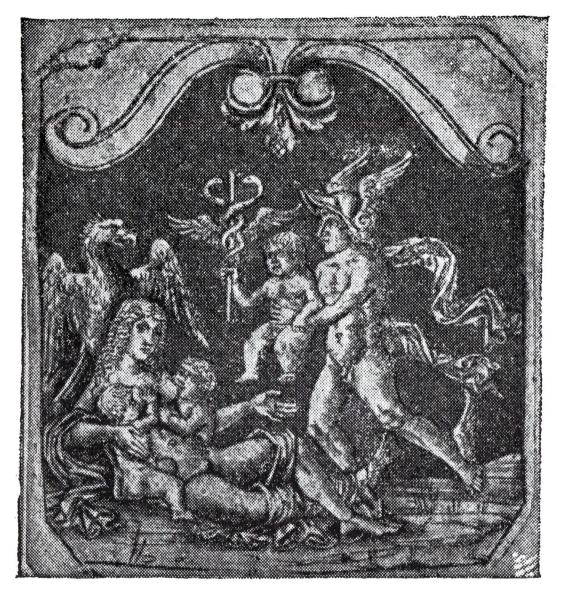

2.11 Peregrino da Cesena, *Mercury Conferring the Son of Semele to Ino*, niello

Contrary to the perceived view of Breu's illustrations as unthought-out and careless,[37] the above examination reveals a deliberate, if at times rather wilful, process of matching images to text. Some possess a concrete and literal relationship with the text; most follow the precepts for *imagines verborum* or word-pictures, traditional among medieval illuminators, by cueing either chief words or concepts of the text with which they are associated.[38] Finally, still others are not related to a particular text but are concerned with generally appropriate concepts that reoccur at intervals in varied forms: the images of music and the figures suggestive of meditation. These, too, have a long tradition within the marginalia of psalters and books of hours.[39]

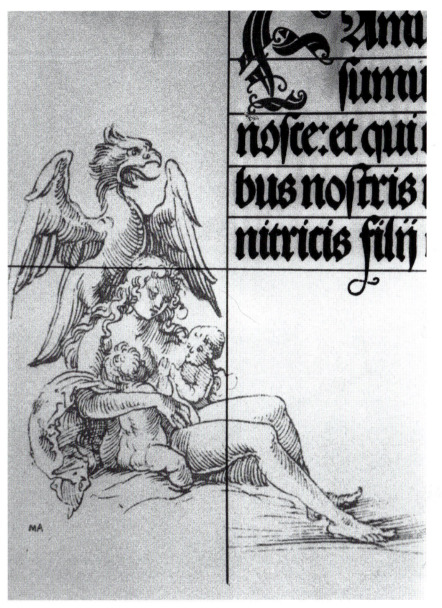

2.12 *Prayerbook of Maximilian*, fol. 86v: *Woman suckling child with eagle*, pen and green ink on vellum

In these manifold responses, Breu was working within time-honoured conventions of book illumination. He differs from the other artists involved in the project in one important respect – each of his drawings is placed adjacent to the beginning of the particular text it illustrates, even if the actual word or passage to which it corresponds occurs on the unillustrated verso. This characteristic places Breu in the tradition of manuscript illumination whereby images marked the beginnings of the text, indicated the natural divisions and acted as a kind of punctuation.[40] Such positioning often allowed the images to be used mnemonically, as cues that would bring to mind

2.13 *Prayerbook of
Maximilian*, fol. 77v:
Prudentia, pen and
green ink on vellum

particular parts of the text.[41] Those images inspired by a single word appear
to have had this function. The allegorical images do the same but, in addition,
act emblematically, as directly referential, not to any concrete image in the
text, but to its meaning. They are thus not 'illustrations', but are to be read
concurrently with the text, offering an access to meaning parallel with the
printed words. How the contemporary reader responded to this relationship

2.14 *Prayerbook of Maximilian*, fol. 83r: *Fortune*, pen and red ink on vellum

between image and text is graphically illustrated in a poem *The Fifteen Joys and Sorrows of Mary* by John Lydgate, the fifteenth-century English poet. He uses a metaphor of the process of reading an illuminated page as an analogy of how he saw the flow and structure of his own poem laid out in his own mind before writing it. First he saw a 'Pity', 'sett out in picture' (a *Pietà*). As he contemplated this 'meditacioun' closely, it resolved itself into

2.15 *Prayerbook of Maximilian*, fol. 91r: *David and Goliath*, pen and red ink on vellum

Rubrisshes departyd blak and Reed
of ech chapitle a paraf in the head
Remembryd first Fifteene of her gladynessys
And next in ordre were set hyr hevynessys.[42]

Such a reading process involved initial meditation upon the image, which then provided a cue for consideration of the Virgin's Sorrows, apprehended via the written text. Breu's allegorical images, such as his *Prudentia* figure, lend themselves to a comparable process, albeit not in the same sequential manner. Meditation upon the attributes contained in the image would accompany and heighten consideration of those same qualities of the Virgin celebrated in the text.

In many cases, Breu employed these small, self-contained allegorical images at the head of the relevant text in a manner that strongly evokes the images of the emblem books, that were to appear only a few years later. These, as their authors often made clear, were to be used for purposes of meditational reminiscence.[43] It is surely significant that Breu's *Prayerbook* designs emerged from that same culture of Augsburg humanists and printers from which issued the first pictorial emblems.

Though it is possible that a number of the designs were unfinished (generalized foliate and arabesque decoration on several pages suggest that he may have intended to fill out the margins more completely), it is clear that the artist intended the majority of his niello-derived images to be discrete and directed to the text. He was not primarily concerned with the decorative intentions of fanciful margin-filling manifested by the other illustrators. This difference suggests that, contrary to the prevailing view, the artist was not following a unified programme of illustration.

The question remains: what prompted him to choose Italian nielli as his chief resource? Though such nielli had been circulating amongst the workshops of south German artists for many years previous to this,[44] it is nonetheless most likely that Peutinger, as literary agent and important member of the Emperor's literary circle, who moreover commissioned Breu and provided him with the vellum leaves, encouraged the artist's approach and possibly furnished him with the models.[45] In this connection, it is possible to see Breu's use of Italian nielli in the light of the Emperor's own taste for the allegorical and the emblematic. In the previous year, Pirckheimer had presented Maximilian with his Latin translation of Horapollo's *Hieroglyphica*, illustrated with hieroglyphics by Dürer. What Wittkower described as 'the greatest hieroglyphic monument', Dürer's *Triumphal Arch* of Maximilian, was published in the following year, at the same time as work on the *Prayerbook* was proceeding.[46] The hieroglyphic portrait of Maximilian that crowns the central register (Fig. 2.16), in which every animal and element represents a particular quality, amply illustrates the Emperor's enthusiasm for symbolism of this kind. Through his humanist circle, the language of hieroglyphs became firmly established in Germany.[47]

It is possible that Breu also, via Peutinger and the *Prayerbook* commission, was not immune to Horapollian symbolism. On fol. 78v of the *Prayerbook*,

directly adjacent to a prayer invoking the protection of the saints, Breu has
drawn a crane, standing on one leg (Fig. 2.17). Precisely this image occurs in
the Maximilian portrait and corresponds exactly to Horapollo's hieroglyph
embodying the notion of 'watchful protection'.[48] The crane appears also in
Dürer's decorations of the *Prayerbook* with apparently the same connotation.
This possible overlap of meaning might suggest Breu's knowledge of this
new symbolism as well as the possibility that it was transmitted to artists by
Peutinger's agency.

 Finally, one might ask whether the classicism of style contained by the
nielli was a factor in Breu's decision to use them. In general, although the
classical character of the original nielli emerges in Breu's borrowings through
the retention of pose or drapery style (*Prudentia, Fortuna*) or attribute (*Venus
Marina*), for the most part, they have been transformed into an idiom, rightly

2.17 *Prayerbook of Maximilian*, fol. 78v: *Crane*, pen and green ink on vellum

described by Giehlow as 'a wonderful naturalism'.[49] Breu appears to have resorted to the Italian designs both for their sheer novelty as pictorial types and for their potential as vessels for metaphorical and allegorical meaning. The 'classical', as a *stylistic* category, remained for him as yet innocent of particular connotation or meaning.

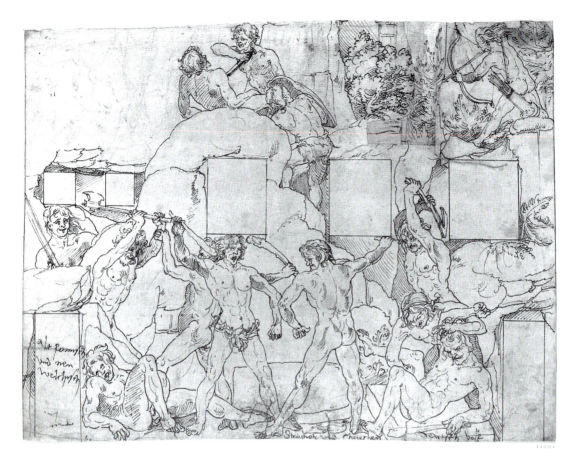

2.18 *Battle of Naked Men*, pen and greyish-brown ink on paper

The frescoes for the Augsburg Town Hall

Breu's involvement in the imperial commissions and his competence in fresco in all probability led to his most prestigious commission in 1516, the following year. As discussed in Chapter 1, Breu painted the façade of the newly rebuilt Town Hall, assisted by Ulrich Apt and Ulrich Maurmüller, between May and September 1516.[50]

It is impossible to reconstruct the style of these lost designs. Two drawings, both datable to 1516, have been associated with the Town Hall frescoes (Figs 2.18 and 2.19). Both are pertinent to a discussion of Breu's classicism, for, like the *Prayerbook* drawings, they are each very close derivations from Italian prints. One is dependent upon Pollaiuolo's famous *Battle of the Naked Men*,[51] the other upon an engraving by Girolamo Mocetto of the *Calumny of Apelles*[52] (itself based on a drawing by Andrea Mantegna): see Figs 2.20 and 2.21. As Bock suggested, the purpose of the battle scene as a design for a fresco is indicated by the rectangular openings that cut into the design, which appear to represent window openings.[53] Bock posited a possible connection between Breu's *Battle* drawing and the Town Hall decoration, one which has remained very difficult

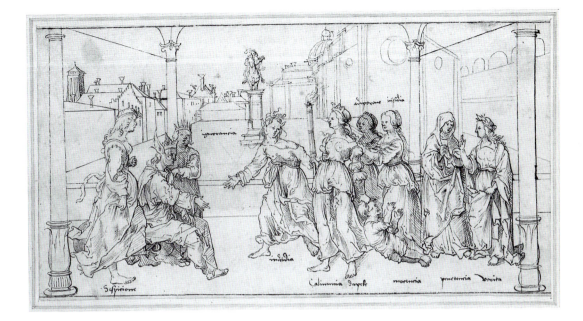

2.19 *Calumny of Apelles*, pen and ink on paper

to verify. The main obstacle is that the apertures of the drawing do not match those of the exterior of the old Town Hall. Nor does the large scale of the figures in the drawing match the battle scenes in the Zimmermann engraving, the sole surviving evidence of the appearance of the Town Hall's façade.[54]

One can be fairly certain nonetheless that Breu's design was intended for a wall decoration of some kind. Though the subject defies definite identification, Breu's elaborations upon the Pollaiuolo print provide certain clues that might determine its context more closely. He has replaced certain figures with others of his own and arranged them in a more symmetrically balanced fashion. Most significantly, he has changed the weapons. Where the combatants face each other, it is with axes and swords on the one hand, against primitive clubs on the other. Breu has deliberately replaced the sword of the frontally-posed fighter of Pollaiuolo's central pair with a club. In addition, his full-frontal nudity has been covered with a rough, leafy loincloth. In this figure one recognises affinities with the Wild Man of the Teutonic Forest.

That the Wild Man was an intrinsic part of civic imagery may be seen in a sandstone relief, of 1450, that was originally set above the north portal of the old Town Hall. Two Wild Men hold up a shield with the Augsburg coat of arms, supported by two crouching lions (Fig. 2.22).[55] In this context, the Wild Men symbolize the ancient origins of the city, deep in the Germanic tribal past.[56] The relief's original setting and gilded and polychrome appearance can be seen in the painted version after Breu's own design of *December*, made originally as a glass roundel for the Höchstetter family (Fig. 2.23).[57] The painted detail, which in all other respects follows the stone relief faithfully,

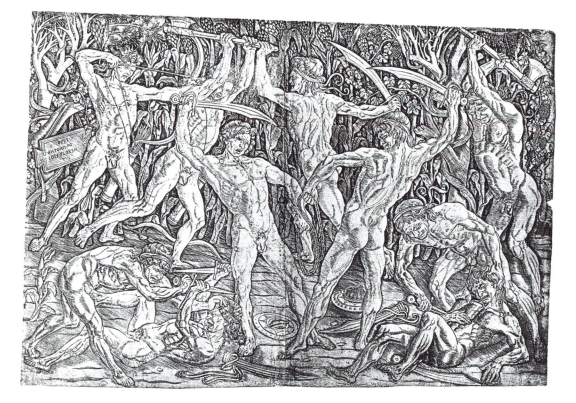

2.20 Antonio
Pollaiuolo, *Battle of
the Naked Men*,
engraving and
drypoint

deviates only in giving the wild men leafy loincloths, similar to that of
Breu's warrior in the Berlin drawing (Fig 2.24).

It is likely that the Berlin drawing depicts a battle involving an ancient
German tribe, a subject imbued with patriotic connotations at this time in
Germany. This notion is given credence by the inscriptions on the drawing.
These read, on the left: *alt romisch und neu welschisch* ('ancient Roman and
modern Italian'); in the centre: *Stradiote und Chriechen* ('Stradiots and Greeks');
and to the right: *Deutsch volk* ('German People'). It is difficult to regard these
other than as costume guides. Clearly no single historical battle could include
both ancient Romans and modern Italians. *Stradioten* were Turkish light
cavalry, usually armed with bows and arrows, and *Chriechen* possibly referred
to contemporary Greeks, also more or less synonymous in the popular western
European mind with the Turks.

Similar qualities of dress and type are to be found in the frontispiece by
Ambrosius Holbein to the second edition of Erasmus's translation of the
New Testament (Fig. 2.25). It was published in Basel in 1519 but executed, as
the monogram and date indicate, in 1517, one year therefore after Breu's
Town Hall fresco designs. At the top of this design one sees the crushing
defeat of the Roman forces under Publius Quintilius Varus by Arminius, the
leader of the rebel, Germanic Cherusci tribe in AD 9, when the latter ambushed
and destroyed three entire legions in the dense Teutoburgensian Forest.
Following the rediscovery of Tacitus's *Germania*, Arminius was turned into a

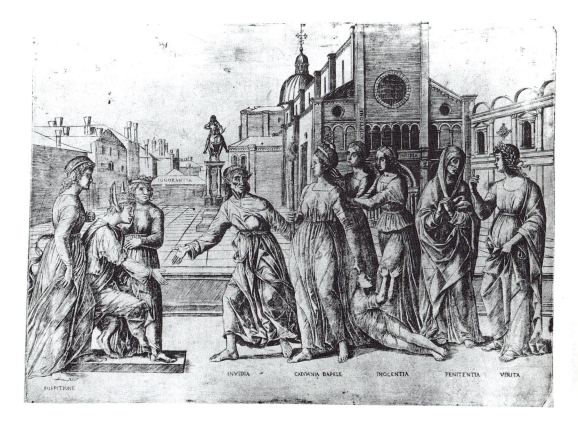

2.21 Girolamo Mocetto, *Calumny of Apelles*, engraving

Germanic hero by nationalistically-minded German humanists such as Conrad Celtis and Jacob Wimpheling, who sought to extol and promote specifically German virtues to rival the cultural dominance of Italy. The inclusion of Arminius and Varus in the context of Erasmus's New Testament is probably a specific allusion to the virtue of German scholarship, as represented in the author.[58] Pertinent to Breu's battle scene is the fact that Holbein has made clear the allegorical nature of the battle by clothing the ancient Germans in the costume of contemporary *Landsknechte*, the Imperial foot soldiers. The Romans by contrast are in a medley of costumes: 'ancient Roman' armour with cuirass and skirt, contemporary clothing with slit hose, and further indeterminate helmets and exotic turban-like headdresses. Here one might recognise analogies with Breu's *alt romisch und neu welchisch, Stradiote und Chriechen* and *Deutsch volk*.

It seems plausible that Breu's design also portrayed the ancient battle of Arminius and Varus. No other battle from the Germanic past acquired so resonant a meaning for contemporary Germans. If this were the case, the drawing might well have been an early sketch of the idea, in which he drew on Pollaiuolo as a starting point to establish the poses, only to clothe the figures later according to the scribbled notes. Even in mapping out the design from his prototype, he dressed his central figure with the Wild Man's loincloth, unconsciously revealing his involvement with the theme.

2.22 Anon., sandstone relief, north portal, Town Hall, Augsburg, *c.* 1450

One further parallel with the Holbein woodcut is found in the latter's pairing of *Arminius* with a *Calumny of Apelles*. The inclusion of this latter scene might have been as symbolic vindication of Erasmus against his detractors, yet it surely has a broader significance, testifying, in the context of the surrounding virtues, to the probity of its German author.[59] Similar meanings might have been intended by a pairing of the two Breu drawings. Previous commentators have suggested as much, in the context of the Town Hall decorations.[60] The two are contemporaneous and it is possible that they formed part of an overall programme dedicated to the allegorical representation of ancient Germanic virtue twinned with the proper dispensation of Justice. Such themes would have been appropriate for a Council Chamber or Chamber of Justice, rather than an exterior site. The *Calumny* was used most famously by Dürer in his decorations of the *Ratssaal* of the Nuremberg Town Hall in 1520–21, which was accompanied on the

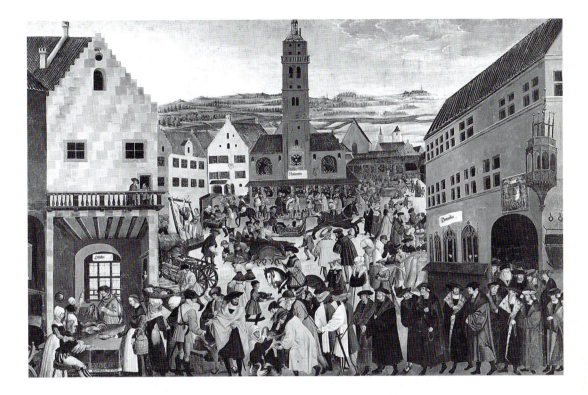

same wall by Maximilian's *Triumphal Chariot*, expressing a specific ideal of imperial justice and virtue.[61]

Though evidence is lacking, it is possible that Breu was involved in the interior refurbishment of the Town Hall as well as the exterior façade decoration.[62] The drawings might have been connected with these, though this must remain speculation. The most one can say is that the internal evidence of the drawings, in subject matter and treatment, suggests an association with an official decorative scheme. Like the *Prayerbook* illustrations, these drawings demonstrate Breu's increasing awareness and employment of both the themes and the style of Italian humanism, applied in the probable context of an official programme and associated specifically with the expression of allegory. This association between classical form and allegorical function was to be greatly developed in Breu's neoclassical works of the later 1520s.

2.23 After Jörg Breu, *The Months of October, November, December*, oil on canvas

The organ shutters of the Fugger Chapel in St Anna, Augsburg

Breu consciously employed an Italianate style in one further commission of the second decade. This was the painting of two sets of organ shutters, one large, one small, that form part of the decorative ensemble of the funerary chapel built by Jacob Fugger as a memorial to himself and his brothers Ulrich and Georg in the Church of St Anna, Augsburg (Figs 2.26 and 2.27 and Plates 5–8).[63] The shutters are of central importance in the artist's oeuvre

2.24 After Jörg Breu, *The Months of October, November, December*, detail

both as a prestigious commission and, today, his only surviving example of monumental painting still in its original context. In this work the painter was presented with an altogether different artistic problem. He had to find an appropriate style for two sets of paintings, which encompassed both religious and secular themes. One required a monumental treatment of traditional religious themes – the twin Ascensions of Christ and of Mary; the other, the expression of a theme unprecedented in painting at that date – the *Discovery of Music*. Above all, the style had to match the self-conscious classicism of what was in effect, the first 'Italian Renaissance' architectural structure north of the Alps (see Fig 1.16).[64] Examination of both the stylistic and iconographical sources of these works reveals something of the path of Breu's developing understanding of Italian art.

The chapel itself is no ordinary chapel, but one that took over the whole western end of the nave. In both size and position it thus dominates the modest proportions of the church. Central to this effect is the organ which is built on the west wall. The painted decoration consists of two huge wings that

2.25 Ambrosius Holbein, frontispiece to Erasmus, *New Testament*, 2nd edition (Basel, 1519), woodcut

flank the pipes of the large organ and two further, rectangular wings that flank the smaller organ in the centre. The large wings are painted on canvas stretched onto shaped wooden frames, and are painted on one side only. Their flimsiness of structure and the unpainted reverse preclude any functional intention, either protective or liturgical. Immovable, they were conceived as a harmonious part of the decorative ensemble made up of the forms and ornament of the architecture, the organ itself, the carved stone epitaphs and the glass windows.

2.26 *The Ascension of Christ*, large organ wing, oil on canvas

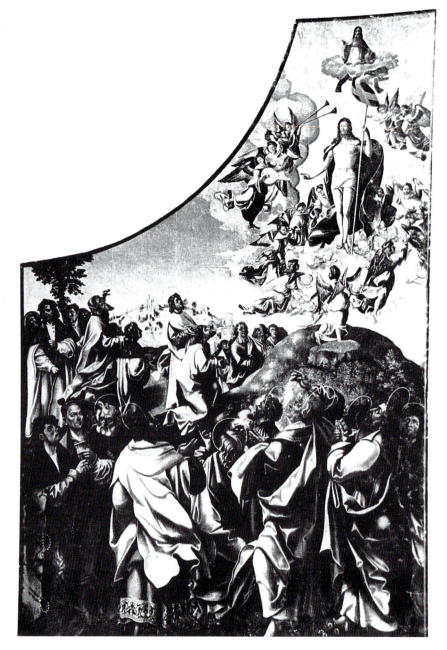

The careful shaping of the wings meets and extends the curve of the vaulting and provides a counterpoint to the central curve of the large organ, which neatly matches the lower circumference of the central circular window.

The shutters of the small organ by contrast are traditional in so far as they are painted on wooden panels and on both sides. The dual nature of these wings, as part organ shutter, part general chapel decoration must be borne in mind when considering their subject matter.

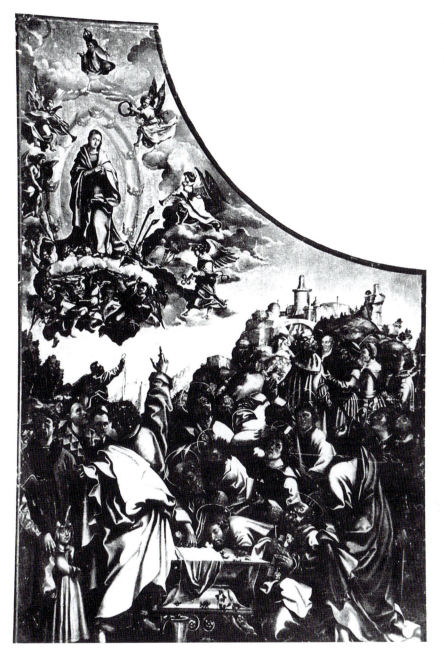

2.27 *The Ascension of the Virgin*, large organ wing, oil on canvas

THE LARGE WINGS

The themes of the large wings are, on the left-hand side, *The Ascension of Christ*, on the right, *The Ascension of the Virgin'* (Figs 2.26 and 2.27). Both divine figures hover within a nimbus, surrounded by musician angels, above groups of gesticulating apostles. The painter has also included the portraits

of a number of contemporaries, of whom, despite much speculation, only two are identifiable with certainty. The features of the figure, third from the left on the lower left-hand side of the *Ascension of Christ* are unmistakably those of Jacob Fugger, the benefactor and patron of the chapel; while on the upper right-hand side of the *Ascension of Mary* is an identifiable likeness of the Emperor Maximilian I.[65]

The presence of Jacob Fugger and in all probability other members of his family, among the biblical figures reflects the commonplace practice of including the patrons within their commission and of associating 'living' members of the family with the hopes of salvation. It reflects the primary purpose of the large organ wings: they extend the theme of hoped-for redemption expressed in the carved epitaphs and the altar statuary of the *Lamentation over the Dead Christ* below.[66] The two *Ascensions*, floating in bright colours above the fixity of the carved tombs below, refer to the expectation of triumphant resurrection of those buried. By their position in the chapel, they provide a sense of narrative ascent to the heavenly sphere from the earthbound, mortal state, suggested by the tombs themselves and the sculpted figure of the dead – mortal – Christ. The complementary portrayal of two ascensions – of both Christ and Mary – in the same scheme, is unusual in German as in Italian art, yet may be seen as an elegant solution to the singular problem posed by a centrally placed organ, that divided the painting field into two. Thematically, they suggest faith in Christ and the intercession of the Virgin as the two chief guarantees of Redemption. In this latter sense they followed traditional epitaph subject matter, as may be seen, for instance, in Hans Holbein the Elder's *Epitaph* for Ulrich Schwarz and his family.[67]

The large organ shutters are remarkable in Breu's oeuvre for their dependence upon Italian models. Röttinger first showed Breu's dependence for his general compositional scheme and certain groups of figures in his *Ascension of Christ* (Fig. 2.26) upon an Italian print of the *Ascension of the Virgin* by Francesco Rosselli (Fig. 2.28).[68] Breu's three apostles on the right-hand foreground, with upraised arms shielding their faces, have been quite literally transposed, as have the four angels with musical instruments to the right of Christ. In Breu's *Ascension of the Virgin*, the figure of St Thomas is copied from the print, as is the apostle leaning over the tomb.

Subsequently, Friedrich Antal demonstrated the surprising yet undeniable dependence of Breu's *Ascension of Mary* upon Filippino Lippi's fresco cycle in the Caraffa Chapel in Santa Maria sopra Minerva in Rome, of 1489–90 (Figs 2.29 and 2.30).[69] The main compositional lines have been fully adopted. Breu has merely unified the groups of apostles which in the Lippi are separated by the altar panel. Because of the shape of the organ wings and because of her position relative to the Christ on the opposite wing, Breu's Virgin and surround of angels have been moved from the centre to the left. The dancing angels, with one omission, have been transcribed accurately in terms of poses, though their faces owe little to Lippi's sweeter style. Even so, exact details have been faithfully reproduced, down to the flaming torches on either side of the Virgin (see Figs 2.27 and 2.29). A further

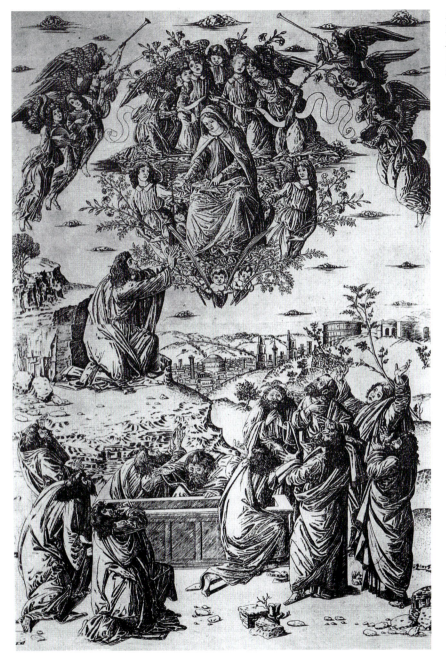

2.28 Francesco Rosselli, *The Ascension of the Virgin*, engraving from two plates

connection with the work of Filippino Lippi was noticed by Blankenhorn, who drew attention to the similarity between the group of the man with a young boy to the left of Jacob Fugger in Breu's *Ascension of Christ*, with a similar pair in Lippi's *Martyrdom of St Philip* fresco in the Strozzi Chapel in Santa Maria Novella in Florence. The scene of the saint's martyrdom in the same fresco also directly inspired the general disposition of Breu's

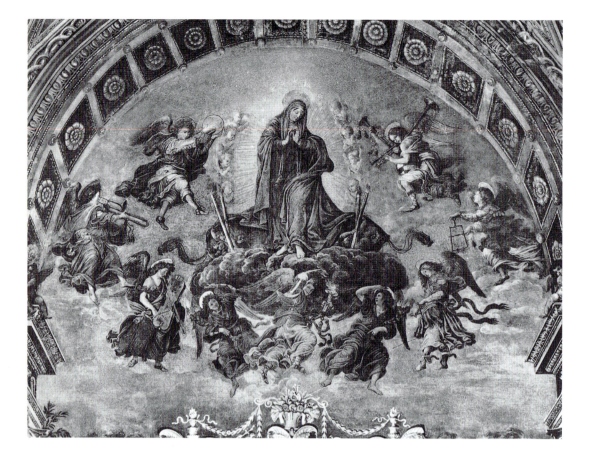

2.29 Filippino
Lippi, *The Ascension
of the Virgin*, detail

Raising of the Cross panel of 1524 in Budapest, a figure supporting a stave
(Plate 9).[70]

Several explanations for such borrowings suggest themselves. One might
posit the existence of lost prints after Lippi, similar to the Rosselli
Assumption, which were available to Breu in Augsburg; or drawings brought
back from Italy by another artist or the patron. One might cite the
contemporary (albeit Italian) copy of a group of two muses from Lippi's
Strozzi chapel, today in the Uffizi, to show how such designs were spread;[71]
or a north Italian drawing, made in connection with a print, that copies
very exactly Lippi's left-hand group of apostles.[72] Finally, such borrowings
might be direct and indicate that Breu was himself in Italy. The exclusivity
of the borrowings from Lippi, from chapels in both Florence and Rome,
and the complete absence in his surviving work of references to other
monuments or works of art, ancient or modern, in those cities, tends to
support one of the first two options.

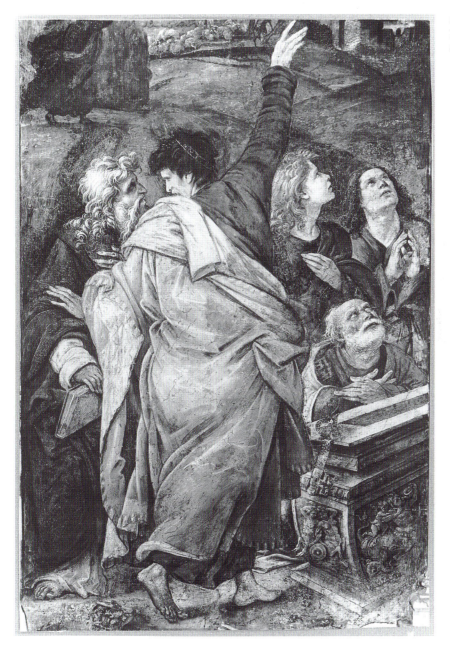

2.30 Filippino Lippi, *The Ascension of the Virgin*, detail

The trip to Italy

That Breu travelled to northern Italy is nonetheless almost certain. All commentators without exception, before and after Antal's discovery, have assumed an Italian journey at some point in the artist's career, though they have differed as to the date. Buchner considered an Italian journey likely shortly after his return to Augsburg after his journeyman travels, or just

2.31 Sheet of sketches with *Venetian canal scene,* pen and ink on toned paper

after his entry into the Guild in 1502; Blankenhorn, in the period shortly before 1520; and Bushart, most recently, in 1520.[73] No concrete documentary evidence of an Italian journey survives. There is, however, a small sheet of sketches in Berlin, so far unnoticed, that provides evidence of the artist's direct knowledge of Italy, the Alps and Venice (Fig. 2.31). The sketches are on the verso of a careful drawing of two angels, holding the host, that was reproduced in the *Catalogue of German Drawings* by Elfried Bock (Fig. 2.32).[74] They constitute a number of rapid, thumbnail drawings that partly overlap each other: a pair of legs, two variations of a castellated building with drawbridge; a town perched on a hilltop; sketchy intimations of a distant landscape with buildings peeping over trees; and, most interestingly, a charming vignette of a Venetian scene, showing a palace façade and garden wall, with a canal in front on which floats a covered gondola. These sketches are mostly notational in character: his interest in the fortified building resides principally in recording the flanged battlements and the drawbridge structure; the summary treatment of the landscapes has the freshness and spontaneity of views directly observed. All have a strong north-Italian character: the shape of the battlements, for example, recalls the walls of the Arsenale in Venice. The details of the canal scene – the high garden walls with yew trees

peeping over, the characteristic Venetian chimney pots and castellations, even the gondola – suggest direct personal knowledge. The one false note is the palace façade, which does not match any known Venetian structure and appears to be imaginary. The same, rather flimsy, three-tiered structure of arcading supported by columns reappears in the scene of *February* in the painted series of the *Seasons*, adapted from Breu's *Months of the Year* glass-roundel series (Fig. 2.33). It might reflect knowledge of the celebrated spiral staircase and loggia of the Palazzo Contarini del Bovolo, designed by Giovanni Candi in *c*.1499. It has analogies also with the elaborate structures in the backgrounds of Carpaccio's scuola paintings, where, in a similar way, the real and the imaginary interweave according to the artist's heightened poetic responses to the architecture of his city.[75]

From this it is clear that Breu's Venetian scene is an imaginative construct, but one made through the grafting together of imaginary elements (them-selves the product of an encounter with Venetian architecture and art) and closely remembered details. This mixing of the real and the imagined is a characteristic of Breu's approach to architecture and is met frequently in the backgrounds of his paintings, for instance in the cityscape of the *Departure of the Apostles* of 1514 (Fig. 2.34).[76] It is particularly obvious in the only other

2.32 *Two Angels Carrying the Host*, pen and dark-brown ink and wash, heightened with white on red-toned paper (recto of Fig 2.31)

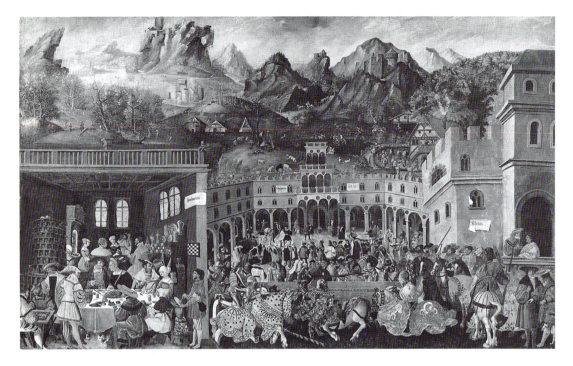

2.33 After Jörg
Breu, *The Months
January–March*, oil
on canvas

drawing of a city in his oeuvre, preserved in the Fogg Art Museum in Boston (Fig. 2.35).[77] Here the combination of observed shapes and types of German buildings with imaginary elements – particularly the 'Renaissance' domed building on the far left – provides a clear parallel with the Venetian scene.

Thus even the intrusion of the imaginary, together with the evidence of direct observation in these sketches, allows one to be confident of Breu's direct experience of northern Italy and Venice. The sheet can be dated with some precision; though Bock left a question mark beside his attribution to Breu, both sides of the sheet show striking and irrefutable connections with Breu's works of 1515. The technique used for the angels on the recto of the drawing, of shading on a coloured ground with wash, heightened with white, is a characteristically Venetian method of drawing, which Dürer had adopted after his own contact with Venetian art. This in itself might suggest direct experience of Venice. Comparison between the treatment of the right-hand angel's curly hair and that of the *Charity* figure from fol. 86v of the *Prayerbook* (see Fig. 2.12) for instance, allows no doubt as to Breu's authorship. The fluent outlining of this latter figure's legs, the prominently up-turned big toe and the manner of shading are all identical in treatment with the legs on the verso of the Berlin sheet (Fig. 2.31).[78]

The drawing style is therefore consistent with his manner of 1515 and one may reinforce with a measure of certainty, the earlier hypotheses that he made a journey to Venice some time close to this date. On this assumption, it is not impossible that Breu travelled via Florence to Rome and had direct experience of the works of Filippino Lippi in those cities. This still remains to be proven. By whatever agency, it is probable that Jacob Fugger, who was

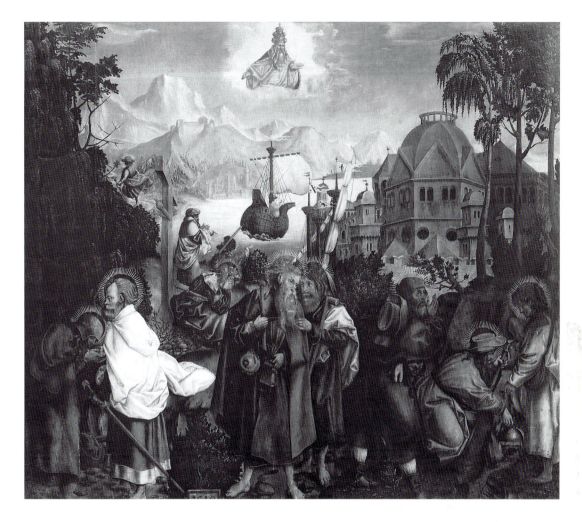

conversant with Rome and with Italian art and who later, in 1522, commissioned a startlingly mannerist altarpiece from Giulio Romano for the family chapel in Santa Maria dell'Anima, Rome, wished to emulate in his own funerary chapel a monumental work by an Italian artist who, in the second decade of the century, was still regarded as one of the great 'moderns' of the day.[79]

2.34 *The Departure of the Apostles*, signed and dated 1514, oil on panel

The small organ shutters

In striking contrast to the large organ wings, the themes of the small organ shutters are without precedent in either German or Italian painting. An intended sequence, following the internal logic of the pictures' composition, has been traditionally identified as follows: the outer panels, linked by a unified architectural frame and space, represent *Jubal's Discovery of Music* (left) and *The Dissemination of Music* (right) (Plates 5 and 6); the inner panels:

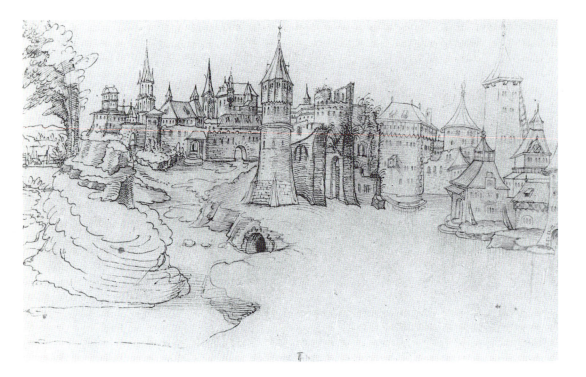

2.35 *View of a Town,* pen and ink on paper

Pythagoras in the Blacksmith's Shop (left) and a *Chapel Choir Scene* (right) (Plates 7 and 8).[80] In the *Discovery of Music*, on the outer left wing, Jubal, the descendant of Cain inscribes the principles of music upon a great marble tablet (Plate 5). Within the Christian tradition, Jubal was the inventor of music. The brief mention of him in Genesis (4, v. 21) as 'the father of them that play upon the harp and organ' was elaborated in the influential *Historia Scholastica* written in the last quarter of the twelfth century by the scholastic Petrus Comestor. He ascribed to Jubal the story from the Greek tradition, of Pythagoras's discovery of the relationship between the weight of hammers and the sound they made, as he passed a blacksmith's shop. Comestor attributed this discovery and thus the codification of the mathematical principles of music to Jubal in his brother, Tubal-Cain's, smithy.[81] In the painting, Jubal is seen inscribing into marble the 'solmization' of tones, that is to say, the system of representing the notes of the six-note scale by syllables. His action relates to a prediction of Adam's, first mentioned in Flavius Josephus's *The Antiquities of the Jews*, popularised in the Middle Ages by Comestor's account, that warned that only those elements of human wisdom that were inscribed in stone or brick columns would survive the great catastrophe that was to envelop the world.[82] The hexachord system that Jubal employs was in fact the invention of Guido d'Arezzo in the eleventh century, who also introduced as a practical method of memorizing his system and for use as hand signals within a choir, the so-called 'Guidonic Hand', by which the various joints and knuckles of the hand represented each of the eleven notes of the scale. The bearded figure opposite Jubal may be interpreted

as an allusion to this.[83] A poetic figure of a modishly dressed young man on the left sits meditatively by a marble cube, upon which is inscribed the hexachordic system. Books and an inkwell lie on shelves beneath and an open book lies at his feet.

The right-hand outer panel shows the marble 'solmization' tablet in the same steep perspective and shared architectural space (Plate 6). Before it a young man in contemporary dress points out the notes of the scale with a pointer to four figures dressed in the costume of a Turk (with a turban), a Jew (identifiable by the Hebraic letters around the hem of his hood), and two contemporary 'Germans' (one with quill and scrolled paper in secular dress, the other in the garb of a doctor/cleric). Rolf Biedermann identified them as representations of Paganism, Judaism and Christianity and suggested that the young man on the left, in contemporary costume with scroll and quill, represented 'Antiquity'.[84] In other words, Jubal's discovery is spread to the whole world. The presence of God the Father and Mary, hovering in clouds in the left and right panels respectively, has the effect, over and above their probable reference to the Fugger device 'Gott und Maria', of underlining the religious significance of Jubal's invention: that, emanating from God, it possesses something of the divine.[85]

The inner panels show respectively, on the left, Pythagoras's discovery of music, in his recognition of the mathematical relation between the weight of hammer heads and the tones achieved when striking them; and, on the right, a church choir (see Plates 7 and 8). In the left-hand scene, the Greek philosopher sits at a table, striking a note on a hammer head, while a bearded companion opposite writes down the discovered intervals in proper musical notation. Behind is a blacksmith's shop, with the blacksmith at the furnace and assistants. Their burlesque actions contrast with the solemnity of the philosopher and his companion, perhaps in order to symbolise the contrast between knowledge and brute ignorance. Once again a specifically religious significance is attached to the scene by the inclusion of two angels, one of whom stands at the table writing down music, while the other peeps over the wall on the left. In their attendance upon intellectual endeavour, they are Christian counterparts to the genius figure of Dürer's *Melancholia I* engraving.

The presence of a recognisable church choir within the scheme has been seen as the final stage in the sequence, showing the contemporary practice of *musica sacra*, the highest consequence of Jubal's and Pythagoras's invention.[86] Beyond this primary meaning, Lieb attempted to identify specific musical practices from the circle of Maximilian, suggesting that the scene was a portrait of the Imperial choir.[87] Bushart extended this argument, noting that the number of singers – a *Kapellmeister*, two under-cantors, three young and three older choristers – is the same as the Imperial choir, led by the famous organist Paul Hofhaimer, as seen in a woodcut of c.1519, by the Petrarch Master. Breu, he suggested, was directly inspired by this print (Fig. 2.36).[88] However, the relationship between the two, as Bushart admitted, is elliptical. Breu's work, like that of the Petrarch Master may well reflect quite accurately the character of the Fugger Chapel's choir, in number and kind. The inclusion

2.36 The Petrarch Master, *The Imperial Choir*, woodcut, *c.* 1519

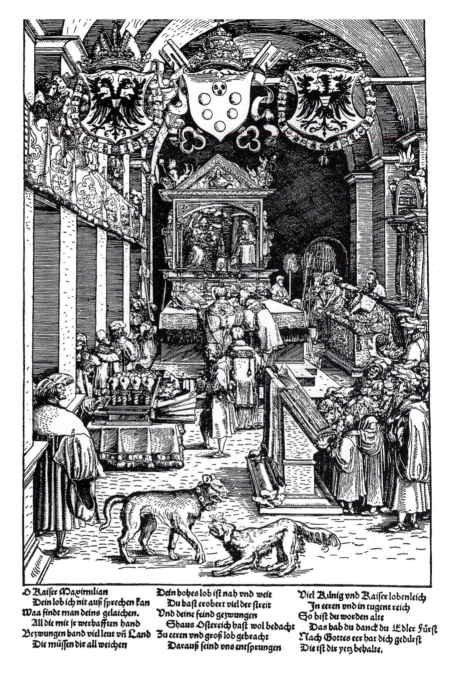

O Kaiser Maximilian
Dein lob ich nit auß sprechen kan
Waa findt man deins gelaichen.
All die mit ir werhafften hand
Bezwungen hand viel leut vñ Land
Die müssen dir all weichen

Dein hohes lob ist nah vnd weit
Du hast erobert viel der streit
Vnd deine feind gezwungen
Shaus Ostereich hast wol bedacht
Zu eeren vnd groß lob gebracht
Darauß seind vns entsprungen

Viel Kunig vnd Kaiser lobenleich
In eeren vnd in tugent reich
So bist du worden alte
Das hab du danck du Edler Fürst
Nach Gottes eer hat dich gedürst
Die ist dir yetz behalte.

of portraits, particularly in the figure of the choir master, is probable, but difficult to verify with exactitude. In other respects, however, the similarity of the works may be explained by the fact that both conform to a well-established iconographical tradition of representing choirs. The motif of a singer with his hand on the shoulder of another in front, cited as evidence for an interdependence of the two works, is a commonplace of choir scenes

and reflects the actual method within choirs of keeping time or marking the entrance of a voice by tapping on the shoulders.[89] Breu's depiction of *musica sacra*, thus conjoins an apparent acquaintance of the actual circumstances of the Fugger's chapel choir with the long-established conventions of a particular pictorial tradition.

Though the general theme of this series of panels – the origins of music, its dissemination in the world and its primary Christian function as an instrument with which to praise God – is clear enough, the tendency of previous scholarship to regard the panels in terms of a sequential narrative is unsatisfactory. There is in fact no logical chronological narrative from one panel to the next; nor does such a reading convincingly explain the identities of certain figures: the long-haired youth in the *Discovery of Music* panel, an 'ancient Greek' in contemporary dress, or a heathen Turk in the *Dissemination* panel presented positively within an otherwise exclusively Judaeo-Christian context.

Despite the lack of painted precedents for such subject matter in German art, both Jubal and Pythagoras occur frequently in woodcut illustrations to *Biblia Pauperum*, works on music theory and encyclopaedic volumes that dealt with the history of music.[90] Such depictions of Jubal or Pythagoras take two forms: either as straightforward narrative or as elements within the allegorical personification of *Music, the Liberal Art*. As an example of narrative, a woodcut from Spechtsart's *Flores Musicae*, printed by Johann Prüss in Strassburg in 1488 may serve (Fig. 2.37). This shows the story of Jubal, weighing his hammers in two large scales, while two smiths forge another; in the background Jubal is seen inscribing musical notation onto two pillars, one of stone, one of brick, following Adam's warning. Only rarely do Jubal and Pythagoras occur together in such 'narrative' treatments. One example is a crude woodcut to F. Gafurio's *Theorica Musice*, printed by Philipp Mantegatius, in Milan in 1492 (Fig. 2.38).[91] Here Jubal is seen establishing the mathematical relationship between tones through the different weights of hammers, each of which is marked by a different number. In the other three scenes, Pythagoras is seen applying this discovery to bells, to water containers, to a stringed instrument and, with Philolaus, to flutes.

An example of the type of representation of Jubal and Pythagoras within an allegorical personification of *Musica*, can be found in the opening page of Part V of Gregor Reisch's popular *Margarita Phylosophica* published in Strassburg by Johann Grüninger in 1504 (Fig. 2.39).[92] A blacksmith, labelled 'Tubal', stands behind a robed figure holding scales, presumably Jubal, though his accompanying *cartellino* has been left blank. They are accompanied by various types of musician, around a central female personification of Music.

While there are no direct formal or compositional borrowings in Breu's organ shutters from these examples, there are shared characteristics which are highly illuminating. In the first place it is plain that Breu's scheme, like the prints, depended upon a literary tradition of the discovery of music that was contradictory. The source of confusion lay in the clash of the Christian

2.37 Anon., *Jubal Discovering Music*, woodcut, in H. Spechtsart, *Flores Musicae* (Johann Prüss, Strassburg, 1488)

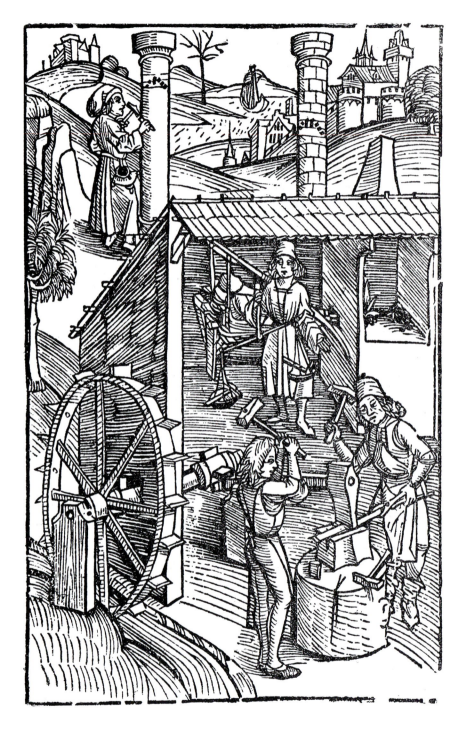

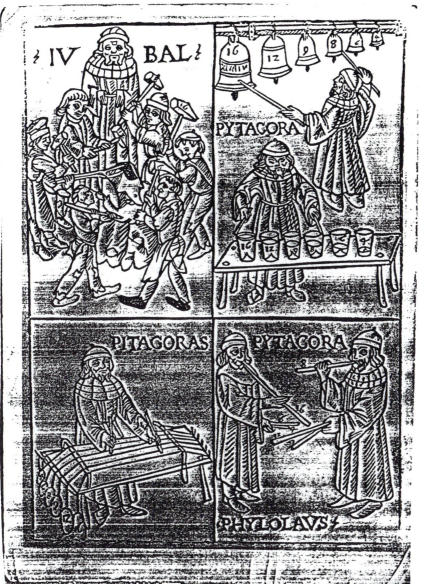

2.38 Anon., *The Invention of Music*, woodcut, in F. Gafurio, *Theorica Musice* (Philipp Mantegatius, Milan, 1492)

and Greek traditions in ascribing the invention of music to either Jubal or Pythagoras. Peter Comestor simply denied primacy to the latter, saying the Greeks were mistaken.[93] But others, having absorbed the 'fact' of Jubal's hammers, fudged the issue by simply mentioning both traditions without further comment, as did Chaucer in his *Book of the Duchess*.[94] Another tradition, following Genesis, made Jubal the discoverer of the 'natural music' of reed and harp, which he used to 'releue hymself while he was an herde, and kepte bestes', while it was left to Pythagoras to create a harmonic system, from his experience in the blacksmith's shop.[95]

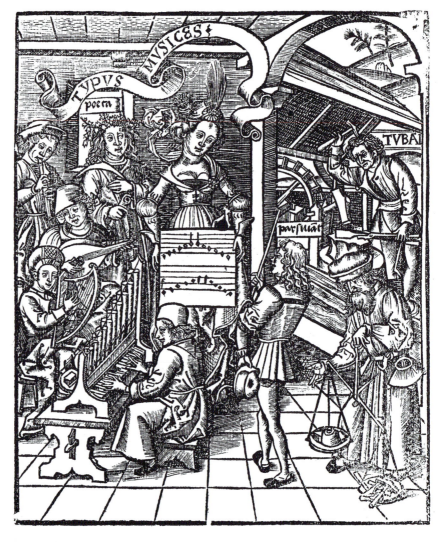

This literary and pictorial tradition of dual and unresolved authorship appears to be reflected in Breu's organ shutters, where Jubal is seen inscribing the same theoretical model on his tablets as that written down by Pythagoras's assistant. This anomaly, however, is in part resolved when one realizes that what is represented across the panels is not a simple historical sequence, but rather a commentary on not only the origins but also the practice and status of music.

For the treatment of the theme, Breu appears to have turned to the woodcut tradition of personifying *Music, the Liberal Art*. The print from the 1504 edition of the *Margarita Philosophica*, mentioned above, shows in a more concentrated form some of the same figures that occur in the organ shutters, including those which have so far have defied specific identification (see Fig. 2.39). In the woodcut, the female personification of *Musica* is surrounded by various figures who represent types of musician. These, as the text explains,

take three forms. There are those who can play stringed instruments with skill but who have no understanding of the principles of harmony and consonance; these are represented in the print by the harpists and organ player. The second type are those who compose songs, through natural rhythmn and instinct, but who are little able to demonstrate harmony or *proportiones*; these are called poets and are represented by a laurel-crowned figure holding a scroll. The third group neither play instruments nor compose songs, but have skill in judging music (*de his tamen iudicandi peritiam habent*); the young man beating time in the print represents this last group.[96]

Comparison with Breu's *Solmization* panels (Plates 5 and 6) is revealing. The young man in the foreground of the *Discovery* panel is analogous with the poet of the print. He shares the long hair and has the attributes of composition around him: books, one open before him, and ink. He has in fact been derived from Giulio Campagnola's poetic engraving *The Shepherd Boy* (Fig. 2.40), a figure that very aptly conjures up the notion of 'natural music', tied to his pastoral setting, his reed flute a sign of an instinctual and untutored musical gift.[97] Breu's 'poet' is more courtly and sophisticated in dress; but the fact that he also holds a reed flute strongly suggests that, like the poet of the woodcut, he represents a conflation of the natural forms of music and poetry. In the same way, the figure counting out the scale on his hands by the Guidonic method in Breu's panel, is the equivalent, in the context of a choir, of the practising musicians of the print. They are the first type of musician of the *Margarita* – those practitioners who play well, but without theorectical understanding of harmony or musical principle.

A further striking connection between the woodcut and Breu's *Dissemination of Music* panel (Fig. 2.39 and Plate 6) is the youth, who in each case points out the scale with his baton. Though the inscription above the figure in the woodcut is incomprehensible, the main text makes clear that he represents the third and 'true' type of musician, the theoretician who possesses understanding of musical principles. The figure in Breu's image appears to carry the same meaning, for he is shown instructing the receptive group in the foreground. Collectively, this group may be taken to represent this third type of musician. This allows a more logical reading of the four foreground figures. They are all theoreticians, belonging to different but related historical traditions and joined here by the attributes and attitudes of learning. The Christian and Jewish Doctors represent the continuation of the Judaeo-Christian tradition; yet the figure with quill and paper, whom Biedermann identified as representative of Antiquity, is more likely to represent what he appears to be – a contemporary musician (possibly an actual person connected to Fugger musical circles). The turbaned figure, rather than representing the heathen Turk – surely an anomaly in a Christian monument – probably represents a Greek philosopher. There is an established iconographical tradition in late-medieval German art of portraying ancient philosophers in such 'eastern' garb. A few years later, Holbein the Younger was to represent Aristotle, albeit in satirical light, as wearing a turban in his print *The Light of the World*.[98]

2.40 Giulio Campagnola, *Shepherd Boy*, stipple engraving

Seen together, the two outside wings, *Jubal's Discovery* and the *Dissemination of Music*, contain precisely analogous elements to those grouped around the personification of *Musica* in the Reisch illustration. In their open state, the shutters reveal therefore not only the origins of Music, but its practitioners: those with natural inborn gifts, those with acquired, practical abilities and those with theoretical understanding of its principles. Collectively they make up the constituent parts of *Musica, the Liberal Art*, symbolized in monumental

glory by the central organ itself, around which, like Reisch's figures around the female personification of *Musica*, they are grouped. This is the real subject of the panels.

Breu's pictorial programme was indebted not only to the woodcut illustration: in the sequence of four panels it also follows the text of the *Margarita Phylosophica*. The section of the *Margarita* that deals with the invention of music is quite explicit in ascribing the invention of 'natural' music to Jubal and the discovery of harmonic relationships to Pythagoras. The author criticizes Comestor's story of Tubal's workshop as unfounded and as having been taken from the Greek tradition.[99] Reisch's account begins with Jubal's discovery of natural music and his recording of it upon the marble and brick panels. It then stresses in narrative and technical detail Pythagoras's discovery and codification of the mathematical relationships between tones. Breu's programme closely reflects the particular emphases of this account. Jubal is surrounded by figures representing the two types of 'natural' music that followed on from his discovery, while Pythagoras is portrayed in the smithy, at work on the theoretical labour of transcribing the relative weights into musical intervals. The narrative confusion introduced by Breu's portrayal of both Jubal and Pythagoras apparently inventing the same Guidonic scale is explained by the artist's reliance upon the limited pictorial tradition of illustrating Jubal's discovery.

Style and dating

The deed of foundation of the Fugger Chapel was drawn up on 7 April 1509; it was consecrated on 17 January 1518 and on 23 April 1521 the regulation of the services to be held there were established.[100] These dates provide a broad perimeter within which the commission to paint the organ shutters must have been made.

The completion of the organ itself can be dated to 1512 from an inscribed signature on the organ case, permission for which was given to the organ builder Jhan von Dobraw by Jakob Fugger retrospectively in 1521. Bushart suggested the unlikelihood of leaving the organ unprotected and assumed that the organ case was also completed in that year, thus providing a *terminus post quem* for the shutters.[101] The evidence of the Italian, Antonio de Beatis, who visited the chapel in 1517, gives incontrovertible evidence that the organ was installed by 25 May of that year.[102] Though he makes no mention of the organ wings – there is a vague reference that the chapel was 'excellently painted' – there is no reason to suppose the wings should have somehow been added on later.

An inscription on a tablet on the right-hand inner shutter, the *Choir Scene*, has been interpreted as a date '1512' (although the last two 'numerals' look like the letters 'CZ'). This has not been considered by historians as the date of the panel, but has been explained away rather wilfully as somehow reflecting the date of completion of the chapel architecture.[103]

2.41 After Jörg
Breu, *The Invention
of Music*, dated 1522
and with later
monogram AA and
date 1522, pen,
brush and ink,
heightened with
white on brown-
toned paper

2.42 After Jörg Breu, *The Invention of Music and the Dissemination of Music*, dated 151[?]7, ink and brush, heightened with white on green-toned paper

To this difficulty, one may add the further problem of two drawings connected with the inner panels of the small organ shutters. Both, as Biedermann has demonstrated, are copies after Breu (Figs 2.41 and 2.42).[104] One in Berlin carries a false Altdorfer monogram and the date 1522, as well as a further, possibly genuine, date of the same year at the bottom centre; the other in the Uffizi carries a date of which the third digit is damaged, but which has been almost unanimously read as 1517 by commentators.[105]

Three dates – 1512, 1517 and 1522 – therefore present themselves as possible starting points for a closer dating of the panels.[106] The most recent attempt to date panels sought analogies between certain of the figures with drawings by Raphael, positing a visit by Breu to the Italian artist's studio in *c*.1520.[107] Yet Breu's points of departure for the whole tone and style of his small organ wings lay closer to home. In the gilded, decorative elements of the inner shutters – the scrolling sphinx- and dolphin-headed legs of Pythagoras's furniture, the acanthus scrolls, the classically-inspired figures at the bases of the columns – Breu was responding to the character of the organ case which

2.43 Hans Burgkmair, *The Court Choir*, woodcut, detail from the *Triumph of Maximilian I*

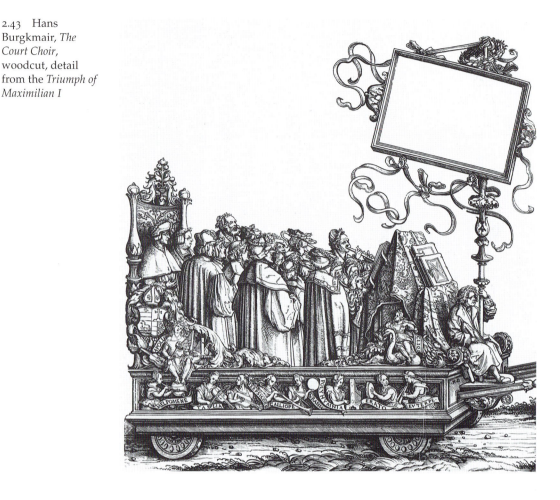

enclosed his panels. The same florid details, the half-vegetal, half-animal, richly scrolling arabesques, the three-dimensional putti on the backs of dolphins, attest to the strong influence of contemporary Venetian decorative and sculptural design that was present in Augsburg in these years. Bushart convincingly attributed the organ case to the workshop of Adolf Daucher and dated it to 1512, the same date as the completion of the organ itself.[108]

Characteristics of the composition are also to be observed in another local source, namely, the woodcuts for the *Triumph of Maximilian* executed by Hans Burgkmair from 1516 until the abandonment of the project at the Emperor's death in 1519.[109] Close parallels between Breu's *Choir Scene* are to be found in the prints illustrating the court musicians and music. In the float carrying the Court Choir, one sees a similarity of conception, if not in pictorial organization (Fig. 2.43).[110] The florid classicism used in the details of Breu's inner-panels – Pythagoras's bench, his companion's chair, the elaborate figural and floral decoration of the pillars above, and the putti, flaming torch and scrolled ornament above the niche of the chapel-master on the *Choir Scene* – is found in richest vein in Burgkmair's floats. In this latter panel, one finds

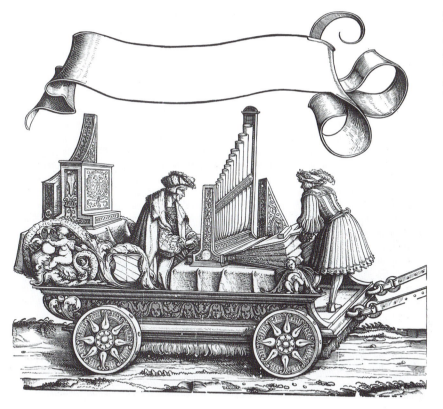

2.44 Hans Burgkmair, *Musica, Rigal und possetif*, detail from the *Triumph of Maximilian I*, woodcut

the similar dense grouping of the choristers, so that several faces are obscured from view; there are also the profiled faces, open-mouthed in song. In Burgkmair's woodcut of the float given over to *Musica, Rigal und possetif* (Fig. 2.44), in which the court organist Paul Hofhaimer sits at the positive organ, one finds in the scrolled organ support at the rear a putto holding a flaming torch, a decorative motif similar to that used by Breu. The stiff, starched folds of the costume of Hofhaimer's assistant in the print appears to have influenced the young man seen from behind in the foreground of Breu's *Choir Scene*. The preference for figures seen from the rear, for the lost profile, for obscured faces, are further shared features of these works. It is possible that Breu was responding – at times rather clumsily, as in the occluded face of Pythagoras's companion (see Plate 7) – to the sustained inventiveness of Burgkmair, who introduced an impressive variety of such poses and viewpoints in order to keep a long tableau of figures in procession visually interesting.

That Breu studied this Burgkmair woodcut closely is confirmed by a design for a glass panel illustrating the *Children of Mercury*, now in Berlin (Fig. 2.45). Here one sees, albeit in reverse, the same profile of an organist and his bellows assistant. The costume and hat of the organist are directly inspired by Burgkmair's woodcut and suggest that Breu, too, was representing Hofhaimer in his roundel. *Music* has lost its traditional association with Eros

2.45 After Breu, *The Children of Mercury*, pen and black ink

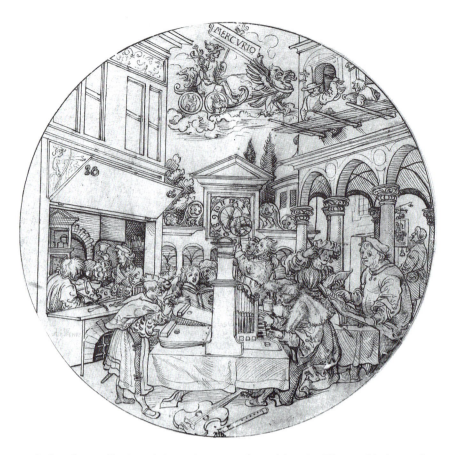

and has been displaced from its normal position in *Planetenkinder* cycles under the sign of Venus; instead, it has been given the seriousness and dignity of a liberal art under the influence of Mercury. These factors also speak for an identification with Hofhaimer.[111]

Burgkmair's woodcuts can be only imprecisely dated. Maximilian's instructions were dictated to his secretary Marx Treitzsaurwein in 1512 for the painted version of the *Triumph*. Quite when the commission for the woodcut designs was given to the artists from Augsburg and Nuremberg is unclear. Burgkmair had drawn 66 of the 137 woodcuts of the *Triumph* by 1519, when the printing project was abandoned. However, plate 28, showing the Court Fools, carries Burgkmair's monograph and the date 1517. As this print immediately succeeds that of the Musicians, it is not unreasonable to suppose that the latter were finished either in that year or before.

Given this fact, and the date of 1517 on the Uffizi copy of Breu's organ shutters, it seems sensible to conclude that the design and execution of the organ shutters took place within these three years. That Antonio de Beatis mentioned the organ *in situ* in May of 1517, also points to a date of completion around this time.[112]

The idiosyncracy of Breu's style in these works may be seen as an attempt to create a suitably monumental and classicizing manner that fitted the

Italianate context of the Fugger Chapel. In doing so, he turned to the classicism of Burgkmair's *Triumphs*, replicating in paint the bold outlines and clear plastic conception of the woodcuts, as well as adopting the grandly-conceived figure style and rich classical ornamentation. In the organ shutters, Breu met the humanist conception of the project with an attempted grandiloquence of style that depended upon the developing classicism of the Imperial commissions. Breu's *Small Organ Shutters* are unique in German art of this period in conflating within a Christian context biblical and classical themes, reconciling the two traditions and thus realizing in visual form one of the chief ambitions of Renaissance humanism. Herein lies their chief significance. Ironically, however, the Fugger Chapel was the last great Catholic monument to be built in the city before the onset of the Reformation. Breu's concern with a classical style disappeared in the next few years as his art reacted in other ways to the ideological cross-currents of the Reformation. It was to resurface only ten or so years later. When it did, it was in a different, highly rhetorical manner that to a large extent grew out of the problems posed for the painted image by Evangelical and Reformed opinion.

Notes

1. Lieb (1955).

2. Bushart (1994), 421.

3. For an exhaustive account of the sources and attributions of the Fugger Chapel architecture and furnishings, see Bushart (1994), esp. 115–42.

4. Bushart (1994), 162.

5. Roeck (1999), 45.

6. Ulrich von Hutten, *Schriften*, ed. E Böcking, vol. IV, Leipzig, 1869, 391–2 and 370; cited in Baxandall (1980), 138.

7. Höhn (1924), 6.

8. See Augsburg (1980), vol. 1, 76. Also Hauttmann (1921), 35.

9. Pfeiffer (1955), 179–88.

10. Kunze (1975), vol. I, 218, 234.

11. Diehl (1933), 15.

12. The elder Holbein used the 1438 Pisanello portrait medal of John III Paleologus in a number of his works (see Goldberg (1978), vol. I, 63); Burgkmair copied Peutinger's antique coins for his woodcut series of Roman Emperors. For other examples see Halm (1962), vol. I, 87, and Falk (1968), 11; cited in Baer (1993), 5, n. 24.

13. Rupé (1923, 167) cites the son of an Augsburg Bürgermeister, who, in 1459, sent home from Padua Italian works of art.

14. See Baer (1993), 9–56.

15. Ibid., 10–18; Blankenhorn (1973), 4.

16. Ibid., 20.

17. Ibid., 22. On Marian symbolism, see *Herder* (1971), vol. 3, 190–98: 'Das Marienbild im Flämischen und Deutschen Kunst.'

18. See for instance Cima da Conegliano's *St John the Baptist Altarpiece* in the church of *Madonna dell'Orto*, illustrated in Humphrey (1993), 149, plate 131.

19. Blankenhorn (1973), 2.

20. Schindler (1985), 48.

21. For a full history of the *Prayerbook* and its surrounding documentation see Giehlow (1899), 33–101; also Chmelarz (1885), 88–102; von Tavel (1965), 55–120; Strauss (1974a).

22. Strauss (1974a, 321) points out that this date according to the modern calendar is 27 December, 1513.

23. Ibid., 321.

24. Giehlow (1899, 100–101) points to this version of Grünewald's name ('Mathis Asschaffenburg') in Basilius Amerbach's collection in 1586.

25. Leidinger (1923), Wölfflin (1905, 285); von Tavel (1965) and Nuremberg (1971, 141–4), no. 260, all take this view.

26. See Giehlow (1907), 6–12; Wehmer (1940), 76; Panofsky (1943), vol. I, 182; Winkler (1957); Strauss (1974a), 322; Landau and Parshall (1994), 207.

27. That two versions of the *Prayerbook* were envisaged is made explicit by Maximilian's reference to the 'gebetbuechl, ain ordinarij, das ander extraordinarij'. See Giehlow (1907), 7, who suggests that the 10 'extraordinary' versions on vellum were to be given to the most illustrious members of the Order, the simpler version, published in quarto in a different type and on paper by Sylvan Otmar of Augsburg (no date), to be given to the lesser and more numerous members.

28. For the possible reasons, see Strauss (1974a), 324.

29. Giehlow (1899), 74.

30. Ibid., 74–5.

31. Ibid. (53), and Strauss (1974a, 181) list the borrowings most completely. These are as follows: fol. 76v *St Michael* or *Fortitudo*, after a niello by Peregrino da Cesena (Paris, Musée du Louvre); fol. 77v *Prudentia*, after a niello by Peregrino da Cesena (Paris, Musée du Louvre); fol. 78r *Hercules*, after a *Hercules and Dejanira* niello by Peregrino (London, British Museum) – Blankenhorn (1973, 39) considered the Hercules to be derived from a drawing by Botticelli (Florence, Uffizi); fol. 79v *Demeter and Neptune* – *Demeter*, according to Blankenhorn (1973, 39), after a drawing of Pallas Athene by Botticelli or Filippino Lippi (Milan, Biblioteca Ambrosiana); fol. 80r *Arion*, after a Bolognese niello (London, British Museum) – Chmelarz (1885, 98) noticed a resemblance to the figure of Neptune on Jacopo da Barbari's *Plan of Venice* of 1499; fol. 881v *Orpheus*, after a niello by Peregrino da Cesena (Berlin); fol. 83r *Mercury*, after a niello by Nicoletto da Modena (Basel); fol. 83v *Venus Marina* Group, after a niello by Peregrino da Cesena (Paris, Musée du Louvre); fol. 85r *Samson/Hercules*, after a niello by Peregrino da Cesena (London, British Museum); fol. 86v *Caritas*, after a Bolognese niello of a *Bacchanal* (London, British Museum); fol. 91r *Goliath*, according to Chmelarz (1885, 98), after a design by Mantegna; for fol. 81r the *Classical Candelabrum*, Baer (1993, 87) suggested comparison with Nicoletto's prints as well as an anonymous Florentine ornamental print (illustrated in Hind (1910), 1, plates 689 and 188).

32. From Ecclesiasticus 24, v. 15: 'Et sic in Syon firmata sum: et in civitate Sancti ficata similiter requievi … ' ('And so I was established in Zion, and in the holy city was I given to rest'). Chapter and verse references of Latin quotations follow the Vulgate, Colunga/Turrado edition, Biblioteca de Autores Cristianos (Madrid, 1982); the English translations are taken from the King James Bible (Cambridge edition).

33. See Randall (1966).

34. Giehlow (1899), 96; Strauss (1974a), 161.

35. Translation by Strauss (1974a), 178.

36. Koetschau (1913), 79, n. 5.

37. See most recently, Anzelewsky (1988), 276.

38. For a recent discussion of this question see Gameson (1995), ch. 1.

39. See Carruthers (1990), 228.

40. Nordenfalk (1951), 1–15.

41. Carruthers (1990), 226–8.

42. Ibid., 224.

43. Thus Wolfgang Hunger, in a letter describing the illustrations in his 1535 translation of Andrea Alciati, as *schweigende Dichtung* ('silent poetry'), the text as *sprechendes Bild* ('speaking picture'), through the combination of which, moral instruction might be pleasantly learned and most easily remembered. See Köhler (1986), 58–9.

44. Altdorfer, for instance, produced a dated engraving after Peregrino's *Prudentia* in 1506. See Friedländer (1893), 22–6.

45. Strauss (1974a), 326.

46. Wittkower (1987), 123.

47. Giehlow (1915), 1–218.

48. In Pirckheimer's translation: 'sich vor aufsatz seines veindts ganntz vernufftiglich zu beschützen und verwaren'; cited by Giehlow (1907), 11.

49. Giehlow (1899), 96.

50. For the rebuilding by Jacob Zwitzel, see Baum (1907), 67f. and Zimmermann (1985), 118.

51. Berlin, Staatliche Museen, Kupferstichkabinett; see Bock (1931), 74.

52. London, British Museum; see Dodgson (1916), 183–9.

53. Compare with a design for a façade bearing the coat of arms of the Nuremberg Imhoff family, designed around the window apertures of the actual building (Berlin, Staatliche Museen, Kupferstichkabinett, inv. no. 1084); Bock (1921), I, 95.

54. Illustrated in Augsburg (1980), vol. 1, 366.

55. The relief was set into the east façade of the Town Hall by Elias Holl, where it remains today.

56. For the transformation of the barbarous Wild Man of the Middle Ages into the symbol of national identity and utopian primitivism, see Bernheimer (1952), Silver (1983), 4–43, and Wood (1993), 152–60.

57. One of the four canvases of the *Seasons* after Breu's Höchstetter glass-roundel designs, now in the Deutsches Historisches Museum, Berlin. Breu's own drawing of the scene shows the bottom part of the relief, indicating that it formed part of his original design, cropped by the roundel shape.

58. Massing (1991), 156.

59. Ibid., 155.

60. Bock (1931), 84, and Dodgson (1916), 188.

61. Mende (1979), vol. 1, 199–211.

62. On the interior refurbishment, see Buff (1893); 21f. and 110f.; Baum (1907), 66, and Cuneo (1991), 297–300.

63. Stiassny (1894), 101–20.

64. Hitchcock (1981), 3.

65. See Moser (1929), 34; and Lieb (1952), 181–3.

66. For an exhaustive discussion of the iconography of both the painted and sculptural elements, see Bushart (1994), 159–74, 202–7 and 313–18.

67. Augsburg, Städtische Museen, inv. no. L.1057; Goldberg (1978), vol. I, 76–82.

68. Röttinger (1909): 31–91, attributed the print loosely to the circle of Botticelli; since then it has been attributed to Francesco Rosselli. See Landau and Parshall (1994), 89.

69. Antal (1928), 29–37.

70. Blankenhorn (1973), 74.

71. Anonymous copy after *Two Muses*, Uffizi, Gabinetto dei Disegni e Stampe, no.14587F; illustrated in, Winternitz (1965): 277.

72. Whereabouts unknown; photographic record in the Witt Library, London. For prints after Lippi, see Walker (1933), 33–5; also Hind (1910), vol. I, 186.

73. Buchner (1928a), 327; Blankenhorn (1973), 50 and 110; Bushart (1994), 261–2.

74. Bock (1921), vol. I, 16, inv. no. 1086. The drawing measures 135 x 181 cm and is on toned paper.

75. See, for instance, the building with tiered arcading in *St George killing the Dragon*, Scuola di San Giorgio degli Schiavoni, painted between 1502 and 1507. Reminiscences of Carpaccio crop up also in the background courtyard scene of the 1518 Koblenz *Nativity*. The four vast canvases of the *Seasons* in Berlin, made after Breu's designs, are based on Carpacciesque tableaux.

76. Augsburg, Städtische Kunsammlungen, inv. no. L.1054.

77. Boston, Fogg Museum of Fine Arts.

78. It is perhaps significant to note the very Venetian character of the architecture in the illustrations that Breu made for the *Constance Breviary* made for Hugo von Landenberg, the bishop of Constance, in 1515; see Hagelstange (1905), 3–17, esp. figs. 1, 2 and 4.

79. On Lippi's reputation, see Gamba (1958), 67–9.

80. Bushart (1994, 243) pointed out that the panels cannot be properly ordered because the fronts and backs do not properly match (the *Pythagoras* is painted on the reverse of *Dissemination of Music*). He attributes this to the carelessness of the artist.

81. Petrus Comestor, *Historia Scholastica*, 'Genesis', ch. 28; cited in Beichner (1954), 10–11.

82. *Flavii Iosephi Opera Omnia*, post Immanuelem Bekkerum recognovit Samuel Adrianus Naber (Leipzig, 1888), vol. I, 14; cited in Beichner (1954), vol. I, 9.

83. Stiassny (1894), 103.

84. Biedermann (1982, 29–30) extends the arguments of Moser (1929, 34) and Lieb (1952, 182), who regarded the figures simply as a Turk, a Jew, a Christian and a Greek.

85. Biedermann (1982), 31.

86. Bushart (1994), 264.

87. Lieb (1952), 184–5.

88. Bushart (1994), 249.

89. The same conventions are to be seen for instance, in the miniature of the choir of the French court, with the court composer Ockeghem, *c*.1530, Paris, Bibliothèque Nationale Ms.Fr.1537, fol. 58v. For this and numerous other, earlier examples from the fourteenth and fifteenth centuries, see Bowles (1977), plates 95, 96, 101, 103. For the practical conventions of choirs, see Schmits van Waesberghe (1966), 1345f., esp. 1346, n. 8, for mention of the Petrarch Master's print.

90. Augsburg examples include: Gunter Zainer, *Speculum humanae salvationis*, *c*.1475, and Anton Sorg, *Spiegel menschlicher Behaltnis*, 1475.

91. F. Gafurio, *Theorica Musice, Impresum Mediolani per Magistrum Philippum Mantegatium dictum cassanum opera et impensa Magistri Ionnis Petri de Lomatis anno salutis 1492*, Paris Bib. Nat., Rés.V.525. Fol. not numbered [6VI]; Proctor 6055. Mentioned by Bushart (1994), *passim* and n. 635.

92. Gregorius Reisch, *Aepitome phylosophiae. Alias Margarita Phylosophica … tractans de omni genere scribili …* (Johann Grüninger, Strassburg, 23 February, 1504), *Liber Quintus: de principiis Musice* (unpaginated).

93. *Historia Scholastica*, 'Genesis', ch. 28: '… Tubal, pleased with the sound of the metals, from their weights thought out their proportions (intervals) and their harmonies which were born of them, which discovery the Greeks erroneously attribute to Pythagoras'; translated by Beichner (1954, 11).

94. Althogh I koude not make so wel
 Songes, ne knewe the art al,
 As koude Lamekes sone Tubal,
 That found out first the art of songe;
 For as hys brothres hamers ronge
 Upon hys anvelt up and doun,
 Thereof he took the firste soun,–
 But Grekes seyn Pictagoras,
 That he the firste fynder was
 Of the art, Aurora telleth so.
 (Geoffrey Chancer, *Book of the Duchess*, 1160–69.)

95. Ranulph Higden, *Polichronicon*, first half 14th century; see Beichner (1954), 14–16.

96. 'Sunt vero musici triplices. Primi qui tantum circa instrumenta versantur musica: qui bene quidem modulantur: & nervos tangunt: sed quare hi nerui moti & non alij consonàtia praestent: non intelligent: nec huiusce modi artis speculationem capiunt. quales cytharedas pene omnes conspicimus. Secundi sunt qui carmina fingunt: ad quae naturali potius instinctu qß [quam] speculatione ac ratiōne feruntur. & hos poetas nominant: quorum multi carmina fingunt: sed harmonicas earum proportiones demonstrare minime possunt. Tertij sunt qui & si nec instrumenta: & neruos tangere: nec carmina fingere noverunt: de his tamen iudicandi peritiam habent.' *Margarita Phylosophica*, Liber Quintus, fol. O.

97. Blankenhorn (1973, 71) made the connection with Campagnola's print.

98. Illustrated in Scribner (1982), 46, fig. 33.

99. *Margarita Phylosophica* , fol. Oii v.

100. See Schott (1878), 205f.; and Lieb (1955), 137–8.

101. Bushart (1994), 238.

102. 'In the Carmelite monastery the Fuggers have made a chapel at one end of the nave of the church. It is raised on some eight steps, is excellently painted, is floored with marbles and mosaics and has a highly decorated tapestry worked in gold and azure and other rich colours … There is also an organ which for such a chapel is very large and fine. According to Jacob Fugger, who is the oldest member of the family and who had it built, the cost of the chapel, together with all these embellishments, was twenty-three thousand florins.' *The Travel Journal of Antonio de Beatis*, ed. Hale (1979), 66.

103. Röttinger (1909, 32) drew attention to the repeated appearance of this date throughout the chapel; his explanation for the date has been followed by Buchner (1928a, 348), Lieb (1955, 184) and Blankenhorn (1973, 60).

104. Biedermann (1982), 28–34.

105. Röttinger, Antal and Lieb read the date on the Uffizi drawing as 1517 and date the small shutters accordingly to *c*.1517; Buchner, Holtze, Blankenhorn and Baer do not use this in their dating of the shutters and all conclude a probable date of *c*.1522, following the second signature of the Berlin drawing as a reliable *terminus post quem*; Bushart (1994, 251) suggests in passing the possibility of 1527 but does not pursue it.

106. Previous commentators have differed widely in their conclusions. *For the large organ shutters*: the date of *c*.1525 was proposed by Stiassny (1893), 111; *c*.1520 by Dörnhöffer (1897, 17) and Röttinger (1909, 34); Buchner (1928a, 342) suggested *c*.1517–18; Antal (1928, 29), followed by Blankenhorn (1973, 49), returned to *c*.1520; Wilhelm (1983, 424, 89) and Bushart (1994, 261), proposed *after autumn 1520*. *For the small shutters*: Stiassny (1893, 102), and Dörnhöffer (1897, 17) suggested 1512; Buchner (1928a, 342), Holze (1940, 1) and Blankenhorn (1973, 62) all say 1522. Biedermann (1982, 28f.) cautiously suggested *c*.1517; Bushart (1994, 261), after autumn 1520.

107. Bushart (1994), 257–62.

108. Ibid., 238.

109. See the facsimile edition, printed and published by Schestag (1883–84); also Chmelarz (1886), 289–319, and Appelbaum (1964).

110. See Appelbaum (1964), 26.

111. See Eikelmann in Augsburg (1993), 77.

112. The chronicler Wilhelm Rem described the chapel as 'gar ausgemacht' in 1517 (Rem, *Chronik*, 82).

3
Breu and the Reformation

The course of the Reformation in Augsburg

Reforming sentiments and ideas made their appearance in Augsburg only months after Luther's posting of his 95 theses in Wittenberg on 31 October 1517. Support for the reformer, at this stage mainly among the educated, was stimulated by the presence in the city of Luther himself the following year, brought to answer charges of heresy at the Imperial Diet. A number of prominent churchmen and patricians – notably Johannes Frosch, the prior of St Anna, and the brothers, Bernhard and Konrad Adelmann, members of the Cathedral Chapter – were quickly converted. Frosch's sermons and the Adelmanns' patronage of the reform-minded preacher, Oecolompadius, at the Cathedral, ensured the rapid diffusion of Lutheran ideas.[1] Yet, despite this early and enthusiastic reception of reforming ideas, a thorough-going reformation of the church, administered and institutionalized by the city authorities, was not effected until 1537, almost 20 years later.

The political history of the Reformation in Augsburg is a story of a careful balancing act. In other cities, such as Nuremberg, the authorities were quick to take reform into their own hands to maintain their grip upon civic politics.[2] In Augsburg, the Reformation took the form of a protracted struggle roughly along class lines, by which popular agitation for the reform of the Church, stemming largely from the poorer classes, was countered for as long as was politically possible, by the patrician City Council. While many of its members were sympathetic to reform, they were forced to balance the danger of internal rebellion within the city against the commercial interests of their class – the foreign investments, trade monopolies and huge banking loans, which defiance to a Catholic emperor would have placed in jeopardy. The religious issue moreover broke at a time of increasing economic polarization within the city. On the one hand there were the merchant families, such as the Fugger, whose enormous fortunes were derived from their foreign banking and trading interests but which brought little economic advantage to the local industries; and on the other, the declining artisan trades, hit by large population growth and rising inflation.[3] The issue of religious reform provided a sudden focus for widespread social resentment. A further factor was the long-standing political disgruntlement of the middling class of artisans and small tradesmen, with whom Breu identified. Their resentment against a self-perpetuating oligarchy of wealthy patricians, who had gradually whittled away the traditional political privileges and rights to government of the

ordinary citizenry, also found a focus in demanding religious reform from a recalcitrant City Council.

The first few years after 1518 were characterized by urgent religious debate and an increasing popular anticlericalism within the city. The effectiveness of the Lutheran preachers and the flood of evangelical writings may be seen in the Bishop of Augsburg's attempt to curb their proliferation. In 1521, he ordered his clergy to deny absolution to anyone who confessed to owning Lutheran works.[4]

The first stirring of popular unrest occurred on 13 July 1523, when a Dominican, speaking of St Margaret as patroness of childbirth, was loudly interrupted by a baker's apprentice, demanding proof of this assertion in Holy Scripture. A small demonstration ensued.[5] It was to be Franciscan radicalism, however, rather than Lutheran teachings, that provided the real impetus for popular revolt. In 1524, the newly appointed lector at the Franciscan Church, Johannes Schilling, began preaching in an un-precedentedly violent and inflammatory manner.[6] He condemned the customary sacraments of the Church and its claims to worldly authority and, more radically, criticized private wealth and advocated a communal ideal in which all goods were to be distributed equally. This conjoining of religious and social reform drew enormous support from among the poor and propertyless.[7] Schilling actively encouraged disorder: those subsequently arrested cited him as the chief instigator of a disturbance in May 1524 at the Franciscan Church, when a monk, challenged to give the mass in German rather than in Latin, was physically manhandled as he attempted to bless holy water. Fearing civil disorder, the City Council petitioned the vicar general of the observant Franciscans to order Schilling's departure from the city. This action prompted the largest demonstration within living memory. On 6 August 1524, 1800 people gathered before the Town Hall, demanding the friar's return. With the reality of civic revolt hanging over them, the Council members hired 600 mercenaries to protect the Town Hall and were forced into a compromise with the ringleaders. Though Schilling was not returned, the Council were forced by popular pressure to accept another preacher to the Franciscan Church, the Zwinglian Michael Keller. He was to prove as radical and forceful in personality as Schilling – and much more politically adept. From this time onwards, Keller's advocacy of the simplified Zwinglian doctrine of the eucharist, the emphasis on communal forms of worship and a collective civic morality, with its implications for social and political change, made his faction a popular alternative to Lutheranism. Keller's bold and uncompromising criticisms of the secular authorities for their failure to remove the corrupt institutions of the traditional Church also ensured a mass support among the poor. The fear of popular rebellion, which the events of 1524 had inspired in the ruling authorities, effectively gave Keller a freedom he otherwise would have lacked.[8]

In 1531, the Zwinglian activists stepped up their campaign for the abolition of the Catholic Church and the institution of their own Church-in-government. They exploited the heightened tensions within the town created during the

previous year's Imperial Diet held in the city, when the Emperor Charles V attempted to reinstitute the traditional faith by force. Particularly harsh economic conditions the following year also fed the already highly volatile and unstable social conditions. By 1534, popular pressure was such that the Council was forced to capitulate. On 22 July, a partial reformation was instituted: Catholic churches, except those under the direct jurisdiction of the Bishop, were closed, many convents and religious houses followed, all gifts and endowments were requisitioned and used towards helping the poor; henceforth, only Protestant preachers, appointed by the Council, were allowed to preach. Three years later, in 1537, the complete abolition of Catholic worship was effected. From this point onwards, until the defeat of the city by Catholic forces in 1548, the Reformation was complete.

The Reformation and the arts

The long-term effects upon the arts in Augsburg of the Protestant ascendancy were profound: religious painting, as a viable economic enterprise endured only in a much reduced capacity, continuing in schematic and desensualized forms reflective of Protestant worship. The creative energy and innovation of the first two decades passed into other fields, particularly metal- and silver-working and the production of luxury goods, an area in which Augsburg was to assume a position of international importance in the course of the century. In the shorter term, during the 1520s and 1530s, before Protestant dominance was established (and in effect, the remainder of Breu's lifetime) the effects of the religious struggles were at once complex and profound. The commissioning of large retable altarpieces fell to a trickle. Only two can be attributed to Breu in the period of the 1520s, none in the 1530s. Painters were forced to find work outside the city. Breu himself was away during 1522 in Strassburg, apparently on official business.[9] His major productions between 1528 and 1530 were secular works for the Duke of Bavaria; and during the 1530s, one of the Breu workshop's largest commissions was the refurbishment of the hunting lodge and chapel of Count Ottheinrich at Grünau. In other words, at a time of artistic drought within Augsburg, Breu found commissions from Catholic patrons outside the city.

 The works Breu executed within the city during this period registered the tremors of the religious upheavals in a number of complex ways. The issue of the legitimacy of religious images that the advent of Protestantism raised, did not become one of pressing popular concern until 1529, the year in which Augsburg suffered its first significant iconoclastic outbursts.[10] Although reduced, a demand for religious painting continued up to and beyond this point, as traditional Catholics, moderate Lutherans and iconophobe Zwinglians fought out their doctrinal differences. Nonetheless, within such a climate the imagery of religion in Augsburg was profoundly affected. Where tenets of belief changed, new iconographical means were found to express them; where new emphasis was given, or a new exegesis made of a familiar theme,

modifications to the traditional iconography were necessitated; in an atmosphere of fierce polemical debate, images of a directly didactic nature were developed to espouse the various sides of the factional divide, either Protestant or Catholic; and new types of subject matter were introduced, appropriate to the new teaching. Conversely, where religious images fell into decline, new species of art emerged to fit the new, if impoverished, artistic environment, often incorporating within themselves some of the secular impulses – the desire to display wealth or social standing being an obvious example – that were latent in the monumental works of older Church art.[11]

In the case of a painter known to have espoused Protestant beliefs, a difficulty of interpretation arises in assessing the degree to which any notionally Protestant elements in his art may be related to the artist's own personal convictions. This problem is unavoidable in the study of Breu. Presented with the unique record of the artist's vehemently evangelical beliefs contained within his *Chronicle*, the temptation to read his paintings of the 1520s and 1530s in the fierce light they cast is very strong. Works of art, however, at this period at least, were rarely the product of private conviction alone. The painter was guided as much by public and external expectations, by the necessity to convey acceptable and apposite imagery that met public demands of setting and usage. The artist, of course, was not somehow merely a cipher of contemporary cultural currents. He worked within and across the cultural assumptions of his day and in his paintings, actively moulded and articulated them with the stamp of his own temperament. His work therefore constitutes a defining part of that culture. Provided with the evidence of Breu's *Chronicle*, the problem lies in evaluating the measure of that personal element in its equation with the public or wider social dimension within his own productions. Used in conjunction with other evidence – literary, iconographical and the broadly historical – drawn from the artist's immediate, surrounding world of significance, a context that addresses both the private and public can be established, in which to place and test the works of art. This is the intention of this chapter. It begins with a study of Breu's *Chronicle* for the evidence it yields about his beliefs and his own brand of piety. This is followed by a number of contextual analyses of works of art that Breu produced in the course of the 1520s.

The *Chronicle*

Though a number of studies have addressed the question of Breu's religious beliefs as revealed through the *Chronicle*, no systematic attempt has been made to locate their precise nature or origins. His rejection of religious paintings and church decorations in the 1530s has been frequently noted. The imagery of certain of his paintings of the early 1520s has been analysed by Gode Krämer in a specifically Lutheran light.[12] Most recently Pia Cuneo has interpreted the disenchanted tone of his later entries, as evidence of

disillusionment with the new Zwinglian ascendancy.[13] A close reading of the *Chronicle* is necessary to enable one to gauge the accuracy of this kind of assertion.

The *Chronicle*'s character and provenance were established by Friedrich Roth in his introduction to the printed edition.[14] He established that the manuscript, today in the Bayerische Staatsbibliothek, Munich, is written in a later sixteenth-century hand.[15] Inconsistencies and gaps in the entries prompted Roth to suggest that the copyist transcribed a collection of loose papers, many undated, some of which were missing, others in the wrong order. This would account for the fact that some events are ascribed to the wrong year, while frequently the chronology of events within a single year is jumbled.[16]

The *Chronicle* is in any case extremely fragmentary. Large gaps appear throughout and there is no sense of continuous narration. It begins with a brief report of the years 1376–78, before leaping to 1512. There are no entries for the years 1516–20 or for 1530. The various entries for the years 1512–16 and from 1520 to 1523 are inconsequential, random, uneven in length, comprising stray events – an execution, official decrees, a marriage – or comments on members of the City Council. From the mid–1520s religious issues assume importance. The years 1524, 1527 and 1529 are very fully recorded and from 1531 onwards, the *Chronicle* becomes a more or less continuous and detailed account of events. This is significant, for these were the years of highest popular agitation and social tension within the town. That the degree of detail in Breu's account corresponds proportionally to the religious tensions, provides a clue to his motivations.

Roth and later commentators criticized Breu for failing to report what have come to be regarded as the great events of the day and for omitting mention of events that left a deep impression on other contemporaries and chroniclers.[17] Only twice did he refer to his own activities as an artist; on matters of artistic life within the city, he was completely silent. Yet to blame Breu for apparently lacking a broad understanding of international politics, or for lacking an historian's perspective on events, is to miss the point. One should rather see value precisely in his limitations: for his account provides insights into the narrow, parochial world of the artisan, hedged about by restrictive and often harsh social, political and economic circumstances.

The style and sentence structure of the *Chronicle* are clumsy and unschooled, reflecting the raw colloquial idiom of the artisan classes. The underlying sensibility is urgent and impassioned. Two themes appear constantly, as often in the choice of story as in the glosses to the narration: the greed and corruption of the ruling classes; and their enmity to the evangelical cause.

What was the purpose of the *Chronicle*? To whom was it addressed? The sporadic and local nature of many of the entries gives the impression of a collection of rather randomly collated diary entries, that had significance for the author, but which have not been moulded into an intelligible narrative. Yet the use of the third person, the only rare intervention of personal verb

forms, might suggest something more formal. That the fragments begin in the year 1376 might indicate that Breu was modelling himself on earlier civic chronicle-writing.[18] As Pia Cuneo has observed, the extremely personal tone of Breu's writing makes it unlikely that his chronicle was intended for a wide audience. Like the chronicle of his contemporary, the merchant Wilhelm Rem, who specifically stated that his honest attempt to record the truth would only cause resentment if it ever went beyond the immediate family circle for which it was written, Breu's work was probably intended for his own family or private circle.[19] Cuneo saw chronicle-writing as the preserve of the socially privileged and saw significance in the fact that an artist of modest social background should write in this genre at all.[20] Yet Breu's writing is best explained not so much in terms of social aspiration as rather exemplifying the growing self-consciousness of his own class, the in-dependent, literate guildsmen of middling income, who in the early sixteenth century discovered the printing presses as a means to make their voices heard. Breu's *Chronicle* begins to take proper form precisely in those years – the early 1520s – when the production of popular pamphlets significantly increased in Augsburg, when the religious uncertainties and the social disruptions that followed the outbreak of Luther's Reformation prompted many layfolk of modest means and education to set down their thoughts, opinions and grievances on paper and have them run off by a local printer. It is concerned with many of the same issues and shares the heightened emotions of the time. On one level Breu's *Chronicle* may be seen as the expression of a similar need to bear witness to the extraordinary and revolutionary events of his day.

Yet, unlike the pamphleteers, Breu was neither polemicist nor agitator. For all the sympathy with radical opinion expressed privately in his *Chronicle*, Breu's position within the politics of the town was essentially that of the middling, respectable and conservative guildsman. He neither identified with the brand of entrepreneurial venture-capitalism espoused by the class of wealthy merchants who dominated the politics of the town; nor did he belong to the vulnerable class of the poor, made up of impoverished guildsfolk, day labourers and journeymen – the majority, in fact, of the population. Rather, he was part of the solid stratum of small craftsmen who formed the basis of Augsburg's economy, operating within small family workshops and guided by a conservative guild ethic. Their sense of social and political standing was expressed in terms of traditional civic rights and privileges, through the corporate structures of the Guild and city government. Social stability was necessary and central to their continued existence. Breu's prominent position within the Guild and his officer status within the civic militia are indications of his good citizenship and his integration within the existing social order.[21] Nowhere in the *Chronicle* is there any evidence that he advocated social change or shared the communistic ideals of Schilling or the more radical pamphleteers.

Nonetheless, the contemporary pamphlets offer a rich context in which to study the wellsprings of Breu's own sentiments and beliefs. The pamphlet

writers for the most part wrote with deliberate didactic intent and the manner in which they addressed particular issues of both spiritual theology or civic abuses was highly polemical in intention and form. Breu's *Chronicle*, on the other hand, is a record of events. His writing is largely unreflective, he merely reacts to circumstances. For all its strength of opinion, it lacks a sense of larger historical perspective or an underlying ideological agenda that might lend significance to the events recorded. While many of the pamphlet writers wrote principally to advocate or to criticize points of doctrine and belief, one should not necessarily expect detailed discussion of such matters in a chronicle of events. The lack of discussion of spiritual theology in Breu's *Chronicle* should not lead automatically to the assumption that the artist was indifferent to these questions, but rather to an awareness of the constraints upon content dictated by the nature of the text.

Breu's Protestantism: a case study in Reformation piety

This proviso notwithstanding, the general orientation of Breu's piety emerges in the many references to religious matters, although the specific nature of his spiritual theology can only be inferred from stray phrases and asides. For example, in 1514 he indicates a conventional belief in the efficacy and necessity of the sacrament of Extreme Unction and the mediation of saints, when he records the execution of a convicted soldier, who on the scaffold scorned the last rites, confession or act of contrition. The man, Breu says, died *als ain vieh* ('like an beast')[22] – in as brutal a manner perhaps – but also in the spiritual condition of an animal, without absolution, appeals to God or to his patron saints. There is no hint in this pre-Lutheran period of any objection to the sacrament of Extreme Unction as a 'human law', unsubstantiated by the Scriptures.

Other early entries in the years 1513 and 1514 reveal a practical, hard-nosed mentality that is striking in an age characterized by relic-worship, ritual and the veneration of saints. He recounts the fate of the Augsburg woman Anna Laminit, who gained modest fame by claiming to exist solely on the consecrated host. Breu contemptuously dismissed her supposed saintliness as sheer trickery ('*solcher puberei*').[23] One encounters here, for the first time, a social distinction made in regard to religious orientation, between the superstitious rich and powerful and the disingenuous poor. The Emperor, he says, King, princes, burghers, the most powerful of the city, put great faith and trust in her and considered and valued her as saintly. The poor, on the other hand, thought very little of her.[24] Whatever the actual truth of Breu's assertion, it reveals an attitude, as early as 1513, that is entirely compatible with his later, passionate condemnation of the excessive material culture and ritualistic practice of the Church and of its wealthy supporters. One may intuit here already, in this pre-Reformation period, evidence of a layman's distance from the official religion dictated by the Church Institution and as observed by the upper elements of society.

From 1523 onwards, the entries of Breu's *Chronicle* increasingly concerned themselves with incidents involving religious reform. The artist participated in the widespread anticlericalism of the 1520s in Augsburg. From his anecdotal and day-to-day account, criticism of the rights and privileges as well as the moral hypocrisy of the clergy emerge as central issues that prompted him to call for reform.[25] The sexual abuses, epitomized by the scandal of open concubinage, for instance, are sarcastically alluded to in Breu's account of the clergy's hypocritical reaction to the marriage of the Lutheran pastor Dr Frosch, one of the first clerical marriages in the city. Breu contemptuously regretted that Frosch did not choose one of the clergy's own women or daughters![26] Much later, in 1537, as the clergy are forced from their livings and the city, he castigated them as 'shameful, lying, whoring priests'.[27] The prodigious legal powers of the clergy, which could result in excommunication and banishment, are brought up in an entry for 1523, which relates how the Bishop of Augsburg, Christoph von Stadion, arrested one Caspar Adler, disputed with him over the 'Word of God and the Gospel' (*das wort gottes und euangelion*), confiscated his books (*ain bibl, euangelion, Paulum*) and banned him from the city and the bishopric. The dispute appears to have centred on the issue of fasting, for in the same episode Breu reported, with apparent approval, the breaking of fasts by many people.[28] In other places, liberally peppering the *Chronicle*, the social pretensions of the higher clergy are castigated. In an elaborate description of the wedding of the daughter of the wealthy patrician Paumgartner family in 1532, Breu contrasted with a kind of scandalized awe the extravagance of the trappings with the plight of the needy. He implicated the many clergymen assembled for the occasion in the wealth, pride and haughtiness of the patrician host and characterized them as 'useless, godless folk' (*unnutz, gotlos volcks*).[29]

His most consistent complaint was levelled against the abuse of the sacred calling of the clergy, epitomized by the practices of the Church, such as the imposed periods of fasting, which he characterized in an entry of 1524 as the product of humanly-ordained, popish laws ('*menschlichen, papstlichen gesatzen*'), which had obscured the true law of God.[30] His disagreement with the official teaching on the sacraments and sacramentals is plain. On Dr Frosch's clerical marriage, he said the pastor 'had done what God had commanded'.[31] That he regarded as superstitious such practices as the blessing of holy water is implicit in his account of the disturbance in May 1524 in the Franciscan Church, when the officiating friar was challenged to leave the water unblessed and to read the mass in German so that all could understand.[32] Breu's sympathies are clear: the common man, he says, was no longer prepared to order offerings and masses, to finance masses for the dead, support vigils or to pay the lifelong *leibpfennig* tax.[33] These complaints address both the sacred powers of the clergy and the economic burdens they brought with them. Much later, in an entry for 1537 describing the 'official' institution of the Reformation, Breu refers to as blasphemy (*gotslesterung*) the mass and ceremonies of the official Church that included singing and bell-ringing 'and other practices'.[34] Church decorations, altars, paintings are described at this

date as 'those things which served idolatry and the idolater' and should have been swept away years ago.[35] By this time, Breu was fully Zwinglian in his affiliations; in the early 1520s iconoclasm was not yet a burning issue. Nonetheless, during this earlier period, he characterized the clergy as 'blind leaders' (*die Blindenfierer*) and 'clerical devils' (*gaystlichen und teuflischen*).[36]

Behind these grudges against the clergy – against their assumed powers and privileges, whether sacred, legal, economic, sexual or political – it is possible to extrapolate something of Breu's own theological ideas. Like those of so many others, his beliefs – in the nature of worship, in the nature of a Church Body, in the nature of Belief itself – were undergoing radical redefinition in the 1520s as the call for reform sparked increasingly public action.

One of the most striking features of Breu's *Chronicle* in the entries that cover the Reformation years is the complete absence of discussion over the nature of the sacraments or of the eucharist. On the chief theological questions that exercised the magisterial reformers Luther, Melancthon, Zwingli and their opponents, he is completely silent. In a chronicle intended to be an account of events, one should not expect close discussion of points of doctrine. Yet their complete absence points to a frame of mind that was practical rather than spiritual in outlook. In seeking indications of his thought, there is one term that crops up repeatedly throughout his description of events, which in its prominence and frequency suggests its centrality in the artist's system of beliefs. This is the word *evangelion* ('Gospel') and the epithet *evangelisch* ('evangelical'). From its repeated use, it is clear Breu believed in an exclusive reliance on the Gospel as the only way to God. This formed the central tenet of his theology. The idea is most clearly expressed in Breu's account of the City Clerk of Kenzingen, who was condemned to death for his evangelical views. Breu recounts the event of his execution in 1524 with the fervour of a martyrologist. Asked whether he would return to the faith and practice of his fathers, the man laughed and, addressing the crowd as 'you poor men and brethren' (*ir armen und brueder*), replied that it was not God's intention that he should stray from the way of Christ. He knew that the Gospel and God's Word had come into the world to ensure eternal life and that this was certain for all believing Christians.[37] A little earlier in the same year, Breu stipulated what he meant by *evangelisch* when he criticized the City Council for aiding the clergy, despite its claims to being reformist: ('when they [the Council] wanted to appear evangelical and adhere to Christ's commandments' (*wann sie [die vom rat] euangelisch sein wollten und halten die gebot Christi …*).[38] Literal obedience to the commands of Christ as found in the New Testament is fundamental to salvation. 'A Bible, New Testament, a St Paul' (*[A]in bibl, euangelion, Paulum*),[39] are what the Bishop of Augsburg took away from Caspar Adler in 1523, when he banished him from the city for his reformed beliefs. These three categories, probably a Lutheran or vernacular Bible, a New Testament and an edition of St Paul, are for Breu the necessary tools of the new Christian. Contained in these was the Word of God, pure and unmediated. At one point Breu actually identifies the

evangelical movement with Christ, saying that those learned blind leaders (*blindenfierer*) who head the traditional Church are against Him; they do not credit Christ with the power of salvation and that those who followed Christ were despised.[40] What emerges is a biblical fundamentalism that is practical rather than spiritual in its orientation. Breu's concern is with laymen, not the clergy. His road to Salvation is via an active lay piety. It is important to note that Breu's desire for change was directed more towards the improvement of *civic* life, rather than Church reform per se.

This attitude underlies the persistent element of social criticism that runs through the *Chronicle*. His complaints against the ruling classes of the town are in fact louder and more frequent than those against the clergy. To Breu, the chief obstacle to a genuinely reformed Church lay in the opposition or sluggishness of the City Council to act. He clearly envisaged change coming from outside the Church rather than from within. Breu's attitude towards the ruling class was the product of a complex knot of resentments by which economic jealousy, a sense of betrayal over questions of religion and moral outrage at the abuse of civic power were tightly entwined. For him, rich and poor receive different treatment at the hands of the law. In 1533, the mild punishment meted out to the patrician Anthoni Fugger for his provocation of public order is met by Breu with a proverb: 'to the wealthy according to wealth, to the poor, God's mercy' (... *das ist die straff gewesen, wie ain sprichwort ist: dem reichen als dem reichen, dem armen, daß got erbarmen*).[41] He frequently compares the pride and excessive material trappings of the wealthy merchant families to the abject state of the poor. The marriage of Hans Philip von Mittelbiberach to an Augsburg merchant's daughter in 1535 was celebrated with 'such pride and arrogance, like a prince's' and utterly 'scornful and contemptuous of poverty' (*solcher hochfart und bracht, aim furstenstand gleich, und die armut ganz veracht und verschmecht*).[42]

Such attacks on the ruling elite belong within the context of a long-standing grievance in the city of the politically dispossessed *mittelere Stufe*, or middle ranks of citizenry, to which Breu belonged. Their rights to a voice in government – as in other cities – had been steadily eroded throughout the preceding two centuries by a self-perpetuating wealthy elite. Indeed, Breu's comments may be understood within the context of a civic idealism that was intrinsic to Augsburg's political history, set in place by the founding guild ordinance, or *Zunftbrief* of 1368. This stipulated that every citizen should belong to a guild and should have the right to vote guild-masters and officials into office. The persistence of that ideal may be seen in a rebellion in 1476, when power was briefly wrested from the Small Council of the oligarchs by the 'middling' guild members of the Large Council. The memory of this event might be seen reflected in the caution of the Council and in the smouldering resentments of the smaller guildsmen, exacerbated by the widening economic rift between the two groups (foreign investments and trade versus the small artisanal trades) helped exacerbate.[43]

For their opposition to Church reform, Council members were condemned by Breu as the enemies of Christ. The executions of two of the protesters in

the aftermath of the demonstration of August 1524 led him to characterize the Council as 'the big wigs, who shit on the Gospel and the New Testament and mock St Paul, … these same pharisees, they are the powerful …' (*grossen heupter, die ins euangelion schissen und ins testament und Paulum verspotten … dieselben phariseer, die sind die gwaltigen …*).[44] As the pressure for reform gathered momentum, Breu castigated the Council for its policy of appeasement, which tried to reassure both popular evangelical opinion and the demands of the Emperor to maintain orthodoxy. Breu saw in their policy of deliberate vacillation only the self-interest of the merchant classes, whose trade routes and foreign investments might have been jeopardized by an Imperial ban. Breu's comments, after the punishment of iconoclasts in the Franciscan Church in 1529, clearly indicate the opposite ideologies of rich and poor and of their political affiliations:

Then it became clear just how the Council and evangelicals [sarcastic] followed the Word of God and adhered to it. This provoked such unrest among the poor Christians that they destroyed the church idols and it was feared the Emperor would come and take over the city because of it … and the Council feared they would be taken over and stripped of their high honours, those heathens, just as some were sent packing in Basel and elsewhere.

da hat man gesehen, wie der rath und evangelier das wort Gottes lassen furgeen und darob halten. da haben die armen cristen so ubl gehandelt, daß sie die götzen erschlagen haben, das man forcht, der keiser kem und nem die stat ein von des grossen ubls wegen … da hat ein rath gefurcht, man lauf über sie, und sie werden von iren eren entsetzt, die widercristen, wie man [etliche] zu Basel und anderswoher hat haimgeschickt.

He continued to parody the Council members:

yes, we're good evangelicals at table: we eat meat, we attend the sermons, we do everything [but] we ask that the feast days are retained, we must hold onto those in order that we keep in with the priests, monks and the emperor … it must not be clear where we stand.

ei, wir seien gut euangelisch im protkorb; wir essen fleisch, wir geen in predig, wir thun alls, [aber] wir pieten die feirtag zu halten, wir muessen darob halten, daß wir dannest mit pfaffen, munch und dem keiser besteen … man sol uns nit ansehen, wie wir steen.[45]

The obverse of these criticisms against the rich in these comments was an obvious and urgent concern he felt for the plight of the poor. This in fact constitutes a sincerely felt undertow upon which his class resentment rested. His account of a woman who was branded on both cheeks for prostitution is revealing. He commented: *armut mueß blagt sein* ('poverty is plagued').[46] Her moral behaviour is explicitly linked to her material circumstances. Here is an attitude that crossed contemporary moral norms of Church and magistrate that simply condemned prostitution as Sin, and instead recognized economic necessity as the determinant of behaviour.[47]

Sympathy for the poor from the other elements of society is not unusual in the period, particularly in times of severe economic dislocation. The chronicler Rem, for example, told with obvious horror of children starving in the streets

and recounted how he himself was moved to distribute bread at his own expense (albeit in part as a means to contain the poor and ensure public order).[48] Breu's attitude differed from such short-term pragmatism, constituting instead a broader moral concern for 'the poor' as an estate and for their social betterment.[49] Questions of social justice are inextricably bound up in Breu's mind with questions of Church reform and its mission in society. In its essence, the evangelical movement was for Breu, a movement of the poor. 'Only the poor masses follow suit, as happened with Christ during his life on earth' (*[A]llein der arm hauf volgt nach, wie Christo geschah in seinem leben auf erden*), he said in 1524, of the disturbance in the Franciscan Church and the swift reaction of the authorities.[50] In 1529, when the notionally evangelical Council punished two iconoclasts, it is 'the poor christians' (*die armen cristen*) who rose up in further acts of destruction. Elsewhere, there is a note of fatality too, about their lot on earth: 'the poor must assert themselves, for the kingdom of heaven is not of this world' (*doch die armen miessen vornen dran, wann das reich der himel ist nicht von diser welt*) – a sentiment that sounds a note close to Franciscan radicalism, to a notion of a righteous brotherhood of the poor.[51]

What emerges from such comments is the notion of a lay fundamental movement, made up of the poor and the lower sections of society, loosely in opposition to the wealthy and privileged. The health and condition of the Church and city government were one. Were those in power as well as ordinary citizens to live a truly evangelical life and follow Christ's example in all their dealings, good government would naturally ensue. Public morality would automatically flow from the exercise of private virtue. By 1530, Zwinglian dogmas offered a simplified framework into which Breu's complex social and religious impulses could be channelled. In 1524, however, his ideas were very much more fluid and the influences upon them apparently broader. It is important to note that Breu's notion of a godly community of believers and his Christocentric piety preceded the influence of Zwingli, and probably drew on ancient Franciscan ideals. At this date there were other influences working upon him, which in their own complexity show the intricate confluence of ideas brought to bear upon the personal piety of a single individual.

To a large extent, Luther's doctrines may be discerned behind Breu's anticlericalism. The artist shared with Luther as well as the humanist reformers the same list of complaints about the temporal institution of the Church. Breu's familiarity with Luther's writings at first hand can be inferred (although not proven) from woodcuts he designed for several printed editions of Luther's works.[52] In addition, Luther's doctrines could have been mediated to him via the sermons of Oecolampadius, Urbanus Rhegius and Johannes Frosch and other Lutheran preachers active in the town from 1518 onwards. Nonetheless, it would probably be wrong to call Breu a Lutheran in any real sense. He used the term 'Lutheran' only twice in his *Chronicle* and then only obliquely, as in the curses of the Franciscan monk against the hecklers in the Franciscan Church disturbance of 1524.[53] The term he used for adherents of

the reform movement was invariably *euangelischen* ('evangelicals') or, in one instance, *die neuen cristen* ('the new christians'), epithets that are at once more general and non-factional in their implication.

Of probable greater importance in the formation of Breu's views was his participation in intense theological discussions with like-minded laymen and laywomen in Augsburg. It is clear, for instance, that he was a voracious reader of religious pamphlets. Their direct agency is embedded in the text of his *Chronicle*. His detailed account of the Anabaptists of Thuringia, for instance, has been drawn largely from a pamphlet on the subject and the *Chronicle* actually concludes with an anticlerical pasquil transcribed from a broadsheet from Salzburg.[54] At one point, he actually named one of the pamphlet writers and cursed as ignorant the members of the City Council for not having read his works. This was the weaver Utz Rychssner, who, as one of those arrested in the Franciscan Church affair, was centrally involved in the disturbances of 1524. Recounting the eventual release of Rychssner and another from custody, Breu exonerates them, saying:

> they weren't guilty of it, but certain mayors were their enemies, for they were good evangelicals. And Ulrich Reichsner made certain booklets, because of which the pharisees and great usurers, the ignorant, stupid pointed-hats, none of whom had read a single letter, were his enemies.
>
> (… *sie waren an solchem nichts schuldig, aber etlich burgermeister waren inen veindt, wann sie waren guet euangelisch. und der Ulrich Reichsner machet etliche buechlen, da waren im die phariseer und die grossen wucherer und die unverstendigen, groben viltzhuet, der keiner nie kein buchstaben gelesen hat, veindt.*[55]

The familiarity implied in the phrasing **der** *Ulrich Reichsner* and the strength of his invective against the authorities, makes Breu's acquaintance with the man and his works quite clear. Given this evidence, Rychssner's writings offer a window into a system of beliefs and opinions, of which one can be sure Breu approved. They reveal more clearly than Breu's *Chronicle* the influences to which literate laymen were subject and the ways in which they were used.

Rychssner came from similar social circumstances as Breu. Like Breu's father, he was a weaver (originally from Strassburg, settling in Augsburg in 1503) and made a sufficient living to pay taxes. He occurs frequently in the records of the City Council as a consistent troublemaker.[56] The tumultuous events of 1524 seem to have prompted him to put pen to paper to call for Church reform. In that year, he wrote four lengthy pamphlets between January and November.[57] As nothing is heard of him after that year, it is possible that he left the city.

Rychssner displays a remarkable range of reading, and listening – drawn from sermons and homilies of the humanists – as well as an extremely good grasp of the Bible.[58] He demonstrates vividly the ability of a layman of modest education and means to assimilate a large range of texts and sermons, humanist and other, and to show an impressive grasp of theological and historical – even philological – arguments.[59]

On the available evidence, Breu's grasp of theology cannot be shown to match the weaver's; the latter, for instance, followed Luther in insisting on communion in both kinds and defending the real presence.[60] Nonetheless, what links them most is their mutual distance from any formal denomination by their emphasis on a pure biblical piety as the means to salvation.

This latter argument is most forcefully put in Rychssner's treatise, *A Goodly Lesson how we are all brothers and sisters in Christ ...* (*Aine Schöne Unterweysung wie vnd wirin Christo alle gebrueder un[d] schwester seyen ...*), of 1524. In it, one may see the closest parallels to Breu, not merely in the ideas but even extending to language. This work promulgates the vision of a universal brotherhood of all Christians and in so doing, it attempts to destroy the pretensions of the clergy to spiritual power over the layman. His complaints against the clergy are couched in the same terminology as Breu's: *plindhait* ('blindess'), *trüm und teuflisch* ('devilish'), *Wee euch heuchlern und schriftglerten* ('woe to you learned hypocrites'), *phariseer* ('pharisees'). The righteous tone of lament derives ultimately from St Paul and also, in part, the Old Testament prophets. Its adoption by both writers reveals their absorption in the common argot of the Evangelical movement.

Rychssner's most important point was to demonstrate through the Scriptures how all fellow men are equal. He was not arguing for temporal equality; he says specifically that the highest and most powerful should be the greatest servants of the rest.[61] Here is a vision, strikingly similar to Breu's, of government and community in which each, no matter what his estate, serves the needs of his fellow citizen. The way to achieving this state of grace, Rychssner explained, was simply to read Scripture and to listen to sermons. This would be sufficient to endow the citizens with the necessary Christian virtues. He recommended carrying out the *Holy Works of Mercy* of Matthew 25: feeding and clothing the needy, ministering to the sick and to prisoners.

Precisely this vision of a godly society, dependent upon the active piety of lay people and propped up by a rather naive faith in the power of the Word, is expressed more obliquely in Breu. Rychssner's ideal of the rulers of society as its most important servants finds its parallel in Breu's (rare) eulogy, in 1535, of a member of the patrician class: Raymund Fugger. He was, says Breu, a powerful but generous man, who gave to the poor so that no one left him empty-handed. A virtuous man, who gave his employees food and drink and invited them to his table, he visited them in their homes, disdaining none, and listened to the sick and advised them about all their troubles and thereby won great praise and love from the common man.[62] In Raymund Fugger, Breu saw an ideal of the virtuous citizen, who used his wealth and station to protect those under his care, undertaking the *Works of Mercy* of Matthew 25 in a spirit of active citizenship.

Even so, Rychssner, like Breu, saw the Evangelical movement overridingly as a movement of the lower orders. Rychssner's fiercely agitating intentions make him insist that the common people take reforms into their own hands. The strong suggestion in Breu's *Chronicle* of his attachment in 1524 to a

general evangelical movement rather than to a specifically Lutheran or Zwinglian order is lent support by Rychssner's explicit reference to an ancient popular religious movement. Believing that he was living in the 'last days', Rychssner refers explicitly to his attempt through his writings 'to save the Reformation', a movement which he said 'had been growing for the previous four hundred years'.[63] This movement was that of the *lex evangelica*, the conservative scriptural religion that constituted for Rychssner the 'true Church'. Though the Zwinglians were to appropriate this notion together with the idea of a practical works holiness in the mid-1520s, Rychssner's statement shows the survival of a popular theology that goes back to the lay and mendicant movements of the thirteenth century. The context in which he invokes this ancient movement, moreover, is traditionally eschatological and quite different from the spirit of early Zwinglianism.

Indeed, it is this strong eschatological seam running through his writings that ties Rychssner closely to popular strains of belief and differentiates him from both Luther and Zwingli. This millennial dimension also marks an important distinction between himself and Breu. Though many of his comments suggest that Breu sincerely believed the Catholic Church to be the instrument of the Devil, nonetheless the urgent concern with the imminence of the Second Coming that marks Rychssner's work so strongly, is absent in his writing.

This possible difference throws into relief the main divergence between Breu and Rychssner, which might be called one of orientation. For Rychssner is concerned more with the nature of the Church and sins of the clergy than with the ruling laity; and, as we have seen, the precise opposite is true of Breu. In a sense, for the weaver, the very imminence of the Second Coming made the need for a redress of civic society irrelevant. For Breu, by contrast, it was the central issue. In this important divide one sees their different starting points and, equally, how each channelled the same beliefs and convictions to different ends. Where the two writers' opinions dovetail and at the points where they diverge, is revealed the unifying power of the reform movement: its ability to bring together individuals whose basic assumptions about society could be quite different. Rychssner's messianic zeal was quite at odds with Breu's social and political aspirations, yet the general grievances against Church and State institutions were sufficient to provide them with a common focus. Reading Breu's utterances in the light of Rychssner's writings thus enables one to place them more exactly within the social and spiritual processes at work during the early years of the Reformation. For Breu, Protestantism was essentially practical rather than spiritual, based upon the moral imperative to live by the literal example of Christ. He expressed this desire in terms of a civic framework of communal idealism, what Steven Ozment has called 'salvation by faith and social responsibility'.[64]

Painting and the Reformation

Where does Breu's activity as a painter stand in relation to these views and beliefs? What effect, if any, did the social and religious disruptions that moved him so obviously, have on his artistic output? Commentators on Breu have accused him at best of cynicism, at worst of hypocrisy for having continued to paint traditional altarpieces and other religious pictures well after the advent of the Reformation movement and for apparently advocating the destruction of works of art at the same time.[65] Was it the case that Breu painted solely to earn a living, lacked any aesthetic or emotional commitment to the subjects of his art, and could therefore welcome the destruction of Church art while continuing to paint traditionally Catholic works in order to make ends meet? How is one to read Breu's apparent censure of poor craftsfolk who did not support the Reformation on the grounds that they thereby lost their source of income, while quite clearly doing the same. It was 'to do with their livelihood', he said (*um ir narung zu thun*), 'they didn't consider their great blasphemy and wrong' (*sie bedachten nit die grossen gotlesterung und unfreundschaft*).[66]

On a number of different levels, Breu's works of the 1520s registered the tremors of the Reformation. Though the question of the use of religious images did not become a pressing populist issue in Augsburg until 1529, one of the immediate consequences was the severe drop in demand for large altarpieces. Only one such commission by Breu, the *St Ursula Altarpiece* (see Fig. 3.24), now in Dresden, survives from the period *c.*1522–25. Of the several religious works Breu executed between 1520 and *c.*1535, all are marked by departures from traditional iconographic convention. What follows is a series of careful examinations of these works in an attempt to explain these modifications. In the process, the complex effects of the Reformation upon Breu's art may be more clearly revealed.

Woodcut illustrations

One area that provided Breu's workshop with modest employment throughout the 1520s and 1530s was the production of woodcut illustrations and decorative frontispiece-borders for the printers of Augsburg. His activity in this field, already well established during the second decade in the numerous woodcut illustrations he had executed for Johannes Schönsperger and Erhart Ratdolt, continued throughout the early Reformation period.

The projects he was engaged in broadly followed the character of the output of the printing houses. The early 1520s saw an interruption in the production of editions and translations of classical literature, in the face of the intense religious debate and the demand for printed religious literature. Only by 1530 could publishers such as Heinrich Steiner feel sufficiently financially secure to return to publishing humanist literature.[67] Accordingly, the majority of Breu's designs during the early 1520s were for confessional literature. In this category,

it is important to stress that he produced woodcuts that were used in both Protestant and pro-Catholic pamphlets and there is every indication that, like the printers who produced them, he attached no personal importance or sentiment to their content. Once he had delivered them to the printer, moreover, he exercised no editorial control over the use of his designs. The same woodcuts reappear in different works, in some cases on opposite ideological sides. Thus, for example, a *David* that first appeared in a traditionally Catholic booklet entitled *Gilgenart einer yetlichen Christlichen Sel*, published by Johannes Schönsperger in *c.*1520, reappeared in the same publisher's edition of Luther's *Ain Betbüchlein* of 1523.[68] Later, in 1530, the year in which he was recording passionately evangelical sentiments in his *Chronicle*, Breu routinely produced a border showing the Trinity, the Virgin, St John the Baptist and the Apostles that was used in Johannes von Eck's, *Contra Luther*.[69] It is therefore difficult to draw conclusions about the artist's personal convictions from his activity for the printers. For the most part, his decorations for these cheaply produced and ephemeral religious tracts (and the generally lacklustre quality of the woodcuts bears this out), may be regarded as routine piecework that brought extra income to the studio.

Only in those cases where he worked for a printer of known radical sentiments or strongly evangelical leanings may it be permissible to deduce a more personal motivation. Yet even in these cases, the theologically-neutral nature of the imagery makes any firm conclusions impossible. Breu's frontispiece to Luther's German translation of the Old Testament, published by the radical evangelical Melchior Ramminger in 1523 is a case in point.[70]

In 1524, Breu executed a careful frontispiece for a tract by Ulrich Zwingli, an educational handbook, dedicated to Zwingli's pupil Gerold Mayer (Fig. 3.1).[71] It was a German translation of a Latin original which had appeared in Basel the previous year. It was published anonymously by the printer Phillip Ulhart who, like Ramminger, espoused extreme evangelical views.[72] The work is significant in being one of the earliest Zwinglian tracts to be printed in the city and coincides, perhaps significantly, with the arrival in Augsburg of Michael Keller, the main exponent of radical Zwinglian views, who replaced Johannes Schilling.[73] It has been pointed out that, unlike the huge volume of Lutheran texts published by the Augsburg publishing houses, the number of Zwinglian works was very small and that most of them issued from Ulhart's press.[74] It is possible that Zwinglians were regarded as too extreme, that they were seen at first closer to Anabaptists and other *Schwärmer* or 'Enthusiasts', in their social as well as religious views.[75] From their earliest appearance, their support base was from the lower orders and they were associated with social reform. Ulhart is thought responsible for printing a brief anonymous pamphlet addressed to the Council, urging them to hear the Word of God and immediately institute a reformation.[76] Breu's activity as illustrator for Ulhart may therefore reflect his personal engagement with the printer's views. Certainly his own support for the poor, his hostile attitude to the Council, his simple Christology and communal outlook are all directly compatible with the views of the Zwinglian preachers.

Ḥerꝛ Ulrich Zwingli leerbiechlein
wie man die Knaben Chꝛiſtlich vnterweyſen
vnd erziehen ſoll / mit kurtzer anzayge
aynes gantzen Chꝛiſtlichen lebens.
M. D. xxiiij

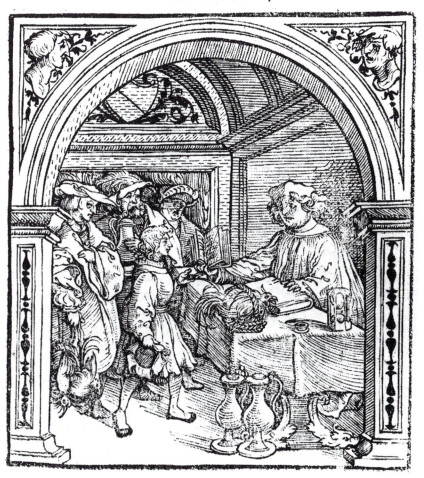

3.1 Frontispiece to Ulrich Zwingli, *Leerbiechlein über die christliche Erziehung von Knaben* (Augsburg, Philipp Ulhart, 1524), woodcut

The frontispiece to Zwingli's pamphlet is remarkable in that, compared with the vast majority of religious pamphlets, it has been designed with obvious care and some expense. Schottenloher suggested that this indicated a private outside commission for this otherwise thrifty printer.[77] It appears to be a deliberate attempt to lend the Swiss reformer dignity and stature and thereby a certain credibility among the citizens of Augsburg. It shows a preacher, presumably Zwingli himself, behind an ornate table, presenting a book to a young man, probably the dedicatee Gerold Mayer, whose guardians offer poultry and drink in exchange. It expresses a relationship between

pastor and flock in which the authority and learning of the former are respectfully acknowledged by the latter. By their gifts, moreover, the patrician laity are shown as the source of the livelihood of their pastor, providing him with modest sustenance. The picture offers a model of Church organization that implicitly criticizes the worldliness and luxury of the Catholic clergy. The scene is further dignified with a classical architectural border. In its content and visual character, the frontispiece addresses the patrician audience at which the text was aimed.

Such pamphlets were strictly speaking illegal. Evangelical literature had been banned by the Edict of Worms, and in Augsburg the Council had summoned the city's printers together in early 1523 and made them swear not to print anything without official permission, commanding that in future all books were to bear the name of the author and printer.[78] Even though the authorities were slow to prosecute, there was a certain risk in producing these pamphlets. The number of local writers who adopted pseudonyms indicates the fear of prosecution.[79] The very cheapness and poor quality of so many of the illustrations to Evangelical works suggests that they were executed under some secrecy or constraint.

A number of such works have been assigned to Breu's hand, though the problems of attribution are legion. The title-page to a *Dialogue between a Franciscan Friar and a Spoon-maker* may serve as an example (Fig. 3.2).[80] It is a piece of hack-work: simply conceived, hurriedly made and for little financial return, possibly with some small risk attached, the simple lineaments of the artist's style rendered invisible by the crude administrations of the block-cutter's knife. It is difficult to attribute this with any certainty to any particular hand, even harder to say whether it was made in a spirit of ideological partisanship. What is clear is that, unlike, say, Hans Schäufelein or Leonard Beck, Breu's output in this area remained small; nor did he create satirical imagery in his own right – that is to say which did not illustrate a pre-existing text. His willingness to carry out 'Catholic' commissions demonstrates his commercial indifference to questions of religion and ideology.

The soldier as unrepentant thief

A more complicated response to the Reformation may be found in Breu's painted works of the early 1520s. The *Raising of the Cross* panel, now in Budapest, is signed in monogram and dated 1524 (Plate 9).[81] It was painted in the year of the first and most intense popular agitation for reform in Augsburg. Nothing is known about the painting's provenance or about the conditions under which it was commissioned. Yet there are oddities of iconography that, taken together, strongly suggest a specifically Protestant context and meaning.

The subject, *The Raising of the Cross*, was relatively new in German art of the sixteenth century.[82] The radical viewpoint, which turns the crosses around 90 degrees, shows cognizance of a crucifixion type developed by Cranach in

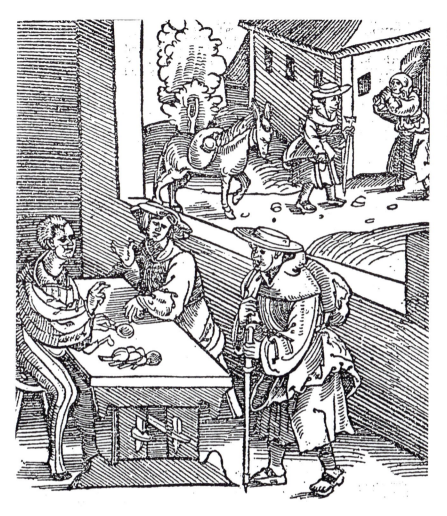

3.2 After Jörg Breu?, frontispiece to *Ain freundlich gesprech, zwyschen ainem Barfuesser Münch … vnd ain Loeffel mache* (Augsburg, 1522), woodcut

his 1503 *Crucifixion* in Munich and by other Danube School painters.[83] The formal idea was probably prompted by the unavoidable diagonal arrangement of Christ's cross which the subject dictated, together with the need to include the two thieves satisfactorily. Yet one should be alert to the possibility that such a format, in which, as Gode Krämer pointed out, the bad thief is brought virtually face-to-face with both his opposite and with Christ, supports a specific meaning.[84]

Unusual, too, in Crucifixion imagery is the agitated pose of the repentant thief, who here twists his body towards Christ in an urgent attitude of penitence, seeking an assurance which Christ bestows in the gesture of benediction with his nailed right hand. This agitation of pose contrasts with the motionless anonymity of the unrepentant thief, whose truncated and foreshortened form faces the other two. The usual Passion iconography has in fact been reversed, for it was normal for the bad thief to be shown writhing in his death agony, while a devil wrenched his soul from his body. The beatitude of the good thief was normally expressed by physical quiet, as

angels carried off his soul to heaven. A third unusual element is that the unrepentant thief on the left side of Christ is portrayed as a contemporary mercenary soldier or *Landsknecht*. How may such oddities be explained?

The artist has gone to some lengths to distinguish the *Landsknecht* from the other soldiers erecting the cross: his anonymous, impersonal presence contrasts markedly with the motley figures below, whose grotesque features and coarse attitudes are drawn in a spirit of caricature. While the thief's costume is clearly and unambiguously contemporary, these latter figures are clad in a type of generic armour traditional to such scenes – a kind of exotic fancy dress made up of archaic and fanciful accessories grafted onto the contemporary. Their deliberately blurred historicism was a common device intended to reduce the historical distance between the biblical event and the actual present of the viewer and thereby maintain the relevance of Christ's Passion to the viewer's own immediate experience. The deliberate contrast of an unambiguously contemporary soldier in the place of the unrepentant thief, however, injects into the historical and devotional idea of the Passion an insistent and jarring element of the present. It points to a meaning specific to Augsburg in 1524.

As is well known, the image of the *Landsknecht* emerged as an independent subject of enormous popularity in the first 30 years of the sixteenth century. Of importance for the form and meanings the *Landsknecht* assumed were the propagandist projects of the Emperor Maximilian I. For it was he who adopted the *Landsknecht* as his own, recognized the mercenary foot soldier as the main instrument of his rule and turned him into a symbol of Imperial Power.[85] In the illuminated version of the *Triumphal Procession*, of c.1513–16, which formed Maximilian's pictorial review of his own military career, the *Landsknecht* is the most important proponent and is portrayed in popular and heroic light (Fig. 3.3). Here, German *Landsknechte* take over the idea of a central portion of Mantegna's *Triumphs of Caesar*, where Roman legionaries hold standards commemorating incidents from the various campaigns.[86] This kind of heroic imagery was widely disseminated through woodcuts illustrating pro-imperial songs, calls for crusades against the Turks and other works of reportage surrounding the various Imperial causes (Fig. 3.4). By such means, the harlequin extravagance of the *Landsknecht's* slashed and plumed costume, sanctioned by Maximilian's exemption of his troops from the sumptuary laws in 1503, came to be associated with the chivalric aspirations of Maximilian's imperium. Collectively, the bristling forests of pikes, the clash and thrust of massed armies in panoramic landscapes, became the most widespread and conventional image of Imperial military might. These two types of imagery fulfilled the demands of both an exclusive, aristocratic art-form and cheap, broadly based reportage and propaganda. In both, the *Landsknecht* possessed the same symbolic role.[87]

Closely allied to this was the fact that the *Landsknecht* was intrinsically German. Nationalistically-motivated humanists like Ulrich von Hutten invested him with the specifically Teutonic virtues they had found in the recently rediscovered *Germania* of Tacitus. The *Landsknecht* became the exemplum of a race of men, free, natural, primitive, courageous – virtues

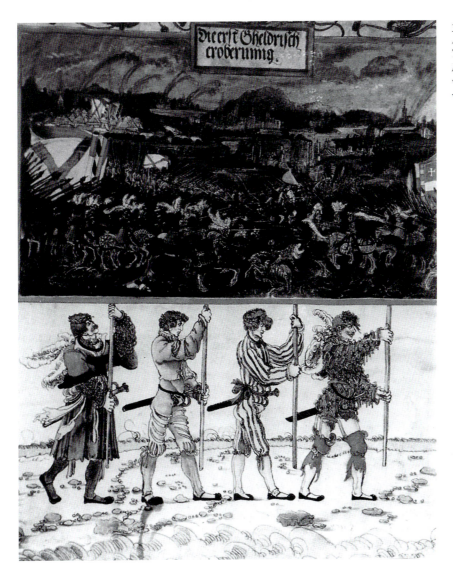

3.3 Albrecht Altdorfer, *The Triumph of Maximilian I*, detail, watercolour on vellum

that provided a positive cultural/historical tradition for the Germans with which to offset their reputation as barbarians in the urbane, Italian South.[88] In this way a cluster of cultural and moral values – bravery, virility, heroism – developed around the *Landsknecht*'s central military and political meaning as imperial symbol. While the raffish outlandishness of costume contained parodic echoes of an older, knightly and essentially Germanic tradition, his swagger and strut, the mustachioed pride of bearing, the assertive codpiece with its implied sexual as well as martial prowess, the peculiarly male glamour – all became the locus of a genuinely popular identity.

Side by side with this heroic and idealized image, propagated by the Emperor and his causes, artists were exploring the *Landknecht*'s baser social reality. For in this meridian period of Imperial expansion, it was the brutality

3.4 Sebald Beham, frontispiece to Hans von Würzburg, *Ain schönes Lied von der Schlacht vor Pavia geschehen* (no place or date), woodcut

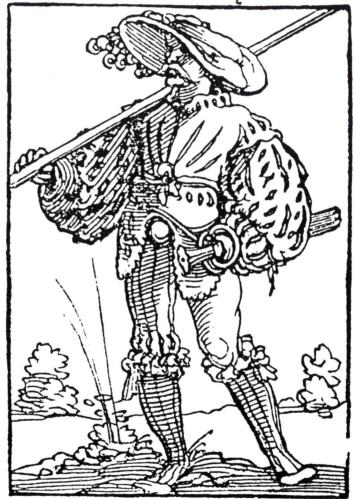

Ein schönes lied von der schlacht vor Pavia geschehē, Ge dicht vñ erstlich gesungen (durch Hansen vō Wurtzburg) In einem newen thonn.

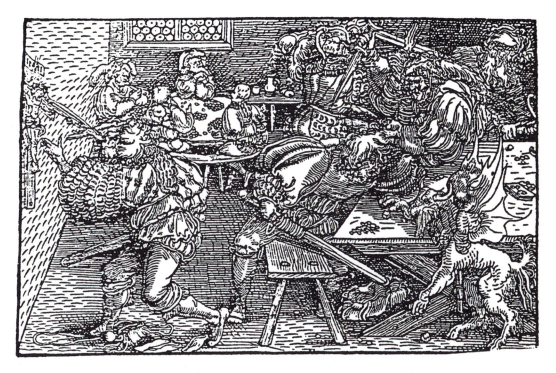

of the *Landsknecht's* calling, the bestial manner of his existence, his excessive drinking, his braggart lechery that artists increasingly portrayed. The Petrarch Master's illustration of a tavern brawl may serve as a characteristic and revealing example (Fig. 3.5). Drunken soldiers fight amongst themselves; one of them vomits over a crucifix hanging on the wall. They are shown as creatures of violence, vice and blasphemy, led on by the figure of the Devil. This woodcut illustrated part of a German translation of Petrarch's *De remediis utriusque fortunae*. Significantly though, no mention of soldiers appears in the text in this context.[89] The artist is using a generally familiar image of depravity to convey the author's point. For by this time the *Landsknecht* had become a common figure of speech to denote debauchery and drunkenness. 'He went about like a *Landsknecht*': thus the Augsburg chronicler Clemens Sender, in 1524, describing Johannes Schilling, the radical Franciscan who, Sender continues, 'led an unchaste life, spent his days in bad company with his belly full of wine'.[90]

By the 1520s, therefore, the *Landsknecht* had come to signify a multiplicity of referents – political, social and moral – that operated between the two chief poles of heroic bearer of Imperial identity and exemplum of godless depravity. It is in the light of these two widely-perceived meanings that Breu's use of the *Landsknecht* might be usefully considered.

The soldier used in this latter sense, as minion and victim of the devil, appears to underlie a similar soldier-thief in an altarpiece by Georg Lemberger, painted two years earlier than Breu's, in 1522 (Fig. 3.6).[91] This Crucifixion scene was designed as the epitaph for the Leipzig doctor Valentin Schmidburg

3.5 The Petrarch Master, *Tavern Brawl*, from F. Petrarcha, *De remediis utriusque fortunae* (Augsburg, 1532), woodcut

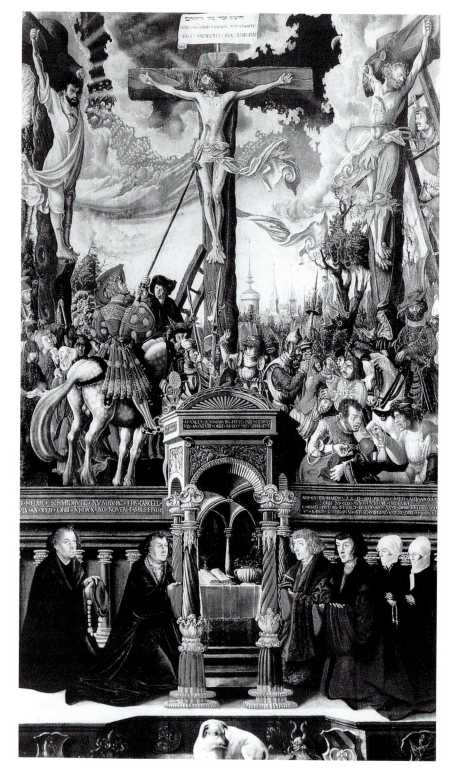

3.6 Georg Lemberger, *Epitaph of the Schmidburg Family*, 1522, oil on panel

by his Lutheran son-in-law, the lawyer Simon Pistoris. The painting shares certain striking iconographical features with the Breu. In each the *Landsknecht* faces a 'good thief' dressed in the traditional Christian's winding cloth. In each, Christ extends to the good thief a two-fingered benediction with his nailed right hand, a gesture that makes clear that the opposition between the two thieves is part of the central meaning of the painting.

Lemberger's painting has been given a Lutheran interpretation (both patron and artist held Lutheran beliefs).[92] Directly below the cross, on the altar table in the illusionistic chapel at which the patron and his family kneel, is an open book, the Bible, the symbol of the family's reliance upon the Evangelical Word. Above, the dignified figure of Longinus is helped in his moment of conversion by a figure dressed in the black garb of a contemporary cleric, who seems to push away the spear that has wounded Christ. The traditional helper of the blind Longinus has become a contemporary minister, who opens the eyes of the previously unseeing to the true way to God. Taken together, these elements create a cogent Protestant message. Christ's gesture to the good thief shows that the way to Salvation lies in following Christ's example, the open Bible, that the means to do this is via the Pure Word of the Gospel; conversion to this belief is prompted by the (Lutheran?) minister. The *Landsknecht's* position in this polemic is unequivocally that of the damned soul. His tattered flamboyance and violence of expression powerfully express his evil condition. He is set below lowering storm clouds and opposite the redemptive radiance of Divine light that emanates from behind the good thief. The heavens themselves are rent asunder to proclaim the righteousness of the Evangelical cause. In representing the damned soul as a soldier, Lemberger has appropriated for solemn theological purpose the image of the *Landsknecht*, as propagated by the popular culture of print, as a potent contemporary symbol of fallen, unregenerate humanity.

Breu's altarpiece of two years later may be read in a similarly Protestant manner, though with significant differences. Unlike Lemberger, Breu's portrayal of the soldier-thief is unemphatic, neutral. It points to a somewhat different meaning. The traditional antithetical qualities of the two thieves as saved and reprobate – indeed the left- and right-hand sides of Christ – had been extended in certain fifteenth-century German paintings to connote other meanings. Typical, as in an anonymous Westphalian panel in the Thyssen Collection (Fig. 3.7), was the allusion to the general principles of Faith and Ignorance, as symbolised by *Ecclesia* and *Synagoga*.[93] One sees here a code of communication in operation, conventional in religious imagery, through the use of what Robert Scribner called 'root paradigms'; that is to say, common images, of standardized format, such as the *Crucifixion*, that act as a channel through which other meanings could be communicated.[94] Breu has deliberately used the familiar Crucifixion type, with its structure of simple opposites, to convey a specifically Protestant meaning.

Because of the radical angle at which the scene is presented, the whole of the foreground becomes, in effect, the left side of Christ and therefore an appropriate site for positioning the enemies of Christ. And indeed, the group

3.7 Anonymous
fifteenth-century
Westphalian Master,
*Allegorical
Crucifixion Scene*,
tempera(?) and
gold-leaf on panel

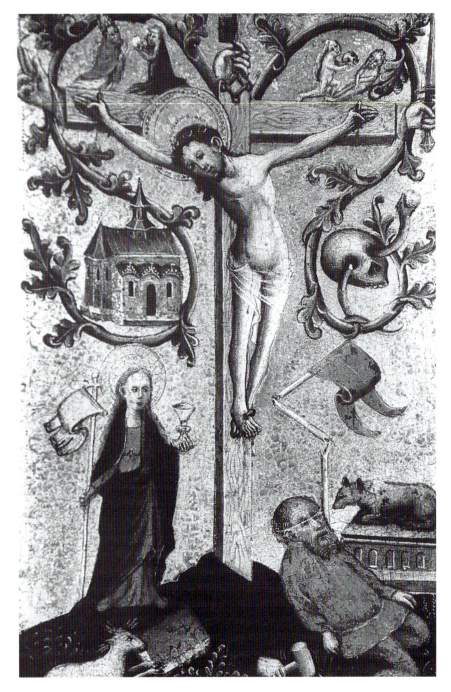

of figures below the bad thief fit into the tradition of portraying the Pharisees who mocked Christ.[95] Yet in this group too, is to be found a further unusual iconographical element. Previous commentators saw in the turbaned figure, the Centurion who was converted, and in the two foreground figures wearing clerical caps and gowns, contemporary portraits of clergymen-donors. They were seen as standing bearing witness to their faith in a manner comparable to similar figures in Ulrich Apt the Younger's *Rehlinger Altarpiece* of 1517 and later Protestant *Merckbilder* by Lucas Cranach the Younger.[96] It was even suggested that the left-hand 'cleric' was an early portrait of Luther.[97] Such an interpretation seemed altogether plausible because the costumes, particularly of the foremost figure, are clerical in character. This latter wears the cap, surplice and gown of an officiating canon. The costume may be compared, for example, with the background cleric in the woodcut of Haug Marschalck's *Blindenführer* pamphlet (Fig. 3.8), or the priest in profile in Breu's woodcut broadsheet, *Why German Minters Must Strike New Coins Daily* (Fig. 3.9).

Close inspection of the left-hand figure, however, reveals Hebrew script around the hem, which identifies him quite unequivocally as a Jewish high priest.[98] The turbaned figure moreover lacks any martial attribute that might identify him with the Centurion. Rather, both he and the Moor constitute pagan types that appear with regularity in earlier Crucifixion scenes. One can therefore rule out the possibility that they are portraits. Since Krämer's article, Susanne Urbach expressed doubts about the portrait theory, though without wholly rejecting it, preferring to see in this monumental figure-group simply the group of Pharisees and Elders who, in Luke's account, stood beneath the cross and mocked Christ.[99] She pointed out the prominence Breu accorded similar figures in other works like the Innsbruck *Mocking of Christ* (see Fig. 3.16). She followed Krämer's suggestion that they might have called to mind the passionate denunciation of the clergy as the 'devilish priests' ('*Geistlichen und Teuflischen*') of Breu's *Chronicle*.[100]

Urbach was surely right to regard these figures as the Pharisees and Elders. Yet their costumes are iconographically unusual. Traditionally the Pharisees were made to look more exotically 'eastern'. Anyone conversant with the satirical pamphlet imagery of the time would have seen in the costume of the foreground figure an unmistakable reference to contemporary Catholic clergy. His corpulence, the amplitude of his heavy gown, the surplice and canon's cap find many comparisons in contemporary satirical prints. The association between the enemies of Christ and contemporary churchmen in Protestant Passion imagery is not uncommon. One might cite a *Crucifixion*, by the Cranach workshop, in the Museo Lazaro Galdiano in Madrid, where a cardinal with crimson hat and robes is placed unequivocally beneath the bad thief amongst other reprobate types.[101] Lemberger's *Schmidburg Epitaph* contains a similar figure, similarly placed.

This visual equation between the Pharisees and contemporary churchmen was probably inspired by evangelical writings. Reformers found in St Matthew's famous passage of Christ's denunciation of the Pharisees, a mirror of the abuses they saw in the clergy of their own day.[102] That Breu uses the

3.8 Anon.,
frontispiece to Haug
Marschalck, *Ain
Spiegel der Plinden*
(Augsburg, 1524),
woodcut

ſtus der herr hat geredt. Jch wird mein glory vor den hoch
weiſen verbergē vnd wird es den kleinē verkünden vnd off
baren. Dañ ee mein glory vnd eer ſolt vndergon/es müſt
ent ee ſteyn vnd holtz reden lernen. Off ſolichs iſt uffge
richt anzüſchawē diſer Spiegel der Blinden.

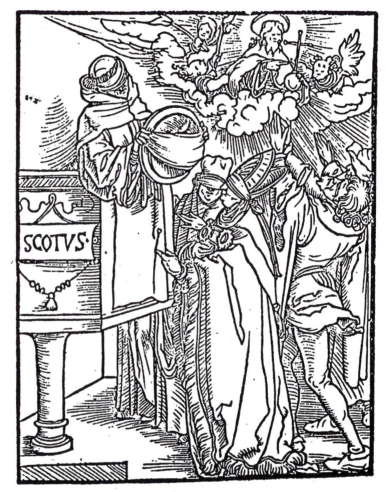

term '*phariseer*' to denounce the elders of his own city shows his awareness
of this equation.[103] The epithet *Blindenführer* ('blind guides') which he also
applies to them, is derived from the same verses in Matthew, referring to the
Pharisees.[104] The Augsburg pamphleteer Haug Marschalck deliberately alluded
to it in the title of his popular pamphlet of 1524, *Ain Spiegel der Plinden*
('Mirror of the Blind'), which denounced the abuses of the clergy. Such
examples show how commonplace the passage was amongst reforming spirits
in Augsburg in the years around 1524. In the same year, the weaver Utz
Rychssner also described the enemies of the evangelical cause as '*phariseer*',

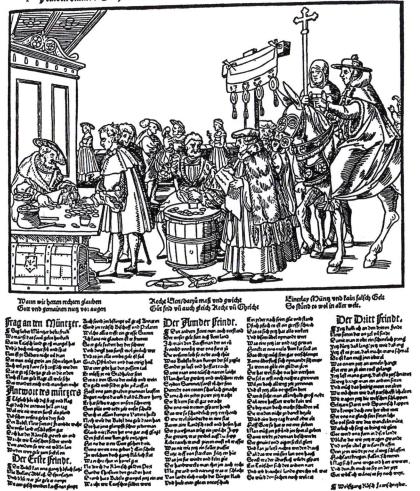

their actions as *'wie das wild mor thet'* ('like the wild sea') and compared them, following St Matthew, with 'the Jews, heathens and other unbelievers' (*'den Juden, hayden und anderen unglaubigen'*).[105] The costumes in Breu's painting could be a visual paraphrase of this description: the Jewish high priest, the Elder, dressed in the turbaned costume associated with the Turk (the most common contemporary symbol of the unbeliever); and the Moor, standing as a further evocation of the pagan. By dressing the Pharisee in the costume of a clergyman, Breu was deliberately identifying the Catholic Church with the traditional enemies of Christ.

Opposite these old and 'false' religions stands the good thief, whose excited attitude together with Christ's answering gesture indicate the *true* way to Salvation for the 'Common Christian Man': through faith in Christ and the

unmediated following of his example. The agitation of the thief's spiritual condition is forcefully expressed not merely in his twisted pose, and in the movement of his drapery, but in the turbulence of the storm clouds around him. In the good thief lies the painting's central meaning, the same Christo-centric message that lay at the heart of Breu's own theology. Like Lemberger's epitaph, it is concerned with Salvation and Faith, only here expressed visually in terms of conversion – by a literal turning to Christ – from the Old Faith to the New. In the good thief one might be permitted to see a kind of spiritual self-portrait of the artist himself.

In the contrast between this figure and the 'enemies of Christ' beneath, there is an unmistakable polemical element. Beyond the good thief, on, as it were, the 'good' side of Christ, where the holy family and mourners stand, are a number of passionately gesticulating figures, dressed in contemporary garb. Their earnest attitudes, with arms outstretched towards Christ, do not suggest the passers-by who mocked Christ, of Luke 23, v. 35 or Matthew 27, vv. 39–40. Rather they seem to recognize the nature of Christ's sacrifice. Perhaps they were intended to represent the 'Common Christian Man', with the Good Thief as their personification.

This system of opposites finds a very close corollary in a later polemical woodcut of *c.*1550, where the bad thief is represented as the Pope, juxtaposed by an unadorned good thief comparable to Breu's (Fig. 3.10).[106] Here too, the good thief is used as a symbol of Conversion. The accompanying text tells us that the good thief represents the Evangelical movement, for it preaches *Christ crucified* and recognizes him as head and lord. By this means, it continues, each man can recognize the true Church *'which is not that of the Jews, the Turks or the Papists'*, but only 'those whom one now calls the new Christians, the Lutherans'. Matthias Gerung's woodcut of roughly the same date, entitled *The Church of the True Christians besieged by the Troops of the Pope and the Church*, shows a similar confrontation between the Evangelical Church and its enemies, similarly characterized.[107] That such ideas were being expressed already in the 1520s is borne out by a woodcut by the anonymous Monogrammist H of 1525, illustrating a pamphlet entitled *Concerning Christ the Cornerstone* (Fig. 3.11). In an elaborate exposition of the main points of Evangelical belief, it too characterized the good and bad thieves as symbols of the Evangelical and traditional churches.[108] Breu himself showed awareness of such allegorical uses of the crucifix in his later illustration of *The Minter's Reply* (see Fig. 3.9). Illustrating a text which blamed papal bulls, indulgences and dispensations in part for Germany's imminent financial ruin, Breu nailed an indulgence to the cross in the place of Christ.[109] These examples reveal an ambience of ideas and provide models of imagery – in which Breu himself participated – through which the painting can best be understood.

Like Lemberger's allegory of Redemption, Breu has created an overtly Protestant statement of Faith. Where, in such a context, does this leave the *Landsknecht*? Again, contemporary pamphlet sources suggest an answer. Peter Flötner's *The Poor Common Ass* woodcut of 1525 depicts an ass, signifying the Common People, ridden by an armoured knight, personifying Tyranny,

together with a Monk and a Jew, representing Hypocrisy and Avarice respectively (Fig. 3.12).[110] Here, the social injustice of the upper orders of society, abetted by other perceived 'enemies', the Jews and the monks, who impose economic burdens upon the common man, stands in direct opposition to the Word of God, represented by the figure on the right with the sword and the book. The Common Man looks to the Word of God as a means to rid himself of economic and social grievances. Might not Breu's soldier have similar connotations of Tyranny as the Flötner?

There are good reasons for thinking so. The year this work was painted, 1524, was marked in Augsburg by the first massive public demonstrations that signalled the beginning of the Reformation there. This year opened to prophecies of apocalypse and last judgement, as the year foreseen by astrologers and prognosticators since the late fifteenth century, in which a fearsome conjunction between Saturn and Jupiter would result in a great flood.[111] Many pamphlet writers and illustrators saw this flood as a metaphor for a rising up of the lower orders against their masters. Typical of the

3.10 Monogrammist IW, *The Good and the Bad Thieves*, hand-coloured woodcut with text

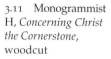
3.11 Monogrammist
H, *Concerning Christ
the Cornerstone*,
woodcut

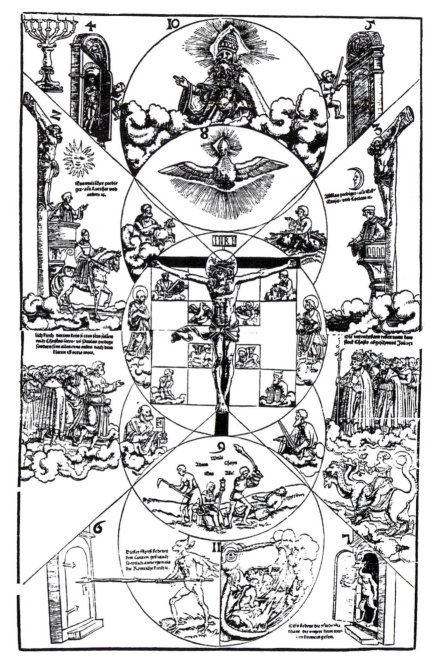

accompanying imagery is the title page to a *Practica* written by L. Reynmann,
published in Nuremberg in 1523 (Fig. 3.13).[112] It shows Jupiter as the Emperor
with a retinue of high churchmen – representatives of the upper echelons of
society – confronted by Saturn, an old man with a scythe, leading an army of
peasants. Such booklets and their illustrations reflected the tradition of
medieval heresy of the Waldensians and Taborites, in the idea that the poor

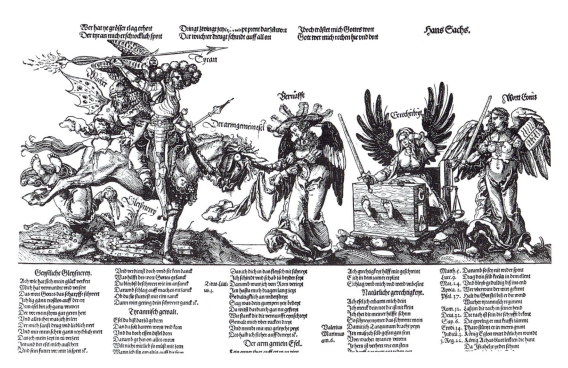

3.12 Peter Flötner, *The Poor Common Ass* (Nuremberg, Hans Guldenmund, 1525), woodcut and text

and propertyless should inherit the kingdom of Heaven. They made publicly explicit the equation between religious and social dissent. In Augsburg, in 1524, the sensitivity of the ruling classes to such ideas was made clear when the City Council arrested apprentices who used such a prognostication as the basis of their Shrovetide play.[113] This imagery may well have fed Breu's adoption of the *Landsknecht* as symbol of the tyrannous upper orders.

Such meanings are expressed in Breu's use of the symbolic association between the *Landsknecht* and Imperial power, outlined above. The soldier lacks individuality: his face is hidden, there are no marks of personality. He is characterized solely by his uniform – the badge, as it were, the very emblem of his allegiance. Through this means he becomes the symbol of the forces of Catholicism, led by the Pope and Emperor. In his *Chronicle*, Breu significantly characterized the two sides of the ideological and religious divide quite specifically as *evangelisch* and *kaiserisch*, 'evangelical' and 'imperial'. He did this not only in a political context of the factions in the Council,[114] he used the same distinction more casually, as a figure of speech, when he described the father of a patrician bride as *kaiserisch* in his affiliations, the mother as *evangelisch*.[115] Throughout the *Chronicle*, Breu regarded the Emperor inimically, as the chief upholder of the traditional Church, the secular arm of the Papacy. In 1529, Breu exhorted the Evangelical side to build high walls and bastions in the face of 'the cruel lies of the Emperor, princes [and] … priests'.[116] During the iconoclastic outbursts of the same year, he bitterly criticized the City Councillors loyal to the Emperor as *antichristen*, as the servants of Antichrist.[117] In 1532, Breu described the Imperial decree that the people of Augsburg return to the traditional faith

3.13 Erhard Schön, frontispiece to L. Reynmann, *Practica auf das Sündflut-Jahr 1524* (Nuremberg, 1523), woodcut

in terms of a return to *[das] entecristen leben*, the way of life of the Antichrist.[118] Here are hints that Breu, like Ryschnner and many of the pamphlet writers, saw the politics being played out around him in eschatological terms, that the Emperor was, in a very real sense, the instrument of the Antichrist, who must be opposed by the true followers of the Gospel. Viewing the painting in this context, the opposition between the *Landsknecht*/thief, the instrument of imperial, Catholic power, and the Common Man represented by the good thief, assumes something of the character of an eschatological confrontation.

Paſſional Chriſti und
Sanfftmütig der Herr kam geritten —

Antichriſti.
Der Papſt in Hoffart und ſtolzen Sytten.

Sich an, dein König kompt dir demüthig, uf einem jungen Eſel, Matthäi 21. (V. 5.). Alſo iſt Chriſtus kommen reitend uf in frembden Eſel, arm und ſanftmüthig, und reit, nicht zu regieren, ſondern uns allen zu einem ſeligen Tode. Johannis 12. (V. 41.)

Die Geiſtlichen ſeind alle Könige, und das bezeugt[1] die Platten uſim Kopfe, duo. 12. q. 1. Der Papſt mag gleich wie der Kaiſer reiten, und der Kaiſer iſt ſein Trabant, uf daß biſchofflicher Würden Gehalt nicht gemindert werde. c. Constantinus 10. c. 6. Dis.
Der Papſt iſt allen Volkern und Reichen vorgeſetzt. Exvag. sup. gentes, Johannis 22.

1 bezeugen.

In this attitude Breu was echoing sentiments that were all too widespread, ones that have already been touched on above. They were made explicit in Luther's very popular *Passional Christi und Antichristi* of 1521, illustrated by Cranach.[119] In a series of opposed images, the simplicity of Christ's way of life and teaching was contrasted with the pride, worldliness and corruption of the Pope. In Fig. 3.14, Christ's humble entry into Jerusalem mounted on a donkey is contrasted with the Pope's grandiose departure from Rome at the head of his retinue of cardinals and bishops. The equation between the Emperor and the *Landsknecht* is made explicit. Cranach has included two Imperial foot-soldiers to indicate the war-like nature of the Pope, but also to illustrate the text: *Der Papst mag gleich wie der Kaiser reiten, und der Kaiser ist sein Trabant ...* ('The Pope can ride like the Emperor and the Emperor is his bodyguard'). By pinning the *Landsknecht* to the cross of the damned thief, Breu has inverted the popular heroic ideal of the Emperor's foot-soldier and thereby consigned the forces of Catholicism to hell.

Such a reading raises certain implications. In the first place, the painting shows Breu resorting in a large-scale painted work to both the imagery and strategies of communication that were being developed in the popular

3.14 Lucas Cranach, *Christ's Entry into Jerusalem/ the Pope's Departure from Rome*, from Martin Luther, *Passional Christi and Antichristi* (Wittenberg, Johann Grünenberg, 1521), woodcuts

medium of woodcut and which thus far had found no general outlet in the official categories of religious art. Breu's painting, executed in the most volatile year of the Reformation in Augsburg, was an attempt to create a valid Protestant statement of belief. The theology it expresses is Christocentric: its central point is the efficacy for human Salvation of simple reliance upon the example of Christ. It is not specifically 'Lutheran' or 'Zwinglian'. As Breu's own *Chronicle* bears out, the Protestant movement in 1524 was amorphous, it had yet to crystallize out into fixed and certain dogmas. Emergent Protestantism of sermon or text still defined itself in negative terms, by reaction to Catholic orthodoxy. In finding a way to express a specifically Protestant meaning in 1524, Breu resorted to similar means – expressing it in terms of contemporary religious and political opposites. Unlike the pamphlet imagery which he parallels, his intention was not primarily propagandist; rather, he adapted the strategies of the propagandists to convey what he saw as a theological truth.

As Robert Scribner and Konrad Hoffmann among others have shown, this antithetical structuring was one of the main strategies of the pamphlet illustrators, by which means the doctrinal differences came to be expressed in terms of polar moral opposites.[120] Literary historians such as Bernd Balzer and Joseph Schmidt discovered, in the writings of popular reformers like Hans Sachs, a similar use of antithetical forms, of argument phrased in the simple colours of opposition.[121] Such structures were deliberately adopted, they argued, to suit a half-educated audience. The same antithetical means was employed too by educated laymen like Jörg Vögeli, the secretary to the City Council of Constance, whose writings reveal a personally meditated theology that drew on both Luther and Zwingli, though adhering strictly to neither. Bernd Hamm's study uncovered in Vögeli's writings a theology, structured in terms of juxtaposed alternatives.[122] What is striking in reading Breu's 1524 *Chronicle* entries, is not only the strength of his language, but that he too has learnt to express his Protestantism in terms of ideological antitheses: the human laws versus the law of God; the spiritual devils and learned doctors versus the poor masses; the leaders of the blind against Jesus himself.[123] Breu's patterns of thought, the mental framework by which he articulated his beliefs, followed the structures of popular polemic. These have assumed visual form in the imagery of the *Raising of the Cross*. As perception is determined by the nature of the thinking that is brought to the act of seeing, such structures offer an insight into the way contemporaries actually looked at and 'read' works of art.

The soldier's contemporaneity, like that of the similar figures in Lemberger's painting, constitutes an important precursor, in the earliest years of the Reformation, to the merging of contemporary with biblical figures that became common in the imagery of the Protestant *Merckbild* which developed in the Cranach workshop in the 1530s. The dual evidence of Breu's painting and his *Chronicle* offers a clue into the usage of such habits of anachronism, or what may be termed symbolic contemporaneity, and help to explain conventions of feeling and meaning such figures embodied.

They offer clues into the ways contemporaries might have regarded religious paintings. Between painting and chronicle runs a two-way blurring of historical moment, a blending of past and present. Just as the *Landsknecht* and the priest inject the urgency of present concerns into the historical, biblical scene, so the *Chronicle* characterizes contemporary political and spiritual figures in biblical and religious terms. In this reciprocal process one sees the degree to which a temperament like Breu's could be moved to interpret the world in terms of the Bible, to use as metaphors for the present the great spiritual truths which the characters and events of the Bible stories, and especially the Passion, embodied. It emphasizes powerfully the urgent relevance of the Bible to the people of the sixteenth century, the degree to which it constituted a source of symbolic meaning through which they interpreted their lives. Through the *Landsknecht* and the priest one may unearth traces of a manner of response that, in a more secular, sceptical age, is difficult to imagine and harder to reconstruct.

Given the tense religious atmosphere of 1524 in Augsburg, one must also assume a measure of iconographic suggestiveness, rather than unequivocal statement in Breu's soldier imagery. Used as the clear enemy of Christ, the *Landsknecht* could be regarded as a single individual, in the manner of Lemberger's, rather than in a more general, pointedly ideological manner. Such suggestiveness, bolstering the clear Evangelical message provided by the Good Thief's conversion to Christ, points to a patron of Protestant convictions. Though the function and setting are unknown, the example of Lemberger's *Crucifixion* suggests the possibility of an epitaph. This *privately* commissioned type formed an important medium through which Protestant allegory found its way from print culture to the dignity of church decoration. Commissioned by individuals rather than 'official' institutional patronage, the epitaph was a means by which private sentiments might find expression within the public space of the Church. It is possible that Breu's painting fulfilled a similar purpose.

Garlic, the Jews and the 'sleep of ignorance': *The Mocking of Christ*

A further group of Breu's works, made between *c.*1520 and 1526, have been interpreted as responding to the religious crisis. Gode Krämer drew attention to two paintings of *The Mocking of Christ*, one in Augsburg, the other in Innsbruck, that may be dated *c.*1522 and *c.*1524 respectively (Figs 3.15 and 3.16).[124] Krämer noticed certain departures from the traditional Passion iconography – in which Breu was well versed. The Augsburg painting depends upon the Dürer woodcut from the *Small Passion* (B.30) (Fig. 3.17). Into this scene Breu has incorporated the figure of God the Father, appearing in clouds through a window above the scene. Rays of golden light, emanating from God's mouth, descend below, creating a nimbus around Christ's head. In addition, the blindfold that covers Christ's face in Dürer's version has been removed and Christ stares out at the viewer. Krämer suggested that

3.15 *The Mocking of Christ*, oil on panel

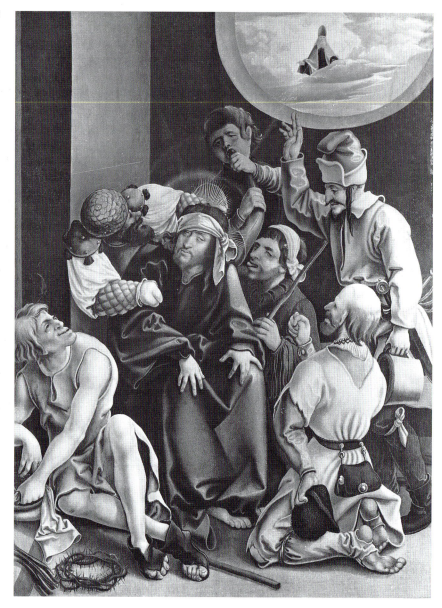

this panel represented one of the central tenets of Protestant teaching, namely, the emphasis on Christ as mediator between God and Man. According to this reading, Christ's significance here is as the embodiment of *Verbum Dei*, the vessel through which the Word was transmitted to mankind, indicated by the beam of golden rays descending onto him. For Krämer, the scene's central meaning was as the embodiment of God's decree that mankind shall be saved through the suffering of his Son.[125]

Both the Augsburg and Innsbruck paintings are striking in the marked diminution in traditional narrative and affective intention. Christ's calm,

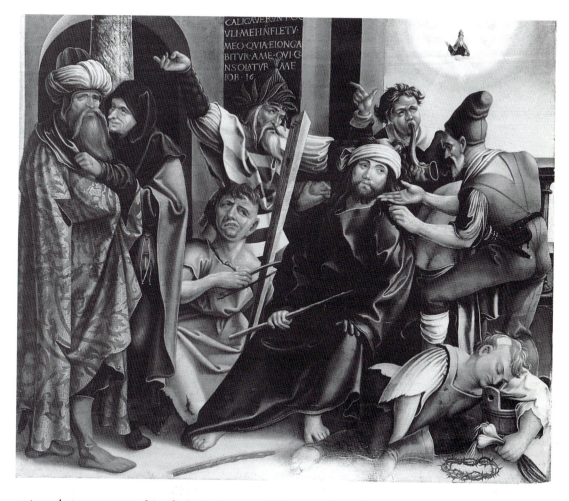

outward stare removes him from the horror of his immediate circumstances and prompts a more general, less immediately emotive, reading. Comparison with Breu's earlier treatments of the theme, in the Aggsbach or Melk altarpieces or even the 1515 woodcut for the von Maen *Passional*, makes this shift in interpretation clear (see Fig. 1.19). As Krämer suggested, such treatment might be seen to have concurred with Luther's prescription for a new kind of Passion imagery that would turn attention away from the emphasis on violence and physical suffering of popular tradition, to concentrate on the redemptive significance of the Passion for mankind. For the reformer, contemplation of an image of the Passion should not so much involve the viewer emotionally with Christ's suffering, as call to mind a doctrine, in this case the Passion's salvatory significance. Meaning was to be apprehended in the heart and in faith, rather than through the senses.[126] Krämer saw the Augsburg and Innsbruck paintings as primarily propagandist in intention, as visual lessons in Protestant doctrine.[127] Such a reading seems persuasive, for it enables one to locate the shift in Breu's art from an affective to a cooler, desensualized style within the broader context of developing

3.16 *The Mocking of Christ*, oil on panel

3.17 Albrecht
Dürer, *The Mocking
of Christ*, from *The
Small Passion*,
woodcut (B.30)

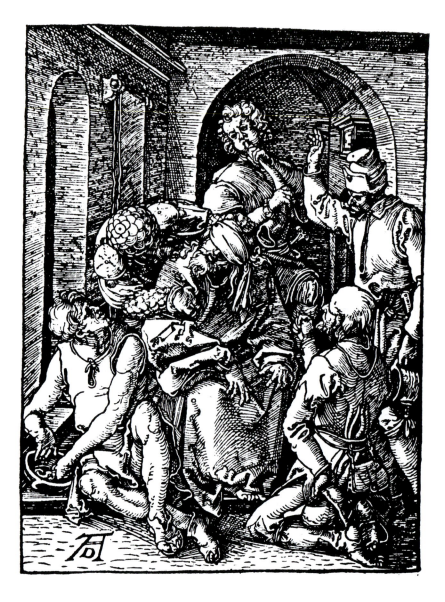

Protestant imagery, which historical writing subsequent to Krämer's article
has shown to have been characterized by a recourse to more symbolic or
emblematic forms.[128]

Nonetheless, there are problems with reading the painting in too didactic
a light. The relatively small size of the paintings suggests a private function.
The panels may better be regarded as extensions of the traditional type
intended for private devotion. The image of the 'Seeing Christ' – of Christ
staring out at the spectator – has precedents in earlier, pre-Reformation
images. It occurs for example in a somewhat earlier panel by Cranach in
Weimar[129] and famously, in Dürer's woodcut frontispiece to the *Large Passion*
of 1510 (B.4) (Fig. 3.18). Here the same idea of the 'Perpetual Passion' that

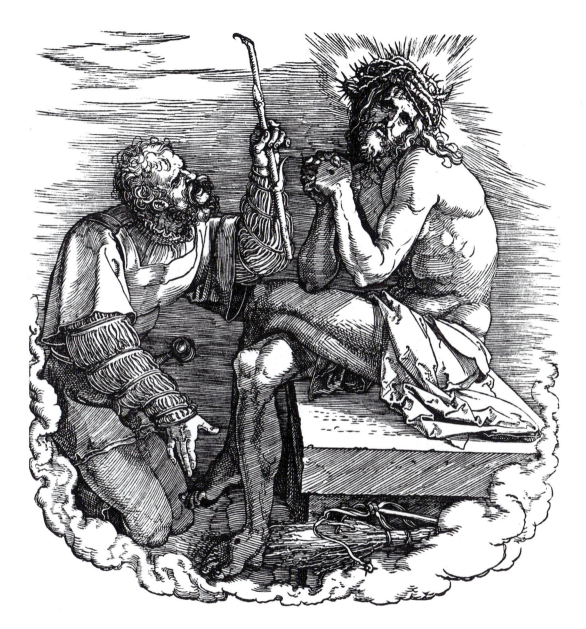

Luther was to use, in which Christ continues to suffer the injuries mankind still inflicts upon him, is shown by the fact that it is the *resurrected* Christ that is represented, bearing the marks of the Passion and mocked by a contemporary soldier. The outward stare, directly addressing the spectator matches the text below, which includes the words 'you pierce my stigmata with your guilty acts'.[130] Though less obviously emotive in treatment, Christ's outward stare in Breu's image has grown out of the same devotional tradition.

A further objection might be that the figure of God hovering in the sky appears in Breu's earlier works, where his presence is equally unwarranted.[131]

3.18 Albrecht Dürer, *Man of Sorrows* (B.4), frontispiece to the *Large Passion*, woodcut

Though the Augsburg painting is distinguished from these earlier examples by the light that emanates down from God the Father to Christ, the earlier usages, in Catholic contexts, should counsel caution in reading the motif as specifically Protestant in meaning. The motif of golden rays issuing from God the Father's mouth is also to be found in earlier art.[132]

Light upon the overall meaning of the panels and their religious orientation may be gleaned by examination of a detail, common to both, that so far has eluded satisfactory explanation. This is the odd inclusion in each of bulbs of garlic: at the bottom left in the Augsburg picture, set beside a crown of thorns – clearly visible, despite a later trimming of the panel; and their recurrence in the Innsbruck version, held by the sleeping figure on the lower right. Garlic occurs in other works by Breu, some much earlier. This peculiar device occurs first in Breu's oeuvre in the drawing, now in Munich, that is related to the Melk version of the *Crowning of Thorns* (Fig. 3.19).[133] In the foreground, close to a kneeling and grimacing tormentor, lies a pair of garlic bulbs, overlapping so as to form a cross; to its right lies a discarded money-belt. The garlic reappears, stuffed into the belt of one of the soldiers erecting the cross in the Budapest *Raising of the Cross* of 1524 (Plate 9). These have not gone unnoticed in the literature on Breu. Following the suggestions of Jochen Pause and Susanne Urbach,[134] Gode Krämer interpreted them as symbolic of one aspect of the physical tormenting of Christ that involved all the senses – in this case the sense of smell.[135] This interpretation seems plausible, particularly in the context of the drawing, where the adjacent tormentor is emphatically grimacing with his mouth wide open. Such an explanation is strengthened by the woodcut version of the scene, executed in 1515 for the von Maen *Book of Devotions*, where a shoe, possibly endowed with similar connotations makes an odd appearance on the bottom right-hand side (see Fig. 1.19).[136] The *Aggsbach Altarpiece* version of the scene incorporated the same notion of olfactory torture with a particularly crude, scatological gesture (see Fig. 1.2).[137] Such an interpretation however, ignores the essential character of the drawing. The garlic is crossed and stands as close to the money-belt as to the grimacing torturer. To whom does the money-belt belong? To Christ? Or one of the torturers? When seen together, garlic and belt acquire a distinctly emblematic character within the drawing, placed prominently in the foreground, while not belonging in any obvious way to the narrative. The same elements occur in similarly emblematic fashion in the quite different context of a *Thesaurus Picturarum* of Markus zumm Lamm (1544–1606), now in the city archives in Worms (Fig. 3.20).[138] An illustration of male Jewish costume of sixteenth-century Worms shows the *Shulkapp* as well as the yellow ring badge which all Jews were made to wear. In his hands he carries, as further identifying symbols, a bunch of garlic bulbs and a money bag. The specific meaning of these attributes is not clear. R. Po-chia Hsia explained them, without further clarification, as representing 'Jewish moneylending and dietary habits'.[139] Fritz Reuter said that the garlic, in Hebrew '*schum*', indicated place of origin in one of the so-called 'Schum-Städte' of Speyer, Mainz and Worms.[140] At the very least, the costume book indicates that

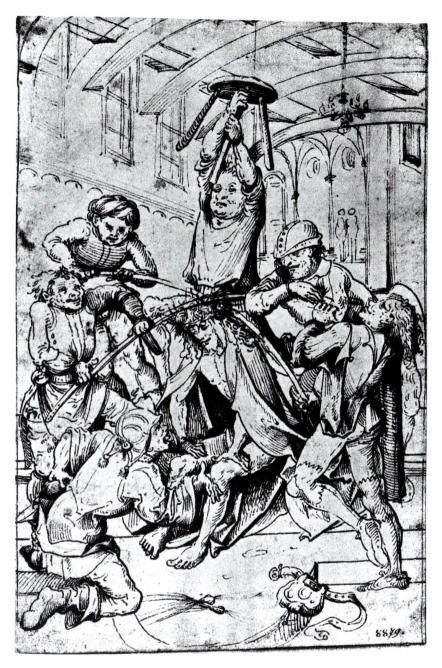

3.19 *The Mocking of Christ*, pen and black ink on paper

Breu's drawing probably contains a symbolism connected with Jewish identity.

The association of garlic with the Jews is an ancient one. It is embedded in popular names for the plant, found all over Germany and the Low Countries: *Judenkost*, *Joddelok* (*Judenlauch*), *jodenjuin* and variants.[141] The association is probably based on biblical references, and in particular, on Numbers 11, v.5.

3.20 *Male Jewish Costume*, ink and wash drawing, *Thesaurus Picturarum des Markus zumm Lamm*

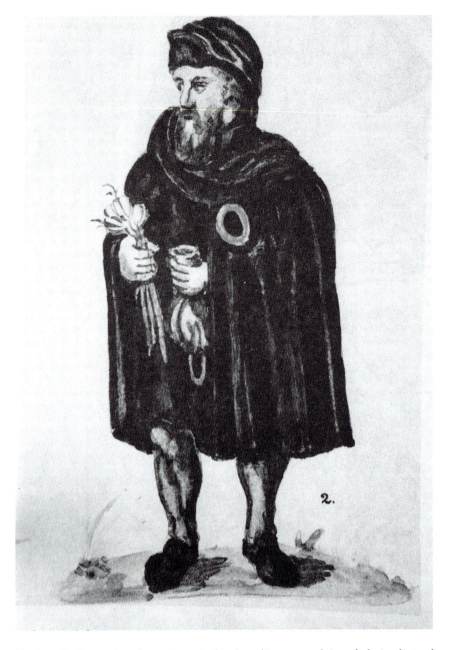

During their exodus from Egypt, the Israelites complain of their diet of manna and remember the fish, cucumbers, melons, leeks, onions and garlic they had enjoyed in Egypt. Medieval commentators on this passage, drawing upon medicinal notions that garlic and onions were generally aggravating to the stomach and the cause of skin disease, used what they regarded as a perverse love of a food that caused physical discomfort, as a parallel for the Jews' spiritual condition.[142] One finds this in Gregory the Great's influential commentary on the passage in Numbers 11, v.5:

The mad (wild, insane) disposition of the unjust takes more pleasure in pursuing the bitter in carnal fashion than the agreeable spiritually; it is nourished more by the sourness of fatigue than by the sweetness of repose. The people of the Israelites demonstrates this to us clearly in their very selves.[143]

Gregory goes on to make onions and leeks and their propensity to cause tears a symbol of attachment to things of the world:

What is expressed by leeks and onions, (which very often bring forth tears [in those] who eat them), other than the difficulty of the present life which is led by lovers of this life and not without sorrow, and yet is loved [despite] all its tears?[144]

He then draws a spiritual distinction between those who would accept the manna of heaven and those who would forsake it in preference for the acrid vegetables of the earth:

Those who forsake the manna therefore, when they have asked for leeks and onions with their melons and meats (for evidently evil minds despise the sweet gifts of quietness through grace, in favour of carnal pleasures), aspire to the wearisome journeys in this life, even journeys filled with tears. They scorn to be situated where they may rejoice in spiritual manner, and eagerly seek where they may groan in carnal fashion.[145]

R. E. Kaske has shown this exegesis to have a long tradition. He quotes an eighth-century text, a *Clavis Scripturae* which pithily sums up the associations between garlic, onions and a sinful condition, connections which he followed well into the fifteenth century:

Onions and garlic, corruption of mind, the pungent taste of sin, which, the more it is eaten, the more it torments with sorrow.

Caepe et Allia, corruptio mentis et acredo peccati, quae quanto amplius editur, tanto magis dolore cruciat.[146]

This symbolism is rare in the pictorial arts. However, a particularly graphic example of it is to be found in the work of Breu's contemporary Jörg Ratgeb. In a panel of the *Passover Meal* formerly in Berlin,[147] garlic is used as the 'bitter herbs' (Exodus 12, v. 8) that God instructed the Jews to eat (Fig. 3.21). The over-abundance of the herb far outweighs its narrative function. The lamb is all but obscured under a covering of garlic stems. Garlic bundles festoon the sides of the building and lie around the floor, an ostentatiously emblematic usage of the plant that is directly analogous to its treatment in Breu's Munich drawing. A male figure in the foreground eats a raw bulb with exaggerated relish. Behind such imagery lies a Christian in-comprehension and mockery of the Jewish practice of eating 'bitter herbs' at the Passover Seder. The Israelites are dressed in contemporary clothes and are extravagantly caricatured. Yet the bizarre festooning of garlic becomes comprehensible only in the light of the commentaries on the passage in Numbers quoted above. The Jews are being associated with sinfulness,

3.21 Jörg Ratgeb,
The Passover Meal,
oil on panel

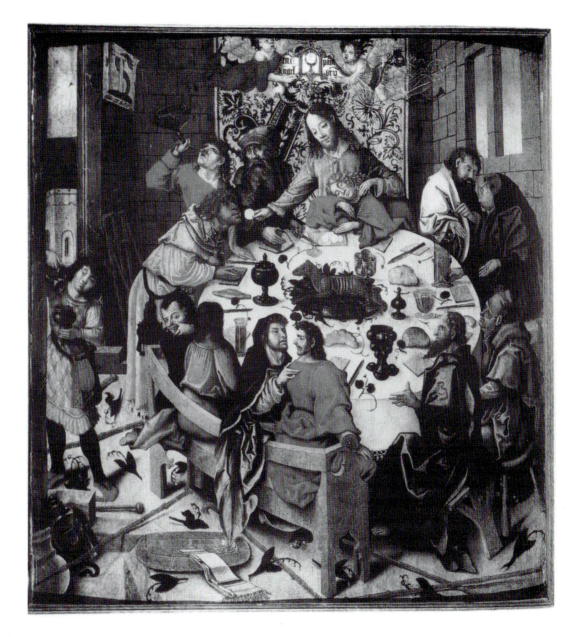

specifically with avarice; in their excessive taste for garlic they have forsaken the spiritual nourishment of manna. That this specific meaning, of garlic as a kind of antitype of manna, was intended by the artist is demonstrated by an earlier *Last Supper* painting, now in Rotterdam.[148] Here, the table and floor are strewn with lilies of the valley (Fig. 3.22). The paschal lamb appears to have been cooked in them. The lily of the valley is of course associated with the purity of the Virgin, the 'lilium inter spinas' of the Song of Songs 2, v. 2. It is also connected with the advent of spring and of the promise of new life,[149] a meaning of direct liturgical relevance to the present scene. The Passover

3.22 Jörg Ratgeb, *The Last Supper*, oil (?) on panel

meal was the traditional Old Testament antitype of the Last Supper and the two scenes were frequently paired.[150] The compositional arrangement of the Berlin panel would suggest that the painting originally formed the side panel of an altarpiece and perhaps originally mirrored a *Last Supper* panel. In such a context, the garlic is to the Jews what the life-giving lily of the valley is to the followers of Christ. The acrid fumes of the one are contrasted with the fragrance of the other. Gregory the Great's words, quoted above, appear here to be directly relevant. The exodus upon which the Israelites are about to embark may be seen to be the 'wearisome journey in this life' in pursuit of 'carnal pleasures', while the lily of the valley of the *Last Supper* is the manna representing 'the sweet gifts of quietness through grace'.

In the Augsburg and Innsbruck *Mocking of Christ* paintings by Breu, the garlic reappears in a similarly emblematic manner (Figs 3.15 and 3.16). They lie beside a Crown of Thorns and evoke a similar meaning. In the Innsbruck painting in particular (Fig. 3.16), the use of the garlic is directly analogous to the meanings Gregory the Great imputed to the plant. The curious figure in the bottom right-hand corner, slumped as if in sleep over a wooden bowl and clutching garlic bulbs, becomes more readily understandable in the light of the medieval readings of Numbers 11, v. 5. He may be seen as one of those of 'mad disposition' who is 'nourished more by the sourness of fatigue than the sweetness of repose'. The wound on his forehead covered by a dressing is the product of his eating of garlic, the physical embodiment of his spiritual corruption.

This figure's 'sleep of ignorance' constitutes a deliberate and symbolic contrast with the image of Christ as 'seeing Faith'. Christ, as in the Augsburg version, stares out of the painting as if oblivious to his tormentors. The man's wound, exacerbated by his attachment to garlic, is a corrupted parallel to the wounds Christ will endure as a result of his faith in the Spirit, signified by the divine light that descends upon him from God the Father on high. This crouched, recumbent figure formally and thematically evokes the blind *Synagogus* (compare with the fifteenth-century Westphalian panel, Fig. 3.7), his sleep a form of unseeing, pointedly contrasted with Christ's enlightened gaze, that is revealed from beneath a raised blindfold.[151] This symbolic contrast helps explain the actions of the other tormentors. Their shrill playing of instruments (in parody of the courtly musician angels who make music around the Christ in Majesty);[152] their tugging at Christ's hair, the ironic pointing to the written inscription, the baring of buttocks and the malodorous properties of the garlic, all signify a crude attachment to the carnal and finite world of the senses (hearing, touch, sight, smell, taste).[153] By this contrast, therefore, Christ is presented to the beholder as the way of Faith as opposed to that of Ignorance. Like the early Passion scenes, the villainy and grotesqueness of the Jews is clearly central to the work's intention. It is emphasized in the horned hat and exotic costume of the figure behind Christ and in the horn-like instrument, which evokes the ram's horn of Jewish ritual.

The inscription on the tablet behind reads in translation: 'My eyes are darkened with weeping, for he who comforts me will depart from me. Job

16.'[154] It invokes the conventional Old Testament antitype of the sufferings of Christ: the physical torments of Job, described in Job 16.[155] However, the inscription is not a quotation but only a very rough allusion to the biblical text. It in fact appears to draw loosely upon two separate biblical references: one from Job 16, the other from Psalm 70, v. 12.[156] Its purpose appears to be that of signifying the moment of Christ's despair, when, assailed by his enemies, he feels abandoned by God the Father. It thereby relates the painting to popular themes of meditation in the devotional literature of the fifteenth century: the *derelictio* or *desolatio Christi*.[157] Yet, more than prompting an affective response of sympathy and compassion, the image shows the triumph of Christ's enduring faith, signalled by his calm and by the radiance that falls from heaven upon him.

In every sense, the Innsbruck *Mocking of Christ* is a reformed picture. It has been purged of the expressive means that might offer direct affective involvement with the narrative scene presented. In its place is a didacticism of intention: Christ is presented as an exemplar – *the* exemplar – of Faith, as the way of the Spirit as against that of the Flesh, of steadfast belief maintained *in extremis* and whose example offers the promise of Salvation. Meaning is grasped rationally, through symbol – the garlic, God's divine light; and by written allusion – the inscribed tablet. Meditation upon further stages of the Passion story is prompted by the inclusion of the column of the *Flagellation* and possibly an allusion to Judas's betrayal and collusion with the High Priests in the left-hand figures. The image depends on a relationship with the beholder that involves meditation upon a theme: here, not just the events of the Passion Story, but the broad significance of Christ's Passion for mankind's salvation.

Yet even though the emphasis has changed, the painting stands within the older devotional meditative tradition. Its character is in fact close to the fifteenth-century types of broadsheet meditational aid, discussed in Chapter 1 (see Fig. 1.4), which could trigger powerful reflection and meditation through crude woodcut image and abbreviated inscription. It demonstrates the continuity into the reformed climate of much older habits of using and regarding images.

The unusual inscription implies the personal invention of a patron conversant with the Bible and exegetic literature. Rather than serving propagandist or pedagogical purposes, the picture was probably intended for private contemplation, representing through rather abstruse references a learned meditation on the nature and necessity of Faith. While it conforms to Luther's prescription for a reformed type of imagery, the theological content is not exclusively, or even particularly, Protestant. Examination of other, similar works made in a context of moderate Catholicism raises the problem of reading such images in too sectarian a light.

St Thomas as exemplar of Faith: humanist responses to the Reformation and the origins of the Emblem

One such example is a poem, printed as a broadsheet, by the publishing firm of Sigmund Grimm between 1525 and 1526 (Fig. 3.23).[158] It was created under the editorship of the humanist Dr Ottmar Nachtigall, the most (reluctantly) exposed Catholic apologist within the city, who had been appointed preacher by the Fugger family at the Catholic stronghold of St Moritz.[159] It is interesting for its complex and highly unusual typographical arrangement. The sheet is centred by an image of St Thomas before Christ, into which is set a scroll containing a verse distich. This is flanked left and right by verses of the ode in italic script and bordered above and below by musical notation with corresponding words, also part of the poem, set in a gothic script. The image is by Breu and indicates his close involvement with humanist publishing endeavours.

The ode is essentially a kind of sermonizing religious poem, a form of humanist *Lehrgedicht*, strictly structured along rhetorical rules of exposition. It constitutes a lament over the current godless times, in which Satan moves freely at large in the world. The poem begins with the distich set into the central image, a plea to God for protection and mercy. It points out the current dangers, evoking an image of human life as an aimless wandering, in which the ship of the soul, without helmsman or captain, will flounder. This is contrasted with an image of a happy golden past, where men lived at peace with each other. In the concluding section, which neatly balances the direct plea at the beginning, the poet turns back to God, full of trust and hope. The music – presumably implying the swelling of an accompanying instrument or voices – which evokes not merely the single poet but a congregation of fearful, wavering humanity, picks up the last rousing distich, itself a neat return to the metaphor of the ship, now returning safely to harbour.[160]

For the historian of images, the interesting question is what purpose Breu's image of the Credulity of St Thomas might serve in the context of a poem which has no reference to that miracle. As Sack showed, it was in part a punning reference to the identity of the poet. The scrolled inscription within the image and the beginning of the poem reads:

> Orbis et clari fabricator astri
> Plasmi tu Soter miserum tuere
> Et pio salva Didymi precatu:
> Celica donans.

> Creator of the World and the shining stars,
> Redeemer, hear the pious entreaty of Didymus:
> Protect and save your wretched creation:
> Give him mercy.

Didymus, the Greek for twin, refers to Thomas, following St John 20, vv. 24–29: 'Thomas, who was called the twin'. Didymus was also however the

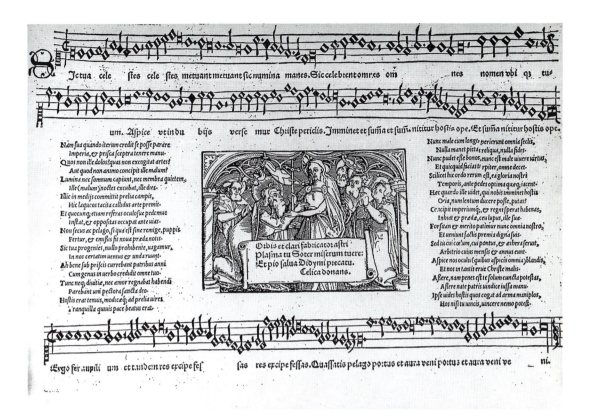

3.23 Thomas Vogler, *Lehrgedicht*, woodcut by Jörg Breu

adopted classicized name of one of the three chief Strassburg humanist friends of the editor Ottmar Nachtigall, a man named Thomas Vogler.[161] Like Nachtigall, Vogler belonged to a theologically moderate humanist sodality, the *Sodalitas Litteraria Argentinensis*, based in Strassburg and centred around the figure of Jacob Wimpheling.[162] Like others of his sodality, he espoused an Erasmian ideal of true Christian piety, based on the exercise of reason and human values.[163] The ode is Vogler's only known poem, written moreover at a time of religious disillusionment, when that ideal was fast being eclipsed by the more extreme forces of religious dissent.

Seen in this light, the inclusion of the image of St Thomas and its inscription at the beginning of the poem was on one level a punning reference to Vogler himself. His prayer to God for protection and mercy in the introductory couplet gives the poem a distinctly private character and was addressed in the first instance to like-minded friends who would have understood the allusion.

On another level, the very centrality of the image and its association with the verse couplet in the scroll, separated from the main body of the text, suggests a further meaning. It portrays the moment of Thomas's conversion from disbelief to belief in the resurrected Christ. In this way, the image serves as an emblem of Belief itself, the basis of which is that Christ is both true man and true God.[164] This idea is underlined by the image and verse

inscription *taken together*: the *human* Christ of the image is apostrophied in the text as the 'creator of heaven and earth', as the divine 'saviour and redeemer of mankind'. As Sack showed, in using the story of St Thomas in this way, Vogler was following St John himself, who explained that his intention in telling the story was as a 'sign', one of many, 'that ye might believe that Jesus is the Christ, the Son of God; and that by believing ye might have life through his name' (John 20, vv. 31–32). The image serves as a similar 'sign'. It is a Christological proof, the very kernel of the lesson Vogler wishes his hearers to learn and by which to be convinced. It is as such that Vogler has placed it at the very heart of his rhetorical poem, forming an integral part of the work. It has first of all a proemial function vis-à-vis the text: like the 'meditacioun' of John Lydgate's poem (discussed above in Chapter 2, pp. 93–5) contemplation upon the significance of the scene presented is necessary before proceeding to the text. Only through this central fact of belief in the Word made flesh can the succour and comfort evoked in the poem become efficacious. More than this, the image functions as *the* central, rhetorical proof, that is to say, it is not only the point of departure for the poem, it is also its spiritual centre.[165]

Sack recognized in this flow of meaning from the image into the poem an early but fully developed form of the emblem. There is in effect the image, motto and explanatory text that was to become the familiar and important literary form of the sixteenth and seventeenth centuries.[166] It is in this sense – as one of the earliest variants of the emblem – that the poem assumes a wider importance in the history of that genre. The poem's form must be considered the product of the collaborative effort of poet, publisher and artist – and composer/musician, for, besides poetry and visual art, music also forms an important part of this early *Gesamtkunstwerk*. As far as is known, Vogler was in Strassburg.[167] Nachtigall, as composer and organist himself, was probably responsible for the musical component and, as editor-in-chief of the Grimm press, was probably the man responsible for advising the artist in sketching the typographical format and in setting the letter-cases. The result was the creation of one of the most original combinations of woodcut, typography and general arrangement so far produced in print, a form that necessitated sophistication and erudition to extrapolate the full meaning.[168]

Given its sophistication and abstruseness of reference, as well as its use of elegant Latin, it seems reasonable to suppose, as Sack did, that the poem was a subtly veiled statement of belief by Vogler, an exhortation to look back to an earlier and better state of Christian life, expressed in a form that underlined the poet's humanist idealism and aimed at the old humanist circles of Strassburg and Augsburg.[169] (These, by 1525, had been split by religious dissensions.) Nachtigall, in producing it, was also doubtless keen to make a veiled point to the humanist members of the City Council, some of whom had once shared his standpoint and ideals, but who now, hiding them under the needs of political expediency, stood at odds with him and his position as Catholic preacher.

Breu's *Mocking of Christ* and Vogler's *Lehrgedicht* appear in their different ways to be concerned with the nature of Faith. Both works have as their central tenet the notion of God the Father manifesting himself through his Son. What Krämer saw as a particularly Protestant theme within the Innsbruck *Mocking of Christ* is also the kernel of the Vogler poem. The transformation of treatment evident in the *Mocking of Christ* from affective narrative to a cooler more ratiocinative form, is also consistent with the treatment of Vogler's *St Thomas* as 'sign' or 'proof' of Faith. Moderate Catholic humanism might therefore have been as important as Lutheran doctrine in shaping the religious imagery of the *Mocking of Christ*. The comparison reveals the artificiality of characterizing the image question in terms of a clear dividing line between Protestant and Catholic. The objectifying tendencies, the shift towards the creation of a dispassionate, emotionally-detached imagery was as much a part of a humanist interest in rhetorical figure and emblem as of the reforming efforts of moderate Protestants.

The *St Ursula Altarpiece*: iconoclasm and the image question

The *Mocking of Christ* panels in Augsburg and Innsbruck as well as the Budapest *Raising of the Cross* of 1524, are evidence of how Breu continued to paint religious subjects well into the 1520s, at the time of increasingly impassioned religious debate within the city. The imagery in the *Raising of the Cross*, in particular, marks a precise historical moment. The directness of its appeal to contemporary issues is unusual in the formal categories of religious painting and Breu employed the subject brilliantly to produce a passionately-felt image of Evangelical belief. Thereafter, such directness of allusion does not recur in his works, exception given for a small number of woodcuts of an overtly satirical nature. In the works that followed in the last 12 years of his life, the effects of the Reformation were felt more generally in ways that registered the social and economic changes wrought by Protestantism rather than directly in a Protestant subject matter.

The reason for this was the dramatic decline of religious commissions. In the 1520s only one major altarpiece may be ascribed to Breu's workshop, the *St Ursula Altarpiece* in Dresden (Fig. 3.24). Buchner dated this reasonably to roughly the middle of the third decade and it is difficult to be more specific.[170] In its ambition to fill three panels of continuous space with a large number of figures, drawn in a wide variety of attitudes and viewpoints, it presupposes a later date. The Italianate nature of certain of the poses, notably the complicated *contrapposto* of the foreground swordsman or the confident energy of the helmsman, also indicates a date within the 1520s.

The subject of the altarpiece is unregenerately Catholic and although nothing is known about the commission or the painting's intended setting, one can be certain it was commissioned by an orthodox Catholic institution which venerated St Ursula. Her cult was not popular in Swabia, though confraternities dedicated to the saint existed in Nuremberg and in Austria.

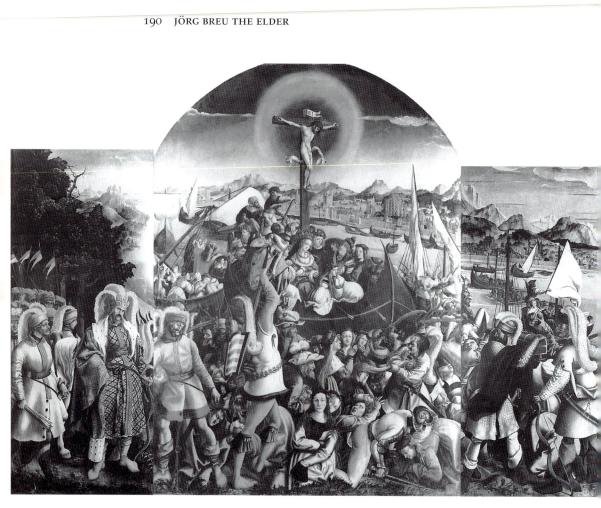

3.24 *St Ursula Altarpiece*, oil on panel

The Augsburg convent of St Ursula would be a likely source of such patronage, though no records have come to light.[171] Gode Krämer drew attention to the apparent iconographic oddity of replacing the mast of St Ursula's ship with the cross of the crucified Christ.[172] He raised the interesting possibility that Breu, in working on a Catholic commission, nevertheless made it acceptable to Protestant, or at least Lutheran sensibilities, by directing devotional attention away from the saint and onto Christ. According to Luther's sermon of 1522 *Vonn der Heyligen erhe*,[173] as well as to Article 21 *Vom Dienst der Heiligen* ('On the Honour due to Saints') of the *Augsburg Confession* of 1530, the saints were to be honoured as examples of exemplary conduct and their sufferings used to help strengthen faith. They were expressly *not* to be prayed to or looked to for practical help; Christ alone could occupy such a role.[174] The central presence of Christ in a scene of martyrdom where he otherwise had no place might therefore exemplify this position.

The combining of the Crucifixion with the Ship of St Ursula, however, was not an uncommon theme in the cult of that saint. It is to be seen, for example, in an altar wing of 1496 by an anonymous upper-Rhenish master for the Cistercian monastery at Lichtenthal (Baden-Baden), in which the pillar-like mast supports a crucifix and St Ursula below stands holding a further

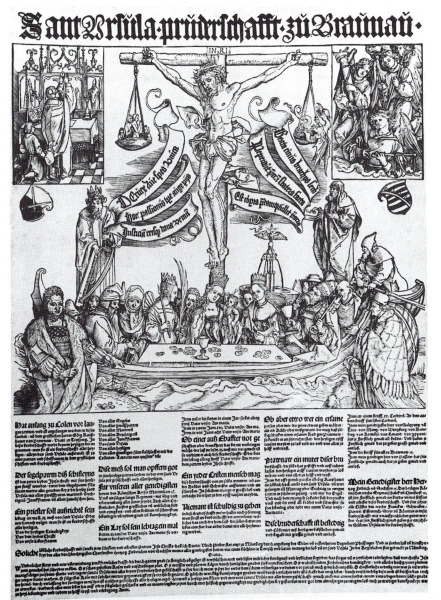

3.25 Hans Suess von Kulmbach (?), frontispiece to *Sant Ursula Pruderschafft zu Braunau*, c. 1512/13, woodcut

crucifix.[175] Such imagery elided two ideas, the Ship of St Ursula with the Ship of Christian Faith, and it was used in particular by Ursuline confraternities. A pamphlet celebrating the founding of the confraternity of St Ursula in Braunau in Austria of c.1512/13, for example, shows a similar arrangement, whereby the mast of St Ursula's ship has become the cross of the crucified Christ (Fig. 3.25).[176] Below, in the centre stands Mary, with St Ursula on her right-hand side, before an altar table with various other saints arrayed around. A fountain of life behind feeds the chalice of St Peter; a Carthusian monk holds the rudder. St Ursula's ship is thus transformed into

a Ship of Faith and this idea is bolstered by a strict hierarchy of arrangement. The suffering Christ is made the central fact of Faith, suggested by the formal prominence accorded him. Forming the ship's mast head, he constitutes the motive force behind the Christian assembly below. The arrangement of the text below makes this hierarchy explicit. The brotherhood is compared with the 'little boat' and continues:

The mast of this little ship signifies the bitter sufferings of Jesus Christ and his five holy wounds; under the mast is Mary, mother full of grace; beside her St Ursula with all the apostles, martyrs, [and] virgins ...

Der segelbawm diß Schifleyns ist das pitter leyden Jhesu christi mit sein heyligen funff wunden/ unter dem Segelpawm Maria ein Mutter aller gnaden/ bey ir die sant Ursula mit allen zwelffpoten/ marterii/.. Junckfrawen/...

The same imagery occurs in the woodcut frontispiece of a pamphlet of the Fraternity of St Ursula in Nuremberg of 1512;[177] and the notion of St Ursula's boat as the Ship of Faith occurs earlier in a mid-fifteenth century woodcut in a Dominican Prayerbook from Nuremberg, where the Christ Child draws St Ursula's ship in to land and the mast is depicted as the flowering Tree of Life. The same kind of imagery continued well into the seventeenth-century Catholic tradition.[178]

Breu's altarpiece depicts the narrative of St Ursula's ship, rather than a Ship of Faith as such. The presence of pope, cardinals and a bishop in the company is consistent with the tradition handed down since the twelfth-century revelations of Elizabeth of Schönau.[179] Concentration upon the narrative is anyway appropriate in a large altarpiece dedicated to that saint. Breu's inclusion of the crucifix therefore followed the usual iconography common to the cult of St Ursula and was executed in a conventionally Catholic spirit.

Previous scholars have found Breu's paintings of overtly Catholic subject matter difficult to match with the passionate Protestant sentiments of his *Chronicle*.[180] Certainly, his later denunciation of 'idols' in the churches would seem at one level at odds with his workshop's persistence in carrying out church decorations for Catholic patrons.[181] As Jörg Rasmussen demonstrated, the image question was far from clear-cut in the first half of the 1520s.[182] Iconoclasm and iconophobia in the city in these years was diffuse and sporadic; it was not to become a defining feature of the Protestant movement until 1529 when the first serious incident of popular iconoclasm took place, orchestrated by Zwinglian radicals. This had been preceded by a single minor incident, in 1524, when two apprentices smeared the effigies of two saints with cow's blood.[183] Unlike other centres in that year, notably Zürich and Nuremberg, where similar actions led to wholesale public demonstrations against images and prompted an official and orderly removal of church furnishings, in Augsburg the incident passed off quietly. The punishments meted out to the offenders were lenient (a year of exile, later commuted) compared to, say, Zürich, where defacement of a crucifix could lead to execution.[184]

Though the image question was discussed in Augsburg in these years, it was not regarded as a central issue.[185] In the five years after 1524, the sympathies of the populace were shared between the views of religious radicals, Lutheran reformers – for whom images counted as *adiaphora*, allowable devotional aids and certainly of no central importance – and emerging iconophobe Zwinglian preachers.

In 1529, Zwinglian reformers, in their attempt to gain political influence in the city, seized upon the use of images as the one issue that could unite the various shades of disaffected opinion behind them. It was as much the social as the theological argument against images that proved decisive. Statues and paintings, the expensive trappings of a material ideology that served only the wealthy, were obvious and emotive targets. This attitude is revealed in the first major public act of iconoclasm that occurred on 14 March 1529, when the Zwinglian preacher at the Franciscan Church, Michael Keller, threw a large crucifix to the ground, proclaiming it an idol (*abgot und götzen*). He then proceeded to parody the *Reliquienkramer* (the 'relic-monger') by offering for sale fragments of the wreckage by the pound, thereby symbolically attacking the economic exploitation that the cult of images encouraged. Five days later the Council published an edict that forbade the destruction of *Bilder, Wappen, Gemeel, unnd annder gedechtnuss* ('images, coats of arms, paintings and other memorials') in chapels and cemeteries, on pain of severe punishment.[186] Implicit in the Council's wording – of church images as memorials – was the fear of damage to family tombs, epitaphs and private chapels. The concern over private property acknowledges social and political rather than religious motives behind the attacks.[187]

By using the image question as one of the main planks of their campaign, the Zwinglians succeeded in making the issue stand symbolically for their cause. The destruction of altarpieces and sculptures, the tangible manifestation of the wealth and corruption of the Catholic Church, was the definitive and necessary outward sign of the establishment of the new order. On a popular level, the theological question of images might therefore be reduced to one of more purely symbolic significance: church furnishings represented the traditional Church; a bare church with pulpit, pews and rough altar table, on the other hand, signified adherence to Zwingli.[188]

Breu's account of acts of iconoclasm is in tune with both the theological and social arguments of the Zwinglians. The significance for him of the destruction in August 1531 of a crucifix and three panel paintings by two patrician burghers' sons was as much political as religious. It acted, he said, as a potent warning to the secular authorities to do away with idolatry and, by implication, usher in a reformation of the Church.[189] He first included church decorations amongst the abuses of the Church only from 1529 onwards – at precisely the date of Keller's first public demonstration. Henceforth, Breu characterized altarpieces, crucifixes and church furnishings as *abgott*, *Gotzen* and *abgötterei* – as idols and idolatry.[190] In an entry for 1531, he recounted the institution of the Reformation in Ulm, describing how the various preachers preached the Word of the Lord to all men against the

Papacy, how flour was distributed to the poor, how 300 horsemen were hired to repulse the 'the attack of the godless hordes'. Yet it was only afterwards, by the removal of the altarpieces, organs and 'idols' from all the churches, that, he says, a new *reformacion* was begun, to the praise of God and the benefit of all![191] Later still, in 1537, the full implementation of the Reformation in Augsburg was seen by Breu in terms of the emptying of the churches of their furnishings, overseen by council officials.[192] Breu's comments make no distinction between religious paintings and other church furniture, including organs. All served idolatrous practices.

Despite his support for the destruction of altarpieces, it remains a fact that his workshop continued to make Catholic images throughout the 1530s. This is difficult to reconcile with his open and enthusiastic support for the Zwinglian preacher Michael Keller. In an entry of 1531, he wrote:

In August master Michael began preaching and aroused great opposition in the Council amongst the godless, the great blasphemers. Thus the Word of God was preached with clear voice, as the prophets have written, although it was of little avail against the mighty idolators, the wealthy and the priests.

… heumonat hat meister Michl angefangen zu predigen, hat ain mechtigen widerstandt gehabyt im rath an den gottlosen, den grossen wuchern. da ist das wort Gottes mit heller stimm geredt und gepredigt worden, wie die propheten geschrieben haben. aber es hat nichts wolen helfen an den großen götzenknechten, reichen und pfaffen.[193]

Though Breu does not mention the content of Keller's sermons, he cannot have been unaware of the preacher's insistent iconophobia. This is un-equivocably expressed in the text of one sermon that survives:

… Oh, the shame, how many people have been through this church who have removed their hats, have bowed and bowed low and prayed before them! By such actions they have blasphemed against God and sinned more by this action than by committing a mortal sin. He who has an altar built or made, or crucifixes or idolatrous effigies of saints that are forbidden by God's laws – he is damned.

… pfui der Schande, wieviel menschen sind durch diese Kirche gegangen, die da den Hut abgezogen, sich davor geneigt und niedergeneigt und davor gebetet haben! Sie haben mit solchem Werck Gott gelastert und sich mehr damit versundigt, als hatten sie eine Totsunde gethan. Wer einen Altar bauet oder machen lasst, auch Crucifixe und Heiligen Gotzenbilder, die in dem göttlichem Gesetz verboten sind, der ist verflucht.[194]

Though Keller's threats of damnation were levelled at those who com-missioned religious images rather than the actual craftsmen who made them, such arguments threatened the basis of the artist's livelihood and came close to implicating his soul by his complicity in this diabolical work. Breu clearly agreed with the arguments over the role of images in religious practice, but, like other artists, economic necessity made him steer his conscience along the narrow line that divided strict religious observance and the practicalities of earning a living. He acknowledged the problem for other craftsmen in a

Chronicle entry of 1537. He commented, without including himself among them, that those whose livelihoods were dependent upon the old Church did not recognize the blasphemy and unsocial and dangerous behaviour involved in their opposition to the Council's decision.[195]

Breu's hostile attitude to images therefore was chronologically in step with that of the Zwinglians – in spirit, if not always in practice. When the *St Ursula Altarpiece* was painted, in the first half of the 1520s, the image question was still open and he could paint it, perhaps with a measure of distaste, but at least free of ideological bias. Nonetheless, it is significant that, with the two exceptions mentioned above, Breu's activity in the field of altarpiece painting essentially ceased after 1525. Henceforth he had to find other outlets to keep his workshop economically afloat.

Breu and Zwinglianism

Breu's close association with the Zwinglian cause may be assumed from the fact that, by the early 1530s, prominent Zwinglians were living as tenants in his house: from 1531, Dr Gereon Sailer, appointed official *Stadtarzt* or City Doctor in 1530, who was closely involved in negotiating with Bucer and Luther for a Protestant settlement; and in 1533 and 1534, the lawyer Balthazar Langnauer who, in 1534, was to draft a crucial memorandum for the city sub-committee, the Council of Religion, outlining the legal justifications for the right of the Council as a temporal body to institute religious changes in defiance of the authority of the Emperor.[196] Breu's hopes for a Christian community that the evangelical way of life would bring about are reflected in a number of *Chronicle* entries during these years. His disappointed reaction to some price-fixing by nominally evangelical citizens, for example, ends with the lament: 'Alas for civic love and brotherly loyalty' ('*o wehe der burgerlichen lieb und bruederlichen treu!*')[197] When, after 1534, Zwinglian influence declined and the oligarchs reasserted tight control over political and religious affairs,[198] the tone of Breu's *Chronicle* entries becomes one of increasing disillusionment. An obscure reference in 1536 to the sale of a house by the Council, that should, according to Breu, have been serving the public good, prompted the response: 'Alack, alack, only through by the skin of our teeth. No one has any conscience to help better his brother, only to obstruct him.' (*o we, we, nu hindurch mit haut und har. da hat niemant kain gewissen seinem brueder zum gueten zu helfen, nur zu verhindern …*); and he concludes, bitterly: 'and the powerful were good evangelicals!' ('*… und waren sie mechtig guet euangelisch*'). In the righteous language of these reactions, one hears the persistence of his Zwinglian convictions into the last year of his life.[199]

Breu's adherence to Zwinglian ideas is registered in a number of works he produced in these years. The two evangelical or satirical prints from the second half of the 1520s that may be attributed to Breu seem to echo the tenor of Zwinglian thought in the general concern with the civic good. *The Minter's*

3.26 *The Cycle of Poverty*, woodcut

Reply (see Fig. 3.9) equates moral decline with broad economic and social factors.[200] A prognosis of the three major economic ills of Germany reveals them to be: the Pope's sale of indulgences; the merchants' introduction of foreign luxuries which produce greed, envy and discontent, especially amongst the German peasantry; and lastly the preoccupation with new habits of dress, the constant introduction of new fashions from abroad. All these things threaten the simple, peaceful, ordered way of life traditional to Germany. The concerns here are Protestant in their antipapal stance; they also confront the wider issues of economic and civic morality, precisely the issues which the Zwinglians were stressing. Another broadsheet, *The Cycle of Poverty* (Fig. 3.26), which charts the equation between economic well-being and good character and the corrupting nature of wealth, echoes a similar ethos.[201]

The Holy Works of Mercy

In one further work by Breu, dating from the second half of the 1520s, one recognizes in its theme a consonance with the artist's religious ideas and in its medium, glass, the attempt to develop an area of production other than the increasingly suspect painted panel.

Four silver-stained glass roundels made after designs by Breu, three formerly in the Berlin Kunstgewerbe Museum and a fourth of unknown provenance and whereabouts, form part of a series of the so-called *Holy Works of Mercy*. The Berlin roundels show respectively *Giving Drink to the Thirsty*, *Giving Shelter to the Homeless* and *Giving Comfort to Prisoners*; the fourth shows *Tending the Sick* (Figs. 3.27, 3.28, 3.29 and 3.30).[202] The second panel is surrounded by an original glass border, with the inscription in Roman script *Hie solt du Beherbergen die Elenden* ('Thou shalt give shelter to

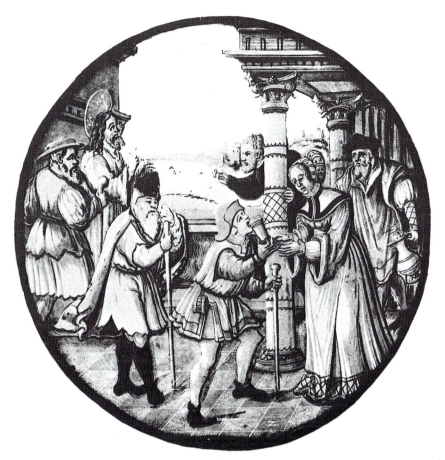

3.27 Follower of
Jörg Breu, *Giving
Drink to the Thirsty*,
silver-stained glass
roundel

the suffering') in the upper half, and an Italianate arabesque decoration
below. The *Tending the Sick* panel is similarly decorated with its own border
inscription. To these may be added two drawings also in Berlin that also
illustrate two of the *Holy Works*: a *Feeding the Hungry*, with a similar inscription
around the upper circumference, and a *Giving Drink to the Thirsty*, upon
which the glass panel of the same subject is based (Figs 3.31 and 3.32).[203] The
other *Work* that one might expect in such a series, *Clothing the Naked* and a
possible seventh, *Burying the Dead*, are lost.

The drawings are by Breu. Stylistically they can be related to his graphic
style of the mid-1520s. Comparison with the 1524 woodcut title-page of the
Leerbuchlein of Ulrich Zwingli (see Fig. 3.1), shows not only the familiar
parallel-hatched shading across forms and the hook-like marks that denote
the planes of the face, but also a similar concern with perspectival space and
classicizing architectural elements. The same arabesque decoration occurs in
each – in the border of the glass panel and the lunettes of the woodcut arch.
These similarities allow a date of around 1525 and after.

The sketchy and shorthand quality of the drawings indicates that they
were early drafts in the series' conception. This impression is confirmed in

3.28 Follower of Jörg Breu, *Giving Shelter to the Homeless*, silver-stained glass roundel

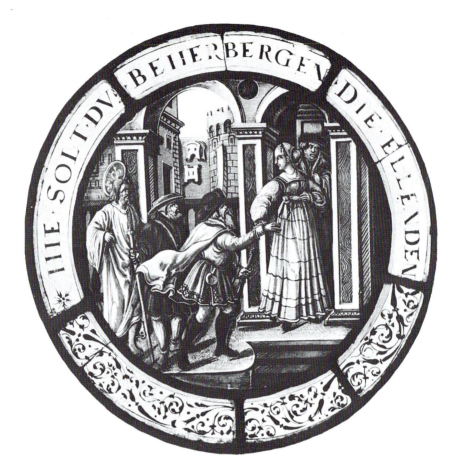

the *Giving Drink* scene (Fig. 3.32) where the figure of Christ has been roughly sketched in outline over the background architecture, as an afterthought. All the other scenes have a fully integrated Christ figure, suggesting perhaps that this was the first work to be drawn.

Nothing is known about the original setting or function of the series. One may infer from the didactic inscriptions which evidently surrounded each panel that they were composed as a self-contained cycle and not as part of a larger scheme. The Roman script, the classical architecture and the patrician figures who dispense charity would strongly suggest that they formed part of a domestic decorative scheme. It is comparable in kind with the Höchstetter *Months of the Year* roundels, which also contain similar patrician figures, albeit in less imaginary architectural contexts.[204] In terms of theme, there would appear to be nothing comparable in surviving contemporary or earlier glass in Augsburg, or indeed any other medium.

The theme is based on Matthew 25, vv. 34–46, in which Christ on the Day of Judgement turns to those on his right side and bids them take their place in the Kingdom of Heaven: 'For I was hungry and you gave me to eat, thirsty and you gave me to drink … ' and so on. An iconographical tradition

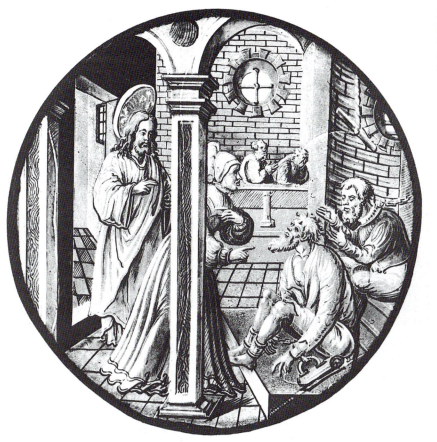

3.29 Follower of Jörg Breu, *Giving Comfort to Prisoners*, silver-stained glass roundel

in Germany goes back to the early twelfth century. Following Matthew, there were six works of mercy: feeding the hungry, giving drink to the thirsty, clothing the naked, sheltering the homeless, visiting the sick and consoling the imprisoned. In the earliest examples, these scenes were to be found associated with depictions of the Last Judgement.[205] In the mid-thirteenth century a seventh 'holy work' – *Burying the Dead* – entered into the tradition and thereafter became commonplace.[206] The *Works of Mercy* in this context underlined the Catholic belief in salvation through good works, an idea that made the subject a fitting decoration for hospitals and other charitable institutions.[207]

The same idea was behind later extensions of the iconographic tradition. The seven *Works of Mercy* came to be associated with other numerically equivalent dogmas, such as the *Seven Sacraments* or the *Seven Deadly Sins*, and thereby divorced itself from the *Last Judgement* context to become an independent theme.

In Breu's series the various acts of charity are carried out by contemporary, well-to-do citizens. In all the surviving scenes it is the woman of the household who is the main dispenser of charity. Only in two of them does a man appear – and then in a subordinate role. This reflected not only well-established

3.30 Follower of Jörg Breu, *Tending the Sick*, silver-stained glass roundel

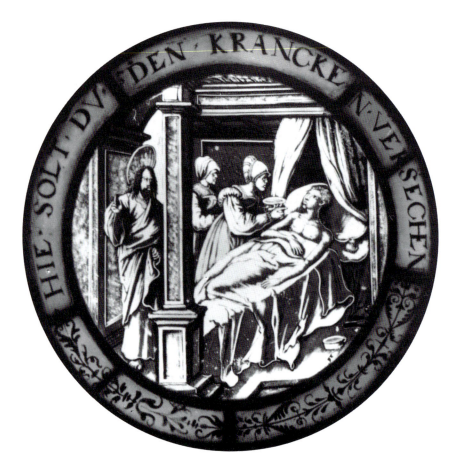

iconographic tradition but, historically, the central position of the woman as mistress of her household.[208]

One feature of Breu's series that appears relatively late in the tradition is the presence of Christ himself in the scenes. This very literal illustration of Matthew's text seems to have gained currency in the North in the later fifteenth century and probably reflected the lay piety of the *Devotio Moderna*, that stressed a strict and literal adherence to Scripture. Two late fifteenth-century panels by the Master of St Gudule show a *Clothing the Naked* and *Giving Relief to Prisoners* in which Christ appears among the recipients of charity.[209] In the former scene, Christ looks out at the spectator as though silently exhorting the viewer to follow the example presented (Fig. 3.33).

The strength of the *Devotio Moderna* tradition in the Netherlands may be seen in another series of seven panels of the *Works of Mercy*, dated 1504 on the frame, originally in the church of St Lawrence in Alkmaar in Holland and now in the Rijksmuseum. An incomplete series of glass roundels of the theme, also in the Rijksmuseum, has been attributed to the same hand. The Leiden artist and glass-painter Pieter Cornelisz carried out at least two series of drawings on the same subject – one in 1524, the other in 1532 – probably

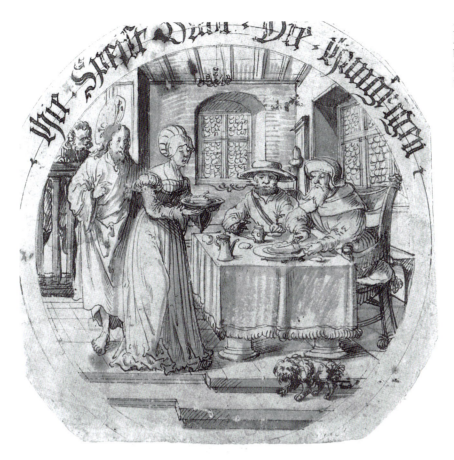

3.31 *Feeding the Hungry*, pen and brush with black ink, with some red tone

as designs for glass paintings or woodcuts. In the former, at least two of the scenes show Christ amongst the recipients of charity, indicated by his halo.[210] These examples indicate that in the northern cities of the late fifteenth and early sixteenth century, the subject of charity-dispensing laymen and women, following the injunctions of Matthew in a spirit of pious literalism, had become a modestly popular theme. The presence in two of the Cornelisz drawings (*Consoling the Sick*, 1524, and *Burying the Dead*, 1532) of Catholic priests and a Franciscan monk, indicates that the series was made within a traditional Catholic context.[211] The inclusion of the seventh work – *Burying the Dead* – also indicates that the series was not made in the reformed spirit of literal adherence to Scripture.

Was Breu's series of glass panels commissioned and designed in a similar spirit? A slight but significant difference between Breu's imagery and the Flemish examples lies in the depiction of Christ. In the latter examples Christ mingles all but anonymously in the crowd of beggars and pilgrims. This provides a precise visual analogue of Matthew's words and conveys the idea that in helping one's neighbour one is helping Christ himself. Breu's Christ does not blend in with the crowd. He is in fact much more prominently placed, standing in two of the scenes at the elbow of the benefactress, and in

3.32 *Giving Drink to the Thirsty*, pen and brush with black ink, with some red tone

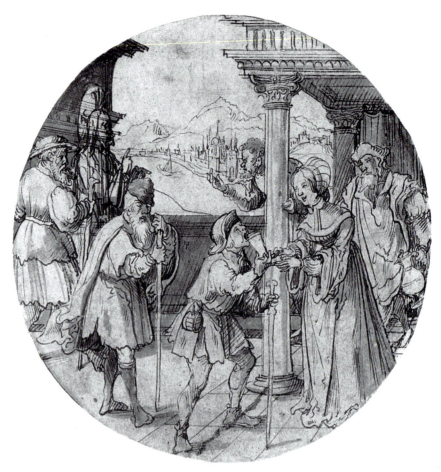

all cases making a gesture of exhortation and approval. Breu has shifted the emphasis. His aim seems to have been more directly didactic, as if driving home the necessity of performing the *Works of Mercy*. His images, together with Christ's commands, writ large around them, possess much more the quality of a visual sermon.[212]

In fact, the *Works of Mercy* were invoked frequently in Augsburg in the early sixteenth century, particularly during the heightened religious tensions of the 1520s. They were used in a number of contexts by evangelicals in their writings and pamphlets. For the revolutionary figure of Sebastian Lotzer, for example, a journeyman furrier from nearby Memmingen who between 1523 and 1525 published at least five pamphlets, the *Works of Mercy* formed an important part of his messianic theology. He saw the fact that laymen had begun to preach the Word of God as the fulfilment of Joel's prophecy of the Second Coming and exhorted his fellow men to prepare for the End.[213] To do this, they should carry out the *Works of Mercy*:

God orders us to do nothing in preparation for the last Judgement other than the six works of mercy, as Matthew says in the twenty-fifth chapter: 'Come here, O chosen

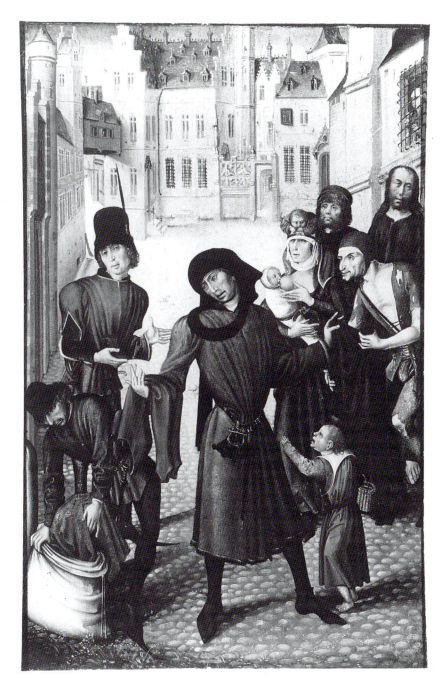

3.33 Master of St Gudule, *Clothing the Naked*, oil on panel

ones of my Father, and inherit the kingdom which has been prepared for you since the beginning of the world.'[214]

In Lotzer's writings one sees the traditional late-medieval 'works-holiness' being transformed into a more urgent need to do those works by which mankind would be saved. The best means of salvation lay in an active ministry of the poor. Lotzer passionately hoped for a Christian society of equals, where money would be distributed according to need: '[W]here there is a company of good people, they should gather whatever they can, collecting whatever they can, and afterwards they should divide the money among the poor people, as they see fit.'[215] Similarly messianic tones are adopted by the Augsburg pamphleteer Haug Marschalck in his pamphlet *Der Blindenspiegel*, which also warned of the Second Coming and advocated that the common people carry out the works of mercy to prepare for Christ's return.[216] The context of his admonition was a bitter complaint against the materialism of contemporary society. To Marschalck, the current greed, luxury and extravagance were clear signs that the last days were imminent and that Christ would return soon.[217]

The Augsburg weaver Utz Rychssner, with whose sentiments Breu shared so much in common, also wrote of the eschatological necessity of the six Works of Mercy. Compared with both Lotzer and Marschalck, for whom the Holy Works were only meritorious after the soul had been mystically purified, Rychssner's theology was extremely simple. According to him, the desire to carry out the Works of Mercy would arise naturally from a reading of Scripture and hearing of sermons and the resultant imbuing in the pious individual of Christian virtue.[218]

Such views explicitly tied the theological doctrine of Good Works to social and political aspirations. They grew out of the background of economic hardship and discontent that ruled among the lower orders in 1520s Augsburg and their language of complaint against the wealthy directly mirrors the tone of Breu's *Chronicle*. In such a context, amidst the shrill hecklings for social reform by the evangelicals, the theme of the Works of Holy Mercy, showing well-to-do burghers giving alms to the poor and destitute, must have contained an urgent contemporary relevance.

The degree to which such imagery could be politicized was dramatically highlighted during the process of cleaning and restoring the Master of Alkmaar's *Works of Mercy Altarpiece* in the Rijksmuseum, during which it was revealed to have been the victim of iconoclastic attacks during the sixteenth century.[219] Significantly, the heads of those dispensing charity had been savagely slashed and scored. In particular, the eyes had been gouged out, not, as the restorer noted, in a casual or indiscriminate way, but deliberately and purposefully (Figs 3.34 and 3.35). The social resentment that lay behind the actions of the iconoclasts and the identification of the painted burghers with the wealthy patriciate of the town are powerfully made manifest.[220]

Yet it is the third way in which the Works of Mercy were invoked by the pamphlet-writers mentioned, particularly by Marschalck – as a positive

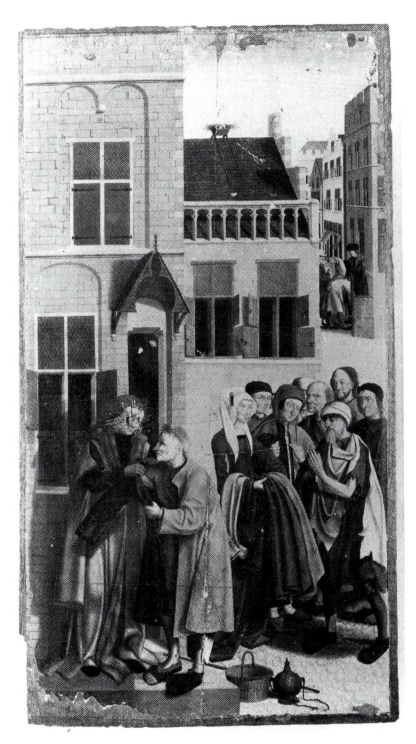

3.35 Master of
Alkmaar, *Clothing
the Naked*, detail,
during restoration

antithesis to the Catholic idea of works-holiness, which lay in offering masses, prayers for the dead, the veneration of relics and indulgences – that the theme assumed a new prominence and importance in Protestant thought. Luther had expressed this antithesis in 1522, in a sermon on the reverence due to saints, calling the poor and needy 'living' saints, who should be actively helped through acts of charity, as opposed to the 'dead saints' of the papists, whom the Catholics honoured by the building of churches and altars.[221]

The prominent figure of Christ in Breu's designs, exhorting the benefactors with grave gestures, assumes a new meaning in the light of these readings. The message to the spectator is a clear appeal to the necessity of following Christ's commands and this didactic intention is underlined by the written inscriptions.

The theology that has informed this series is probably closer to Rychssner's simple piety than to the Pauline notions of Salvation of Marschalck, or the

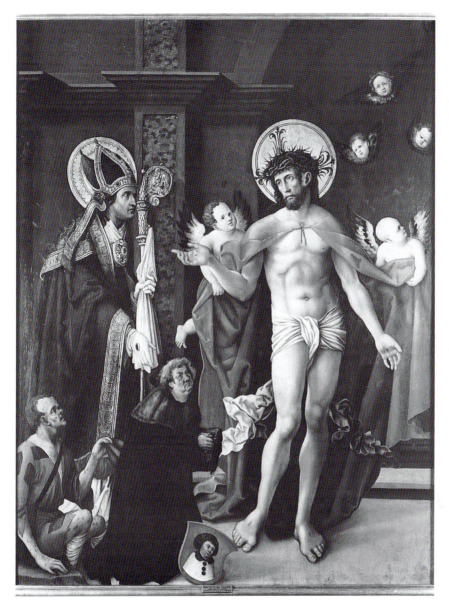

3.36 Leonard Beck, *Christ as Man of Sorrows with St Martin and the donor, Martin Weiß*, detail from the *Votive Diptych of Martin Weiss and his Wife*, oil on panel

messianic communism of Lotzer. One may be permitted to see in the treatment of the theme a reflection of Breu's pragmatic theology, influenced by the Zwinglianism that took root after 1524.

Whether the strong didactic element was introduced into the series out of the artist's personal convictions or at the behest of the patron cannot be determined. Giving emphasis to a particular theological viewpoint should anyway not obscure the obvious general intention of the series: of showing charitable acts by members of the patriciate. Though nothing so overtly secular in treatment has survived in Augsburg from this period, there is

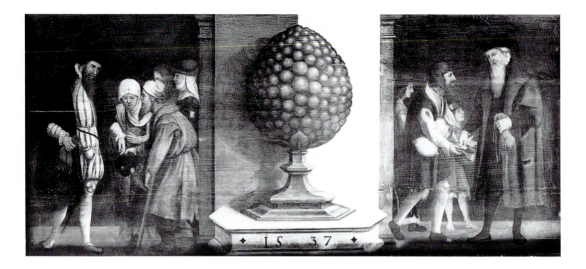

3.37 Anon., *The Dispensing of Civic Charity*, oil on panel

much evidence that the dispensing of charity and a conscious desire to be seen dispensing charity were important themes that informed both major altarpieces and private votive images in the late-medieval period. Holbein the Elder's large *St Sebastian Altarpiece* of 1516, for example, shows in its right-hand wing St Elizabeth dispensing alms to very graphically depicted beggars and cripples.[222] Hans Burgkmair's *St John Altarpiece*, probably painted for Augsburg Cathedral, shows on the right-hand wing, St Martin giving alms to a beggar.[223] Images of this type underlined the role of the Church or of the patron of the altarpiece as protector of the poor. In the votive diptych of the prosperous weaver Martin Weiss and his wife, painted by Leonard Beck in *c*.1510, one sees Christ as a *Man of Sorrows* and the Virgin and Child, flanked again by Sts Martin and Elizabeth, dispensing charity to extremely vividly painted beggars (Fig. 3.36).[224] These examples are sufficient to show that both the Church institution and pious individuals placed great importance on their role as dispensers of charity; in the former case, to assert its traditional role as protector of the poor, in the latter, in order to win a place in heaven and grateful remembrance on earth.

From 1522 onward, such imagery became increasingly rare, for in that year, the civic authorities had passed an *Almosenordnung* or Poor Law, designed to remove the provision of charity from the Church and place it under the aegis of the City Council. All alms were henceforth to be given to four 'Lords of Charity' (*Almosenherren*), elected by the Council, who would then distribute money strictly according to need, after claimants had been personally assessed through home visits.[225] The secularization of the dispensing of charity was given vivid visual form in a small panel, dated 1537, that came from a room in the Town Hall (Fig. 3.37).[226] It shows well-to-do patrician burghers giving alms to the poor, flanking a large, central pine cone, the city coat of arms. The tripartite format echoes that of a traditional altarpiece. The municipal symbol, representing the city authorities has replaced the traditional central saint or deity, and laymen stand in place of the charity-

dispensing saints of the wings. One may see in this – possibly unconscious – continuation of formal type, in the appropriation of a religious symbolism of form into the secular sphere, some of the important social meanings of the late-Gothic altarpiece.

In a somewhat different manner, Breu's series may also be seen as a secularization of the same impulses to express wealth and responsibility, at a time when the veneration of the saints was being popularly condemned. It took the expression of good citizenship out of the altarpieces and placed it within the domestic realm. It turned the specifically Protestant doctrine of good works into an expression of civic responsibility. Through the expensive medium of glass, it reflected status and wealth; through its imagery, the exercise of wealth tempered by the dues of civicism. In this series one sees the paradoxical conjoining of the artist's own passionate advocacy of an ethic of Christian civic communality and the desire of the wealthy to parade in an expensive medium their own charitable pretensions.

Notes

1. Broadhead (1981), 86–95. For an exhaustive narrative account of the events of the Reformation, see Roth (1881); also Schuhbert (1955), 283–300.

2. Pfeiffer (1966), 147f.

3. See Broadhead (1981), ch. 1, for an examination of the social and economic aspects behind the Reformation.

4. Ibid., 92–3.

5. Ibid., 199.

6. No record of his sermons exists, only reactions, hostile and positive; see Roth (1881), vol. I, 125f.

7. See Broadhead (1981), 117.

8. Ibid., 158.

9. This is known from an entry in the city *Baurechnung* for 1522: 'It[em] 4 gulden Jorigen Brewen, maler, für ein vererung omb das err von Baden awß gen Straßbourg gezogen und die bastenen daselbs abgerissen und entworfen hat. S.p. felicitatem' (29 November), StAA, *Baurechnung*, Bt.50b.

10. Rasmussen (1980), vol. III, 95–114.

11. For the effects of Protestantism elsewhere, see Christensen (1979); also Baxandall (1980).

12. See Krämer (1980a, b).

13. Cuneo (1991), 573.

14. Breu (1906). The manuscript probably came from the library of the councillor Paul Hektor Mair (1517–79), himself a chronicler. In the eighteenth century, it was acquired by the librarian of the Bayerische Hofbibliothek, Andreas Felix Oefele (1706–80), passing, through his great-nephew in 1902 to the Königliche Hofbibliothek in Munich.

15. Staatsbibliothek, Munich, *Cod.Oef.* 214.

16. Roth (1926), 8.

17. See especially Kramer-Schlette (1970), 32–8.

18. On the tradition of chronicle writing in Augsburg, see: Weber (1984) and Joachimsohn (1894), 1–32; for the genres of chronicles, Schmidt (1958); most recently, Cuneo (1991), 27–47 for a comparative study of Breu's with three other contemporary chronicles.

19. Rem, *Cronica*, ed. Roth (1881), 1–2. Cited by Cuneo (1991), 43.

20. Ibid., 31.

21. Evidence for this latter post comes from a note dated 1520 written by Breu and signed *maller*

und *underhauptmann* ('painter and lieutenant') that survives in the Augsburg city archive (StAA, *Sammlung Nachtrag* 1, 1519–25); cited by Roth in the introduction to his edition of *Breu, Joerg, Chronik* (1906), 5.

22. *Chronik*, 19, 1514: 'der ging auss als ain vieh, weder beicht noch bericht, ungessen und untrunken seins rechttags, daß er ... weder horen sagen von Got noch von sein heiligen.'

23. Ibid., 20.

24. Ibid., 20: 'auch ir so gross guet zugeschickt haben kaiser, könig, fürsten und herren, edlen und unedlen burger und die mechtigsten zu Augspurg, die solch gross glauben und hoffnung zu ihr gehabt haben, dass man sie fur heilig geacht und geschetzt hat ... doch kain armer nit vil auf sie gedacht hat oder gehalten.'

25. On the importance of anticlericalism in the call for reform, see for example: Goertz (1982), 182–200; also Cohn (1979), 3–31; Scribner (1987), 243–56.

26. *Chronik*, 33, 1525: 'wann er [Dr Frosch] sunst hett ainem sein weib oder tochter genommen, so wers ain köstlich stuck gewesen.'

27. Ibid., 81, 1537: 'Item auf das aufziehen und fliehen der schendtlichen, lugenhaftigen, huerischen pfaffen ...'

28. Ibid., 24 '... Also hat vil volck die fasten fleisch geessen und ire, [der pfaffen], gsatz prochen.'

29. Ibid., 50.

30. Ibid., 27.

31. Ibid., 33: 'da hat er tun, was Got geboten hat und gepredigt, das hat er gehalten'.

32. Ibid., 24.

33. Ibid., 27: 'und war die gemain guet, das gesetz gottes anzunemen und das menschlich abzutreten. da wollten die geistlichen und teuflischen also wietig werden, daß man nichts von iren menschlichen, bapstlichen gesatzen mehr wollt halten, wann man wollt nimer opfern noch meß friemen, besingknussen leuten, weder vigil stiften noch umb leibpfennig nichts geben.'

34. Ibid., 76: '... eines erbern raths ernstlicher bevelch und straffung wer ... der gotslesterung abzusteen und kein meß noch ceremonia zu brauchen, weder mit singen noch glocken leuten oder andern, gar nichtzit.'

35. Ibid., 78: 'ja, daß man sie nit vor vil jaren vertriben hat, die geistlichen väter!'

36. Ibid., 27.

37. Ibid., 27: ' ... hat er angefangen zu lachen und gesagt, das woll Got nit, mein herr, das ich von Christo abfall und weich, wenn er wiß, daß das Euangelium und wort Gottes kumen sei in die welt uns zu hail und sicherung zum ewigen leben, daß das gewiß sei allen glaubigen cristen, darauf will ich frölich sterben und hab umb Got nie verdient umb seinetwillen zu sterben. also hört ir armen und brueder ... '

38. Ibid., 24.

39. Ibid., 24.

40. Ibid., 27: '... da waren all verstockt blindenfierer und die gsatzglerten der schrift wider Jesum, daß man im [nit] glauben gab und dem ewigen leben anhieng. also geschicht noch denen, die Christum nachfolgen, die veracht und stockt man.'

41. Ibid., 53.

42. Ibid., 62.

43. See Broadhead (1981), 46–8.

44. *Chronik*, 32.

45. Ibid., 43–4.

46. Ibid., 55.

47. On prostitution in Augsburg, see Roper (1989), 89–132.

48. Rem, *Cronica*, 73–5.

49. For the problem of defining accurate social groupings in the period, see Otwinsoka (1976), 194–202; Blickle (1975), 127–131; and Lutz (1979).

50. *Chronik*, 27.

51. Ibid., 25.

52. For instance, his frontispiece to an edition of Luther's *Das alte Testament deutsch* (Melchior Ramminger, Augsburg, 1523). See Röttinger (1908), 51, no.7.

53. *Chronik*, 24: '... hett der munch gesagt, er wöll den lutherischen seuen und puben den weichprunnen segnen ...'

54. Ibid., 82, n. 3.

55. Ibid., 25.

56. Russell (1986), 121; also, Laube et al. (1983), vol. I, 439–40.

57. See Bibliography, Printed primary sources.

58. He himself recounts how he heard the famous Alsatian preacher Gayler von Kaisersberg in Strassburg, as well as an unnamed preacher from Ulm. *Gesprächbüchlein, Weber/Pfaffen*: 'Es ist wol dreyundzwayntzig jar da was ich zu Strasspurg an Doctor Kayserspergers predig ... '

59. At one point he uses a rather dubious linguistic argument to bolster his attack upon the legitimacy of the Papacy, claiming that the German word Felß ('rock'), upon which Christ built his Church, was confused with the Hebrew *fölß*, which he translated as 'God'. Thus, he argued, Christ built his church not on the rock of St Peter, but on his *Bekanntnus des glaubens*, or 'faith'. Such arguments reveal his acquaintance with the issues of translation with which Luther and Erasmus were concerned. Rychssner, *Ain Schöne Unterweisung ...* (Augsburg, 1524), fol. Ciiv.

60. Rychssner, *Gesprächlein/Weber, Pfaffen*; see Russell (1986), 125.

61. Ibid., fol. IIIv: '... Mathei am xiii capitel. Ir solt euch nit Mayster nennen lassen / dann ainer ist ewer Mayster/ir aber seyent all brüder/unnd ir sollent nyemandt vater haysen auff erden dann ainer ist euwer vatter der im hymel ist/ Wa ist dann unnser aller hayligster Vatter Bapst/ un[d] and[er] gnädig/ hailig wirdig vater/ un[d] herre? ... Item wöllicher der grösser ist under euch/ der sol ewer aller diener sein. Dann wer sich erhöhet der würdt ernydert.'

62. *Chronik*, 69: 'er ist gewesen ain mechtiger, milter mann, sonderlich den armen zu geben, niemand von im leer geen lassen. ain tugenthaftiger herr, hat seinen handwercksleuten essen und trinken geben und an seinen tisch geladen. ist zu inen in ir heuser gangen, niemand veracht, alle kranken menschen, so schadhaft und für in komen sindt, selbs gehört, inen freundtlich zugesprochen und guten beschaidt geben. damit hat er ain gross lob und lieb von allermenigelich erlangt.'

63. Rychssner, *Gesprächbüchlein, Weber/Pfaffen*; cited by Russell (1986), 126.

64. Ozment (1973), 7.

65. *Chronik*, 16; Kramer-Schlette (1970), 79.

66. Ibid., 77.

67. See Bellot (1980), 89–93.

68. Dodgson (1911), vol. II, 112, nos. 8 and 9.

69. Johann von Eck, *Contra Luther, Prima Pars Operum*, (A. Weissenhorn, Augsburg, 1530); cited in Röttinger (1908), 61.

70. Röttinger (1908), 51, no.7. Melchior Ramminger was noted by the Council as an agitator ('*vil red getriben*'), in the crowd of demonstrators before the Town Hall on 6 August 1524. Another printer (Phillip Ulhart) and a book-seller (Wolf Miller) were also among the crowd. StAA, Urgichten, 3, 1524.

71. *Hern Ulrich Zwingli leerbiechlein wie man die Knaben Christlich unterweysen und erziehen soll/ mit kurzer anzaige aynes ganzen Christlichen lebens, M.D.xxiiij* (Phillip Ulhart, Augsburg, 1524), Augsburg Staats- und Stadtbibliothek, 4, Th.H.2995.

72. Schottenloher (1921), 131. Ulhart was recorded in the same Council report (see note 70) as having joined hands with a carpenter in demanding the return of Johannes Schilling.

73. Also in 1524, appeared: Zwingli's, *Ain Epistel Huldrich Zwingli's an alle christenliche bruder zu Augspurg*, and a year later, Leo Judd's Zwinglian justification of the symbolic nature of the eucharist: *Ain Christenlich widerfechtung Leonis Judd wider Mathis Kretz zu Augspurg, false End christliche mess und priesterthumb, auch das prot und weyn des froyenleychnams un[d] blut Christi kain opfer sey* (Augsburg, 1525).

74. Bellot (1980), vol. I, 164, cat. 80.

75. A contemporary report in a letter associated the two in recounting how '... ein widertäufer oder ein zwingelscher' preacher drew more than 16,000 people, as compared with the paltry number other preachers attracted (see Arneke (1916), 74). When in 1531, the Zwinglians won the battle for religious dominance in the city, Luther advised his adherents in the city to avoid Zwinglian services, even to have their children baptised by Catholics, rather than *Schwärmer* (Luther *WA., Briefe,* vol. VI, 244–5). See Broadhead (1981), 264–7.

76. *Getrewe Christenliche und nutzliche Warnung etliche obrigkait die das Evangelion zu predigenn zulassen und befehlen und straffen doch desselben volziehung* (Augsburg, 1525). Schottenloher (1921), 121, no.113) ascribed this to Ulhart.

77. Schottenloher (1921), 31.

78. StAA, *Ratsbuch*, fol. 26, 1523; cited by Broadhead (1981), 96.

79. The artist Heinrich Vogtherr the Elder, for example, between 1523 and 1526 used several pseudonyms when publishing his religious polemics (which he also illustrated). All used the initials H.S., after his latinized name Heinricus Satrapitanus, thus: Heinrich Spelt, Hans Scharf, probably Heinrich Summerhart. See Geisberg (1927), 96–100; also Muller (1987), 275.

80. *Ain freundlich gesprech, zwyschen ainem Barfuesser Münch, … vnd ainem Loeffel/ macher …* (Heinrich Steiner, Augsburg, c.1522); attributed to Breu by Röttinger (1908), 61, no.8; most recently atttributed to Heinrich Vogtherr the Elder by Muller (1997), 231, no. 169. On the difficulties of attribution, see Morrall (1998c), 317–19.

81. Budapest, Szépmüvészeti Museum, Inv.no.6219.

82. For an account of the origins and development of the iconography see Rose (1977), 56–96 and 273–89.

83. Munich, Alte Pinakothek, inv.no.1416; other examples of the *Raising of the Cross* include woodcut versions by Baldung-Grien (1507) and Altdorfer (1513) and Wolf Huber's monumental painted version of 1522–24 in Vienna. For these and other examples see Rose (1977), 273–89. The closest formal arrangement to Breu's foreshortened and truncated unrepentant thief, and his probable direct inspiration, is Hans Burgkmair's *Crucifixion Altarpiece*, of 1519, Munich, Alte Pinakothek, inv. no.5239.

84. Krämer (1980a), 27.

85. See Hale (1990), 93–105.

86. Winzinger (1972–73).

87. See Moxey (1989), 73–8.

88. For the influence of Tacitus, see Tiedemann (1913), and Riess (1934); for the influence upon Ulrich von Hutten, see Holborn (1937).

89. This point is made by Hale (1990), 25–6. He dates the woodcut 1532, the date of the printed edition. It is however highly probable that the illustrations had been made by 1523 for the printing house of Wirsung and Grimm.

90. Sender, ed. Roth (1894): 'Er ist … wie ain landsknecht gangen … da hat diser barfüsser, wie er zu Gmünd hat auffrur gemacht, unkeuschait triben und ist täglich vol wein gewesen, also hat er zu Augsburg auch than und hat hie ain soliche gesellschaft.'

91. Leipzig, Museum der bildenden Künste, inv.no.609; see Leipzig, Museum der bildenden Künste (1973), 24.

92. See Berlin (1983), 364, no. E57.

93. Lübbeke (1991), 110–15.

94. Scribner (1982), 58.

95. As described in Mathew 27, v. 41; Luke 23, v. 35; Mark 15, v. 31.

96. Krämer (1980a), 127–8.

97. Elek (1931), 388.

98. His tasselled costume would seem to be an echo of the *arba' kanfot*, a kind of scapular of white linen with the tied *ziziyyot*, hanging in front and behind, attached to its four corners, as seen in the costume of a Jewish youth in an illuminated manuscript of c.1460 (London B.L. MS. Add.14762, fol.8 v); illustrated in Metzger (1985), plate 198.

99. Luke 23, v.42. Berlin (1983), 72.

100. *Idem.*

101. Aznar (1991), 59.

102. Matthew 23.

103. *Chronik*, 25. His imagery is explicitly biblical, not merely in the term *phariseer* but also in the words *wucherer* (usurers) and *vilzhut* (possibly *spitzhut*), a derogatory term for the Jews, referring to the pointed hats they traditionally wore.

104. Matthew 23, vv.16–17: 'Woe upon you, ye blind guides, which say, Whosoever shall swear by the temple, it is nothing; but whosoever shall swear by the gold of the temple, he is a debtor. Ye fools and blind: for whether is greater, the gold or the temple that sanctifieth the gold?'

105. *Ain Schöne vnderweysung wie und wirin Christo alle gebrueder vn[d] schwester seyen …* (Augsburg, 1524), fol. C, ii v.

106. See Hamburg (1983), 183, cat. no. 57.

107. Ibid., 196–7, cat. no. 71.

108. Ibid., 193, cat. 66. On the good thief's side is 'the evangelical preacher … such as Luther and others', above the common folk; on the bad thief's side is the church of the Antichrist, the

preacher representing the 'indulgence preachers, such as Eck, Emser and Cochleus', reinforced by a crowd of Pope, cardinals, clergy and the emperor. The mounted figure beneath the good thief represents the figure 'Faithful and True' from Revelation 19, v.11, representing the pious ruler who allows the gospel to be preached in his lands; he stands opposite the Whore of Babylon, a contrast which introduces an eschatological dimension to the confrontation of the two churches. See Scribner (1982), 211–16.

109. 'Ein Frag an eynen Müntzer/wahin doch sovil geltz kumme das man alltag müntzet: Antwort des selben Müntzers/ Von dreyen Feinden …' (Wolfgang Roesch/Formschnyder, Augsburg [n.d.]), in Geisberg, rev. and ed. Strauss (1974), vol. I, 323.

110. *Der arm gemein Esel* (Nuremberg: Hans Guldenmund, 1525), woodcut with printed text by Hans Sachs (Hamburger Kunsthalle, Kupferstichkabinett, inv. no. 10994).

111. See Reeve (1969); also Kurze (1958).

112. Warburg Institute Library, London University.

113. Rem, *Cronica*, 204.

114. *Chronik*, 26–7.

115. Ibid., 62.

116. Ibid., 46: ' … da machten wir hoch meur und pasteien, vielen vor danider von den grausamen lugen der k[aiser] und fursten, auch der pfaffen …'

117. Ibid., 43–4.

118. Ibid., 52.

119. Lucas Cranach the Elder, *Sanfftmütig der Herr kam geritten – Der Papst in Hoffart und stolzen Sytten*, woodcut illustrations for M. Luther, *Passional Christi und Antichristi* (Johan Grünenberg, Wittenberg, 1521). See Fleming (1973), 351–68; cited by Burke (1974), 308, n. 49.

120. Scribner (1982), esp. 196–206; Hoffmann (1978), 145–77.

121. See Balzer (1973), 14f.; and Schmidt (1977), 9. See also Köhler (1981).

122. Hamm, (1978), 232f. He contrasts the prison of human teaching with true Christian freedom, trust in the efficacy of good works with trust in Christ's infallible promise, the sacrificial mass with the true mass, and so on.

123. *Chronik*, 26–7.

124. Augsburg, Städtische Kunstsammlungen, inv. no. L.1701, and Innsbruck, Tiroler Landesmuseum Ferdinandeum, inv.no.953; see Krämer (1980a), 125.

125. Ibid., 119.

126. Krämer (1980?), 19–20. On Luther's attitude to imagery, see Katzenbach (1974), esp. 64.

127. Krämer (1980a?), 121: '… da das Bild schwerlich als Altartafel oder Teils eines Altares anzusehen ist, wäre vielleicht an eine Propagandatafel, eine Art Thesenbild zu denken, das mehr religiösen und tagespolitischen Gesichtspunkten als künstlerischen zu genügen hatte.'

128. See Koepplin and Schuster in Hamburg (1983), 115–249.

129. Schade (1974), plates 84–6; cited by Berlin (1983), 363–4, cat. no. E564.

130. 'Tuque ingrate mihi: pungis mea stigmata culpis/Saepe tuis …'

131. As, for example, in the – overtly Catholic – Small Organ Wings of the Fugger Chapel, where the figures of God the Father and Mary hover in the sky, in equally unusual contexts; or again, in the 1514 *Departure of the Apostles* in Augsburg.

132. See for example, the *Trinity* panel of an altarpiece fragment by Barnaba da Modena (National Gallery, London, inv. no. 2927), where God the Father breathes golden rays of his Spirit onto his crucified Son.

133. Munich, Staatliche Graphische Sammlung, inv. no. 38009.

134. Dresden (1971), 93–4, cat. no. 91.

135. Krämer (1980a), 120–21.

136. From Wolfgang von Maen, *Das Leiden Jesu unseres Erlösers* … (Hans Schönsperger the Younger, Augsburg, 1515).

137. Krämer (1980a), 120.

138. StAA. Worms, 2030, fols 4–5. See also a facsimile edition, *Thesaurus picturarum des Markus zumm Lamm (1544–1606)*, Hessische Landes-und Hochschulbibliothek (Darmstadt, 1971), vol. XXIII, 121.

139. Po-chia Hsia (1988), 166, caption to fig. 11.

140. Reuter (1987), 68.

141. Heukels (1907), 13; Müller (1923), vol. 3, 1227.

142. See Curry (1926), 45–6, for the parallels he draws between the alopecia of Chaucer's Summoner and his eating of 'garleek, oynons and eek lekes' (General Prologue, 634–8):

> Wel loved he garleek, oynons and eek lekes,
> And for to drynken strong wyn, reed as blood;
> Thanne wolde he speke and crie as he were wood.
> And whan that he wel dronken hadde the wyn,
> Thanne wolde he speke no word but Latyn.

143. *Moralia in Job*, xx, xv, 40 (Job 30, v. 7), Migne (1844–64), vol. 76, 160–61: '… vaesana iniquorum mens plus se assequi aspera carnaliter quam tenere blanda spiritualiter gaudet, plus acerbitate fatigationis quam quietis dulcedine pascitur. Quod aperte in semetipso nobis Israeliticus populus ostendit …'; quoted in Kraske (1959), 481–4.

144. Ibid., 'Quid per porros ac cepas exprimitur, quae plerumque qui comedunt, lacrymas emittunt, nisi difficultas vitae praesentis, quae a dilectoribus suis et non sine luctu agitur, et tamen cum lacrymis amatur?'

145. Ibid., 'Manna igitur deserentes, cum peponibus ac carnibus porros cepasque quaesierunt, quia videlicet perversae mentes dulcia per gratiam quietis dona despiciunt, et pro carnalibus voluptatis laboriosa hujus vitae itinera, etiam lacrymis plena, concupiscunt; contemnunt habere ubi spiritualiter gaudeant, et desideranter appetunt, ubi et carnaliter gemant.'

146. Kraske (1959), 482. He also quotes an anonymous fifteenth-century Parisian *Liber de Moralitatibus*, which not only interprets spiritually the physical connection between garlic and leprosy, but includes other interpretations of *alium* suggestive of spiritual depravity, corrupting influence on others, lustfulness and blindness to realities beyond the material.

147. Formerly Berlin, Staatliche Museen; see Fraenger (1972), 71, plate 22.

148. Rotterdam, Museum Boymans-van Beuningen, inv. no. 2294; see Fraenger (1972), 62–6.

149. *Herder Lexicon* (1971), vol. 3, 192. Its presence in the *hortus conclusus* of the Virgin in many fifteenth-century German paintings demonstrates the connection with the Virgin's purity. See, for example, *The Garden of Paradise*, by an anonymous Rhenish artist of *c*.1410, Städelsches Kunstinstitut, Frankfurt (illustrated, for instance, in *Stefan Lochner, Meister zu Köln. Herkunft, Werke, Wirkung*, Köln (1993), 41); for its general association with spring-time, see the painting *Summer*, by a follower of Breu (Deutsches Historisches Museum, Berlin), where a young gallant wears a wreath of lily of the valley, made for him by his lover (illustrated in Boockmann (1994), colour plate 2).

150. For instance, two overmantels painted in 1517 by Leonard Beck in St Moritz; mentioned in Wilhelm (1983), 75.

151. My thanks to Professor Larry Silver for his helpful suggestions on this point.

152. See, for instance, the three panels by Hans Memling with Christ as Salvator Mundi amongst musical angels (Antwerp, Koninklijk Museum voor Schone Kunsten, inv. nos 778–780); illustrated in Os (1994), 288–91. An angel plays a similar tromba marina, the single-string instrument played by the left-hand figure in Breu's painting.

153. This usage represents an extension of the tradition derived from the Golden Legend, discussed by Krämer (1980a, 126), in which all of Christ's senses were attacked by his assailants.

154. It reads: 'Caligaverunt oculi mei in fletu meo quia elongabitur a me qui consolatur me. Iob 16.'

155. See van der Osten (1953), 153–8, esp. 156.

156. Vulgate, Job 16, v. 17: 'Facies mea intumuit a fletu, et palpebrae meae caligaverunt' (King James, Job 16, v. 16: 'My face is foul with weeping. And on my eyelids is the shadow of death'); and Vulgate, Psalm 70, v. 12: 'Deus, ne elongeris a me' (King James, Psalm 71, v. 12: 'O God, be not far from me'). Krämer (1980a, 124) saw the inscription as an elision of various verses of Job 16 and translated the passage freely, making a plural out of the singular verb forms ('they' rather than 'he'), which considerably alters the meaning.

157. See Thomas à Kempis, *Orationes et meditationes de vita Christi*, vol. I, 2, 6; *Opera Omnia*, 5, ed. Pohl (1904), 68f.; cited by van der Osten (1953), n.4.

158. See Sack (1988), for the identification of the printing house and date, as well as for an exhaustive literary analysis of the poem, which she convincingly shows to have directly influenced the form and content of Luther's *Ein Feste Burg*, the anthem of the Lutheran movement.

159. See Sack (1988), 12–14; also Schröder (1893), 83–106.

160. Ibid., 41–6.

161. Sack (1988), 16–18. On the life and works of Vogler, see Schmidt (1879), vol. II, 149–54 and 407.

162. Lutz (1984); 45–60. For further references see Sack (1988), 13, n.18.

163. In 1514, Vogler wrote a panegyric to Erasmus, which he delivered to the arch-humanist in person, at a symposium held in Strassburg in that year. See Sack, 17, n.36.

164. Sack (1988, 51–2) quotes St Augustine's use of St Thomas as a spiritual model of Faith. Sermon 258: 'After Thomas had placed his hand in the wound, his belief was complete. What constitutes perfect belief? It is this: that one believes that Christ is Man and God, not only man and also not only God. Perfection of belief consists in believing that "the Word was made flesh and dwelt among us".' Migne (1844–64), vol. 38, col. 1196.

165. Sack (1988), 52. She links this method of exposition with Quintilian's definition of and use of *signa*, which, together with *argumenta* and *exempla*, are the 'artistic proofs', that is, proofs that can only be discovered by means of the art of rhetoric (Quintilian, *De institutione oratoria* … , V, 9, 1). Though they outwardly resemble 'natural proofs', for they are examples drawn from ordinary experience, the *signa* assume meaning only through rhetorical skill, in the way the poet links them with the two other elements. The *signa* should have no obvious connection with the other two elements, but yet should contain a higher, hidden meaning that is revealed by their conjunction. See Quintilian, *Inst. orat.*, V, 8, 4–7, and the discussion in Lausberg (1960), paragraphs 355–9.

166. Ibid., 53–4. On the development of the emblem form, see Homann (1971), esp. 25–40; he follows the definition of Schöne (1968), vol. II, 17–63; see also Miedema (1968), 234–50.

167. Sack (1988), 55.

168. The first printed emblem book to contain images, Alciati's *Emblematum Liber* was first published in Augsburg in 1531 by Heinrich Steiner. Sack (1988, 126–8), pointed out that the italic typeface employed in the Vogler poem was the same as that used in the Alciati edition. She concluded that the latter was therefore orginally made under the auspices of Grimm and Wirsung, at much the same time that Vogler's ode was produced. She argued that the Alciati typefaces and woodcuts were bought up by Heinrich Steiner when Grimm and Wirsung were declared bankrupt in 1527. This explains the odd delay in the book's publication.

169. Ibid., 55–6.

170. Dresden, Kunstmuseum, inv. no. 1888; see Buchner (1928a), 364.

171. On the Ursuline foundations in Bavaria see Munich (1960), 87 and 112.

172. Krämer (1980a), 126, n.57.

173. WA, X, 3, esp. 408.

174. *Das Augsburger Bekenntnis des Glaubens und der Lehre* … , 4th edn, Zwickau o.J., 17f.; cited by Krämer (1980a), 126, n.57.

175. See Zehnder (1985), plate 1.

176. Woodcut, Vienna (Graphische Sammlung Albertina, inv. no. 1969/1000, Geisberg 757), attributed to Hans Suess von Kulmbach; see Winkler (1941), 19–20. Winkler connected it with a small book by Ulrich Pinder, published in 1513, on the brotherhood.

177. *Sancte Ursule fraternitas*, Nürnberg (Nuremberg, Friedrich Peypus, 1513); see Köln (1978), cat. no. 24, fig. 71, attributed to Peter Vischer the Elder.

178. See, for example, a painting by Alejandro de Loarte (c.1590–1626) in the parish church of Los Yébenes, Toledo, entitled *La Nave Eucharistica* and signed and dated 1624. A variation of the theme by a follower, entitled *la Nave de la Christiana Patience* ('The Boat of Christian Patience'), appeared at auction at Christie's, New York; illustrated in *Christie's New York, Wednesday, May 18th, 1994*, 100, cat. no. 152.

179. For the growth of the St Ursula story see de Tervarent (1931).

180. See *Chronik*, introduction, 12. Most recently Cuneo (1996, 1–20) has interpreted Breu's responses to iconoclasm as ambiguous and as indicating a lukewarm response to the Zwinglian demands for the removal of church decorations.

181. As late as 1536, the Breu workshop was fully engaged in the decoration of the chapel of the hunting lodge of the Catholic Pfalzgraf Ottheinrich at Grünau. See Rott (1905), 17–18.

182. Rasmussen (1980), vol. 3, 95–114.

183. *Chronik*, 24.

184. Wandel (1990), 125.

185. The issue was aired in print by Ludwig Haetzer's *Ain Urtayl Gotes unsers eegemahels wie man sich mot allen götzen und bildnussen halten soll, auss der hayligen geschrifft gezogen* (Sigmund Grimm, 1523).

186. StAA, *Ratserlässe*, 19 March 1529.

187. Rasmussen (1980), vol. 3, 97.

188. Rasmussen demonstrated the symbolic nature of the iconoclastic act by an example of *Catholic* vandalism, when, during the Diet of 1530, Imperial soldiers smashed the pews and pulpit of the Zwinglian stronghold, the Franciscan Church, thereby removing the outward signs of Protestant worship. Ibid., 96.

189. *Chronik*, 50, 13 August 1531: 'man hats der oberkait heftig anzaigt, die abgotterei darvon zerthun, aber da hats niemant thun wollen.'

190. Ibid., 49, 50, 53, 76.

191. Ibid., 49, 20 May, 1531: ' ... also haben sie die prediger geschickt ... allen menschen das wort des herren wider das bapstumb zu verkundigen, damit alle ire unterthanen hörn und sechen, wamit sie umbgeen; auch darzu verordnet protmel den armen da zu geben die zum predigen komen aus den flecken. auch 300 pferd angenomen [abzuweren], das einfallen der gottlosen haufen. also haben sie darnach die altar, orgeln und götzen aus allen kirchen geworfen und ein andere reformacion angefangen, Got zu lob und dem negsten zur besserung.'

192. Ibid., 75–6: 'item, adj.16.jenner ist ain erber rath, groß und klein, gesessen, abgelegt alle meß und das [bot] gemacht die gotzen hinweck zerthun bis auf ain cristlich concilium und weitern beschaidt. Got schicks zum besten!'; and eight days later: 'auf solchs nach mittag ist der vogt mitsambt andern vom rath, auch zimerleuten, maurern, schmiden, das dann zu diser arbait notdurftig gewest ist, in Unser Frauen kirchen komen und die kirchthur zuthun und darnach altar, bildwerck, gemel und alles, das zu den götzen und der abgotterei dient hat, zerschlagen, zerprochen disen tag.'.

193. Ibid., 50.

194. Roth (1881), vol. I, 305.

195. *Chronik*, 77: 'Also dem gemainen mann, schneidern, schuestern u[nd anderen]., den was etwas daran gelegen und umb ir narung zu thun; sie bedachten nit die grossen gotlesterung und unfreundtschaft [und die gefar] in der spaltung aufruerig zu werden.'

196. Ibid., 316 and 382–3; also Sieh-Burens (1986), 145–6.

197. Ibid., 48, 49.

198. See Broadhead (1981), 292 and esp. 352–91.

199. Ibid., 70.

200. The print, complete with text, exists in a single copy in Gotha, Schloß Friedenstein; see Röttinger (1908), 2. For a discussion of the print, see Cuneo (1991), 171–90.

201. Oxford, Bodleian Library; see Röttinger (1908), 3. For an analysis of the print's iconography, see Cuneo (1991), 139–69.

202. Destroyed 1945. See Schmitz (1913), vol. I, 135, nos 221, 222, 223. He attributed them to Breu the Younger though without giving any grounds.

203. Berlin, Staatliche Kunstsammlungen, Kupferstichkabinett, inv. nos 4370 and 5061; see Bock (1921), vol. I, 15.

204. Compare for instance the interior scene of the *Giving Food to the Hungry* drawing with the *October* scene from the *Months* (see Fig. 2.45).

205. As, for example, on the 'Galluspforte' in Basel of c.1170. See 'Barmherzigkeit, Werke der', in *Herder Lexicon* (1968), vol. I, 245f.

206. Ibid.; cf. the rood-screen of Strassburg Cathedral.

207. For example, a series of keystone carvings of 1472, depicting individual acts of mercy, in the vaulted ceiling of the ward of the *Heiliggeist-Spital* in Biberach in Württemberg.

208. See, for instance, the series of six panels of the North rose-window of Freiburg Cathedral, where a woman is the provider in all cases, though a man, as in Breu's designs, is present in all.

209. Cluny and ex-Sammlung Figdor, the latter recorded in the Witt Library, London University.

210. See *Giving Drink to the Thirsty* and *Giving Food to the Hungry*, Berlin, Staatliche Museen, Kupferstichkabinett, inv. nos 1191 and 1193.

211. Berlin, Staatliche Museen, Kuperstichkabinett, inv. nos 1195 and 1190.

212. They fulfil Luther's recommendation for an acceptable Protestant form of imagery, that combined an image with surrounding explanatory text. Luther described how the 'Last Supper' should be ideally represented: '... mit großen güldenen Buchstaben umher geschrieben, daß sie für den Augen stunden, damit das Herz daran gedacht, ja auch die Augen mit Lesen Gott loben und danken müßten'; Luther, *WA*, vol. XXXI, 1, 415.

213. Joel 2, vv. 28 f.: 'I will pour out my spirit on all flesh; and your sons and your daughters shall prophesy ...'

214. S. Lotzer, *Ain hailsame Ermahnunge an die ynwoner zu horw das sy bestendig beleyben an dem*

hailigen wort Gottes mit anzaigug der göttlichen hailigen geschrifft (1523). Translation by Russell (1986), 92.

215. Ibid., 92

216. Haug Marschalk, *Ein Spiegel der Plinden* … (Augsburg, 1523): '… du sollt den elenden herbergen, den nackenden kleyden, den hungrigen unnd durstigen speisen und trancken … unnd dyss daselbst mer auch Math am XXIIII ca[pitel] wie er die sechs werck der heyligen Barmherzigkeit so starck anzeucht und sogar streng wirt für sich nemen zu straffen.'

217. Ibid., 'Die welt ist hart verstickt in zeitliche wollust mit ubel gesinnung d[er] zeitlichen guter mit Bosem gebracht mit unreyner hoffnung un[d] ist alles mit Bosem geitz überleffen. Mancher Beschwert und verderbt hart seinen eben menschen und christlichen bruder dadurch er grossz gut zu im bringt und uff ein hauffen zeucht darin er grossz sund wurckt …'

218. Rysschner, *Eine schöne Unterweisung* … (Augsburg, 1524). See Russell (1986), 125–6.

219. De Bruyn Kops (1975), part 4, 203–26.

220. See Freedberg (1985), 29–32.

221. Luther, *Predigt am 20.Sonntage n. Trinitatis [2 Nov.], 1522, 'Vonn der heyligen erhe'*, in *WA*, vol. X, 3, 407: 'nemlich das man yhe eyn underscheydt mache under den heyligen, die do thott seyn, und den die do lebendig seyn … Die lebendigen heiligen sein dein nehsten, die nackenden, die hungerlichen, die dorstigen, arme leut, die weyb und kyndleyn haben, die schandt leiden: do wendt hin dein hulff, do leg dein werck an, do brauch dein tzungen hyn, das du sie beschu tzest, dein mantel auff sie deckst und tzuern helffst. Das haben nu unser papisten umb gewendt, das haben sie auff die thoten heyligen gelegt, kirchenn gestifft, altar gebaut.'

222. Munich, Alte Pinakothek, inv. no. 668; see Steingräber (1986), 256, no. 668.

223. Munich, Alte Pinakothek, inv. no. 20; Steingräber (1986), 124, no. 20.

224. Augsburg, Staatsgalerie, inv. nos. L.1051, L.1052; see Goldberg (1978), 22.

225. Sender, *Chronik*, 164; Rem, *Cronica*: 173; cited by Broadhead (1981), 94. See also Fischer (1979), 179–81.

226. See Augsburg (1980), vol. I, 204–5, cat. no. 134, which cautiously attributes it to Christoph Amberger or his circle.

4
The *'deutsch'* and the *'welsch'*: neo-classicism and its uses

The numerous glass-designs and occasional surviving glass roundels that date from the 1520s are testimony to the fact that Breu found in this medium an increasingly popular and profitable alternative to the declining market for religious panel painting. He chose subjects that required a serial treatment over a number of roundels, a conception of glass decoration that he appears to have consciously developed. The themes tended to be drawn from the Bible, from classical history, exemplary literature, or more traditional serial themes such as the *Months of the Year*.[1] Such subjects suggest they were made largely for private, domestic contexts, a factor that allowed him to invent freely in a spirit of genre storytelling.[2] This is undoubtedly true of his only complete series of glass panels, *The Story of Joseph*, which, with its tales of foreign travel, was abidingly popular amongst the merchant class (see Fig. 1.38).[3] The same inventiveness applies to his most influential work, the series of the *Months of the Year*, made for the Augsburg merchant family, the Höchstetters.[4] In these roundels, the traditional agrarian, aristocratic imagery was adapted with great originality to reflect the habits and activities of an urban patrician.[5] In certain roundel designs depicting classical subjects, such as the *Ulysses and the Suitors* in Berlin, *The Death of Caesar* in Leipzig, or a *Titus Manlius* in Berlin (Figs 4.1, 4.2 and 4.3) one encounters subjects that appealed specifically to literary, humanist tastes and the series from which they came probably decorated the private rooms of educated patricians. The style in which they are executed is also new. It is overtly classicizing, drawing upon Italian models in the depiction of Roman armour and details of architecture. There is a clear attempt in these works to match classical subject matter with classical form. These works all date on stylistic grounds from the second half of the 1520s and early 1530s and seem to reflect a new publishing interest in popular editions of classical history and literature.[6] What is remarkable is Breu's own knowledge and imaginative grasp of a wide variety of often obscure classical sources. These roundels provide a vivid insight into the intellectual range of an artist of modest formal education and reveal by their style and subject matter, further evidence of his close identification with the humanist culture within his city.

The development of this style may be charted in the few panel paintings that exist from the later 1520s and 1530s. The *Samson and the Philistines* in Basel, datable to *c.*1525 (Fig. 4.4), is the first of these works to register these elements.[7] The tangle of foreground bodies, their varied poses and disjunctions of scale recall the Virgins of the *St Ursula Altarpiece*. These

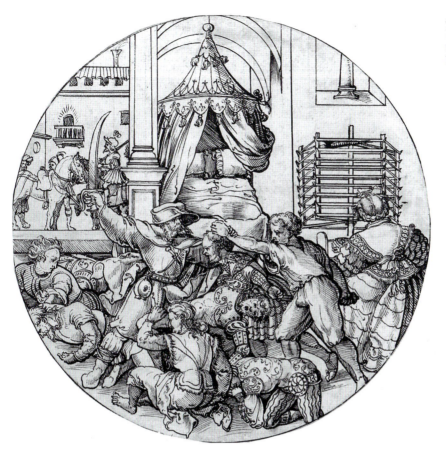

4.1 *Ulysses and Telemachus slaying the Suitors*, pen and black ink on paper

characteristics are now combined with a new stylization of musculature, evident in the figure of Samson and the breastplate of the soldier to his left, as well as a concern with details of armour and architecture that is deliberately classical in tone, based largely upon Italian print and nielli sources.[8] Nothing is known of the original context of this work, though the subject of an Old Testament hero destroying the idols of the Temple might have had a particular contemporary relevance in Augsburg of the later 1520s, when the image question was being fiercely debated.

This classicizing tendency is even more developed in Breu's *Story of Lucretia*, in Munich (Plate 10).[9] Unlike the *Samson* it is well documented and therefore allows one to examine the premises of his classicism with more accuracy. It was painted in 1528 as the first in a cycle of paintings of *Heroines*, commissioned from a number of prominent artists of Bavaria and Swabia by Wilhelm IV, the Wittelsbach Duke of Bavaria and his wife, Jacobaea von Baden. A further series of *Heroes* was commissioned at the same time, to which Breu also contributed a panel, *The Battle of Zama* (Fig. 4.5). These cycles hung in the Residenz in Munich, though their precise location there is unknown.[10] The prestige attached to such a commission may be judged by

4.2 After Breu, *Death of Caesar*, pen and brown ink on paper

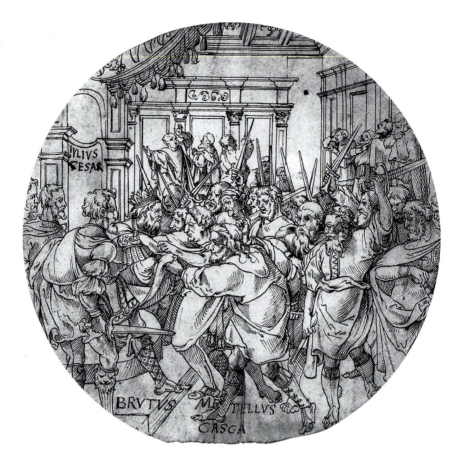

the fact that Albrecht Altdorfer declined a term as mayor of Regensburg in order to paint his *Battle of Issus*, depicting the defeat of Darius by Alexander the Great in 333 BC, today the best-known painting of this cycle.[11]

The *Lucretia* is painted in a self-consciously neoclassical style. The story of Lucretia's rape, her suicide, the avowal of revenge by her family and the subsequent revolt against the Tarquins is told in continuous narrative form within an elaborate classical architectural setting. The existence of a preparatory drawing of the *Lucretia* in the Szépmüvészeti Museum, Budapest, provides insights into the planning of the composition as well as into Breu's approach to the classicism of the finished painting (Fig. 4.6). The difference in character between the two is immediately apparent. While the figures in the painting possess costumes and physiques that are exotically classical in style, in the drawing they are dressed in a kind of generically 'noble' costume, based loosely upon contemporary fashions. In this initial conception there has been no attempt at historical or 'archeological' reconstruction. The figures are drawn in a fluent and graceful idiom that is entirely unforced, the product of the artist's native, German training. Breu's familiarity with the drapery style, with the cut and fall of such garments, is clear in the easy and practised manner with which he could abbreviate their details. In marked contrast are

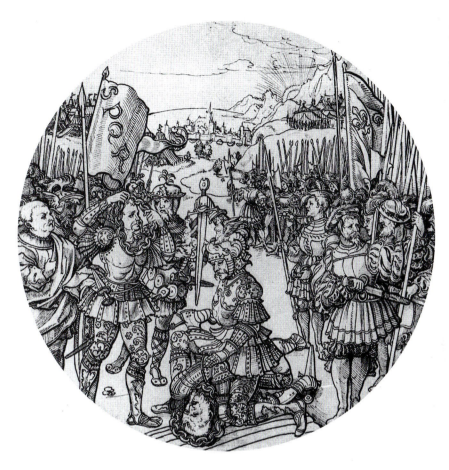

4.3 *Titus Manlius has his Son Beheaded*, pen and brush with black ink, heightened in white on green-toned paper

the figures of the painting, dressed in fanciful Roman attire, the natural and graceful gestures of the drawing transformed into stiff, mannequin-like poses. Their artificiality is exacerbated by bulging 'antique' musculature of chest, calf and knee. The natural twist of the figure on the extreme right has been rendered painfully wooden by the painter's compulsion to endow him with a martial torso and a particularly heroic set of knees.

The comparison shows the artist consciously employing two manners of style at will, one individual and indigenous, the other Italianate. Michael Baxandall has shown that contemporary artists were aware of and had terms for such stylistic distinctions: the *welsch* and the *deutsch*. He cited a woodcut of *Veit the Sculptor*, forced by lack of work to join the ranks of mercenaries, by Peter Flötner, datable to some time in the 1530s. In the accompanying verses the sculptor claims: 'Many fine figures have I carved / With skill, in *deutsch* and *welsch* manners …'[12] The term *welsch* was generally used to denote the foreign or the exotic; when applied to art, it usually referred to the Italianate. The use of the term *deutsch* as applied to artistic style is interesting for it suggests a contemporary recognition of certain generic or shared qualities amongst essentially individual styles. It also explicitly acknowledges cultural

4.4 *Samson and the Philistines*, oil on panel

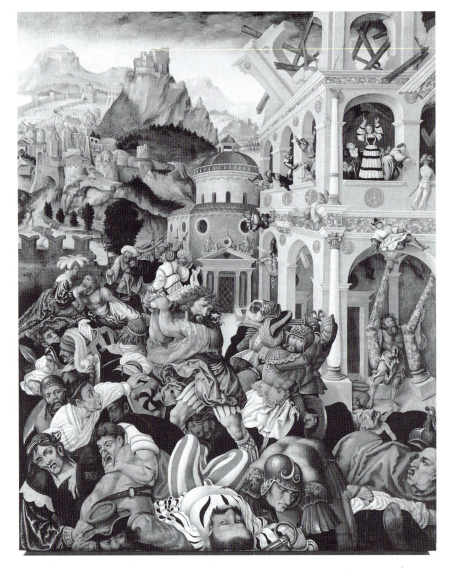

distinctions made along national lines. Between Breu's drawing and the finished painting one sees the abandonment of his own normative *deutsch* style, used unthinkingly in the informal planning stages of the composition, and the transformation in the finished painting into a self-consciously *welsch* idiom.

The drawing allows one to reconstruct the wilful process of rationalization from sketch to finished composition. In the architecture (the first element to be drawn in, for the columns run through the figures placed in front) one may see the degree to which Italian perspective construction governed his usual compositional habits. The columns and arcade have been established by ruled verticals and horizontals. The orthogonals conform generally to the vanishing point on the right-hand side. Yet it has not been the artist's intention

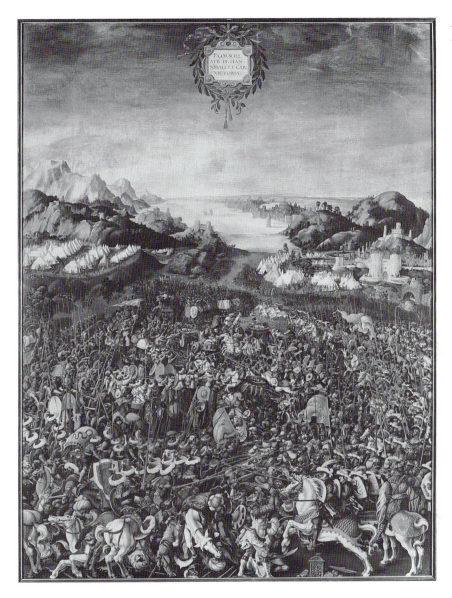

4.5 *The Battle of Zama*, oil on panel

to create either a credible building or a logical architectural space. The figures
do not relate with strict accuracy to the ground nor does their scale recede
proportionately. The figure grouping has been arrived at additively and in a
linear manner, rather than in terms of volumes in space, and disparities of
scale are everywhere apparent. The figures of the foreground group are
linked together by an entirely ad hoc lighting system, of patterned lights and
darks that run through them but without concern for a single light source. It
is a graphic convention entirely characteristic of Breu and indeed of
widespread German practice. Its employment reveals Breu to be oblivious to
the Albertian system of working out the respective scale and distance of
figures and objects in space, of which, largely through Dürer, German artists

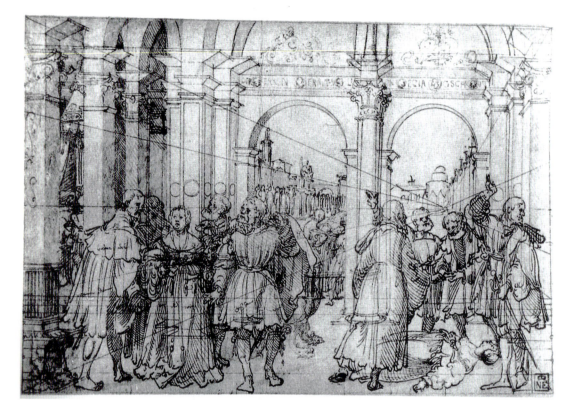

4.6 *The Story of Lucretia*, pen and ink

in the later 1520s and 1530s were increasingly aware. Erhard Schön's reduction of Dürer's instruction to a practical formula, although published in his *Kunstbuchlein* of 1542, is indicative of studio practice that was current much earlier. Instead, Breu composed his sketch in an informal and accomplished manner within the idiom of his training and mature development.

The most perplexing element is the system of orthogonal lines, which radiate out from the vanishing point. They do not relate to the architecture and, together with the horizontal grid that maps out the tiled floor in the painting, have been drawn *over* the design, that is to say after the drawing had been completed. These elements reveal a process of rationalization. The horizontal lines that run from points running up the right-hand edge show the artist now employing the Albertian method of establishing the degrees of recession relative to a viewing distance from a point on the horizon line.[13] Secondly, the orthogonals are arranged so that four of them proceed to the corners of the sheet, while the others neatly divide the areas above and below the horizon line into two. It is as if, having established the design, the artist was attempting to rationalize the composition with a systematic grid-system which would unify architecture and floor with the 'aperture' of the picture frame.

This process has been carried out in the finished painting: architecture and floor now conform to the same vanishing point. Nonetheless, compared

with the fluency of the drawing, the painting creaks with the effort of acquired theory. Though the orthogonals of the tiled floor are more or less correct, the foreshortening of the circle and lozenge patterns within it are not and the floor is tilted too steeply to carry the figures. Moreover, although there is an indication of a single light-source in the cast shadows and in the shadowing of the capitals, it is subsumed beneath a greater interest in decorative colour, pattern and detail. The insistent detail of the roundel reliefs on the pillars, for instance, pulls the eye constantly away from an easy passage into depth dictated by the perspective lines. It might be said that all the constructive elements of Italianate composition – pictorial space, lighting, the classical treatment of the figure and of decorative form and detail – exist in Breu's work as discrete elements that nudge and jostle against each other uncomfortably.

How does one explain so complete and dramatic a change of style, such a concentrated effort to paint in a manner foreign to the painter's training and artistic instincts? The sources of Breu's forms, that helped determine this strange hybrid style and his own notion of welsch art, lay, once again, principally in prints. Like those in the Samson, the decorative roundels of the pillars depend upon Italian nielli. Similar exotic capitals and frieze decorations are to be found in decorative architectural prints from northern Italy. Underlying the structure of the composition, discernible particularly in the drawing, is the example of Mocetto's print after Mantegna of The Calumny of Apelles, of which Breu had already made a copy (see Fig. 2.21).[14] The townscape background with Venetian chimneys and the figure pointing upwards on the extreme right recall the Italian model. The drapery style, the details of armour and the classical physique derive chiefly from prints of Mantegna and his school. Comparison with the Mantegnesque Flagellation of Christ, with the Pavement (see Fig. 1.24), reveals in the right-hand figure a similarly muscled cuirass and skirt, lion ornament on the leg armour, and sandalled feet. As discussed above in relation to Breu's designs for sculpture, one can be sure that Breu knew this print at first hand, because he had adapted the left-hand scourger for a design of his own some years earlier. In this case we see the artist using a highly classicizing Italian print as a source for a pose, not for the Italianate sense of style contained within it. Another striking example of this kind of borrowing can be seen in a design for a glass roundel, datable to the mid-1520s, depicting a classical subject: the Murder of Agamemnon by Clytemnestra and Aegisthus (Fig. 4.7).[15] The pose of the king pulling off his robe has been cleverly, if inexpressively, adapted from the figure of Minerva in Marcantonio Raimondi's print after Raphael's Judgement of Paris (Fig. 4.8).[16] Though one sees in the bulging calves, thighs and muscled torso the clear influence of Italian form, the 'classicism' of this drawing – that is to say, the desire of the artist to recreate an antique atmosphere and setting – is entirely home-grown. The difference between this borrowing and the ostentatious neoclassicism of the Lucretia suggests that Breu attached specific meaning to the latter style, that he had a deliberate intention in fashioning his painting thus. The 'classical' conception into which he fitted

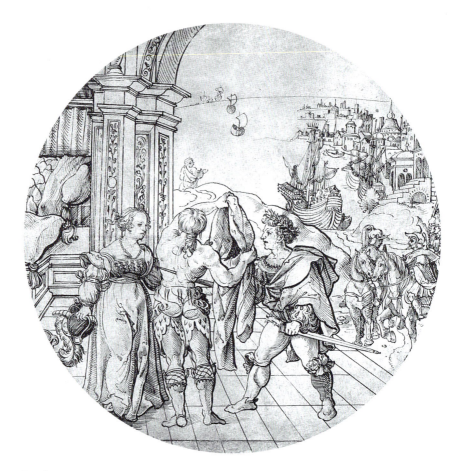

his borrowed details is not obviously modelled upon Italian example; it is personal and idiosyncratic, a vision of the Antique that has been formed under the pressure of its own meanings and compulsions and not those of mere mimesis.

Some light as to the method of assimilating and applying Italianate motifs and the qualities artists attached to them is to be found in a treatise on Art, the *Kunstbüchlein* of the Strassburg painter, Heinrich Vogtherr the Elder.[17] Though it was first published in 1538, a year after Breu's death and a full 10 years after the *Lucretia*, Vogtherr was active in Augsburg during the early 1520s. His teacher is not known but, as John Rowlands has pointed out, the most prevalent influence upon him seems to have been Jörg Breu.[18] His style of decorative classicism of the 1530s is very close to that of Breu's late style and that of his son and successor, Jörg Breu the Younger (*c.*1510–47), who took over his father's studio. It is likely that the *Kunstbüchlein* reflects the methods of Vogtherr's Augsburg contemporaries. It contains none of the theory, condensed or otherwise, of the Albertian tradition that characterized Dürer or Schön. Instead, it conforms to an essentially medieval pattern-book format, consisting of a large number of designs, of Italianate/classical character, of exotic head-dresses, of designs for armour, weapons, escutcheons,

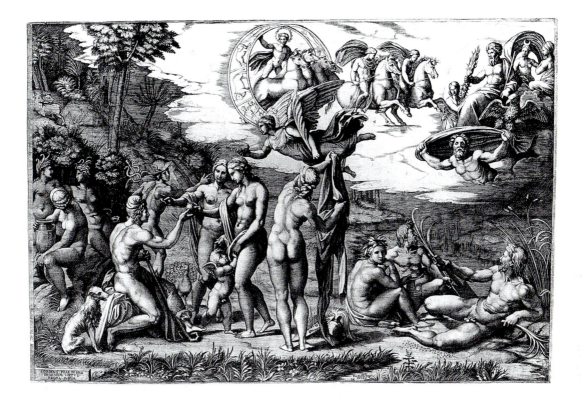

4.8 Marcantonio Raimondi, after Raphael, *The Judgement of Paris*, engraving

capitals and pilasters, all fantastically elaborated in shape and decoration. Together with these are pages of character types, hands, arms and feet, drawn in different poses and gestures and from different angles (Fig. 4.9). The work was practical in outlook and purpose. As Vogtherr wrote in the preface, it was intended to be of use to all artists, whether painters, goldsmiths, embroiderers, sculptors, cabinet-makers, and in particular those stay-at-home German artists, burdened with wife and children, who were unable to broaden their outlook and knowledge through travel.[19]

What is striking is the closeness of conception of these 'classical' details to those Breu exhibits in the *Lucretia* as well as his other commission for Wilhelm's history cycle, *The Battle of Zama*, painted at the same time (Plate 10 and Fig 4.5). Though they share a common source in Italian nielli and prints, the similarity between individual capitals or helmets, even sections of anatomy, is so close that one might almost infer that Vogtherr drew in part upon Breu's own works for his examples. Vogtherr's collection of individual details of Italianate designs and anatomy surely reflects in codified form the method by which artists such as Breu acquired a 'classical' manner, a studio practice of assiduously building up a store of isolated motifs and elements, plundered magpie-like from Italian prints. The awkwardnesses of a figure such as the man on the extreme right of the *Lucretia* may be explained if one sees his body as a composite of discrete borrowings, such as those offered by Vogtherr. This would explain the concentration upon details at the expense

4.9 Heinrich Vogtherr the Elder, pages from the *Kunstbüchlin*, (Strassburg, Heinrich Vogtherr, 1538), woodcuts

of the whole, the unnatural emphasis placed upon the knees, the stiffness of the torso and the awkward relationship between the upper and lower body.

Vogtherr asserted in his preface that he wrote the *Kunstbüchlin* because, as a result of the new religious atmosphere (of Protestantism) the arts in Germany were in a calamitous state.[20] He feared that artists would give up their profession in great numbers. His book was therefore to act as a means to maintain the standards of German art in this difficult period, in order that

the German Nation uphold its position amongst other nations, 'not as rough barbarians but with great achievements in all the arts'.[21] He therefore has brought together everything that is 'foreign' and 'most difficult' and 'imaginative' in order to stimulate artists that they might bring to the light of day even higher and finer achievements, so that art would once again rise to its proper position of honour and prestige and Germans rival other nations.[22]

In these words one sees Vogtherr's prescription for a new art. Robbed of its traditional religious purpose as a consequence of the Reformation, art has become a secular exercise. Its purpose is one of general cultural prestige – to show other nations that the Germans are not barbarians, but a 'German Nation', with a culture and tradition of their own. One recognizes here the cultural chauvinism of the Strassburg literary humanists such as Jacob Wimpheling, whose efforts in literary creation had been made in a spirit of strident competition with Italian humanism.[23] Vogtherr usefully enumerated the essential qualities that he invested in the classical elements he presents: the foreign, the exotic, virtuosity in execution, imagination and invention. These factors have guided his choice of materials in the pages that follow – in the heads, costumes, weapons and architectural and anatomical parts. It is such notions that colour his idea of the Italian, the same connotations that the term *welsch* itself implies.

These qualities also infuse Breu's *Lucretia*: the variety and invention shown in the decorative elements, the exoticism of the costumes, the straining after Italian effect in the spatial organization and in the details of anatomy. The *decorative* nature of the *Kunstbüchlein*'s examples is of great significance, since Vogtherr was unconcerned either with subject matter or with the expressive elements of art. That he addressed his book not only to painters and sculptors but to goldsmiths, embroiderers and cabinet-makers as well, reveals a belief in the status of pure decoration, in and of itself. German artistic prestige shall be maintained by a notion of elevated and exotic style.

Vogtherr's model of decorative classicism found its most fertile expression in the applied arts, particularly metalwork, and within an aesthetic and theoretical framework increasingly governed by notions of display.[24] The book was reprinted, twice by himself in 1539 and again in 1540, twice with Latin, once with a German text. Further editions were printed in Strassburg after his death, in 1545, 1559 and 1572. In 1540 and in following years, versions with Spanish and French texts appeared in Antwerp. It was thus an important precursor to the kinds of pattern-books of the type popularized by Jacques Androuet Ducerceau and Hans Vredeman de Vries later in the century.[25] It codified and helped spread an attitude to the classical style and a method of producing it that Breu was one of the first to pioneer and therefore links Breu to the broader Northern 'classical' movement of the sixteenth century.

Given Breu's stylistic influence upon Vogtherr's brand of classicism, can one attribute the same motivations in the use of this style to the older artist? Was Breu's attitude to classicism also primarily decorative, and if so, what meanings did such decoration convey? It might be reasonable to suppose that

the change in style from drawing to the finished panel in the *Lucretia* was determined by the demands of the patron, Wilhelm IV. Yet the Duke does not seem to have imposed particular requirements of style upon his painters. The other works within the same cycle of *Virtuous Women* lack the same degree of classicism. The figures in Hans Schöpfer's *Story of Virginia* of 1535, for instance, are dressed in contemporary sixteenth-century costume, with the single exception of a solitary Roman soldier on the right foreground. Only in the frescoes on the right-hand background buildings does one see a perfectly developed Italianate style, that imitates a Venetian fresco style. Yet these *welsch* elements are restricted to broader details of an imaginary architecture. From the evidence of such subsequent paintings, it appears that the choice of decorative classical setting and style in the *Lucretia* belonged to Breu.

One might look instead to the function of the painting as a determining factor of style and composition. For the *Lucretia* was not merely an historical narrative; the heroine was intended to be an exemplum of matronly chastity and virtue; one of a series that included Cloelia, Susannah, Virginia, Esther and the Empress Helena. In a manner comparable to the decoration of fourteenth-century palaces and public buildings with *Viri Illustres*, or the *Nine Heroes and Heroines*, Wilhelm's series showed exemplary deeds and events which were supposed to mirror the virtues of the ideal ruler. This is expressed in formal terms by Lucretia's pose, facing the spectator frontally in the attitude of a *Man of Sorrows*: one might compare her attitude of martyrdom with that of Christ in Dürer's *Small Passion* woodcut of *Doubting Thomas* (B.49).[26] Breu has here adopted the humanist tradition of Petrarch and Boccaccio in portraying Lucretia as an image of virtue and her fate as a kind of martyrdom, whose death has become a signal for revolt, rather than the older medieval Christian usage of her as a victim of tyranny and a motif of despair.[27]

In an article of 1935, Hermann Beenken criticized what he saw as the coldness and stylistic decline of this painting and accused the artist of 'reducing the drama of Roman female virtue to a conversation-piece, where the stage is of more importance than the action'.[28] Yet a review of early sixteenth-century Augsburg art reveals the same kind of classicizing form and decoration belonging to the province of allegorical and exemplary representation. It is found in the allegorical woodcuts of Hans Burgkmair: his *Wrath* from a series of Virtues and Vices, is depicted in the classical armour of Mars, standing in a niche formed by a classical arch and socle. In this figure, as in another woodcut of *Mars* himself (Fig. 4.10), one finds the same elaborately decorative costume that is to mark the later classicism of Breu's battling Romans in the *Battle of Zama*, and indeed of Vogtherr's fragments. Closer in narrative format to Breu's *Lucretia* is a small limewood panel of *c.*1520, possibly by Sebastian Loscher, of an *Allegory of Power and Wealth* (Fig. 4.11), in which a seated, emperor-like figure (who has been identified as Jacob Fugger), receives the figure of Wealth, introduced by a classically dressed herald.[29] The architecture in the *Allegory* is generically close to Breu's and has a similar monumental effect.

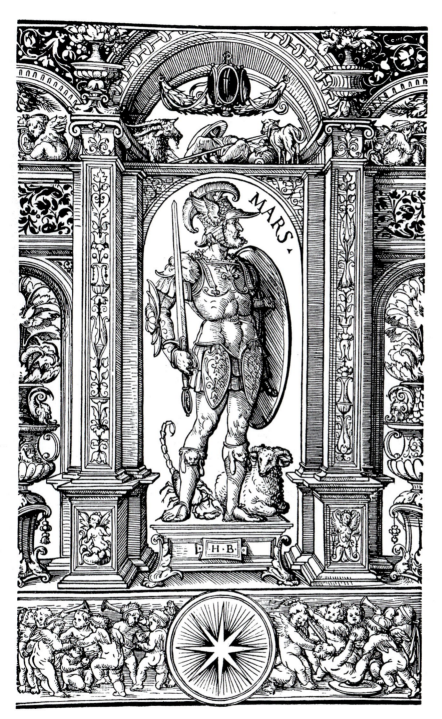

4.10 Hans Burgkmair, *Mars*, woodcut

4.11 Sebastian Loscher, *Allegory of Power and Wealth,* limewood relief

4.12 Doman Hering, *The Temple of Friendship*, Solnhofen limestone relief

The link between classical architecture and the representation of exemplary types, of the visual expression of nobility and virtue through classical style is made quite explicit in another commission for Duke Wilhelm of *c.*1534: the so-called *Temple of Friendship* atttributed to Doman Hering (Fig. 4.12).[30] Its imagery is founded on the exemplary tradition mentioned above, for it is based on Burgkmair's woodcut of the *Three Good Christians* (B.64). Onto the figure of Burgkmair's Charlemagne have been imposed the portrait features of Duke Wilhelm, onto King Arthur, those of Pfalzgraf Ottheinrich, and onto Godfrey of Bouillon, those of Pfalzgraf Philipp der Kriegerische. The reliefs in the coffering show, among others: Lucretia, the Judgement of Paris, Susanna and the Elders, Pyramus and Thisbe, Marcus Curtius, Judith, Cleopatra, and Cimon and Pera: in other words those exemplars of particular virtues that the three figures below embody. In the relationship between these panels

and the portrait figures beneath, one sees in miniature the intention of the painted series vis-à-vis the living Duke.

In the *Lucretia*, Breu used a similar classicizing form and decoration to express the same notion of the exemplary. The grandeur of the forms and of the architecture was intended to convey not merely time and place, but something of the moral authority and antiquity of ancient Rome and of Roman example. The architecture both frames the narrative elements and through its rich ornamentation, gives rhetorical force to the two central episodes, the suicide itself and the avowal of revenge.

Breu thus found in the Augsburg/Burgkmair allegorical tradition a fruitful starting point for his own representation of the exemplary. The decorative classicism recommended by Vogtherr in his treatise for use by German artists had in this context a semantic function beyond the merely decorative. Can one find further corroborative evidence that style was endowed with particular moral or ethical qualities? And what of the second notion, raised by Vogtherr's treatise, that classical ornament be used to create a self-conscious Germanic classical style, in competition with that of Italy?

Overt competition with Italian style was explicitly and consciously registered in other areas of production, notably printing. The Augsburg printer Günther Zainer produced a calendar in traditional Gothic type in 1472 but, in the same year and in the following, reprinted it in Italian *antiqua* type. Signing his name at the end, he explicitly stated that he had produced it in a happier medium: *ne italo cedere videamur* ('lest we be seen to cede to Italy').[31] This seems to be the only known case of a printer of the fifteenth century commenting upon his typographical practice but it gives a clear expression of the confidence to compete typographically with Italian printers on their own terms and in a borrowed idiom.

A further, more complicated, manifestation of this spirit of competition with Italy is to be seen in an album of script types, the *Proba centum scriptorum*, produced in 1517 by Leonard Wagner, one of the last and greatest professional scribes in Augsburg. He placed at the beginning as his most favoured script for all books that did not serve the liturgy, a script known as *gothico-antiqua*, or *Rotonda* (as he himself called it). He described it thus:

Of all the scripts it is the most noble. It is called the mother and queen of the others, and excels over all other scripts in its style [*racione*], its authority and its excellence. Style, because it is more legible, authority because it is more noble, excellence, because it is more distinguished [*praestancior*] and more ancient [*antiquior*]. (Fig. 4.13).[32]

Here, in the field of script design, are to be found ethical qualities attached to style: authority through nobility of style, excellence through historical precedent and its antiquity. Without the example of the script, one might assume from this description that Wagner was referring to *antiqua* script. Both Dürer and Erasmus praised this latter script for similar qualities of legibility and a dignity afforded by its antique origins. And from Basel to Antwerp, it became the favoured type for humanist and classical texts.[33] Yet

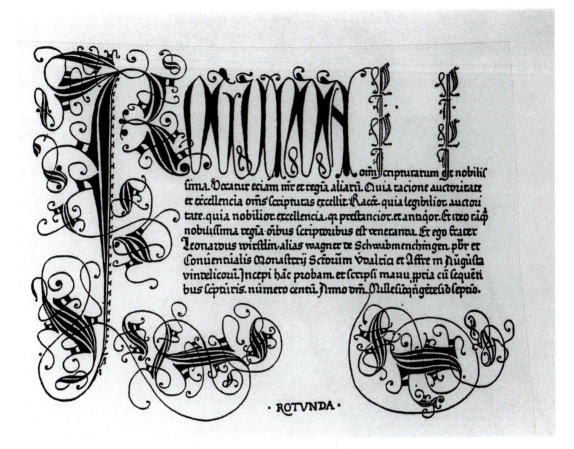

4.13 Leonard Wagner, *Rotonda Script*, page from *Proba centum Scriptorum*

in Augsburg, between 1470 and 1520, the *gothico-antiqua* took root, alongside the imported *antiqua* of Italy, as a suitable, modern substitute for the old-fashioned Gothic.

As its name implies, the *gothico-antiqua* conjoined Gothic forms with simpler, clearer 'antique' elements. In this case however, those latter elements were derived from a northern antique tradition, of *romanesque miniscule*. In this conscious historicism, drawing from an *indigenous* classical tradition, one might perceive a taste for forms, suitably authoritative in their antiquity, that belonged to a native historical tradition, as alternatives to that of Italy.

In the pictorial arts, one finds in Hans Burgkmair's sketch for a proposed equestrian monument to Maximilian a cognate of Wagner's *gothico-antiqua* (Fig. 4.14). It is an image of the Emperor as knightly hero of the Teutonic medieval tradition, yet constructed in the unmistakable forms of the Italian Renaissance equestrian monument – as Wehmer put it, a kind of northern Colleoni. On the plain, rectangular, classical pediment, as if matching these dual elements of pictorial style, the Latin inscription is written in *gothico-antiqua* script and signed by Leonard Wagner.[34]

Breu's familiarity with the meanings inherent in scriptural style may be inferred from his cooperation in the humanist printing projects for the

4.14 Hans Burgkmair, design for Gregor Erhart's *Equestrian Statue of the Emperor Maximilian I*, pen and wash on paper

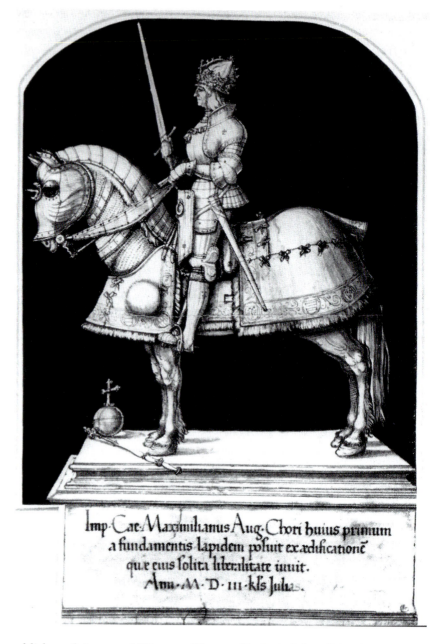

Imp·Cæ·Maximilianus Aug·Chori huius primum
a fundamentis lapidem posuit ex ædificatione
quæ cuius solita literalitate iuuit.
Ano·M·D·III·kls Julias.

publishers Grimm and Wirsung. Thomas Vogler's *Lehrgedicht*, for example, discussed in Chapter 3 (see Fig. 3.23), is given an added emotional force at certain points in the work by the use of music. The choice of different types, a *gothica-textura* at the emotionally loaded parts, a modern *antiqua* for the expository sections, are meant to mirror the content and to aid oral exposition.

The equation between Gothic form and religious feeling that this typographical arrangement registers was also made by Leonard Wagner and other users of script in their keeping a Gothic type or script for liturgical

purposes. This practice might have implications in the wider usages of the *welsch* and the *deutsch* styles in the fine arts. Breu's sensitivity to this type of meaning inherent in different orders of decoration, may be inferred from his sketch for a family epitaph, executed some time in the 1520s (see Fig. 1.28). He draws the 14 Auxiliary Saints in an entirely *deutsch* manner, comparable to that of the *Lucretia* sketch. The architecture that surrounds them is classicizing, but is softened by Gothic decorative elements that are in keeping with traditional tone of religious devotion. It too forms a pictorial equivalent of the *gothica-antiqua*.

Hans Fugger, in a letter of 1568 to David Ott in Venice, expressed vividly the difference in tone between the two styles when he wrote to reject an Italian painting of the *Resurrection*. He criticized the Italianate manner of using gratuitous artistic effects at the expense of a proper and accurate treatment of the theme, desiring in its place the simpler and more decorous style of the German tradition. He wrote of the painting:

it has certainly been artfully painted, but the Resurrection hasn't been made as it should, for our Lord should stand up out of the tomb and not fly around as he does here ... The panel is therefore not appropriate, it is too much *à la italiana*, flashy [*frech*] and in such a manner that standing in front of the altar, one can't tell what is going on.

In its place, he continued:

I would like something devout and beautiful and not this kind of thing, where the painter is showing off his skill and nothing else. ... Your *welsch* painters are far too fanciful [*vagi'*].[35]

Hans Fugger might have felt much the same way about Jörg Breu's *Meitinger Epitaph* of 1534, (Fig. 4.15) which, like the *Lucretia*, is painted in a wilfully classical style. This is explicable in terms of a well-to-do and worldly merchant family wishing to have their memorial in the fashionable style of Italy, rather in the manner of the Fugger Chapel in St Anna. The patron, Conrad Meiting, was married to Barbara Fugger and their epitaph was intended for the same church. Even so, it might be worthwhile to consider the painting within the context of the relationship between the classical style and the Reformation. For one finds here the style applied to a religious work, painted, moreover, at the height of the iconoclastic outbursts in Augsburg, three years before the full official implementation of a Protestant reform of the city's churches. The fact that Breu painted this work at all in the light of the strong Zwinglian sympathies he expressed in his *Chronicle* in the 1530s is difficult to explain other than that he was forced to continue making a living. Given the apparent contradiction, one might ask whether the style he so conspicuously adopted was in any way a response to the increasingly problematic status of religious images within the city. Might the style have been in some way both acceptable to the Catholic sensibilities of the commissioning family, conscious of the need to address reformers' questions of pictorial decorum, as well as allowing

4.15 *The Meitinger Epitaph*, oil on panel

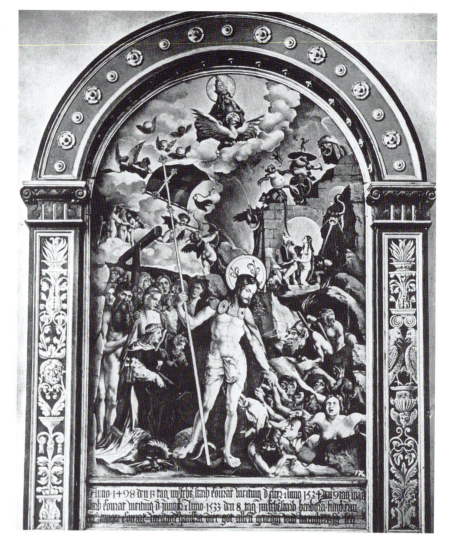

the Protestant artist a form of religious expression that squared with his antipathy to devotional imagery?

It is true that there existed a Protestant tradition that equated the classical style with paganism, Rome and, by extension, Popish superstition. When Hans Burgkmair, Altdorfer or Lucas van Leyden portrayed *Solomon's Idolatry*, the pagan deity to which he knelt was dressed in a manner both classical and exotic, comparable to that used by Breu and Vogtherr.[36] This tradition finds its apogee in John Milton's vision of classical magnificence in Satan's palace of Pandaemonium, half noble, half corrupt:

> Built like a Temple, where Pilasters round
> Were set, and Doric pillars overlaid
> With golden Architrave; nor did there want
> Cornice or Frieze, with bossy Sculptures grav'n;[37]

Yet despite this persistent undercurrent of hostility, another tradition within Protestantism saw positive values in the classical manner, as a substitute for an older Gothic style, tainted with associations of superstitious usage. This attitude was particularly strong in Augsburg, a city proud of its Roman origins and traditions where, as discussed above, with its close geographical and commercial links with Italy, the *welsch* style took root easily. On the one hand, Italian fashions in art and architecture were identified with the wealthy merchant classes. The Renaissance style of the Fugger family's funerary chapel in St Anna's was regarded by certain members of the German aristocracy as a nouveau-riche parading of wealth.[38] On the other hand, within the context of the power struggle between the secular authorities and the Church during these years, the classical style was also used to assert the pedigree of the city's secular civic community by reference to its Roman imperial heritage. On 26 Febuary 1537, the year of the Protestant Reformation in the city, the Bishop of Augsburg, Christoph von Stadion, wrote a letter to the Emperor and Reichstände, bitterly complaining about the removal of a statue of St Ulrich, the patron saint of the city, from its position above a fountain in the main square, and its replacement by a full-size naked 'idol': an emphatically *welsch* Neptune (Fig. 4.16).[39] While St Ulrich was a traditional symbol of the community, in style and subject it clearly also contained an assertion of the authority of the Church within the secular life of the city. Its removal by the Council marked a desire to remove all such traces within the town. St Ulrich was traditionally associated with water and the choice of a Neptune to replace him might be seen as a deliberate secular alternative. It is significant that while the Bishop could refer to it as an 'idol', its secular symbolic properties presumably prevented such a brazen display of the *welsch* style from offending Protestant sensibilities.

In the *Meitinger Epitaph*, Breu's Christ figure is based upon Dürer's visual essay in ideal proportions: the figure of Adam in his 1504 *Fall of Man* engraving (Fig. 4.17). The comparison illustrates the wide divergence between Dürer's intellectual humanism and Breu's notion of decorative style in their respective approaches to the classical. Dürer had written: 'Just as they [Greek and Roman artists] attributed the most beautiful human shapes to their false God Apollo, so we will use the same proportions for Christ our Lord, who was the most beautiful man in the universe.'[40] Dürer captured the *expressive* beauty of Italian classicism: the supple athleticism of the human body at its most beautiful is used to express an *inner* perfection of spirit. Breu's application of style by contrast is purely external: the effect is cold, artificial, impersonal, and calculated to distance. Reformers from Luther to Zwingli condemned as 'idolatrous' all images that, by their mimetic exactness to the life, inspired reverence towards themselves, and not the personage re-presented. For Luther, however, of all the reformers the most tolerant towards images, cheap woodcut images continued to serve as legitimate mnemotic aids and stimuli to devotion. As he said, 'One does not pray to penny images, nor does one trust them. They are *Merckbilder* [mnemonic images – to help 'mark' in the memory], and we do not reject them.'[41] Luther praised

4.16 Sebastian
Loscher attrib.,
Neptune, bronze

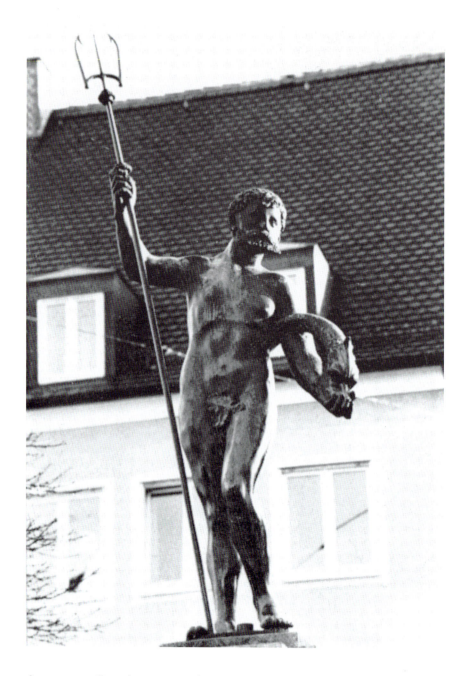

the very crudity of execution, for it limited the image to the function of a sign that referred directly to its substance without external reference or aesthetic distraction. The expressive poverty of such images ensured that they could not be taken at face value.[42]

A classical style, something perceived as foreign, decorative and inherently unnaturalistic could perform a similar distancing function. By representing the divine in so stylized a manner, it too presented no danger of idolatry for it

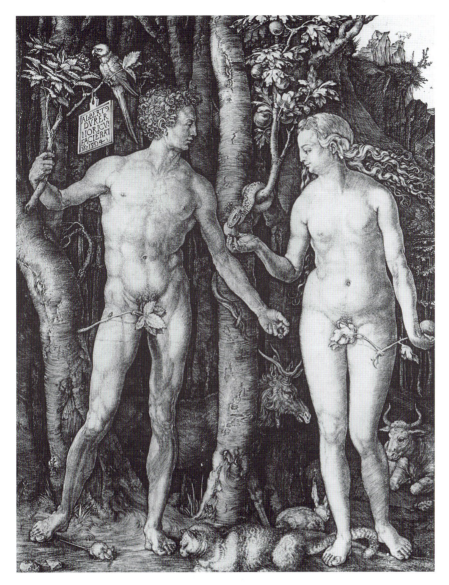

4.17 Albrecht Dürer, *The Fall of Man* 1504, engraving

could not be taken at face value as a representation of 'reality'. The classical form of the *Meitinger Epitaph* could thus present a credible and acceptable alternative to the Gothic. Unlike the cheap woodcut, it possessed a rich aesthetic character, the semantic meanings of which were borrowed from the tradition of exemplary forms of classical allegory. In this way Breu's use of the *welsch* evolved from its beginnings in classical subject matter into a general rhetorical convention, denoting an 'elevated' or grand manner that did honour to its subject through style rather than expressive means. When applied to religious subjects, it provided a new stylistic model which, tied more to allegory than to realism, could, in principle at least, successfully bypass the issue of idolatry and win the acceptance of Catholics and moderate reformers alike.

Breu's idea of the 'classical' was therefore very different from the monolithic tradition of ideal form as which, since Winckelmann, it has tended to be regarded. Together with a degree of interest in Italian formal construction, the *welsch* was to him primarily a form of exotic, valued for its strangeness, its richness and its grandeur of forms – an attitude governed by a largely historically naïve idea of Ancient Rome and its artefacts.

As the Reformation took hold, the tradition of a personal, individual style tied to the expression of religious sentiment, gave way, as Vogtherr registers, to a decorative, secular style governed by notions of prestige and outward display. The jump between the drawing and the painting in the formation of the *Lucretia* registers a particular moment in that progress from the individual to the generic. Drawing on a tradition of decorative classicism in the representation of the allegorical and the exemplary, and created in a city with strong Roman roots and imperial traditions, Breu's classicism also displays the desire to emulate, if not surpass, the Italians in a consciously home-grown classical style. In this sense, from the 1530s onwards, the *welsch* paradoxically became a new and assertive form of the *deutsch*.

Notes

1. See Appendix.

2. For a summary of the evidence of the contexts in which glass roundels were placed and further bibliographical references, see the introductory essay in Husband (1991), 17–20. Certain of Breu's series, such as *The Professions* (Dresden, Kunstgewerbe Museum) might suggest more civic contexts, such as a guild hall.

3. Munich, Bayerisches Nationalmuseum, inv. nos G723–34. Nothing is known of its original setting. See Los Angeles (2000), 225–32.

4. See Wegner (1959).

5. This is fully discussed by Dormeier (1994), 102–27.

6. See Bellot (1980), 90–91.

7. Basel, Öffentliche Kunstsammlung, inv. no. 133. The dating of this work has not been consistently agreed upon. Röttinger (1909, 34), Antal (1928, 31) and Cuneo (1991, 541–2) regarded it as a work of c.1515; the majority of writers have followed Buchner (1928a, 372) in dating it c.1525, a dating to which I also subscribe.

8. Blankenhorn (1973, 98) found sources for the medallions in the temple structure in Italian plaquettes. Baer (1993, 93) found parallels between the details of architecture and Venetian Renaissance architectural relief mouldings, as well as similarities for the triple-arcaded temple with similar structures in the paintings of Carpaccio. The middle-ground structure is clearly based upon the Pantheon.

9. Munich, Alte Pinakothek, inv. no. 7969.

10. On the circumstances of the commission, see Goldberg (1983).

11. Wood (1993), 19.

12. Baxandall (1980), 135–43.

13. See L. B. Alberti, *Della Pittura*, ed. Spencer (1977), Book 1, 56–8.

14. Buchner (1928a), 370.

15. New York, Pierpont Morgan Library, inv. no. 1966.1.

16. Oberheide (1933).

17. Heinrich Vogtherr, *Ein Frembdes und wunderbarliches Kunstbüchlin/ allen Molern Bildtschnitzern/ Goldschmiden/Steynmetzen/ waffen/ und Messerschmiden hochnützlich zügebrauchen/ Dergleichen vor nie keines gesehen/ oder in der Trück kommen ist* (Strassburg, 1538).

18. Rowlands (1988), 148.

19. Vogtherr, *Kunstbüchlein*, Aii verso: 'habe ich Heynrich Vogteherr/Moler und Burger zu Straßburg/ auß Bruderlicher liebe/ menigklichen zu nutz/ und sollichen künsten zur fürderniß/ auch den jhenigen/ so inn gemelten künsten/ mit wieb und kinden beladen/ auch etlichen/ so von natur weit umbreysens ungewohnt …'

20. Ibid., Aii: 'Nach dem der barmherzig Gott auss sonderer Schickung seines Heyligen worts/ jetz zu unsern zeiten in ganzer Teutscherr nation/ allen subtilen und freien Künsten/ ein merckliche verkleynerung unnd abruch mitgebracht hat …'

21. Ibid., Aii: 'und solche Künstler … volfürter handlung in kunstlichen übungen nit matt oder müd werden und sich in gemeyner Christenheyt nit alss die groben Barbari/ sondern wie man … Teutsch Nation inn allen künsten hohelichen auffgestigen syhet.'

22. Ibid., Aii verso: 'aller frembden und schweresten stücken/ so gemeinlich vil fantasierens/ nachdenkens haben wollen/ … zusamen in ein büchelin gebracht … die hochverstendigen visierlichen Künstler dardurch ermundert unnd ermanet werden/ noch vil hoher und subtiler kunsten aus bruderlicher liebe an tag zubringen/ damit die Kunst widerumb in ein auffgang/ und seinen rechten wirden und ehren komme/ und wir uns anderen Nationen befleissen fürzuschreiten.'

23. See Joachimsen (1910); Borchardt (1971).

24. See, for instance, Dacosta Kaufmann: (1985), 11 f.; and (1982), 119–48.

25. See Jessen (1920) and Jervis (1974).

26. Blankenhorn (1973), 89.

27. See de Chapeaurouge (1960), 145–6; and, for a useful discussion of Lucretia imagery, Garrard (1989), 216–39.

28. Beenken (1935), 565: 'Überall ein verbindliches Kommen und Gehen, man verschwört sich unter konventionellen Beteuerungsgesten. Das Drama römischer Frauentugend ist hier zum Konversationsstück geworden, bei dem die Bühne mehr als die Handlung gilt.'

29. Berlin, Staatliche Museen Preußischer Kulturbesitz, Skulpturengalerie, inv. no. M98; see Augsburg (1980), vol. 2, 194, no. 568.

30. Relief of Solnhofen stone and scagliola (the scagliola probably a 17th-century addition), 36.2 x 29.3 cm., Schloß Neuenstein, Hohenlohe-Museum, inv. no. NL69; see Goldberg (1983), 62–3. For the attribution to Doman Hering, see Eser (1996), 287–90.

31. See Wehmer (1955), 145–72.

32. Ibid., 148: 'Omnium scripturarum est nobilissima. Vocatur eciam mater et regina aliarum, quia racione, auctoritate et excellentia omnes scripturas excellit. Racione, quia legibilior, auctoritate, quia nobilior, excellencia, quia prestancior et antiquior.'

33. See Panofsky (1971), 258.

34. Wehmer (1955), 158.

35. Baxandall (1966), 127–44.

36. See Falk (1980), 13, no. 4; Marrow (1981), vol. 12, 162, no. 30; and Koch (1980), vol. 14, 12, no. 4.

37. John Milton, *Paradise Lost*, Book 1, 713–22. See Thomas (1995), 225.

38. See Ulrich von Hutten, *Schriften*, ed. Böcking (1860), vol. IV, 391–2; quoted in Baxandall (1980), 137–8.

39. '… daß die von Augsburg, als widersinnige Leute, S. Ulrichs, deß heiligen Bischofs Bildnuß, so lange Zeit auff den Berlach gestanden ist, verachter weiß hinweg gethan/ vnd an derselben statt deß Abgotts Neptun Bildnuß auff den Brunnen gestellt haben.' Quoted in Augsburg (1980), vol. 2, 502, cat. 502. The statue is attributed to Sebastian Loscher.

40. Quoted by Panofsky (1969), 213–14, n.36.

41. 'Die Groschen Bilder betet man … nicht an, man setzet kein vertrawen drauff, sondern es sind Merckbilde … [D]ie verwerffen wir nicht.' 'Seventh sermon on Deuteronomy, 21 October 1529', in Martin Luther, *WA*, vol. XXVIII, 677; quoted in Koerner (1993), 381.

42. Ibid., 382.

5
Conclusion

In 1535, two years before Breu's death, the Nuremberg artist Georg Pencz produced a broadsheet illustration to accompany verses by Hans Sachs that showed the *Nine Muses*, pale, hungry and bedraggled, emerging in their sandalled feet from a dark, wintry, German forest (Fig. 5.1).[1] As they tell the huntsman who encounters them, where once and for so long they had been celebrated and honoured in Germany, under the current circumstances they are unwanted and neglected. They are therefore leaving to go back to Greece. Though Sachs blamed this exodus of artistic inspiration from Germany chiefly upon capitalistic greed and speculation, the print registers the eclipse of the efflorescence in the arts of the previous generation, brought about largely by the Reformation. Pencz's Muses conjure up this flourishing earlier period, for they are consciously derived from Dürer's allegorical figures which adorned the floats of the Emperor Maximilian's *Triumphal Procession*, a lasting symbol of Germany's leading patron of the arts and of German cultural prestige (Fig. 5.2). Pencz here inaugurates the powerful nostalgia for the *Dürerzeit* that was to be felt so keenly in the later sixteenth century and which was to be picked up with renewed strength by the Romantics, three centuries later.[2] Yet though, for Sachs, the Muses had been toppled from their triumphant thrones and were returning sorrowfully to Mount Parnassus, in fact, both the arts and the influence of the South were to endure, albeit in diminished form. As Pencz's print itself paradoxically registers, both the idea and the forms of classicism were to survive. In Augsburg, the type of decorative classicism developed by Breu and his contemporaries continued after his death and took strongest root in, on the one hand, fresco schemes for the façades of the merchant houses, and, on the other, the small-scale luxury arts: in ivory-carving, printed books, manuscript illumination, glass painting and metalwork.

The tenacity with which Breu's designs survived after his death is testimony as much to his powers as a designer as to the waning artistic vitality of the succeeding generation. His designs were adopted both literally and in elaborated variations in a variety of media, both by his son, Jörg Breu the Younger, and by subsequent artists. Mention has been made of the lasting influence of his glass-roundel designs throughout the century;[3] and clearly his designs continued to be an important resource for the workshop after his death. The point is illustrated in Jörg Breu the Younger's most impressive surviving work, his illuminations to Hans Tirol's *Antiquitates* of 1541, a lavishly produced book containing more than 200 illustrations, privately

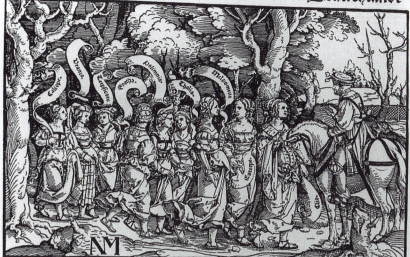

5.1 Georg Pencz, hand-coloured woodcut illustration to Hans Sachs, *Die Klage der Musen Über Deutschland*, 1535

commissioned by Jacob Hörworth, a Bürgermeister of Augsburg, as an intended gift to Henry VIII of England.[4] Many of the illustrations are adapted from the father, at times quite literally, as in a copy of the glass design of *Architectura* (Fig. 5.3); at times in a spirit of creative variation, as in his version of *Scenes from the Life of Lucretia* (Fig. 5.4). In this latter example, while the general disposition of the poses has been retained, the overt classicism of the original has been turned into an undogmatic, hybrid style: classical reference is maintained brilliantly in the architectural surround but in the figure group it survives only in a certain urbanity of stance and

5.2 Albrecht Dürer, Detail from *The Triumphal Procession*, woodcut

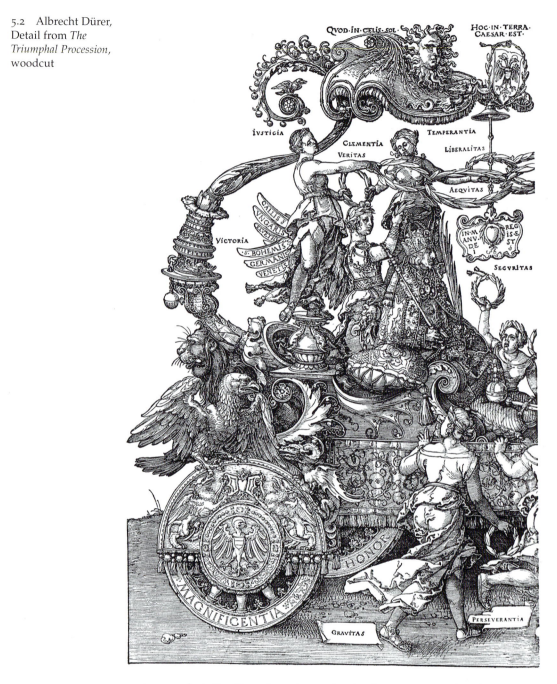

gesture and stylization of anatomy (as in the exaggerated calves) of the foreground male figures. The costumes are elegantly contemporary, more akin to Breu the Elder's *Lucretia* sketch than with his finished painting. This brand of descriptive naturalism inflected by certain Italianisms of form constituted, in fact, one of the elder Breu's most important legacies to the Augsburg tradition.

5.3 Jörg Breu the Younger, *Architectura*, pen and brown and black ink, with watercolour, body colour and gold on vellum, illustrated page from *Joannis Tirolli Antiquitates*, 1541

Similarly, Breu's dense conglomerations of twisting and convoluted soldiers and horses and the classicism of the armour that he had developed in the *Battle of Zama* were transcribed literally into glass-roundel form by the Breu workshop, as a surviving design, today in the E. B. Crocker Collection in Sacramento, testifies (Fig. 5.5); and the same formal vocabulary reappears as elaborate and sophisticated decoration in a design for a scabbard by Jörg Breu the Younger, of *c*.1545 (Fig. 5.6).[5]

In such ways, deprived of the social functions which had given religious art a position of primacy within the culture, painting in Augsburg survived as a minor, decorative activity into the second part of the sixteenth century. The departure of the Holbein family in the second decade and the deaths of Hans Burgkmair and Leonard Beck in 1531 and 1542 respectively, effectively ended the progressive tendency towards an art that was based upon perceptual realism. It was continued in the next generation by the brilliant but largely unique figure of Christoph Amberger and, in the Reformed climate, it could find root only in portraiture. Long before the century's end, an indigeneous 'Augsburg School' of painting had ceased to exist and any artists of note came as temporary visitors from outside.[6]

5.4 Jörg Breu the Younger, *The Story of Lucretia*, pen and brown and black ink, with watercolour and body colour and gold on vellum, illuminated page from *Joannis Tirolli Antiquitates*, 1541

Viewed within this broader context of Augsburg art in the sixteenth century, Breu the Elder assumes a position of some importance, for his art powerfully embodied a general tendency that ran parallel with and, in a sense, counter to the Renaissance aesthetic of realism that has usually been regarded as the main defining feature of the German Renaissance. In fact, Breu's art, like that of the majority of contemporary artists trained in the Gothic, craft-based tradition, represents a retreat before perceptual realism. As has been seen, at all stages of his development his art perpetuated the Gothic pattern-book method of assimilating and adapting second-hand motifs. This was a method

5.5 Workshop of Breu the Younger (?), *Battle Scene*, design for glass roundel

that grew out of the production of religious imagery. This, in turn, depended upon a manner of looking that was rooted in common epistemological principles of the Middle Ages, in particular, upon the assumption that the outward, physical objects of the visible world were symbols of a higher, spiritual reality.[7] In the mystical practice of late-medieval devotions, a central function of the image was to help the worshipper progress from a purely physical 'seeing' to a higher level of spiritual contemplation. The role of perceptual realism in this exercise, while by no means incompatible, was neither immediately obvious nor even desirable.[8] In Germany, two kinds of imagery emerged to serve this kind of devotion. One was the ideogrammatic, symbolic representation of deity or saint, which tended to emphasize the mystery and unknowable nature of the Divine; the other was an affective realism of the type which characterized Breu's earliest works, which served in a process of mystical identification with the Sacred. The continuation of such forms of devotion effectively delayed any progression in religious art towards a dispassionate interest in the actual.

5.6 Jörg Breu the Younger, *Design for a Scabbard*, pen and wash in black ink, heightened with white and gold, on blue-toned paper

It is the survival of these fundamentally medieval habits of seeing and the habits of representation they encouraged, which gives an underlying consistency of outlook to the outward twists and turns of Breu's artistic development, from the affective imagery of the early altarpieces, the symbolic and emblematic forms of the 'reformed' imagery of the 1520s, to his adoption of classical forms in the late works. These habits determined his response both to Italian art and to the problems of pictorial decorum and content posed by the Reformation. They most clearly underlie the appearance of the early Austrian altarpieces. The powerful naturalism that he developed in these panels exploited the *expressive* possibilities of the real rather than a dispassionate recording of nature; they strove for affective response over aesthetic interest. It was a naturalism at the service of religious rather than perceptual truth. The kind of seeing such images required was not a detached act of objective looking, of regarding the image as something separate; it was one that involved an intensely emotional relationship with the divine or saintly person represented. An aesthetic based upon the careful scrutiny of natural phenomena was supererogatory to its intentions.

The ingrained habit of inward seeing, of regarding an image as something to be 'seen through', as a means of breaking the veil to a higher metaphysical reality, did not abruptly cease with the advent of the Reformation, or with the demise of the emotion-laden, affective image. It has been suggested that the introduction of Italian 'realist' principles of composition, particularly linear perspective, encouraged the decline of the 'affective gaze' and allowed the development of a new, more objective mode of seeing.[9] In the hands of Hans Holbein – both father and son – or of Burgkmair or Dürer, this notion might hold true. Yet in the case of Breu, the adoption of the principles of Italian composition was unsatisfactory and half-hearted at best and clearly uncongenial to the artist's temperament and artistic intentions. This is evident

in the structural awkwardnesses of such works as the Koblenz *Adoration of the Magi* (see Fig. 1.6). Although, by 1528, the *Lucretia* panel shows an adequate mastery of such principles, in general Breu's essentially 'Gothic' attitude to the image caused him to respond not so much to the formal elements of Italianate composition as to the symbolic, decorative and rhetorical potential that this foreign style contained. His adoption of Italian nielli for his designs for Maximilian I's *Prayerbook* was carried out in this spirit. By using classical and allegorical motifs as visual metaphors of the text, the traditional process of 'looking through' the subject represented to perceive an intended meaning was continued within the new idiom of humanist taste.

A similar attitude is manifest in Breu's response to Reformed tastes for a more sober, unemotional imagery. The Innsbruck *Mocking of Christ* (see Fig. 3.16) exhibits a kind of aesthetic neutrality, where beauty has no relevant place and the ugly, divested of proper narrative function, has become a more purely ideogrammatic signifier of evil. In the systematic stripping away of pictorial effect, in the stern denial of the power of paint to involve the senses, may be seen Breu's struggle to express theological significance in coolly emblematic terms. This picture stands at an opposite pole to the early affective images. No longer a process of mystical identification, it depends instead upon a relationship with the viewer that involves sober, inner reflection and cogitation upon a specific theme, a looking through the subject represented to grasp its wider meaning.

Only gradually did Breu discover in classical forms an idiom that allowed him to reclaim a sense of stylistic coherence and aesthetic dignity that did not conflict with the devotional intention. Understanding classical form, not in its expressive nature, but as an outward rhetorical clothing, he could dress an allegorical or religious idea represented in such works as the *Lucretia* or the *Meitinger Epitaph* with an elevated aura of Antique authority (Plate 10 and Fig. 4.15). Furthermore, the lack of naturalism diverted attention away from the narrative subject, allowing the general significance of the scene to be more fully grasped – in these cases, matronly virtue and the triumph of Christ over the Devil. In this way, Breu's development of a style of classical idealism ensured the continuation, in new secular guise and through new secular themes, of older habits of metaphysical contemplation within the Northern tradition.

Notes

1. Gotha, Schloßmuseum, inv. no. 37,10. See Berlin (1983), 228, no. C 57.

2. See Kaufmann (1993), esp. ch. 3, 79–99, for aspects of later sixteenth-century interest in Dürer.

3. On the influence of the Höchstetter *Months of the Year*, see Wegner (1959).

4. Dodgson (1934), 191–209.

5. Leipzig, Museum der bildenden Künste; see Paris (1993), 88, no. 31.

6. See Krämer (1980b), vol. II, 36–8.

7. On the influential Augustinian formulation of this theory of vision and its influence, see Miles (1985).

8. See Brinkmann (1980); also Ringbom (1969), 159–70.

9. On this question and for the continuation of such visual habits, see Scribner (1989), esp. 463–4.

Appendix: Hand-list of surviving or recorded designs for glass and glass roundels

Series

1 THE MONTHS OF THE YEAR

Glass roundels

Augsburg, Maximilianmuseum:
 October
Kaiserslautern, Kunstgewerbe Museum:
 July

Designs

Basel, Kunstmuseum, Kupferstichkabinett:	11
Berlin, Staatliche Museen, Kupferstichkabinett:	9
Bern, Historischesmuseum, Kupferstichkabinett:	10
Copenhagen, Nationalmuseum, Kupferstichkabinett	2
Dresden, Stadt Kupferstichkabinett:	1
Göttingen, Kunstsammlung der Universität	12
(complete series, monogrammed HB)	
London, British Museum, Department of Prints and Drawings:	3
Nuremberg, Germanisches Nationalmuseum:	2
Paris, Collection Masson, Bibliothéque Nationale:	8
Vienna, Albertina:	1
Washington, National Gallery:	2
Munich Art Trade, 1913 (present whereabouts unknown):	1

The location of versions of the individual months may be summarized as follows:

January:	6	Basel, Bern, Göttingen, Copenhagen, Vienna
February:	5	Basel, Bern, Berlin, Göttingen, Paris
March:	8	Basel, Bern, Berlin (x2), Göttingen, London
April:	5	Basel, Bern, Berlin, Göttingen, Paris
May:	6	Basel, Bern, Berlin, Copenhagen, Göttingen, London
June:	5	Basel, Dresden, Göttingen, Paris, Washington
July:	6	Basel, Bern, Berlin, Göttingen, London, Paris
August:	5	Basel, Bern, Göttingen, Nuremberg, Paris

September: 5 Basel, Bern, Göttingen, Paris, Washington
October: 4 Basel, Bern, Göttingen, Paris
November: 5 Basel, Bern, Berlin, Göttingen, Paris
December: 3 Bern, Berlin, Göttingen

2 THE TRADES

Glass roundels

Series of 6 panels in Dresden, Museum für Kunstgewerbe:
 Venacio
 Vestiaria
 Metallaria
 Mercatura
 Milicia
 Coquinaria (lost 1945)
Darmstadt, Schloßmuseum:
 Mercatura
London, Victoria and Albert Museum:
 Coquinaria
New York, Metropolitan Museum of Art, The Cloisters:
 Architectura (signed with monogram SZ)

Designs

Munich, Kupferstichkabinett:
 Coquinaria
Vienna, Albertina:
 Architectura (signed with monogram SZ and dated 1563)
 Vestiaria
 Metalaria
 Mercatura
Leiden, Prentenkabinett der Rijksuniversiteit:
 Milicia
London, British Museum Print Room:
 Tobias Stimmer: Architectura
 Vestiaria
Berlin, Sammlung Nagler:
 A drawing, *Der Landbau*, mentioned by Dörnhöffer, perhaps related to this
 series, or possibly the Months.

3 THE WARS AND HUNTS OF THE EMPEROR MAXIMILIAN I

Designs

Munich, Staatliche Graphische Sammlung:
 14 Battles from the Wars of Maximilian
 4 Scenes of the Hunts of Maximilian.

The Hague, F. Koenigs Collection (formerly):
 The War against Venice
Salzburg, Museum Carolino Augusteum:
 The Swiss War
Paris, Bibliothèque Nationale:
 The Stag Hunt

Glass panels

Eisenach, Wartburg:
 roundel of one of the Wars, mentioned in Schmitz 1933, 1, 257, fig. 36a;
 possibly identical with a panel now in:
Erfurt, Angermuseum-Museum für Kunst und Kunsthandwerk
New York, Metropolitan Museum of Art:
 The Capitulation of the Town of Grandson to Charles the Bold (?)
Formerly Salzburg, Museum Carolino Augusteum: The Swiss War.

4 THE STORY OF JOSEPH

Glass roundels

Darmstadt, Hessiches Landesmuseum:
 The Meeting of Joseph and Jacob
Munich, Bayerische Nationalmuseum:
 A series of 12 glass panels
Salzburg, Museum Carolino Augusteum:
 The Meeting of Joseph and Jacob

5 THE HOLY WORKS OF MERCY

Glass roundels

Formerly Berlin, Kunstgwerbe Museum, (Schmitz):
 Bringing Relief to Prisoners
 Giving Drink to the Thirsty
 Sheltering the Homeless
Munich, Staatliche Graphische Sammlung:
 Tending the Sick (photographic record in the Dörnhöffer archive)

Designs

Berlin, Staatliche Museen, Kupferstichkabinett:
 Feeding the Hungry
 Giving Drink to the Thirsty

6 THE CHILDREN OF THE PLANETS

Glass roundels

Glasgow, Burrell Collection:
 Saturn
Frankfurt, Museum für Kunsthandwerk:
 Luna

Related designs

Linz, Stadtmuseum, Linz-Nordico:
 Mars
Vienna, Sale, Gustav Nebehay, 1927; Munich, Sale, 29
Helbing, 1933; and Sotheby's Old Master Paintings, London, 29 October
1998, lot 21:
 Saturn (oil on panel, recorded 1927 as a 'rustic scene'; and in 1933 as
 'Allegory of Injustice'; present location unknown)
and *idem*, as pendant to the above:
 Jupiter (recorded, in 1933, as 'Allegory of Injustice'; and in 1998 as 'A
 Scene of Justice')

7 THE CHILDREN OF THE PLANETS

A further group of drawings from other series:

Glass roundels

Berlin, Schloßmuseum:
 Saturn
Erlangen, Sammlung der Universitätsbibliotheque (1E 3):
 Sol (circle of Breu)
New York, The Metropolitan Museum of Art, The Cloisters:
 Venus

Designs

Berlin, Staatliche Museen, Kupferstichkabinett:
 Saturn
 Mercury
Erlangen, Sammlung der Universitätsbibliotheque (1G 33):
 Mars
The Hague, F. Koenigs Collection:
 Mercury
Leipzig, Museum der bildenden Künste:
 Sol
Weimar, Grossherzogliches Museum:
 Luna

8 DAVID AND URIAS

Glass roundel

Salzburg, Museum Carolino Augusteum:
 David and Urias

Design

Oxford, Ashmolean Museum:
 The Death of Urias

9 OTHER SURVIVING GLASS PANELS

Augsburg, Maximilianmuseum:
 Tournament Scene
Nuremberg, Germanisches Nationalmuseum:
 Tournament Scene and related drawing
The J. Paul Getty Museum:
 Tournament Scene

Classical subjects

London, British Museum:
 Titus Manlius Torquatus killing the Gaul
London, British Museum:
 Ulysses and Telemachus slaying the Suitors
Berlin, Staatliche Museen, Kupferstichkabinett:
 Death of Marcus Curtius
Frankfurt am Main, Graphische Sammlung im Städelschen Kunstinstitut:
 Cleopatra (?)
New York, Morgan Pierpont Library:
 The Murder of Agamemnon
Sacramento, E. B. Crocker Collection:
 After Breu: Battle Scene (from the *Battle of Zama*)

A SERIES FROM THE *Gesta Romanorum*:

Frankfurt am Main, Graphische Sammlung in Städelschen Kunstinstitut:
 The Emperor Orders the Child Killed
Private Collection:
 The Lying-in Chamber and Christening
Private Collection:
 The Duke Discovers the Child in the Forest
Private Collection:
 The Emperor and the Page

Los Angeles, J. Paul Getty Museum:
 A Bridal Scene

Religious subjects

Berlin, Staatliche Museen, Kupferstichkabinett:
 The Israelites and the Manna from Heaven (rectangular format with shaped
 upper corners)
Bern, Sale, Klipstein and Knorfe, 16 June, 1960, present location unknown:
 Christ in Limbo (rectangular format, divided into six panes)
Darmstadt, Schoßmuseum:
 Adam and Eve
New York, Metropolitan Museum of Art:
 Scene of Martyrdom/Punishment
New York, Sale, Parke-Bernet, 8 May, 1947:
 St George and the Dragon (oil on circular panel)
Nuremberg, Germanisches Nationalmuseum:
 Scene from the St Ursula Legend
Veste Coburg:
 Martyrdom of St Victor (Execution of Bessus?)
Vienna, Albertina (attributed to Jörg Breu)
 Martyrdom of St Stephen
 Martyrdom of St Paul

Bibliography

Unprinted primary sources

STADTARCHIV, AUGSBURG (STAA)

Reichstadt Schätze:
16 (civic notary's collection of civic ordinances);
46b Schmiede Zunftbuch;
72a Zunftbuch der Maler, Glaser, Bildschnitzer und Goldschläger, 1498–1548.

Steuerbücher: 1498–1550

Protokolle der Dreizehn: vol. 1, 1524–6; vol. 2, 1525–9; vol. 3, 1530–; vol. 4, 1539–40.

Baumeisterbücher: 1500–48.

Strafbücher des Rats: vol. 1, 1509–26; vol. 2, 1533–9.

Stadtgerichtsbücher: 1500–50.

Urgichten: vol. 1, 1497–1522; vol. 2, 1523; vol. 3, 1524; vol. 4, 1525; vol. 5, 1527–29; vol. 6, 1530 (missing), 1531; vol. 7, 1532; vol. 8, 1533; vol. 9, 1534; vol. 10, 1535.

Handwerkerakten: Bildhauer 1509–1699;
 Briefmaler, Illuministen, Formschneider, 1529–45;
 Glaser, 1548–1645;
 Goldschläger, 1556–1690;
 Goldschmiede, 1532–80;
 Maler, 1515–1603;
 Waffenschmiede, 1541–1811.

Handwerksordnungen: A (c.1500–33); B (1548–51); C (1548–c.1570).

Ratserlasse: 1507–99.

Anschläge und Dekrete: 1522–1682.

Literalien: 1500–48.

STAATS- UND STADTBILIOTHEK AUGSBURG

Aberzhauser, Gregorius, *Liber Rerum Monasterey Sanctae Crucis. Ordinis Canonicorum Regularium Beati Augustinii, Conscriptus a Fratre Gregorio …*, 1618, Augsburg, 2 Cod. Aug. 330.

Ilsungisches Wappenbuch, 1623, 2 Cod. Aug. 452.
Krankheitsgeschichte Wolfgang Rehlinger, 2 Cod. Aug. 301.

HAUPTSTAATSARCHIV MÜNCHEN

Codex Oefeleana 214. Hs. s. 16. *Chrönikalische Aufzeichnungen zur Geschichte von Augsburg 1376– [1387]. und 1512–1542.*

Printed primary sources

Alberti, Leon Battista, *Della Pittura*, ed. J. Spencer, New Haven/London (1979).

Alciatus, Andreas, *Emblematum Liber*, Heinrich Steiner, Augsburg, 1531.

Anon., *Das büechlin ist genannt der Gilgengart ainer yetlichen Christlichen Sel …,* Augsburg, 1521.

Avila, Ludovicus de, *Ein nutzlich Regiment der Gesundtheit … durch Mich. Krantwedeln verteuscht*, Augsburg, 1531.

Barthema, *Die Ritterliche und lobwirdig Raysz … Ludowico Vartomans von Bologna, von den Landen Egypto, Syria, Arabia, Persia, India …,* Hans Miller, Augsburg, 1515.

Beatis, Antonio de, *The Travel Journal of Antonio de Beatis,* transl. and ed. J. R. Hale, London, 1979.

The Book of Hours of the Emperor Maximilian the First, decorated by Albrecht Dürer, Hans Baldung Grien, Hans Burgkmair, Jörg Breu, Albrecht Altdorfer and others. Printed 1513 by Johannes Schönsperger at Augsburg, ed. and with an introduction by W. L. Strauss, New York 1974.

Brant, Sebastian, *Narrenschiff*, ed. F. Zarncke, Leipzig, 1854.

——, *The Ship of Fools*, transl. and ed. E. H. Zeydel, New York, 1944.

Breu, Jörg, *Die Chronik des Malers Georg Preu des Älteren*, in Roth, F. (ed.), *Chronike der deutschen Städte*, vol. 29, Leipzig, 1906.

Cicero, Marcus Tullius, *Officia … Ein Buch, so M.T. Cicero … zu seinem Sune Marco geschrieben … Hrn Johannes von Schwarzenberg verteuscht*, Heinrich Steiner, Augsburg, 1531.

Erasmus von Rotterdam, *The Poems*, ed. C. Reedijk, Leiden, 1956.

Fortunatus: Von Fortunatus und seynem Seckel auch Wünschhütlein, Hans Otmar, Augsburg, 1509, ed. R. Noll-Wiemann, Hildesheim/New York, 1974.

Gafurio, F., *Theorica Musice, Impresum Mediolani per Magistrum Philippum Mantegatium dictum cassanum opera et impensa Magistri Ionnis Petri de Lomatis anno salutis 1492.*

Hutten, Ulrich von, *Schriften*, ed. E. Böcking, Leipzig, 1860.

Judd, Leo, *Ain Christenlich widerfechtung Leonis Judd wider Mathis Kretz zu Augspurg, false End christliche mess und priesterthumb, auch das prot und weyn des frohenleychnams un blut Christi kain opfer sey*, Augsburg, 1525.

Karlstadt, Andreas Bodenstein von, *Von Abtuhung der Bylder*, Wittenberg, 1522. Reprinted in *'Ohn' Ablass von Rom kann man wohl selig werden': Streitschriften und Flugblätter der frühen Reformationszeit*, Hoffmann, K., intro., Nördlingen, 1983, no. 9.

Keller, Michael, *Frag und Antwort etlicher Artickel zwischen D. Michaelen Keller, predicanten bey den parfussern und D. Mathia Kretzen, predicanten auff dem hohe stifft zu Augspurg, newlich begeben!*, Augsburg, 1525.

Kempis, Thomas à, *Orationes et meditationes de vita Christi, vol I, 2, 6. Opera Omnia*, ed. M. J. Pohl, Freiburg, 1904.

Lamm, Markus zum, *Thesaurus picturarum des Markus zumm Lamm (1544–1606)*, facsimile edition, Hessisches Landes- und Hochschulbibliothek, 23, Darmstadt, 1971.

Lotzer, Sebastian, *Ain hailsame Ermanuge an die ynwoner zu horw das sy bestendig*

beleyben an dem hailige wort Gottes mit anzaigu[n]g der göttlichen hailigen geschrifft, 1523. In Goetze, A. (ed.), *Sebastian Lotzers Schriften,* Leipzig, 1902, 36–47.

Luther Martin, *Martin Luthers Werke: Kritische Gesamtausgabe,* 40 vols, Weimar, 1883–.

Maen, Wolfgang von, *Das Leiden Jesu Christi unseres erlösers …* , Johannes Schönsperger the Younger, Augsburg, 1515.

Marschalck, Haug, *Ein Spiegel der Plinden// wan Christus der her hat geredt// Ich wird mein glory von den/ hochweisen verberge/ vnd// wird es den kleine// verkünden vnd offbaren.// Dann ee mein glory vnd eer solt undergon// es musten die steyn vnd holtz/ reden lernen. Uff solichs ist vff//gericht anzuschauwe dises Spiegel der Blinden. 1523,* Augsburg, Staats- und Stadtbibliothek, Nr. 4 Aug 881.

——, *Der hailig ewig wort gots/ was dz in Kraft/ sterke/ tugent/ frid/ fred/ erleuchtung vnnd leben/ in aym rechten/ Christen/ zuerwecken vermag/ Zu gestellt dem edlen/ gestrengen/ Riter vn kaiserliche/ hauptman/ Herrn Jorgen von Fronnsperg zu Mundelhain, Augsburg, 1523.* Augsburg, Staats- und Stadtbibliothek, Nr. 5 Aug 884.

Migne, J. P. (ed.), *Patrologia Latina,* 141 vols, Paris, 1844–64.

Milton, John, *The Complete English Poems,* ed. G. Campbell, London, 1909.

Petrarcha, Francizus, *Von der Artzney bayder Glück, des guten und widerwertigen …,* Heinrich Steiner, Augsburg, 1532.

Quintilian, M. F., *De institutione oratoria e libri duodecim ad codicum veterum fidem recensuit et annotatione explanavit,* Georg Ludovicus Spelding, Hildesheim, 1969.

Reisch, Gregorius, *Aepitome omnis phylosophiae. Alias Margarita Phylosophica … tractans de omni genere scribili …,* J. Grüninger, Strassburg, 1504.

Rem, Wilhelm, *Cronica neuer geschichten von Wilhelm Räm. Die Chroniken der deutschen Städte vom 14. bis ins 16. Jahrhundert,* in F. Roth, (ed.), Chroniken der deutschen Städte, vol. 25, Leipzig, 1896.

Russ, Wolfgang, *Waher die Bilder oder Götzen mit jrem gespreng Baid der Haiden und genanten Christen kumen,* Augsburg, 1532.

Rychssner, Utz, *Ain schöne vnderweysung/// wie vnd wirin Christo alle gebruder// vn[d] schwester seyen/ dabey angezaigt// nicht allain die weltlichen/ wie sy es//nennen/ sonder auch die gaistlichen// zu straffen/ wa sy anders in der leybe// dessen haubt Christus ist wolle sein// auff die geschrifft gotes gegründt// vn[d] daraus gezoge/ zu nutz// alle die das gotlich wort// lieben seindt. MDXXiiij, Augsburg, Staats- und Stadtbibliothek, Nr. 1964. 2379.*

——, *Ain gesprech buchlin/ von ainem Weber// vnd ainem Krämer über das Buchlin Doctoris// Mathie Kretz von der haimlichen Beycht// so er zu Avgspurg vnnser frawen// Thun gepredigt hat. im M.D.XXiij, Augsburg, Staats- und Stadtbibliothek, Nr. 4 Aug. 1136.*

——, *Ain hübsch Gesprechtbiechlein/ von aynem// Pfaffen vnd ainem Weber/ die zusamen kumen seind// auf der strass was sy für red/ frag/ vn antwort/ gegen// ainander gebraucht haben/ des Euangeliums vnd an//derer sachen halben.1524,* Sonderforschungsbereich der Universität Tübingen, Spätmittelalter und Reformation. Projekt Zl, Flugschriftenkatalog, Nr. 00983.

——, *Ayn Ausszug/ auss der// Cronika d Bapst vn// iren gesatze/ wie gleych//formig sy de gesatze gots// vn leer der apostel seyen// zu vergleichen/ auff das// kürtzest vn ainfaltigest/ zusamengefugt. 1524,* Augsburg, Staats- und Stadtbibliothek, Nr. 4 Aug. 1132.

Sachs, Hans, *Hans Sachsens Werke,* ed. A. Keller and E. Goetze, 26 vols, Tübingen, 1870–1902.

Schoen, Erhard, *Kunstbuchlein,* Nuremberg, 1542.

Sender, C., *Die Chronik von Clemens Sender von den ältesten zeiten der Stadt bis zum 1536,* Die Chroniken der deutschen Städte vom 14 bis ins 16 Jahrhundert, ed. F. Roth, vol. 23 Leipzig, 1894.

Sehling, E., *Die evangelischen Kirchenordnungen der 16. Jahrhunderts,* 12, Bayern, 2. Teil: Schwaben, Tübingen, 1963.

Speculum humanae salvationis, Gunter Zainer, Augsburg, c.1475.

Spiegel menschlicher Behaltnis, Anton Sorg, Augsburg, 1475.

Stetten, Paul von, *Kunstgeschichte der Reichstadt Augsburg*, Augsburg, 1779.

Vogtherr, Heinrich, *Ein Frembdes und wunderbarliches Kunstbüchlin/ allen Molern Biltschnitzern/ Goldschmiden/ Steynmetzen/ waffen/ und Messerschmiden hochnützlich zügebrauchen/ Dergleichen vor nie keines gesehen/ oder in der Trück kommen ist*, Strassburg, 1538.

Zwingli, Ulrich, *Hern Ulrich Zwingli leerbiechlein wie man die Knaben Christlich unterweysen und erziehen soll/ mit kurzer anzaige aynes ganzen Christlichen lebens, M.D. xxiiij*, Phillip Ulhart, Augsburg, 1524. Augsburg, Staats- und Stadtbibliothek, 4, Th. H. 2995.

——, *Ain Epistel Huldrich Zwinglis an alle christenliche bruder zu Augspurg*, 1524.

Secondary sources

Amsterdam, Rijksmuseum (1986), *Kunst voor de Beeldenstorm. Noordnederlandse Kunst 1525–1580*, ed. J. P. Filedt-Kok et al.

Antal, Friedrich (1928), 'Breu and Filippino', *Zeitschrift für bildende Kunst*, **62**, 29–37.

Anzelewsky, Fedja (1968), 'Zum Problem des Meisters des Aachener Altars', *Wallraf-Richartz Jahrbuch*, **30**, 185–200.

—— (1971), *Albrecht Dürer*, Berlin.

—— (1984), 'The Prayerbook of Emperor Maximilian I', in Guillaud, 276.

Appelbaum, S. (ed.), (1964), *The Triumph of Maximilian*, facsimile edition, New York.

Arneke, F. (1916),'Ein Augsburger Privatbrief aus der Reformationszeit', *Archiv für Reformationsgeschichte*, **13**.

Augsburg (1955), *Augusta 955–1955. Forschungen und Studien zur Kultur- und Wirtschaftsgeschichte Augsburgs*, ed. H. Rinn and C. Bauer, Augsburg.

—— (1980), *Welt im Umbruch. Augsburg zwischen Renaissance und Barok*, ed. B. Bushart et al., 3 vols, Augsburg.

—— (1993), *Die Fugger und die Musik*, ed. R. Eikelmann, Städtische Kunstsammlungen, Augsburg.

Aznar, J. C. (1991), *Guia del Museo Lazaro Galdiano*, Madrid.

Baer, C. (1993), *Die italienischen Bau- und Ornamentformen in der Augsburger Kunst zu Beginn des 16. Jahrhunderts*, Frankfurt-am Main.

Baldass, L. von (1913), 'Hans Burgkmairs Entwurf zu Jörg Erharts Reiterbildnis Kaiser Maximilians', *Jahrbuch der Kunsthistorischen Sammlungen des Allerhöchsten Kaiserhauses*, **31**, 247–334.

—— (1923), *Der Künstlerkreis um Maximilian I*, Vienna.

—— (1938), 'Albrecht Altdorfers Künstlerische Herkunft und Wirkung', *Jahrbuch der Kunsthistorischen Sammlungen in Wien*, N.F. 12, 117–56.

Balzer, B. (1973), *Bürgerliche Reformationspropaganda: die Flugschriften des Hans Sachs in den Jahren 1523–1525*, Stuttgart.

Bange, E. F. (1928), *Die Kleinplastik der deutschen Renaissance in Holz und Stein*, Florence and Leipzig.

Bartsch (1978–83), *The Illustrated Bartsch*, ed. W. L. Strauss, 48 vols, New York.

Baum, Julius (1907), 'Das alte Augsburger Rathaus', *Zeitschrift des Historischen Vereins für Schwaben und Neuburg*, **33**, 67.

—— (1923), 'Die Monatsscheiben des Älteren Breu und ihre Nachbildungen', *Altschwäbische Kunst*, 112–20.

Baumeister, E. (1933), 'Zu den Basilikenbildern des Katharinenklosters in Augsburg', *Münchener Jahrbuch*, NF 10, 1–7.

—— (1957), 'Unbekannte Zeichnungen von Jörg Breu dem Älteren', *Zeitschrift für Kunstwissenschaft*, **11**, 45–54.

Baur-Heinold, M. (1952), *Süddeutsche Fassadenmalerei*, Munich.

Baxandall, M. (1966), 'Hubert Gerard and the Altar of Christoph Fugger: the Sculpture and its Making', *Münchener Jahrbuch der bildenden Kunst*, **17**, 127–44.

—— (1980), *The Limewoood Sculptors of Renaissance Germany*, New Haven.

Beadle, R. and King, P. (eds) (1984), *York Mystery Plays. A Selection in Modern Spelling*, Oxford.

Beeh-Lustenberger, S. (1973), *Glasmalerei um 800–1900 im Hessischen Landesmuseum in Darmstadt*, 2 vols, Darmstadt.

Beenken, H. (1935), 'Beiträge zu Jörg Breu und Hans Dürer', *Jahrbuch der preußischen Kunstsammlungen*, **56**, 59–73.

Beichner, E. (1954), *The Medieval Representative of Music, Jubal or Tubalkain?*, Notre Dame, Indiana.

Bellot, J. (1967), 'Konrad Peutinger und die literarisch-künstlerischen Unternehmungen Kaiser Maximilians', *Philobiblon* **11**, 171–90.

—— (1980), 'Augsburger Buchdruck und Buchillustrationen im Zeitalter der Glaubenskämpfe', in Augsburg (1980), vol. 1, 89–94.

Benesch, O. (1928), 'Der Zwettler Altar und die Anfänge Jörg Breus', in Buchner and Feuchtmayr (1928), vol. II, 229–71.

—— (1972), *Collected Writings, volume three. German and Austrian Art of the Fifteenth and sixteenth centuries*, ed. E. Benesch, London/New York.

Benzing, J. (1982), *Die Buchdrucker des 16. und 17. Jahrhunderts im deutschen Sprachgebiet*, 2nd edn, Wiesbaden.

Berlin (1983), Staatliche Museen zu Berlin, *Kunst der Reformationszeit*, Leipzig.

—— (1977), Staatliche Museen Preußischer Kulturbesitz, *Der Mensch um 1500. Werke aus Kirchen und Kunstkammern*, Berlin.

Bernheimer, R. (1952), *Wild Men in the Middle Ages: A Study of Art, Sentiment and Demonology*, Cambridge, Mass.

Beutler, C. and Thiem, G. (1960), *Hans Holbein der Ältere, Die spätgotische Altar- und Glasmalerei*, Augsburg.

Biedermann, R. (1982), 'Jörg Breus Entwurfszeichnungen für die Orgelflügel der Fuggerkapelle', *Zeitschrift des deutschen Vereins für Kunstwissenschaft*, **36**, 28–34.

Blankenhorn, H. (1973), 'Die Renaissancephase Jörg Breu des Älteren', unpublished PhD dissertation, University of Vienna.

Blickle, P. (1975), 'Thesen zum Thema "Der Bauernkrieg" als Revolution des "gemeinen Mannes"', in P. Blickle (ed.), *Revolte und Revolution in Europa, Historische Zeitschrift, Beiheft 4*, Munich, 127–31.

Bock, E. (1921), *Katalog der Zeichnungen der Deutschen Schule im Berliner Kupferstichkabinett*, 2 vols, Berlin.

—— (1931), 'Jörg Breu der Ältere, Ein Kampf nackter Männer', *Old Master Drawings*, **5**, 74–5.

Boerlin, P. (1982), 'Hans Holbein der Aeltere: Bildnis eines Herrn mit Pelzmütze, 1513', *Pantheon*, **40**, 32–9.

Boockmann, H. (ed.) (1994), *'Kurzweil viel ohn' Maß und Ziel'. Alltag und Festtag auf den Augsburger Monatsbildern der Renaissance*, Deutsches Historisches Museum, Berlin/Munich.

Borchardt, F. (1971), *German Antiquity in Renaissance Myth*, Baltimore.

Bowles, E. A. (1977), *Musikleben im 15. Jahrhundert*, Part 8, *Musikgeschichte in Bildern*, ed. W. Bachmann, Leipzig.

Brady, T. A. jun. (1978), *Ruling Class, Regime and Reformation at Strasbourg, 1520–1555*, Leiden.

Brinckmann, A. (1907), *Die praktische Bedeutung der Ornamentstiche für die deutsche Frührenaissance, Studien zur deutschen Kunstgeschichte*, 90, Strassburg.

Brinkmann, H. (1980), *Mittelalterliche Hermeneutik*, Darmstadt.

Broadhead, P. (1981), 'International Politics and Civic Society in Augsburg during

the Era of the Early Reformation 1518–1537', unpublished PhD dissertation, University of Kent.

Bruyn Kops, C.J. De (1975), 'De Zeven werken van Barmhartigheid van de Meester van Alkmaar gerestaureerd', *Bulletin van het Rijksmuseum*, **23**, part 4, 1975, 203–26.

Buchner, E. (1928a), 'Der Ältere Breu als Maler', in Buchner and Feuchtmayr (1928), vol. II, 273–383.

—— (1928b), 'Leonard Beck als Maler und Zeichner' in Buchner and Feuchtmayr (1928), vol. II, 388–413.

—— and Feuchtmayr, K. (eds) (1928), *Beiträge zur Geschichte der deutschen Kunst*, 2 vols, Augsburg.

Buff, A. (1886), 'Augsburger Fassadenmalerei', *Zeitschrift für bildende Kunst*, 58.

—— (1892), 'Rechnungsauszüge, Urkunden und Urkundenregesten aus dem Augsburger Stadtarchiv', *Jahrbuch der Kunsthistorischen Sammlungen des Allerhöchsten Kaiserhauses*, **13**, 1–25.

—— (1893), *Augsburg in der Renaissancezeit*, Bamberg.

Burke P. (1974), *Tradition and Innovation in Renaissance Italy*, London.

Bushart, B. (1987), *Hans Holbein der Ältere*, Augsburg.

—— (1994), *Die Fuggerkapelle bei St. Anna zu Augsburg*, Augsburg.

Camille, M. (1992), *Art on the Edge*, Chicago.

Carruthers, M. (1990), *The Book of Memory. A Study of Memory in Medieval Culture*, Cambridge.

Cawley, A. C. (ed.) (1959), *Everyman and Medieval Miracle Plays*, New York.

Chapeaurouge, D. de (1960), 'Selbstmorddarstellungen im Mittelalter', *Zeitschrift für Kunstwissenschaft*, **14**, 135–46.

Chmelarz, E. (1885), 'Das Diurnale oder Gebetbuch des Kaisers Maximilian I', *Jahrbuch der Kunstsammlungen des Allerhöchsten Kaiserhauses*, **3**, 88–102.

—— (1886), 'Die Ehrenpforte des Kaisers Maximilian I', *Jahrbuch der Kunsthistorischen Sammlungen des Allerhöchsten Kaiserhauses*, **4**, 289–319.

Christensen, C. (1979), *Art and the Reformation in Germany*, Detroit.

Clasen, C.-P. (1976), *Die Augsburger Steuerbücher um 1600*, Augsburg.

—— (1984), 'Armenfürsorge in Augsburg vor dem dreißigjährigen Krieg', *Zeitschrift des Historischen Verein für Schwaben und Neuburg*, **78**, 64–115.

Clemen, O. (1937), *Die Volksfrömmigkeit des ausgehenden Mittelalters. Studien zur Religiösen Volkskunde 3*, Dresden/Leipzig.

Cohn, H. J. (1979), 'Anti-clericalism in the German Peasants' War 1525', *Past and Present*, **83**, 3–31.

Conway, C. A. (1976), 'The Vita Christi of Ludolph of Saxony ... a descriptive analysis', *Analecta Carthusiana*, **34**.

Cuneo, P.-F. (1991), 'Art and Power in Augsburg: The Art of Jörg Breu the Elder, (c.1475–1536)', unpublished PhD dissertation, North Western University, Evanston, Ill.

—— (1996), 'Propriety, Property and Politics: Jörg Breu the Elder and Issues of Iconoclasm in Reformation Augsburg', *German History*, **14** (1), 1–20.

—— (1998), *Art and Politics in Early Modern Germany. Jörg Breu the Elder and the Fashioning of Political identity ca.1475–1536*, Leiden.

Curry, W. C. (1926), *Chaucer and the Medieval Sciences*, New York.

Curtius, E. R. (1948), *Europäische Literatur und lateinisches Mittelalter*, Bern. English edn (1953): *European Literature and the Latin Middle Ages*, trans. by W. R. Trask, London.

Dehio, G. (1907),'Deutsche Kunstgeschichte und Deutsche Geschichte', *Historische Zeitschrift*, **100**, 1907.

Detroit (1983), *From a Mighty Fortress: Prints, Drawings and Books in the Age of Luther 1483–1546*, ed. C. Andersson and C. Talbot, Detroit.

Diehl, R. (1933), *Erhart Ratdolt*, Vienna.

Dirr, P. (1913), 'Studien zur Geschichte der Augsburger Zunftverfassung, 1368–1548', *Zeitschrift des Historischen Vereins für Schwaben und Neuburg*, **39**, 144–243.

Dodgson, C. (1900), 'Beiträge zur Kenntnis des Holzschnittwerkes Jörg Breu des Aelteren', *Jahrbuch der preußischen Kunstsammlungen*, **21**, 192–214.

—— (1903), 'Jörg Breu als Illustrator des Ratdoltschen Offizin', *Jahrbuch der preußischen Kunstsammlungen*, **24**, 335–37.

—— (1911), *Catalogue of Early German and Flemish Woodcuts Preserved in the Department of Prints and Drawings in the British Museum*, 2 vols, London.

—— (1916), 'The Calumny of Apelles', *Burlington Magazine*, **19**, 183–9.

—— (1934), 'Ein Miniaturwerk Jörg Breu des Jüngeren', *Münchener Jahrbuch der bildenden Kunst*, **11**, 191–210.

Dormeier, H. (1994), 'Bildersprache zwischen Tradition und Originalität. Das Sujet der Monatsbilder im Mittelalter', in Boockmann (1994).

Dörnhöffer, F. (1897), 'Ein Cyklus von Federzeichnungen mit Darstellungen von Kriegen und Jagden Maximilians I', *Jahrbuch der Kunsthistorischen Sammlungen des Allerhöchsten Kaiserhauses*, **18**, 1–55.

Dresden (1971), *Deutsche Kunst der Dürerzeit*, Kunstmuseum, Dresden.

Duffy, E. (1992), *The Stripping of the Altars. Traditional Religion in England, 1400–1580*, New Haven/London.

Egg, E. (1950), 'Der Glasmaler Gumpoldt Giltlinger', *Tiroler Heimatblätter*, **25** (3/4), 38.

Elek, A. (1931), 'A Szépmüvészeti Múzeum új szerzeményei. Képek, szobrok', *Magyar Müveszet*, **6**, 379–92.

Eser, T. (1996), *Hans Daucher. Augsburger Kleinplastik der Renaissance*, Munich/Berlin.

Evans, M. B. (1943), *The Passion Play of Lucerne. A Historical and Critical Introduction*, The Modern Language Association of America, Monograph Series 14, London.

Falk, T. (1968), *Hans Burgkmair. Studien zum Leben und Werk*, Munich.

—— (1973), 'Altarreliefs nach Entwürfen von Hans Burgkmair', *Pantheon*, **31** (1), 22–6.

—— (1976), 'Notizen zur Augsburger Malerwerkstatt des Älteren Holbeins', *Zeitschrift des deutschen Vereins für Kunstwissenschaft*, **30**, 3–20.

—— (ed.) (1980), *The Illustrated Bartsch, Vol. II, Burgkmair, Schäufelein, Cranach*, New York.

Feuchtmayr, K. (1921), 'Ein Marienbild von Jörg Breu dem Älteren', *Kunstchronik und Kunstmarkt*, NF 32, 793–801.

—— (1927), 'Viktor Kayser', in Thieme and Becker (1907–50), vol. 20, 46–7.

Fichtenau, H. (1961), *Die Lehrbücher Maximilians I und die Anfänge der Frakturschrift*, Hamburg.

Fischer, T. (1979), *Städtische Armut und Armenfürsorge im 15. und 16. Jahrhundert*, Göttingen.

Fleming, G. (1973), 'On the Origin of the *Passional Christi und Antichristi* and Lucas Cranach the Elder's Contribution to Reformation Polemics in the Iconography of the *Passional*', *Gutenberg Jahrbuch*, 351–68.

Forde, G. O. (1984), 'When the Gods Fail: Martin Luther's Critique of Mysticism', in C. Lindberg (ed.), *Piety, Politics and Ethics: Reformation Studies in Honor of George Wolfgang Forell*, Kirksville, Missouri, 15–26.

Fraenger, W. (1972), *Jörg Ratgeb. Ein Maler und Märtyrer aus dem Bauernkrieg*, Dresden.

Frankl, P. (1912), *Die Glasmalerei des 15. Jahrhunderts in Bayern und Schwaben*, Strassburg.

Freedberg, D. (1985), *Iconoclasts and their Motives*, Maarssen.

—— (1989), *The Power of Images*, Chicago.

Friedländer, M. J. (1893), 'Notiz über Albrecht Altdorfer', *Jahrbuch der preußischen Kunstsammlungen*, **14**, 22–6.

—— (1969), *Reminiscences and Reflections*, ed. R. M. Heilbrunn, trans. by R. S. Magurn, London.

Fröning, O. (n.d.), *Das Drama des Mittelalters*, Stuttgart.

Gallicus, J. (1864–76), *Scriptorum de musica medii aevi nova*, Paris.

Gamba, F. (1958), *Filippino Lippi*, Florence.

Gameson, R. (1995), *The Role of Art in the Late Anglo Saxon Church*, Oxford.

Garrard, M. (1989), *Artemisia Gentileschi*, Princeton.

Garside, C. (1966), *Zwingli and the Arts*, New Haven.

Gazette des Beaux Arts (1996), Editorial: 'Principales Acquisitions des Musées en 1995', *Gazette des Beaux Arts*, series 6, **127**, March, 102.

Geisberg, M. (1924–30), *Der Deutsche Einblatt-Holzschnitt in der ersten Hälfte des 16. Jahrhunderts*, 40 vols, Munich.

—— (1927), 'Heinrich Satrapitanus und Heinrich Vogtherr', *Buch und Schrift*, **1**, 96–100.

—— (1974), *The German Single-Leaf Woodcut: 1500–1550*, revised and ed. by W. L. Strauss, 5 vols, New York.

Giehlow, K. (1899), 'Beiträge zur Entstehungsgeschichte des Gebetbuches Kaiser Maximilian I', *Jahrbuch der Kunstsammlungen des Allerhöchten Kaiserhauses*, **18**, 33–112.

—— (1907), *Kaiser Maximilian I Gebetbuch mit Zeichnungen von Albrecht Dürer und anderen Künstler*, Vienna.

—— (1915), 'Die Hieroglyphenkunde des Humanismus in der Allegorie der Renaissance', *Jahrbuch der Kunsthistorischen Sammlungen des Allerhöchsten Kaiserhauses*, **32**, 1–218.

Goertz, H. J. (1982), 'Aufstand gegen den Priester. Antiklerikalismus und reformatorische Bewegungen', in P. Blickle (ed.), *Bauer, Reich und Reformation. Festschrift für Günther Franz zum 80. Geburtstag*, Stuttgart, 182–200.

Göhler, H. (1936), 'Der Zwettler Altar des "pictor ex Khrembs"', *Kirchenkunst*, **8**, 14–17.

Goldberg G. (ed.) (1978), *Staatsgalerie Augsburg. Städtische Kunstsammlungen, Bd 1: Altdeutsche Gemälde*, Munich.

—— (1983), *Die Alexanderschlacht und die Historienbilder des Bayerischen Herzogs Wilhelm IV und seiner Gemahlin Jacobaea für die Münchener Residenz*, Munich.

Gombrich, E. H. (1969), *In Search of Cultural History*, Oxford.

—— (1984), *Tributes. Interpreters of our Cultural Tradition*, Oxford.

Guillard, J. and M. (eds) (1984), *Altdorfer and Fantastic Realism in German Art*, New York.

Hagelstange, A. (1905/6), 'Jörg Breus Holzschnitte im Konstanzer Brevier von 1516', *Anzeiger des Germanischen Nationalmuseums*, 18/19, 3–17.

Hale, J. R. (1990), *Artists and Warfare in the Renaissance*, New Haven.

Halm, P. (1962), 'Hans Burgkmair als Zeichner, Teil 1', *Münchener Jahrbuch*, 3 F., 13, 87.

Hamburg (1983), Kunsthalle, *Luther und die Folgen für die Kunst*, ed. W. Hoffmann, Munich/Hamburg.

Hamm, B. (1981), 'Laientheologie zwischen Luther und Zwingli: Das reformatische Anliegen des Konstanzer Stadtschreibers Jörg Vögeli aufgrund seiner Schriften von 1523/4', in J. Nolte et al. (eds), *Flugschriften als Massenmedium der Reformationszeit*, Stuttgart.

Hauttmann, M. (1921), 'Dürer und der Augsburger Antikenbesitz', *Jahrbuch der preußischen Kunstsammlungen*, **42**, 34–50.

Herberger, T. (1851), 'Conrad Peutinger und seine Verhältnisse zu Kaiser Maximilian', *Jahresberichte des historischen Kreis-Vereins im Regierungsbezirke von Schwaben und Neuburg, 1851, 1850*, Augsburg, **4**, 56–72.

Herder Lexicon der Christlichen Ikonographie, ed. E. Kirschbaum, 8 vols, 1971.

Hetzer, T. (1929), *Das Deutsche Element in der italienischen Malerei*, Berlin.

Heukels, W. (1907), *Woordenboek der nederlandsche volksnamen van planten*, Uitgabe der Nederlandsche Natuurhist, Vereenig.

Hind, A. M. (1910), *Catalogue of early Italian Engravings preserved in the British Museum*, ed. S. Colvin, 2 vols, London.

Hitchcock, H. R. (1981), *German Renaissance Architecture*, Princeton.

Hoffmann, K. (1978), 'Typologie, Exemplarik und reformatorische Bildsatire', in J. Nolte et al. (eds), *Kontinuität und Umbruch. Theologie und Frömmigkeit in Flugschriften und Kleinliteratur an der Wende vom 15. zum 16. Jahrhundert. Spätmittelalter und Neue Frühzeit*, Tübingener Beiträge zur Geschichtsforschung, 2, Stuttgart, 145–77.

—— (ed. and intro.) (1983), *'Ohn' Ablass von Rom kann man wohl selig werden': Streitschriften und Flugblätter der frühen Reformationszeit*, Nordlingen.

Hoffmann, R. (1894), 'Der Maler Gumpold Giltlinger', *Zeitschrift des Historischen Vereins für Schwaben und Neuburg*, 1–2, 115–22.

Höhn, H (1924), *Nürnberger Renaissanceplastik*, Nuremberg.

Holborn, H. (1937), *Ulrich von Hutten and the German Reformation*, New Haven.

Hollstein, F. (1954), *German Engravings, Etchings and Woodcuts*, 45 vols, Amsterdam.

Holze, O. (1937/8), 'Ein Selbstbildnis Jörg Breus', *Münchener Jahrbuch der bildenen Künste*, NF 12, 38–9.

—— (1940), 'Die Kunst Jörg Breu des Älteren', *Pantheon*, **25**, January, 5–12.

Homann, H. (1971), *Studien zur Emblematik des 16. Jahrhunderts: Sebastian Brant, Andrea Alciati, Johannes Sambucus, Mathias Holtzwart, Nikolaus Taurellus*, Utrecht.

Hügelshofer, H. (1928), 'Zeichnungen aus Jörg Breus Frühzeit', in E. Buchner and K. Feuchtmayr (eds), *Beiträge zur Geschichte der deutschen Kunst*, **2**, Augsburg, 384–7.

Humphrey, P. (1993), *The Altarpiece in Renaissance Venice*, New Haven/London.

Husband, T. (1991), *Stained Glass before 1700 in American Collections: Silver-stained Roundels and Unipartite Panels.' (Corpus Vitrearum Checklist 4)*, Studies in the History of Art, 39, National Gallery of Art, Washington, Hanover/London.

Huth, H. (1967), *Künstler und Werkstatt der Spätgotik* (2nd edn), Darmstadt.

Jervis, S. (1974), *Printed Furniture Designs before 1650*, London.

Jessen, P. (1920), *Der Ornamentstich*, Berlin.

Joachimsohn, P. (1894), 'Zur städtischen und klösterlichen Geschichtsschreibung Augsburgs im 15. Jahrhundert', *Alemania*, **22**, 1–32.

—— (1910), *Geschichtsauffassung und Geschichtsschreibung in Deutschland unter dem Einfluss des Humanismus*, Leipzig/Berlin.

John, J. (1984), 'Die Augsburger Sozialstruktur im 15. Jahrhundert', in G. Gottlieb et al. (eds), *Geschichte der Stadt Augsburg*, Stuttgart, 187–201.

Katzenbach, F. W. (1974), 'Bild und Wort bei Luther in der Sprache der Frömmigkeit', *Neue Zeitschrift für systematische Theologie*, **16**.

Kaufmann, T. Dacosta (1982), 'The Eloquent Artist: Towards an Understanding of the Stylistics at the Court of Rudoph II', *Leids Kunsthistorisch Jaarboek*, **1**, 119–48.

—— (1985), *The School of Prague. Painting at the Court of Rudolph II*, Chicago/London.

—— (1993), *The Mastery of Nature. Aspects of Art, Science, and Humanism in the Renaissance*, Princeton.

Kerr, H. E. (ed.) (1943), *A Compendium of Luther's Theology*, Philadelphia.

Kiessling, R. (1971), *Bürgerliche Gesellschaft und Kirche in Augsburg im Spätmittelalter*, Augsburg.

Koch, A. (ed.) (1980), *The Illustrated Bartsch, Vol. 14, Early German Masters, Altdorfer, Monogrammists*, New York.

Koepplin, D. (1983), 'Reformation der Glaubensbilder', in W. Hoffmann (ed.), *Luther und die Folgen für die Kunst*, ex. cat., Munich/Hamburg, 115–249.

Koerner, Joseph, Leo (1993), *The Moment of Self-Portraiture in German Renaissance Art*, Chicago.

Koetschau, K. (1913), *Bartel Beham und der Meister von Messkirch*, Strassburg.

Köhler, H. J. (ed.) (1981), *Flugschriften als Massenmedium der Reformationszeit*, Stuttgart.

Köhler, J. (1986), *Der 'Emblematum liber' von Andreas Alciatus (1492–1550). Eine Untersuchung zur Entstehung*, Hildesheim.

Köln (1978), Wallraff-Richartz Museum, *Die Heilige Ursula und ihre Elftausend Jungfrauen*, Cologne.

—— (1993), Wallraff-Richartz Museum, *Stefan Lochner, Meister zu Köln. Herkunft, Werke, Wirkung*, ed. F. G. Zehnder, Cologne.

Krämer, G. (1980a), 'Jörg Breu der Ältere als Künstler und Protestant', in Augsburg (1980), vol. 3, 115–33.

—— (1980b), 'Malerei in Augsburg, 1560–1610', in Augsburg (1980), vol. 2, 31–5.

—— (2000), 'Zu zwei Gemälden von Jörg Breu den Älteren ans Jahre 1509: Verkündigung an Maria – Anbetung der Könige', in F. M. Kammel and E. B. Gries (eds), *Begegnungen mit Alten Meistern. Altdeutsche Tafelmalerei auf dem Prüfstand*, Nuremberg.

Kramer-Schlette, C. (1970), *Vier Augsburger Chronisten der Reformationszeit: Die Behandlung und Deutung der Zeitsgeschichte bei Clemens Sender, Wilhelm Rem, Georg Preu und Paul Hektor Mair*, Lübeck/Hamburg.

Kraske, R. E. (1959), 'The Summoner's Garleek, Oynons and eek Lekes', *Modern Language Notes*, **74**, June, 481–4.

Kriss-Rettenbeck, L. (1975), 'Jörg Breus "Apostelteilung" und die Überlieferung hochmittelalterlicher Steckkreuze', *Die Anregung. Beiheft: Geschichte*, Munich, 22–34.

Kunze, H. (1975), *Geschichte der Buchillustration in Deutschland, vol. 1, Das 15. Jahrhundert*, Leipzig.

Kurth, W. (ed.) (1963), *The Complete Woodcuts of Albrecht Dürer*, New York.

Kurze, D. (1958), *Prophecy and History: Lichtenberger's prophecies of things to come from the 15th to the 20th centuries: their reception and diffusion*, London.

Lanckoroñscka, M. (1958), *Die christlich-humanistische Symbolsprache und deren Bedeutung in zwei Gebetbüchern des frühen 16. Jahrhunderts*, Baden-Baden.

Landau, D. and Parshall, P. (1994), *The Renaissance Print 1470–1550*, New Haven/London.

Laube, A. et al. (eds) (1983), *Flugschriften der frühen Reformationsbewegung, 1518–24*, 2 vols, Berlin.

Lausberg, H. (1960), *Handbuch der literarischen Rhetorik*, 2 vols, Munich.

Leidinger, G. (1923), *Albrecht Dürers und Lukas Cranachs Randzeichnungen zum Gebetbuch Kaiser Maximilians in der Bayerischen Staatsbibliothek zu München*, Munich.

Leipzig (1973), *Altdeutsche und altniederländische Meister der 15. und 16. Jahrhunderts*, Museum der bildenden Künste, Leipzig.

Levenson, J. A., Oberhuber, K. and Sheehan, J.L. (1973), *Early Italian engravings from the National Gallery of Art*, National Gallery of Art, Washington.

Lieb, N. (1952), *Die Fugger und die Kunst*, Munich.

—— (1959), 'Augsburgs Anteil an der Kunst der Maximilianzeit', in *Jakob Fugger, Kaiser Maximilian und Augsburg 1459–1959*, Stadt Augsburg, Augsburg, 59–76.

—— and Stange, A. (1960), *Hans Holbein der Ältere*, Munich.

Los Angeles (2000), The J. Paul Getty Museum, *Painting on Light. Drawings and Stained Glass in the Age of Dürer and Holbein*, ed. B. Butts and L. Hendrix, Los Angeles.

Lübbeke, I. (1991), *The Thyssen-Bornemisza Collection. Early German Painting 1350–1550*, London.

Lutz, H. (1984), 'Die Sodalitäten im oberdeutschen Humanismus des späten 15. und 16. Jahrhunderts', in W. Reinhard (ed.), *Humanismus im Bildungswesen des 15. und 16. Jahrhunderts*, 45–60.

Lutz, R. (1979), *Wer war der gemeine Mann? Der dritte Stand in der Krise des Spätmittelalters*, Munich/Vienna.

Lutze, E. and Wiegand, E. (eds) (1937), *Kataloge des Germanischen Nationalmuseums zu Nürnberg. Die Gemälde des 13. bis 16. Jahrhunderts*, 2 vols, Leipzig.

Mâle, E. (1982), *Religious Art from the Twelfth to the Eighteenth Century*, Princeton.

Marrow, J. (1979), *Passion Iconography in Northern European Art of the Late Middle Ages and Early Renaissance: A Study of the Transformation of Sacred Metaphor into Descriptive Narrative*, Ars Neerlandica, 1, Kortrijk.

—— et al. (eds) (1981), *The Illustrated Bartsch, Vol. 12, Baldung, Springinklee, Van Leyden*, New York.

Massing, J. M. (1991), *Du Texte à l'Image. La Calomnie d'Apelle*, Strassburg.

Meller, S. (1928), 'Ein unbekanntes Werk Viktor Kaysers im Budapester Nationalmuseum', in Buchner and Feuchtmayr (1928), vol. I, 440–42.

Mellinkoff, R. (1993), *Outcasts. Signs of Otherness in Northern European Art of the Later Middle Ages*, 2 vols, Berkeley.

Mende, M. (ed.) (1979), *Das alte Nürnberger Rathaus. Baugeschichte und Ausstattung des großen Saals und der Ratstuben*, vol. 1, Nuremberg.

Menz, C. (1982), *Das Frühwerk Jörg Breus des Älteren*, Augsburg.

Metzger, T. and M. (1985), *Jewish Life in the Middle Ages. Illuminated Hebrew Manuscripts of the Thirteenth to the Sixteenth Centuries*, London/New York.

Miedema, H. (1968), 'The term "emblema" in Alciati', *Journal of the Warburg and Courtauld Institutes*, **31**, 234–50.

Miles, M. R. (1985), *Image as Insight: Visual Understanding in Western Christianity and Secular Culture*, Boston.

Moeller, B. (1977), *Deutschland im Zeitalter der Reformation*, Göttingen.

Morrall, R. A. (1993), 'Saturn's Children: a Glass Panel by Jörg Breu the Elder in the Burrell Collection', *Burlington Magazine*, March, 212–14.

—— (1994), 'Die Zeichnungen für den Monatszyklus von Jörg Breu d. Ä. Maler und Glashandwerker im Augsburg des 16. Jahrhunderts', in H. Boockmann (ed.), *'Kurzweil viel ohn' Maß und Ziel'. Alltag und Festtag auf den Augsburger Monatsbildern der Renaissance*, Berlin/Munich.

—— (1996), 'Jörg Breu the Elder (c.1475–1537). Renaissance and Reformation in early sixteenth-century Augsburg', unpublished PhD dissertation, Courtauld Institute, London University.

—— (1998a), 'Defining the Beautiful in early Renaissance Germany', in F. Ames-Lewis and R. Rogers (eds), *Concepts of Beauty in Renaissance Art*, Aldershot, 80–91.

—— (1998b), 'The *Deutsch* and the *Welsch*. Jörg Breu the Elder's sketch for the *Story of Lucretia* and the uses of classicism in sixteenth century Germany', in S. Currie (ed.), *Drawing 1400–1600. Invention and Innovation*, Aldershot, 109–31.

—— (1998c), 'Heinrich Vogtherr the Elder': review of F. Muller: 'Heinrich Vogtherr l'Ancien', *Print Quarterly*, **xv** (3), 317–19.

Moser, J. H. (1929), *Paul Hofhaimer, ein Lied- und Orgelmeister des deutschen Humanismus*, Stuttgart/Berlin.

Moxey, K. (1989), *Peasants, Warriors, and Wives: Popular Imagery in the Reformation*, Chicago.

Muller, F. (1987), 'Heinrich Vogtherr, alias Heinricus Satrapitanus, alias the "Master H.S. with the Cross"', *Print Quarterly*, **4**, 274–82.

—— (1990), 'Heinrich Vogtherr der Ältere (1490–1556). Aspekte seines Lebens und Werkes', *Jahrbuch des Historischen Vereins Dillingen an der Donau*, **92**, 172–275.

—— (1997), *Heinrich Vogtherr l'Ancien. Un artiste entre Renaissance et Réforme*, Wolfenbütteler Forschungen, 72, Wiesbaden.

Müller, J. (1923), *Rheinisches Wörterbuch*, Bonn/Berlin.

Munich (1960), Münchener Stadtmuseum. *Bayerische Frömmigkeit: 1400 Jahre Christliches Bayern*, Munich.

Musper, T. (1921/22), 'Der Anteil der Augsburger am Gebetbuch des Kaiser Maximilians I', *Münchener Jahrbuch*, **12**, 130–37.

Nauck, E. T. (1969), 'Dr Sigmund Grimm, Arzt und Buchdrucker zu Augsburg', *Zeitschrift des Historischen Vereins für Schwaben und Neuburg*, 59/60, 131f.

Nicholas, L. H. (1994), *The Rape of Europa. The Fate of Europe's Treasures in the Third Reich and the Second World War*, London.

Nordenfalk, C. (1951), 'The Beginning of Book Decoration', in O. Goetz (ed.), *Essays in Honour of Georg Swarzenski*, Chicago, 1–15.

Nuremberg (1971), *Albrecht Dürer 1471–1971*, ed. P. Strieder, Germanisches Nationalmuseum, Nürnberg, Munich.

Oberhammer, V. (1935), *Die Bronzestandbilder des Maximiliansgrabmals in der Hofkirche zu Innsbruck*, Innsbruck.

Oberheide, A. (1933), 'Der Einfluß Marcanton Raimondis auf die nordische Kunst des 16. Jahrhunderts', unpublished PhD thesis, University of Hamburg.

Os, H. W. van (1994), *The Art of Devotion in the Later Middle Ages in Europe, 1300–1500*, Princeton.

Osten, G. van der (1953), 'Job and Christ', *Journal of the Warburg and Courtauld Institutes*, **16**, 153–8.

Otwinsoka, B. (1976), 'Der "Gemeine Mann" als Adressat der volkssprachlichen Literatur in der Renaissance' in R. Weimann et al. (eds), *Renaissance Literatur und frühbürgerliche Revolution*, Berlin/Weimar, 194–202.

Ozment, S. (1973), *Mysticism and Dissent. Religious Ideology and Social Protest in the Sixteenth Century*, New Haven.

Ozment, S. (1975), *The Reformation in the Cities*, New Haven.

Panofsky, D. (1943), 'The Textual Basis of the Utrecht Psalter's Illustrations', *Art Bulletin*, **25**, 50–58.

Panofsky, E. (1969), 'Erasmus and the Visual Arts', *Journal of the Warburg and Courtauld Institutes*, **32**, 213–14.

—— (1971), *The Life and Art of Albrecht Dürer*, 4th edn, Princeton.

Paris (1993), *Chefs-d'oeuvre du Musée des Beaux-Arts de Leipzig*. Musée du Petit Palais, 10 sept.–5 déc., 1993, Paris.

Parker, K. T. (1926), *Drawings of the Early German Schools*, London.

Pegg, M. (1973), *A Catalogue of German Reformation Pamphlets (1516–46) in Libraries in Great Britain and Ireland*, Baden-Baden.

Pfeiffer, G. (1966), 'Das Verhältnis von politischer und kirchlicher Gemeinde in den deutschen Reichsstädten', in W. Fuchs (ed.), *Staat und Kirche im Wandel der Jahrhunderte*, Stuttgart, 147f.

Pfeiffer, W. (1955), 'Conrad Peutinger und die Humanistische Welt', in Augsburg (1955), 179–88.

—— (1965), 'Der Entwurf zu einem Augsburger Renaissancerelief', *Anzeiger des Germanischen Nationalmuseums*, 120–26.

Po-chia Hsia, R. (1988), *The Myth of Ritual Murder. Jews and Magic in Reformation Germany*, New Haven/London.

Radocsay, D. (1963), *Gothic Panel Painting in Hungary*, Budapest.

Randall, L. (1966), *Images in the Margins of Gothic Manuscripts*, Berkeley.

Rasmussen, Jörg (1980), 'Bildersturm und Restauration', in Augsburg (1980), vol. 3, 95–114.

Rauch, M. (1973), *Zwei Jahrtausende Farb und Stein: Augsburger Baugeschichte im Wandel der Zeit*, Augsburg.

Reeve, M. (1969), *The Influence of Prophecy in the Later Middle Ages. A Study in Joachimism*, London.

Reuter, F. (1987), *Warmaisa. 1000 Jahre Juden in Worms*, Frankfurt am Main.

Riedmüller, L. (1916–19), 'Ein vergessenes Freskobild des älteren Jörg Breus', *Archiv für die Geschichte des Hochstifts Augsburg*, **5**, 629–31.

Riehl, B. (1912), *Bayerns Donautal*, Leipzig and Munich.

Riess, H. (1934), *Motive des Patriotischen Stolzes bei den Deutschen Humanisten*, Berlin.

Ringbom, S. (1969), 'Devotional Images and Imaginative Devotions: Notes on the Place of Art in Late-Medieval Piety', *Gazette des Beaux-Arts*, series 6, 73, 159–70.

Roeck, Bernd (1995), 'Kulturelle Beziehungen zwischen Augsburg und Venedig in der Frühen Neuzeit', in *Augsburg in der Frühen Neuzeit. Beiträge zu einem Forschungsprogramm* (Colloquia Augustana vol. 1), ed. J. Brüning and F. Niewöhner, Berlin, 421–34.

—— (1999), 'Venice and Germany: Commercial Contacts and Intellectual Inspirations', in B. Aikema and B. L. Brown (eds), *Renaissance Venice and the North. Crosscurrents in the Time of Bellini, Dürer and Titian*, New York, 44–55.

Roh, J. (1955), 'Jörg Breus kleine Orgelflügel in der Fuggerkapelle zu Augsburg', *Die Kunst und das schöne Heim*, 53, 164–7.

Roper, L. (1989), *The Holy Household. Women and Morals in Reformation Augsburg*, Oxford.

Rose, P. A. (1977), *Wolf Huber Studies. Aspects of Renaissance Thought and Practice in Danube School Painting*, New York/London.

Rosenberg, A. (1875), 'Georg Prew', *Kunstchronik*, 10, 388–92.

Rosenberg, J. (1938), *Old Master Drawings*, 21, 46.

Roth, F. (1881f.), *Augsburgs Reformationsgeschichte 1517–1537*, 4 vols, Munich.

—— (1900), 'Wer war Haug Marschalk genannt der Zoller von Augsburg?', *Beiträge zur bayerischen Kirchengeschichte*, 6, 229–34.

Rott, H. (1905), *Ottheinrich und die Kunst*, Heidelberg.

Röttinger, H. (1908), 'Zum Holzschnittwerk Jörg Breus des Älteren', *Repertorium für Kunstwissenschaft*, 31, 48–62.

—— (1909),'Breu-Studien', *Jahrbuch der Kunstsammlungen des Allerhöchsten Kaiserhauses*, 28, 31–91.

—— (1910), 'Jörg Breu der Ältere', in Thieme and Becker (1907–54), vol. 4, 594–6.

Rowlands, J. (1984), *German Drawings from a Private Collection*, London.

—— (1988), *The Age of Dürer and Holbein. German Drawings 1440–1550*, London.

—— (1993), *Drawings by German Artists and Artists from German-Speaking Regions of Europe in the Department of Prints and Drawings in the British Museum. The Fifteenth Century and the Sixteenth Century by Artists born before 1530*, 2 vols, London.

Rupé, H. (1923), 'Hans Burgkmair the Elder as an Illustrator of Books', *Print Collector's Quarterly*, 10, 167.

Rupprich, H. (1954), *Das Wiener Schrifftum des ausgehenden Mittelalters*, Vienna.

—— (1956–69), *Dürers Schriftlicher Nachlass*, 3 vols, Berlin.

Russell, P. A. (1986), *Lay Theology in the Reformation. Popular Pamphleteers in South West Germany 1521–25*, Cambridge.

Sack, V. (1988), *Glauben im Zeitalter des Glaubenkampfes. Schriften der Universitätsbibliothek, Freiburg im Breisgau*, Freiburg im Breisgau.

Schade, W. (1974), *Die Malerfamilie Cranach*, Dresden.

Scheidig, W. (1955), *Die Holzschnitte des Petrarca-Meisters*, Berlin.

Schestag, F. (1883), 'Der Triumph Kaisers Maximilians I', *Jahrbuch der Kunsthistorischen Sammlungen des Allerhöchsten Kaiserhauses*, 1, 154–81.

Schindler, H. (1985), *Augsburger Renaissance. Bavarica Antiqua 24*, Munich.

Schmelzing, W. H. von (1936), 'Geschichtliche Beiträge zu Kunstwerken des deutschen Museums in Berlin: Madonna mit Heiligen, gemalt für die Marienkapelle des Schlosses Reichenstein', *Jahrbuch der preußischen Kunstsammlungen*, 57, 10–14.

Schmid, H. (1893–94), 'Jörg Breu der Ältere und Jörg Breu der Jüngere', *Zeitschrift für bildende Kunst*, NF 5, 21–4.

Schmidt, C. (1879), *Histoire littéraire de l'Alsace*, Strasbourg.

Schmidt, H. (1958), *Die deutschen Stadtchroniken als Spiegel des bürgerlichen Selbstverständnisses im Spätmittelalter*, Göttingen.

Schmidt, J. (1977), *Lestern, Lesen und Lesen Hören*, Bern.

Schmidt, W. (1896), 'Notizen zu deutschen Malern', *Repertorium für Kunstwissenschaft*, **19**, 285–7.

—— (1900), *Handzeichnungen Alter Meister im Königlichen Kupferstich Kabinett zu München*, ix Lieferung, Munich.

—— (1903), 'Notizen zu Georg Breu, Caspar de Crayer, Franciabigio', *Repertorium für Kunstwissenschaft*, **26**, 133–5.

—— (1910), 'Gemälde aus der Sammlung Röhrer', *Monatshefte für Kunstwissenschaft*, **3**, 141–4.

Schmits van Waesberghe, J. (1966), 'Singen und Dirigieren der mehrstimmigen Musik im Mittelalter', in *Mélanges offerts à René Crozet*, Poitiers, 1345.

Schmitz, H. (1913), *Die Glasgemälde des Königlichen Kunstgewerbemuseums in Berlin. Mit einer Einführung in die Geschichte der deutschen Glasmalerei*, 2 vols, Berlin.

—— (1923), *Deutsche Glasmalereien der Gotik und Renaissance: Rund-und Kabinettscheiben*, Munich.

Schöne, A. (1968), *Emblematik und Drama im Zeitalter des Barock*, 2 vols.

Schott, E. (1878), 'Beiträge zu der Geschichte des Carmelitenklosters und der Kirche von St Anna in Augsburg', *Zeitschrift des Historischen Vereins für Schwaben und Neuburg*, **7**, 205f.

Schottenloher, K. (1921), *Philip Ulhart, ein Augsburger Winkeldrucker und Helfershelfer der 'Schwärmer' und 'Wiedertäufer' (1523–29)*, Munich.

Schröder, A. (1893), 'Beiträge zum Lebensbilde Dr Otmar Nachtgalls', *Historisches Jahrbuch der Görres-Geschichte*, **14**, 83–106.

Schuhbert, F. (1955), 'Die Reformation in Augsburg', in Augsburg (1955), 283–300.

Schuster, P. K. (1983), 'Abstraktion, Agitation und Einfühlung: Formen protestantischer Kunst im 16. Jahrhundert, in Hamburg (1983), 115–249.

Scribner, R. W. (1981), 'Fluggblatt und Analphabetentum: Wie kam der gemeine Mann zu Reformatorischen Idee?', in H.-J. Köhler (ed.), *Flugschriften als Massenmedium der Reformationszeit*, Stuttgart, 65–76.

—— (1982), *For the Sake of Simple Folk. Popular Propaganda for the German Reformation*, Cambridge.

—— (1987), *Popular Culture and Popular Movements in Reformation Germany*, London.

—— (1989), 'Popular Piety and Modes of Visual Perception in Late-Medieval and Reformation Germany', *Journal of Religious History*, **15** (4), 448–69.

Sieh-Burens, K. (1986), *Oligarchie, Konfession, und Politik im 16. Jahrhundert: Zur sozialen Verflechtung der Augsburger Bürgermeister und Stadtpfleger*, Munich.

Silver, L. (1983), 'Forest Primeval: Albrecht Altdorfer and the German Wilderness Landscape', *Simiolus*, **13** (1), 4–43.

Springer, A. (1860), 'Die dramatischen Mysterien und die Bildwerke des späten Mittelalters', in *Mitteilungen der Zentralkommission zur Erforschung und Erhaltung der Baudenkmale*, **5**, 125–51.

Stange, A. (1964), *Malerei der Donauschule*, Munich.

—— (1967), 'Gedanken über Jörg Breus Werke und Wege (anläßlich eines bislang unbekannten Madonnenbildes)', *Jahrbuch der Staatlichen Kunstsammlungen in Baden-Württemberg*, **4**, 20.

Steif, M. (1930–31), 'Zwei frühe Fresken bei den Minoriten in Brünn', *Zeitschrift für bildende Kunst*, **64**, 221–5.

—— (1931), 'Jörg Breus Fresken im Ölmützer Dom', in H. Trenkwald et al. (eds), *Festschrift für E.W. Braun*, Augsburg, 62–9.

Steingräber, E. (1928), 'Süddeutsche Goldemailplastik der Frührenaissance', in Buchner and Feuchtmayr (1928), vol. I, 223–33.

Steingräber, E. (ed.) (1986), *Alte Pinakothek, München, Katalog der Bayerischen Staatsgemäldesammlungen*, Munich.

Stiassny, R. (1893), 'Jörg Breu von Augsburg', *Zeitschrift für christliche Kunst*, **6**, 289–98.

—— (1894), 'Jorg Breu von Augsburg', *Zeitschrift für christliche Kunst*, **7**, 101–20.

—— (1897–98), 'Jörg Breu und Hans Knoder', *Zeitschrift für bildende Kunst*, NF 9, 296–8.

Stift Florian-Linz (1965), *Die Kunst der Donauschule, 1490–1540*, Stift Florian-Linz.

Strauss, W. L. (ed.) (1973), *The Complete Engravings, Etchings and Drypoints of Albrecht Dürer*, 2nd edn, New York.

—— (1974a), *The Book of Hours of the Emperor Maximilian I*, New York.

—— (1974b), *The Complete Drawings of Albrecht Dürer*, 6 vols, New York.

Tavel, H. C. von (1965), 'Die Randzeichnungen Dürers im Gebetbuch Maximilians', *Münchener Jahrbuch*, **16**, 55–120.

Tervarent, G. de (1931), *La Légende de Sainte Ursule dans la Litérature et l'Art du Moyen Age*, 2 vols, Paris.

Thieme, U. and Becker, F. (eds) (1907–50), *Allgemeines Lexikon der bildenden Künstler von der Antike zu Gegenwart*, ed. H. Vollmer, 37 vols, Leipzig.

Tiedemann, H. (1931), *Tacitus und das Nationalbewußtsein der deutschen Humanisten*, Berlin.

Thomas, K. V. (1995), 'English Protestantism and Classical Art', in L. Gent (ed.), *Albion's Classicism. The Visual Arts in Britain 1350–1660*, New Haven and London.

Thöne, F. (1936), *Tobias Stimmer. Handzeichnungen mit einen Überblick über sein Leben und sein gesamtes Schaffen*, Freiburg-im-Breisgau.

Tietze, H. and Tietze-Konrat, E. (1932), 'Neue Beiträge zur Dürerforschung', *Jahrbuch der Kunstsammlungen des Allerhöchsten Kaiserhauses*, NF 6, 135–8.

Urbach, Suzan (1987), 'Research Report on Examinations of Underdrawings in some Early Netherlandish and German Panels in the Budapest Museum of Fine Art', in H. Verougstraete-Marcq and R. Van Schoute (eds), *Le Dessin Sous-Jacent Dans La Peinture, Colloque VI*, Louvain-la-Neuve, 45–62.

Vetter, E. W. and Brockhaus, C. (1972), 'Das Verhältnis von Bild und Text in Dürers Randzeichnungen zum Gebetbuch Kaiser Maximilians', *Anzeiger des Germanischen Nationalmuseums*, 70–120.

Vischer, R. (1886), *Studien zur Kunstgeschichte*, Stuttgart.

Volkmann, L. (1923), *Bilderschriften der Renaissance: Hieroglyphik und Emblematik in ihren Beziehungen und Fortwirkungen*, Leipzig.

Walker, J. (1933), 'A note on Cristofano Robetta and Filippino Lippi', *Bulletin of the Fogg Museum*, 33–5.

Wandel, L. P. (1990), 'Iconoclasts in Zurich', in R. W. Scribner (ed.), *Bilder und Bildersturm im Spätmittelalter und in der frühen Neuzeit*, Arbeitsgespräch, Wolfenbüttel, Wolfenbüttel, 125–41.

Wayment, H. G. (1979), 'The Great Windows of King's College Chapel and the Meaning of the Word "Vidimus"', *Proceedings of the Cambridge Antiquarian Society*, **69**, 365–76.

Weber, D. (1984), *Geschichtsschreibung in Augsburg: Hektor Mülich und die reichsstädtische Chronistik des Spätmittelalters*, Würzburg.

Webster, J. W. C. (1938), *The Labors of the Months in Antique and Medieval Art to the End of the Twelfth Century*, Evaston, Illinois.

Wegner, W. (1954), 'Ein Schwert von Daniel Hopfer im Germanischen Nationalmuseum in Nürnberg', *Münchener Jahrbuch*, **5**, 124–30.

—— (1959), 'Die Scheibenrisse für die Familie Höchstetter von Jörg Breu dem Älteren und deren Nachfolge', *Zeitschrift für Kunstgeschichte*, **22**, 17–36.

Wehmer, C. (1940), *Hans Schönsperger der Drucker Kaiser Maximilians. Altmeister der Druckschrift*, Frankfurt am Main.

—— (1955), '"Ne Italo Cedere Videamur"', in Augsburg (1955), 145–72.

—— (1962), 'Mit Gemäl und Schrift. Kaiser Maximilian und der Buchdruck', in *Libro Humanitas, Festschrift für W. Hoffmann*, Stuttgart, 244–75.

Wescher-Kauert, H. (1924), 'Das Ende der altdeutschen Malerei und die antiklassische Strömung', *Cicerone*, 996–9.

Wilhelm, J. (1983), *Augsburger Wandmalerei 1368–1530. Künstler, Handwerker und Zunft. Abhandlungen zur Geschichte der Stadt Augsburg* 29, Augsburg.

Winkler, F. (1936–39), *Die Zeichnungen Albrecht Dürers*, 4 vols, Berlin.

—— (1941), 'Die Holzschnitte von Hans Suess von Kulmbach', *Jahrbuch der Preußischen Sammlungen*, 62, 19–20.

—— (1957), *Albrecht Dürer, Leben und Werk*, Berlin.

Winternitz, E. (1965), 'Muses and Music in a Burial Chapel. An interpretation of Filippino Lippi's Window Wall in the Capella Strozzi', *Mitteilungen des Kunsthistorischen Institutes in Florenz*, **11**, Part 4, 277.

Winzinger, F. (1972–73), *Die Miniaturen zum Triumphzug Kaiser Maximilians I*, 2 vols, Vienna/Graz.

Wittkower, R. (1987), *Allegory and the Migration of Symbols*, London.

Wöllflin, H. (1931), *Italien und das deutsche Formgefühl*, München.

Wood, C. S. (1993), *Albrecht Altdorfer and the Origins of Landscape*, Chicago.

Zehnder, F. G. (1985), *Sankt Ursula. Legende-Verehrung-Bilderwelt*, Cologne.

Zimmermann, E. (1985), *Augsburg und sein Rathaus. Eine Dokumentation*, Augsburg.

Zimmermann, H. (1863), 'Urkunden und Regesten aus dem Kaiserlichen und Königlichen Haus, Hof, und Staatarchiv in Wien', *Jahrbuch der Kunsthistorischen Kunstsammlungen der Allerhöchsten Kaiserhauses*, **1**, part 2, 65, no. 400.

Zschelletzschy, H. (1975), *Die drei gottlosen Maler*, Leipzig.

Index

Page references in *italic* type indicate illustrations

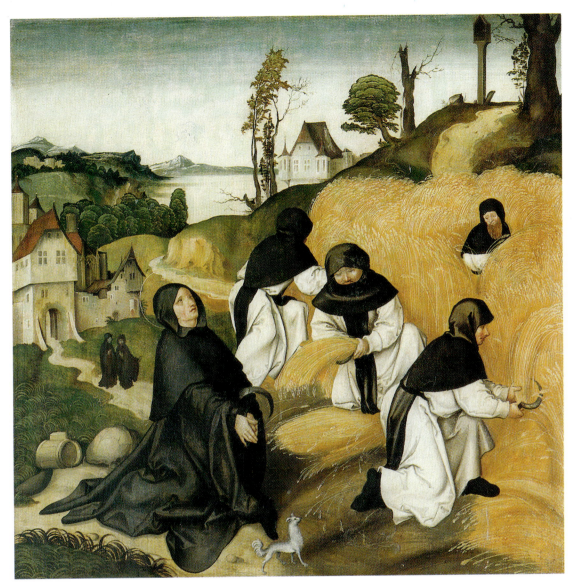

1 *St Bernard in the Fields*, oil on panel, inner wing, Zwettl Altarpiece

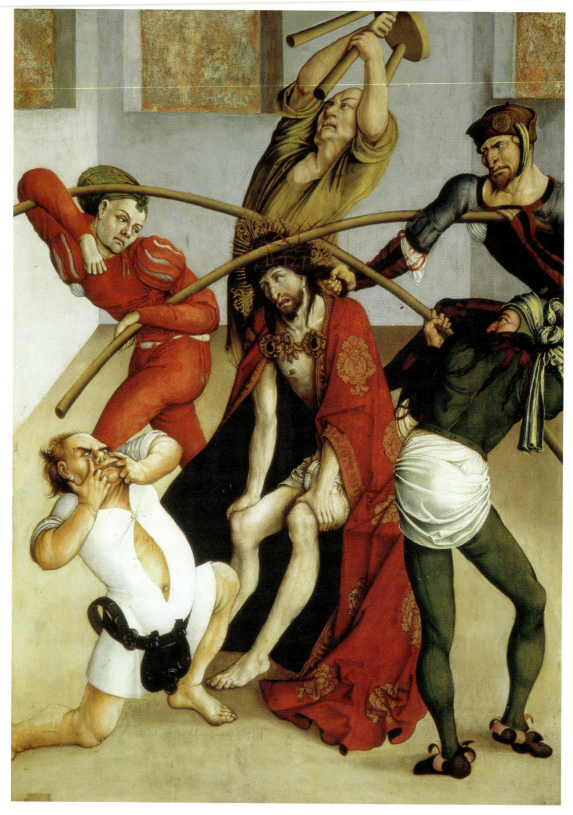

2 *The Crowning of Thorns*, oil on panel, outer wing, Melk Altarpiece

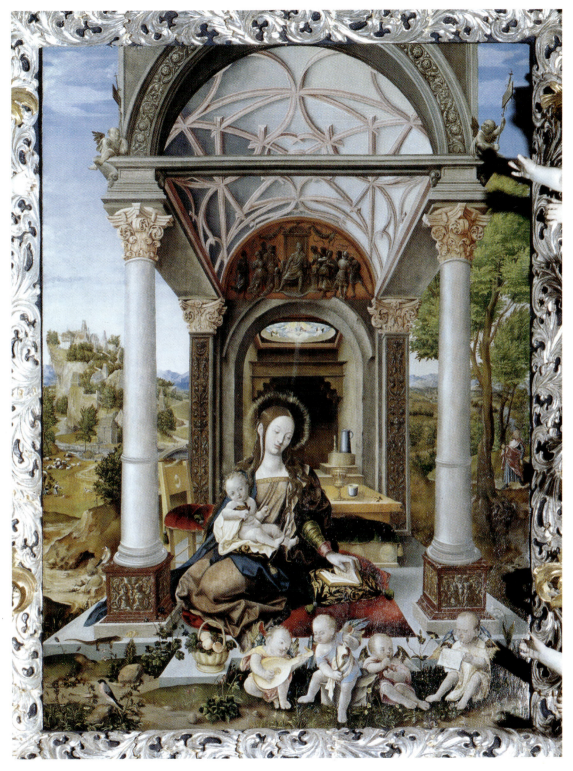

3 *Madonna and Child*, oil on panel

4 *The Month of June*, pen and black and brown ink

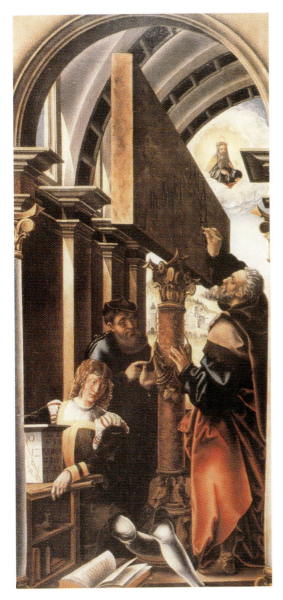

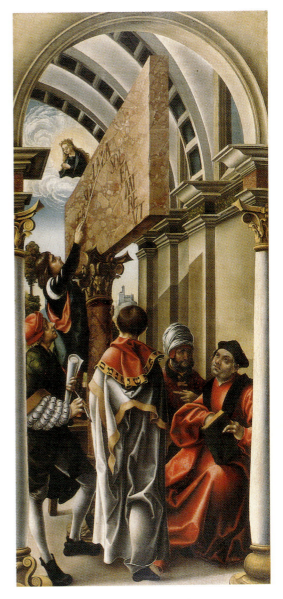

5 *The Discovery of Music*, small organ
shutter, oil on panel

6 *The Dissemination of Music*, small organ
shutter, oil on panel

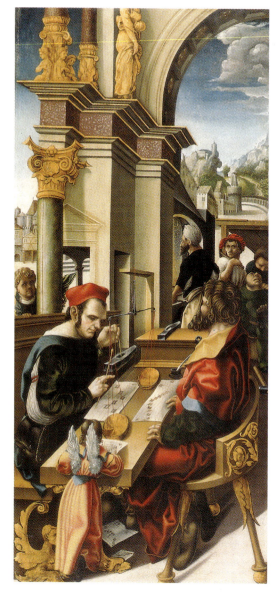 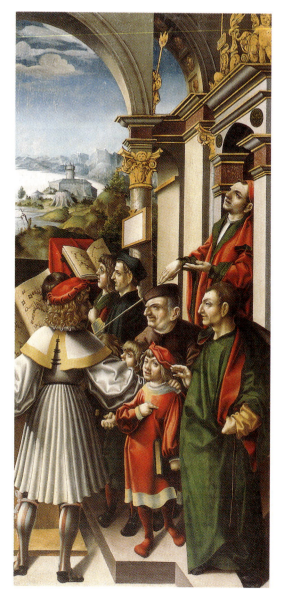

7 *Pythagoras in the Blacksmith's Shop*, small organ shutter, oil on panel

8 *Choir Scene*, small organ shutter, oil on panel

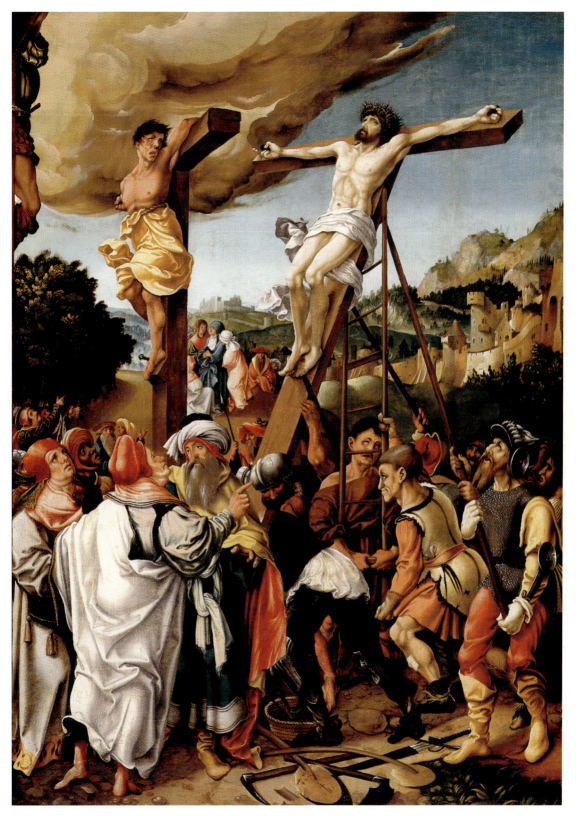

9 *The Raising of the Cross*, monogram and dated 1524, oil on panel

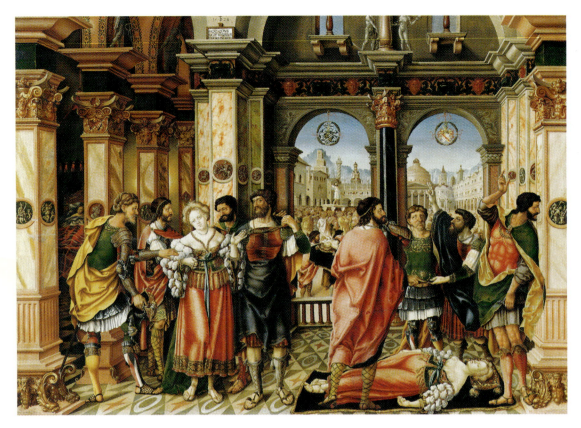

10 *The Story of Lucretia*, 1528, oil on panel